LANDSCAPE AND VISION IN NINETEENTH-CENTURY BRITAIN AND FRANCE

Landscape and Vision in Nineteenth-Century Britain and France

Michael Charlesworth

ASHGATE

Published by
Ashgate Publishing Limited
Gower House
Croft Road
Aldershot
Hampshire GU11 3HR
England

Ashgate Publishing Company
Suite 420
101 Cherry Street
Burlington, VT 05401-4405
USA

Ashgate website: http://www.ashgate.com

British Library Cataloguing in Publication Data
Charlesworth, Michael, Dr
 Landscape and vision in nineteenth-century Britain and
 France
 1. Landscape in art 2. Gardens in art 3. Arts, British -
 19th century - Themes, motives 4. Arts, French - 19th
 century - Themes, motives
 I. Title
 700.4′2

Library of Congress Cataloging-in-Publication Data
Charlesworth, Michael, Dr.
 Landscape and vision in nineteenth-century Britain and France / Michael
 Charlesworth.
 p. cm.
 Includes bibliographical references and index.
 ISBN 978-0-7546-5664-7 (hardcover : alk. paper)
 1. Landscape in art. 2. Gardens in art. 3. Arts, British--19th century--
 Themes, motives. 4. Arts, French--19th century--Themes, motives.
 5. Perception. I. Title.

 NX650.L34C43 2008
 700′.42094109034--dc22

 2007015606

ISBN: 978-0-7546-5664-7

Printed and bound in Great Britain by MPG Books Ltd, Bodmin, Cornwall.

Contents

Illustrations

Colour plates

1 Caspar David Friedrich, *Morning in the Riesengebirge*, 108 × 170 cm (43 × 67 inches), oil on canvas, 1810, Schloss Charlottenburg, Berlin: Stiftung Preußischer Schlösser und Gärten Berlin-Brandenburg

2 J.M.W. Turner, *Vision of Medea*, 173.5 × 249 cm (68 × 98 inches), oil on canvas, 1828, Tate Gallery, London / Art Resource, NY

3 J.M.W. Turner, *Slave Ship (Slavers Throwing Overboard the Dead and Dying – Typhoon Coming on)*, 90.8 × 122.6 cm (35¾ × 48¼ inches), oil on canvas, 1840, Museum of Fine Arts, Boston, Henry Lillie Pierce Fund, 99.22 Photograph © 2008 Museum of Fine Arts, Boston

4 William Dyce, *Pegwell Bay: A Recollection of October 5th, 1858*, 63.5 × 89 cm (25 × 35 inches), oil on canvas, 1860, Tate Gallery, London / Art Resource, NY

5 'China' in the garden at Biddulph Grange, Staffordshire, late 1850s. Photo: author

6 Durlston Park, Dorset: George Burt's Large Globe, Portland stone, 1887. Photo: author

7 Claude Monet, *Etretat, Sunset*, 60.5 × 81.8 cm (24 × 32 inches), oil on canvas, 1883, North Carolina Museum of Art, Raleigh, purchased with funds from the State of North Carolina

8 Ermenonville: the Temple of Philosophy, 1770s. Photo: author

9 Ermenonville: the Altar of Reverie, 1778. Photo: Henri Gaud © Editions Gaud

10 Antoine Watteau, *Embarkation from Cythera*, 129 × 194 cm (51 × 76½ inches), oil on canvas, 1717, Musée du Louvre, Paris. Réunion des Musées Nationaux / Art Resource, NY

11 Edouard Manet, *Le Dejeuner sur l'herbe*, 208 × 264.5 cm (82 × 104 inches), oil on canvas, 1863, Musée d'Orsay, Paris. Réunion des Musées Nationaux / Art Resource, NY

12 William Hodges, *View of Maitavie Bay, Otaheite*, 137.1 × 193 cm (54 × 76 inches), oil on canvas, 1776, National Maritime Museum, London, MoD Art Collection. Neg. BHC2396 © National Maritime Museum, London

13 Paul Gauguin, *Nevermore*, 60.5 × 116 cm (24 × 45⅝ inches), oil on canvas, 1897,

The Samuel Courtauld Trust, Courtauld Institute of Art Gallery, London

14 Paul Gauguin, *Barbarian Tales (Contes Barbares)*, 131.5 × 90.5 cm (51½ × 35½ inches), oil on canvas, 1902, Museum Folkwang, Essen, Germany. Photo © Museum Folkwang, Essen

15 Claude Monet, *Poplars (Wind Effect)*, W.1302, 100 × 73.5 cm (39⅜ × 28⅞ inches), oil on canvas, 1891, Musée d'Orsay, Paris. Réunion des Musées Nationaux / Art Resource, NY

16 Claude Monet, *Poplars (Banks of the Epte, View from the Marsh)*, W.1312, 88.3 × 92.7 cm (34¾ × 36½ inches), oil on canvas, 1891, private collection

Black and white figures

1.1 Henry Flitcroft, The Hoober Stand, Wentworth Woodhouse, Yorkshire, for the Marquess of Rockingham, 1746–48. Photo: author

1.2 Thomas Sandby, *A Camp in the Low Countries*, 25 × 115 cm (10 × 45¼ inches), graphite and watercolour, 1748, British Library, London. Photo © British Library Board. All rights reserved. Add. Mss. 15968(a)

1.3 Robert Burford, engraving from descriptive leaflet for a *Panorama of Canton, the River Tigress, and the surrounding country*, 1838

1.4 Robert Burford, engraving from descriptive leaflet for *A View of the Island and Bay of Hong Kong*, 1844

1.5 J.M.W. Turner, *View of London from Greenwich*, 21.3 × 28 cm (8⅜ × 11 inches), ink and watercolour, c.1825, The Metropolitan Museum of Art, New York

2.1 E.G. Robertson's Phantasmagoria, 1798, reproduced from C.W. Ceram,

Archaeology of the Cinema (New York: Harcourt Brace & World, not dated)

2.2 J.M.W. Turner, *Snow Storm – Steam-Boat off a Harbour's Mouth Making Signals in Shallow Water, and Going by the Lead. The Author was in this Storm on the Night the Ariel Left Harwich*, 91.4 × 121.9 cm (36 × 48 inches), oil on canvas, 1842, Clore Collection, Tate Gallery, London / Art Resource, NY

3.1 Durlston Park, Swanage, Dorset: Durlston Head and Durlston Castle, 1880s. Photo: author

4.1 Ermenonville: the Isle of Poplars and Rousseau's Tomb, 1778. Photo: author

5.1 Jean-Léon Gérôme, *Venus Rising (The Star) (Vénus – L'Etoile)*, 129.5 × 79.5 cm (51 × 31 inches), oil on canvas, 1890, private collection. Reproduced from Gerald M. Ackerman, *The Life and Work of Jean-Léon Gérôme: with a catalogue raisonné* (London and New York: ACR Edition Internationale, 1986)

5.2 Edouard Manet, *Olympia*, 130.5 × 190 cm (51½ × 75 inches), oil on canvas, 1863, Musée d'Orsay, Paris. Réunion des Musées Nationaux / Art Resource, NY

5.3 Titian, *Venus of Urbino*, 119 × 165 cm (47 × 65 inches), oil on canvas, c.1538, Galleria degli Uffizi, Florence

6.1 William Hodges, *Tahiti Revisited*, 92.7 × 138.4 cm (36½ × 54½ inches), oil on canvas, 1776, National Maritime Museum, London, MoD Art Collection. Neg. BHC1932 © National Maritime Museum, London

6.2 Paul Gauguin, *Spirits of the Dead Watching (Manao Tupapau)*, 92.1 × 113 cm (36½ × 44½ inches), oil on burlap mounted on canvas, 1892, Albright-Knox Art Gallery, Buffalo, New York, A. Conger Goodyear Collection, 1965

Acknowledgements

Publication of this book has been supported by a University Co-operative Society Subvention Grant awarded by the University of Texas at Austin.

Thanks to Paul Hayes Tucker and Acquavella Galleries for your practical help.

I would like to thank all my colleagues, friends and family who have helped to improve and sustain my ability to write this book, either through your moral support, practical help, or the example of your own work.

My greatest debt must be acknowledged first, and is to my friend and colleague Janice Leoshko, who teaches Buddhist art at the University of Texas at Austin, for coaxing me to think differently about a whole range of issues in visual culture through many conversations, and for enhancing my understanding of Buddhism and Gauguin.

My understanding of Baudelaire and Nerval was much improved through conversations with Jenny Hylton. I thank also Ann Bermingham, Marcia Pointon, Stephen Bann, Richard Shiff, Patrick Eyres, Michael Rosenthal, Stephen Daniels, Brian Lukacher, Tim Barringer, Roger Cardinal, Hugh Prince, John Dixon Hunt, Charles Harrison, Nassos Papalexandrou, Wendy Frith; Sally Dinsmore, Rupert and Nicholas Charlesworth; Lee and Amelia Dinsmore; Liz, Barbara and Sarah Charlesworth; James and Thora Barker; Jeffrey Chipps Smith, Sherry Smith, Gay Gillen-Stone, Richard Silver; John Wyver and Clare Paterson; and Sally Penfold.

Pat Allen Naidorf did not live to read my thanks to her in print, but she helped me such a lot when I was first getting started as a scholar that I owe her a huge debt of gratitude and I still think about her, Lou.

Preface

This book covers the period 1745–1900, since it is impossible to discuss the nineteenth century without embracing much of the eighteenth. Landscape in the period is a huge subject, but scholarly approaches to it are not necessarily broad. Usually scholars discuss either literature or visual art; normally they write about France or Britain; particularly they often neglect extensive discussion of vision: that is, not just perception, but the various visions (interpretations and imaginations) stimulated by landscape. The present work aims to extend the approach by integrating the fields designated above in a study of selected themes. Being interested in the factors propelling and responses arising from varied representations of landscape, this book is therefore concerned with imagination as well as with works such as paintings, poetry, novels, travel accounts, gardens and spectacular public entertainments. The arts of landscape are occasioned by and stimulate personal interpretations within specific cultural environments. Exploring these enriches the ways in which we can consider the concept of landscape within cultural history, recovering for it a central place in human experience.

Fundamental to the book are both landscape and the questions of vision. One is more or less objective, based on nature or the physical world, and most often formed as a collection of objects brought together by an arranging sensibility. The other is largely subjective, and can range, in the period 1745–1900, from cases in which 'vision' is understood medically or scientifically – as the investigation of optical processes – to instances where it designates poetic interpretation or metaphorical vision. In this study, vision requires a varied definition: it can mean unproblematical viewing from high places; or (often in the plural) the sight of ghostly apparitions and hallucinations; or it can indicate interpretation, of geological evidence, or of colonial landscape, to give two relevant examples; or there can be inward vision, often synonymous with reverie and imagination. This book deals with each of these applications, so the narrative goes back and forth, somewhat like a weaver's shuttle, using both familiar and recondite evidence to build up its exploration of these themes.

The content of this book is far from encyclopaedic. The first three chapters are mainly, though not exclusively, about Britain. Chapter 1 discusses the panoramic representation of landscape after 1740, including the famous Panorama entertainments that proved popular in Britain and France throughout the nineteenth century, and for which the word 'panorama' was coined in 1792. The chapter demonstrates the pre-existence of the panoramic visual field in military drawing and also analyses responses to Panorama that were manifested once the purpose-built entertainments had become an established part of the culture. An imperial, empirical and even scientific cast of mind is implied by panoramic representation and this is constelled with further varied manifestations of such a cast of mind in later chapters dealing with the impact of the rise of geology and with colonial landscape. The theme of Chapter 2, suggested by contrast with the discussion in the first chapter, embraces the imaginative and associative. Ghostly visitation, hallucination and madness impinge on landscape. The Gothic novel, popular non-fiction analysing hallucinations, the Phantasmagoria as a public entertainment, and the paintings of J.M.W. Turner are discussed, with special reference to the period 1790–1850. The radical subjectivity implied by all this is revealed to be considerably culturally determined, however, and further discussions of subjectivity ensue in later chapters that deal with reverie and imagination, disputes over the place of the antique world in modern culture, positivism *versus* phenomenology, etc.

Landscape is propped upon nature, and ideas of nature are as heavily penetrated by the discourses of religion and science as they are by art. Chapter 3, 'Into the abyss of time', therefore examines the moment (1857–60) and the place (the British seashore) when religion and science created the classic Victorian dilemma by contesting each other's authority directly. The effects of this are traced through a landscape painting and two landscape gardens in order to gauge their concrete impact. Religious belief brings up the subjective domain very directly, and Chapter 4, examining subjectivity, deals with reverie and imagination in the work of Rousseau, Wordsworth and Baudelaire, which is to say in poetry, art criticism and in a landscape garden, as modes of internalized individual vision deriving from intimate engagement with the natural world and bearing on landscape. In Chapter 5 the discussion of imagination becomes more specifically developed via an example, the island of Cythera, and through it the question of the antique past and that past's place in modern French culture before and during Napoleon III's regime of 1851–70. Cythera's colonial *alter ego*, Tahiti, becomes the focus of attention for the painters William Hodges (1744–97) and Paul Gauguin (1848–1903) in Chapter 6, while Chapter 7 returns us to mainland France in its discussion of a series of paintings by Claude Monet and their connection, or lack of it, with literary works by Stéphane Mallarmé during the last decade of the nineteenth century.

The book discusses landscape gardens, literature, spectacles and entertainments of varied kinds, as well as landscape drawings and paintings. In a period of extraordinary inventiveness and the explosion of new modes of representation and consumption, other practices could have been considered, such as photography: they have not been discussed here since they are less germane to the argument being presented. My hope is that the juxtapositions of varied evidence made in this book will stimulate further thinking by students and scholars.

Selective rather than encyclopaedic, the book concentrates on moments and places in which landscape intersects in interesting and urgent ways with interpretive vision. Omissions, however, are not limited to the subject matter covered. So far as method is concerned, I have not attempted in the later chapters to conduct much analysis of the social conditions of cultural production. Instead, concentration has been invested in explorations of the works' significance, aesthetic charge and thematic contribution. Works of art, literature or entertainment possess an integrity of their own and an energy by which beholders and readers are shaped, and it is this level I have tried to explore in this book. Elucidating this element constitutes an important part of a cultural history, the main energies of which can otherwise seem as if they are always taking place elsewhere (I am particularly taking issue with the discussion of consumption of works that are sometimes made to seem as if they had little or no content). While I accept and have used extensively here and in my other work an analysis based on the conviction that subject fields are discursively constituted and ideologically framed, I have not in this book engaged in overt theoretical discussion in this regard. Instead I have, as it were, taken these views for granted, since they have become immanent in my thinking as a scholar.

While much has been left out, the reader will notice that I do spend time and effort siting discussions in specific landscape locations, and in the actions and decisions of particular individuals represented and embodied in specific texts and visual works. The first, interest in specific landscape locations and what they contribute to debates or to the exploration of themes, hardly needs extra protective justification here. With respect to the latter question of individual agency, the last thing I wish to be thought of as doing is trying to reinstate the misguided Great Man-ism of the past, rightly and decently interred when Roland Barthes and Michel Foucault announced 'the Death of the Author' a generation ago. In this unhelpful old view the individual biography (of the artist, poet, entertainment entrepreneur) masqueraded as an explanation of the art or artefact produced. In this book few of the figures I examine in any detail can claim to be a prime mover or inventor of any part of a discourse or discursive formation or of practices linked to one, although Rousseau has some claims in this respect, as does, on a different scale and in different mode, Thomas Sandby. My interest, however, is not so much in who

'originates' what, as in individual agents intervening in and contributing to discourses and practices that pre- and post-date their activity. It is on the scale of specific participation by individual agents that the immense debate implied but not invented by Foucault plays itself out: the debate being that of free will *versus* determinism. This book's attention to thought processes of individuals shows us in a very close-up manner the impact of larger discursive formations and their contestation.

Given the variety in definitions of vision, and in types of place or work studied, this book is built up out of a number of intersections. For my purposes, an 'intersection' is a space where two activities draw close to each other. Fundamental to the structure of the inquiry and contributing directly to the formation of our subject are those between the arts of landscape; that is, the intersections between landscape gardening, painting and drawing, and poetry, together with some prose, not all of it non-fiction. These can be traced in both Britain and France, and there are also intersections between French and British culture, while the most important intersection, presiding over all, is that between explorations of landscape and imaginative vision. Whatever the geopolitical relations between the two nations during the period, there were considerable cross-Channel exchanges that flood landscape and vision with great energies: for example, from Rousseau (himself stimulated by the writings of the English deist Samuel Clarke) to Wordsworth and the English Romantics, to Baudelaire and thence to Gauguin. There are intersections between literature and painting which cut across disciplinary boundaries as they do national divisions: for example, between utterances by Bougainville who was not a painter but a sailor and prose writer, and works by William Hodges, a painter. It is because of the nature of such intersections and the concepts and works they produced that a sustained interdisciplinary analysis is necessary.

I should add here that all translations from the French are my own except where otherwise indicated.

Panorama

The Panorama entertainments invented in 1787–89 were important to cultures of landscape in several European countries during the early nineteenth century. Those entertainments were material concatenations of objects. However, if we define 'panorama' as not any material object but as a visual field, we can see that the panoramic visual field both pre-dated these entertainments and survived the waning of their popularity. The entertainments, housed in purpose-built circular structures, gave rise to the word 'panorama' and thus define the particular elongated visual field in question and mark the high point of its irruption into urban entertainment. Here we must discuss the optics of those entertainments, trace their prehistory in military drawing, and evaluate their structural relationship with Jeremy Bentham's famous prison, the Panopticon. By doing this we can assess the powerful impact the panoramic visual field had on vision and the imagination of vision during the nineteenth century.

Prehistory

The context for the emergence of the Panorama entertainments includes a large number of strategic drawings made by European artists, naval officers and artillery officers as a form of military intelligence-gathering in the period of forty or fifty years before the invention of the entertainment. Military surveillance was celebrated by one landowner in the north of England who built an ornamental watchtower in his large landscape garden. The Hoober Stand was built in the garden of Wentworth Woodhouse, in the West Riding of the English county of Yorkshire, between 1746 and 1748 (Figure 1.1).[1] This tower stands on the summit of a low ridge that crosses the Wentworth Woodhouse estate in a west–east orientation; it is unique in British architecture: triangular in plan, at a height of about 15 feet (4.5 metres) the walls start to taper inwards and thus become narrower. At the top (approximately 100

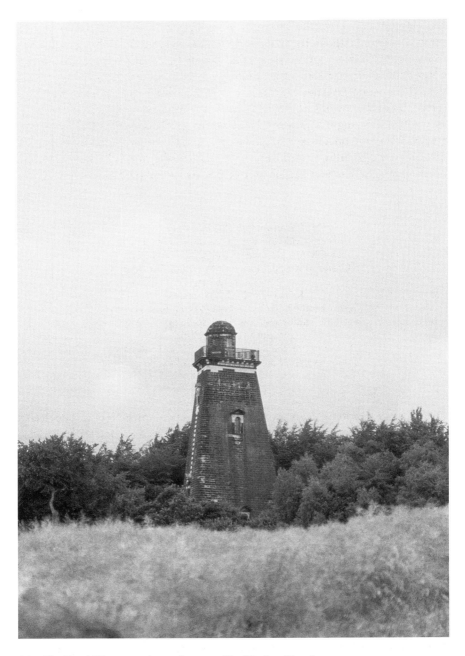

1.1 The Lord-Lieutenant's watchtower: The Hoober Stand,
Wentworth Woodhouse, Yorkshire

feet (30 metres) above the ground), they support a platform topped by an open hexagonal cupola. By an optical illusion induced from the combination of triangular and hexagonal plans, and by the fact that from the ground, by sheer force of habit from other buildings, we customarily read the tower, visually, as square rather than triangular, the cupola, although it stands in the centre of the tower's platform, appears to move from one side to the other as the visitor's angle of approach to the tower changes. Visitors climb the stairway, emerge on a breezy platform, and enjoy immense panoramic views over a busy agricultural and industrial countryside, up to 50 miles (80 km) northwards and eastwards. The building bears the following inscription:

1748

This Pyramidall Building was Erected,
by his MAJESTY'S most Dutyfull Subject,
THOMAS, Marquess of ROCKINGHAM &c
in Gratefull Respect to the Preserver of our Religion,
Laws and Libertys,
KING GEORGE The Second,
Who, by the Blessing of God, having Suppressed
that most Unnatural Rebellion,
In Britain, Anno 1746,
Maintains the Balance of Power, and Settles
A Just & honorable Peace in Europe

1748

The Hoober Stand is thus defined as a political monument. The 'most Unnatural Rebellion' that his majesty 'suppressed' was the Jacobite rebellion of 1745–46, an attempt by the supporters of the Roman Catholic Stuart kings of Britain (forced into exile after 1688) to restore the Stuarts to the throne by force of arms at the expense of the usurping Hanoverian royal family, in the person of King George II. The Hanoverians had been invited to the throne in 1715 to ensure a Protestant royal succession; and the 1745 Jacobite rebellion had been bloodily 'suppressed' in a brutal defeat at Culloden, in Scotland, with ensuing massacres among the population of the Highlands. We may notice that the inscription contains an unusual use of the word 'unnatural', which is employed to stigmatize the Jacobites' efforts. Nature is annexed by Hanoverian Whigs, and the 'unnatural' Jacobites are left out in the cold. On a building in a garden, where nature by definition takes on an enhanced significance, the employment of 'naturalness ... disguises processes that are deterministic, institutional, and rational'.[2] To class actions taken against the king as 'unnatural' presupposes that everybody agrees on who is the rightful king, and this is precisely where Hanoverians were on shaky ground. In fact the judgement of which of the rival contenders, Hanoverian or Stuart, should be regarded as the true king was an intellectual and moral choice that had to

be taken by every adult in the nation. The Hoober Stand's inscription seeks to sweep aside such moral considerations and to consign to rejection and obscurity the heroism that led Jacobites to agonizing deaths on the scaffold, or on the battlefield, or in the Hanoverian massacres of soldiers and non-combatants in the days following Culloden.[3]

The landowner who built the monument, an ambitious Whig politician, was Earl of Malton when the rebellion broke out among the clans of Highland Scotland. As the rebels' army passed through adjacent counties on its march south into England, and again as it retreated northwards, Malton seized the opportunity to become the chief Hanoverian intelligence officer in the north, receiving reports in his large house, transcribing them personally, and generally within half an hour sending them on their way to Hanoverian headquarters.[4] Military intelligence was important to the Hanoverians: it had been by running a huge secret service, secretly financed, that successive Whig administrations had defeated some of the other Jacobite plots in the years 1715–45.

The Hoober Stand was Malton's symbolic watchtower, dramatizing the process of surveillance by giving the opportunity for visitors to see immense views from the top, while symbolizing in its inscription the Hanoverian victory. It could also have been used as a real watchtower had another rebellion broken out. Jacobite efforts to regain the throne for the Stuarts were not finally ended even by the defeat of the '45. Even after that date the Hanoverian party still needed means of persuasion about the fitness of Hanoverian rule. In light of this, it is interesting to note some evidence that we have of the use of the Hoober Stand as an entertainment. In August 1774, a small party of artists on a watercolour sketching tour of the north of England visited Wentworth Woodhouse. The party included Theodosius Forrest, William Elves, William Tyler and Samuel Cotes. The Marchioness of Rockingham, wife of the second Marquess (who had been Prime Minister in 1765 and was to be again in 1782), was at home and provided them with an entertainment that included drinking tea in an octagonal summerhouse, and a visit to a grotto 'illuminated by a number of wax lights', all preceded by an ascent of the Hoober Stand itself.[5] The party was excited and delighted by the views from the top, which stretched as far northwards as York Minster, 42 miles (76 km) away, and they stayed up the tower for an hour and a half. Their enjoyment was greatly enhanced, no doubt, by the Marchioness's thoughtful provision, for their use, of a 'large reflecting telescope'. With it they could seal off, enhance and magnify details of the huge prospect, therefore penetrating it and exercising over it an optical power greater than that of the naked eye.

The Hoober Stand can further help us come to terms with the place of panoramic art in broader British culture if we concentrate on the identity of one of the visitors on that afternoon in August 1774. Thomas Sandby (1723–98) was one of the party that made the ascent. His position in society had

equipped him peculiarly well to understand and appreciate the building as a whole.[6] Sandby was a watercolour painter specializing in architectural subjects. He was draughtsman and steward to the Duke of Cumberland, uncle of King George III and the commander in chief of the Hanoverian army, the 'Butcher' Cumberland who instigated the massacres after the Battle of Culloden. Sandby lived close to Cumberland in Richmond Park. In 1745 he had been in Scotland, working as a humble draughtsman to the Board of Ordnance, a branch of the army that specialized in artillery and fortification, and he had participated in the events of that year which were to be celebrated in the Hoober Stand's inscription. In particular, one source credits him with having been the first person to alert the Hanoverian authorities to the outbreak of the Jacobite rebellion.[7] Sandby's long association with Cumberland began immediately. His job with the Duke was to provide military intelligence in the form of landscape drawings, and his plan and drawing of the battlefield of Culloden are in the Queen's collection at Windsor Castle. He also undertook this work on the Duke's continental campaigns of 1746–48, alluded to in the Stand's inscription. The job of steward to the Duke followed in 1764. Cumberland had received the sinecure of Ranger of Windsor Great Park, and after Cumberland's death Thomas Sandby was confirmed by his successor as Deputy Ranger (which was not an official post: it must have been created and paid for especially for him). As designer and builder of part of Cumberland's landscape garden at Virginia Water in Surrey, including the cascade, he would also have appreciated the Hoober Stand as a garden building. At Virginia Water, Cumberland had built by 1750 a triangular tower (named Fort Belvedere) designed by Henry Flitcroft, the architect of the triangular Hoober Stand.[8] Cumberland became Grand Master of the London Freemasons, and in 1776 Sandby was elected Grand Architect of the Freemasons' Lodge. When the Royal Academy was formed in 1768 under the patronage of Cumberland's nephew, George III, Sandby became Professor of Architecture, an appointment that was somewhat surprising as he had only designed one building by then. In 1777 he was appointed Architect of the King's Works.

These facts show how close to the centre of political power and cultural patronage Sandby was. One example of the extent of Hanoverian reward to him is that Sandby continued to draw his salary from the Board of Ordnance, amounting to £100 per annum, for the rest of his life, despite ceasing to work as an Ordnance draughtsman in the late 1740s. The salary thus became a sort of pension, or reward for services rendered. Why was Sandby so generously rewarded by the Hanoverian regime? In his drawings from the military campaigns of 1746–48 Sandby provided a kind of portable version of the type of view gained from the Hoober Stand. Sometimes (as in his drawing of Fort Augustus in Scotland, c.1746), the view is represented as if seen from a projection a few feet (a metre or so) above the land's surface: the result is a very assured depiction of the rises and falls of the ground in a topographically

complicated valley bottom. Here Sandby has perfected a panoramic visual field which could show the rise and fall of the land's surface particularly clearly, from an elevated point of view, and could therefore give the officers who studied the images a tactical advantage over the enemy. Such drawings could form an archival record of particular terrain, but they could also be consulted by officers who wished to attack across a certain stretch of country. The drawings can show dead ground, possible cover, fields of fire[9] and other tactically valuable features.

Thomas Sandby showed convincingly how landscape drawings made on campaign could be used as military intelligence. The British Museum possesses four views by Sandby of camps in the Low Countries, from the campaign of 1746–48. Two are signed and dated 22 June 1748, and represent an extensive tract of flat country, with towns and church spires indicated in the distance, and troops and camps in the foreground. In one (Figure 1.2), a church on the horizon is labelled 'Op Zeeland'. Some of the tents in a camp visible in the right foreground seem to be camouflaged with branches: hedges appear to have arched entrances and tents sticking out of the other end. Other tents have hedges reared up near them and in one case sods stacked around.[10] In the distance is a line of tents and a Union Jack flying next to a line of cannons. The vanishing point of the perspective is three inches (7 cm) in from the left, in a painting measuring about 10 × 45¼ inches (25 × 115 cm). A small chapel is shown in the distance here. Sandby even shows the way in which part of a field of wheat or barley has been broadly trampled flat, and a footpath made through the rest of the crop. A farmhouse is in the trees at the extreme right and one single figure trudges along a road between fields.

Another picture is much longer (about 10.5 × 66 inches, or 27 × 168 cm) and much more elaborately coloured. The trees and bushes are all very obviously drawn in ink first and washed in green, brown or a blueish (for distant trees) colour.[11] The main subject is an unidentified town. No people are shown. On the left a big fire in the distance sends clouds up into a thinly washed sky. There is a slight ambiguity about ground level to the left, but the drawing shows an amazing display of low hills beyond the town, as well as of the town roofs and the buildings themselves. Old town defences are partly dilapidated. The whole town is surrounded by elaborate stakes like a palisade, or perhaps trenches. Apparent floodwater is coming, in blue, from the right. Tiny cannons crouch on a distant bastion to the right. A hill in the extreme right foreground hints that the artist is standing on a similar hill in line with the one that we can see. Sandby has even, on the tiniest possible scale, painted in the brick coping of the stone fortification walls of the town and distinguished between it and sod fortifications. Most of the roofs are blue, interspersed with occasional orange tiles. The elevations of the main church and town hall are particularly fine. Tone rendered in watercolour paint is the only element that gives the direction of light. It is a wonderful picture: placing us in front of

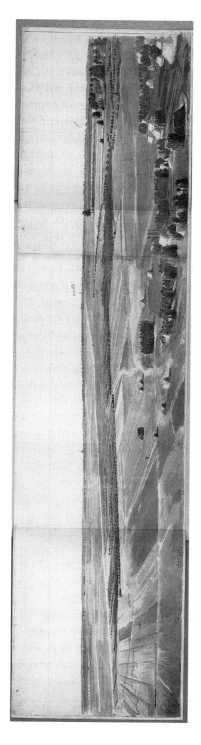

1.2 Panorama on active service: Thomas Sandby, *A Camp in the Low Countries*, 25 × 115 cm (10 × 45¼ inches), graphite and watercolour, 1748, British Library, London

an unnaturally quiet town in the Low Countries on a sunny afternoon in the summer of 1748.

These drawings are panoramic[12] in their dimensions but also in the way they handle the subject matter. Clearly and crisply drawn details function as the telescopic element in panorama's dual visual field, so well exemplified at the Hoober Stand. Verbal notations of time and distance are also of crucial importance. This mode of drawing pre-dates Thomas Sandby. In the absolute, of course, panoramic strategic drawing goes back to Sebald Beham's circular drawing of the Siege of Vienna in 1529, a drawing which shows how approaches to Vienna were covered by fields of fire.[13] Panoramic drawings were popular in Holland during that country's years of conflict in the sixteenth and seventeenth centuries. In the Netherlands the panoramic visual field had also made the transition from merely utilitarian strategic drawing into 'high art' within a colonialist context: Frans Post painted 33 paintings of Brazil for Maurice de Nassau, the Captain-General of Dutch Brazilian possessions 1636–44. Nassau gave these paintings to Louis XIV in 1679 and they are now in the Louvre. One two-part painting shows a panoramic view of the house of a sugar planter in north-eastern Brazil: the plants are recognizable, the topography looks reliable, and slaves are shown at work in the village.[14] The English learned from the Dutch, whose expertise no doubt relates to their long strategic struggle for independence, the Eighty Years War.[15] However, the situation in England was of course unique, and some art historians attribute a national interest in sophisticated topographical landscape to the visit to Britain by the Italian artist Canaletto which began in 1746.[16] It is therefore important for us to understand what Thomas Sandby was able to do before the visit of Canaletto. In 1741, at the age of 17, Sandby made a series of drawings of his home town, Nottingham, which were engraved and published in Charles Deering's history of the town, *Nottinghamia Vetus et Nova*, in 1751. Two plates in the book were from drawings by Sandby of panoramic views, including 'East View of Nottingham, taken from Sneinton Hill a little on ye left of Newark Road'. Another engraving in the same book shows considerable skill employed in a perspective drawing of a complicated subject, 'The Stocking Frame', and, like the south and east views of Nottingham, it amounts to a remarkably assured achievement for a 17-year-old. Sandby's father was a manufacturer of knitted goods whose business used such frames, so Sandby would have understood how the machine functioned. Deering compiled his history of the town from materials collected by John Plumptre, one of a wealthy and powerful local family, Member of Parliament for Nottingham, and Treasurer of the Board of Ordnance. It seems most likely that Plumptre, impressed by his drawings, found employment for Sandby in the Ordnance office by 1743 (Sandby's father having died in 1742). James Gandon states that it was through Plumptre that Sandby obtained his position as draughtsman to the Board of Ordnance.[17]

The evidence suggests that Sandby was highly proficient in dealing with this visual field – and proficient in explanatory drawing in general – before he left Nottingham. While bird's-eye views were common in Britain before Sandby's career began, they are, with few exceptions (those largely confined to the work of Wenceslas Hollar and Francis Place),[18] wildly erratic in the projection of perspectival space and distance, and usually completely useless in representing the rise and fall of the land's surface. Sandby was the first artist in Britain since Hollar and Place who brought a sure systematized approach to these problems. The historical evidence also suggests that he was attached to the Duke of Cumberland 'in recognition of his merits as an artist and his services to the state'[19] – that is, because magnates and institutions of the Hanoverian state found his art to be of strategic use to them.

Hoober Stand is a panoramic device that functions within, and as a product of, class relations. The middle-class artists climb a building erected by a ruling-class landowner who twice held supreme political power. At the top, they are provided with the surrogate eye of the rulers (the telescope) and indulge, for the space of an afternoon only, in the 'view from the top' which is usually the purview and property solely of the rulers. In comparison with the later panorama entertainments this is an early and limited distribution of fantasized power, which enforces and necessitates another class seeing the world vicariously through the eyes of the ruling class, and by extension being induced to identify with that class's ruling interests. Such a distribution of the effects of power became a speciality of the much more widely accessible panoramic structures of the nineteenth century. In the eighteenth century, by contrast, the primary audience for Sandby's work was a small group of army officers, followed later by the Duke of Cumberland and his family and friends after Sandby started work for him as draughtsman, with the later addition of students at the Royal Academy.[20] A question arises, therefore, about how, or even whether, Sandby's art had any larger influence.

Thomas had a brother eight years younger than himself, Paul. Their father had died when Paul was 11 years old, and we must assume that Thomas taught his younger brother to draw. 'As a watercolourist, [Paul] Sandby remained very much under the influence of his older brother, and their drawing styles can be vexedly close'.[21]

Although Paul Sandby was also, presumably through his brother's recommendation, employed at the Board of Ordnance (1747–51)[22] and later as Chief Drawing Master at the Royal Military Academy at Woolwich (1768–97), his life was led in the shadow of his elder brother, through whom, among other things, Paul met patrons.[23] As Drawing Master at the Academy at Woolwich, which trained officer cadets for the artillery, Paul Sandby initiated future officers in the type of panoramic drawing that Hanoverian geopolitical strategy was finding so useful. Paul taught the artillery cadets how to represent battlefields, potential battlefields, fortifications and places

of strategic importance, and thus he helped to disseminate Thomas Sandby's perfection of the military gaze more widely throughout society – or military society, at any rate. Changes in the *Rules and Orders of the Royal Military Academy* during Paul's employment indicate the changing importance accorded to drawing. In 1764, four years before Paul joined, the *Rules and Orders* call for the Drawing Master (then Gamaliel Massiot) to be paid £54 15 shillings per year, and to teach on Tuesday, Thursday and Saturday mornings. The *Orders* simply required the Drawing Master to teach a 'Method of Sketching Ground, the taking of Views, the Drawing of Civil Architecture and the Practice of Perspective'.[24] When Sandby joined, Massiot became his junior. By the writing of the next *Rules and Orders*, in 1776 the Chief Drawing Master (Sandby) received a salary of £150, and the second Drawing Master's compensation was increased to £100 (the Professor of Mathematics also received a 100 per cent increase). In addition to Sandby, an Inspector and a clerk had been added to the personnel, which now numbered 12. Instructions about what to teach in drawing classes were now more elaborate and specific. The Chief Drawing Master was ordered to teach only on Saturday mornings, with his deputy teaching on Monday, Wednesday and Friday mornings. While he dealt with the 'elements of perspective', military 'embellishments', copying landscapes and drawing in 'black lead and Indian ink', the Chief taught 'the best Method of describing various Kinds of Ground, with its Inequalities, as necessary for the drawing of Plans; the taking of Views from Nature; the drawing of civil and military Architecture, and the practice of Perspective'.[25] The actual progression of classes was arranged so that 'Describing all the various Kinds of Ground [etc.]; and Drawings from Nature' constituted the most elevated class, the climax in skill level of the entire training.[26] The Woolwich Academy's Lieutenant Governor, in a report of 1792, stated that with Paul Sandby cadets 'proceed to take views about Woolwich and other places, which teaches them at the same time to break ground and forms the eye to the knowledge of it'.[27] Clearly these arrangements reflect an increased investment in drawing on the part of the artillery, but the increase only proceeded extremely slowly.[28] Even by 1782, after the American emergency, the number of cadets increased only to 60 (from approximately 40).[29] Since it was a two-year curriculum, this would hardly flood the army with highly trained officer/artists.

Bruce Robertson claims that evidence for Paul's influence among military officers in North America after 1768 is 'curiously weak',[30] but his own essay is full of examples of artists using the panoramic visual field, including known students of Sandby such as James Cockburn and George Heriot,[31] as well as artists who show the brothers' stylistic influence, including lesser known figures such as William Strickland and William Roberts.[32] While the practices set up by the Sandby brothers grew only slowly, they endured a long time, since artillerymen were still being trained in field sketching and the taking of views in both World Wars of the twentieth century. The poet, Edward Thomas,

drew landscapes as part of his training as an artillery observer during the Great War, and several Second World War gunners made careers as artists in civilian life.[33]

The prevalence of panoramic representations in colonialist art can be attributed to the demands made by Hanoverian institutions (the Board of Ordnance, the Royal Military Academy, the Royal Navy) for landscape representation to function as a storehouse of information. It was an art on which men's lives could be staked, and in it breadth of artistic or atmospheric effect had to be subdued to the primary purpose of conveying information. The information embraced the overall view; at the same time, it also depended on getting all the details in. A change in the nature of watercolour painting took place at about the end of the Sandby brothers' lives. At the Royal Academy exhibition of 1799, the summer after Thomas Sandby's death, J.M.W. Turner exhibited his *Caernarvon Castle* and Thomas Girtin exhibited *View near Beddgelert, North Wales*. These works have been linked to a sea change in the aesthetics of watercolour painting towards exploiting it as freehand painting and away from the wash drawing and body-colour work that the Sandbys had popularized.[34] Watercolour painting therefore begins to lose the traces of its origin as a by-product of military drawing. In this regard it is interesting to recall Joseph Farington's summary of Paul Sandby's art in 1811. Farington sums up Sandby from the point of view of the newer, more fluid and broader type of watercolour painting that was current at the time of writing: 'I could not but sensibly feel the great difference between his works and those of artists who now practice in Water Colours. His drawings, so divided in parts, so scattered in effect – detail prevailing over general effect.'[35] The clear details of a landscape drawing can be interpreted as an equivalent of a telescopic dimension. Farington is surely sensitive here to what might be termed the trace of the military gaze in Paul Sandby's work: the technical consequences of the demands made by Hanoverian military and imperialist strategy. Both kinds of approach to watercolour continued to be taught to amateur artists, including women, however; thus we find extraordinary panoramic images of both Australia and Scotland from this period by women amateurs.[36]

In the panoramic visual field close-up views are only possible through telescopes, and therefore come at the price of being decontextualized from their surroundings. Indeed, for Ford Madox Ford's fictional character Gringoire in the First World War, laying aside the telescope is the precondition for him being able to see the view as an ordinary human being.[37] In this military panorama, there is no interplay with local people, who often do not even know that they are being watched. The visual field is designed to yield information that the army deems to be of value, such as the rise and fall of the land, woodlands, divisions of terrain, broad economic functioning (agriculture, industry, logging, fishing, quarrying) and the location of villages and towns. In recording all this, from a distance, panoramic representation

automatically shuts out other forms of information, and in particular any information that could induce a sympathetic understanding of the wishes and hopes of local inhabitants. Such information might include understanding of those inhabitants' customs and habits, the difficulties they encounter with their work, their social and familial relations, their festivals, religious beliefs, history, attitude to outsiders, their fears, hatreds and humour. The olympian view from a high place can, by definition, never provide any of this. Even the telescopic vignettes, recorded as crisp detail in the eighteenth century, or arranged around the main image,[38] can only provide a hallucinated form of proximity – flattened because monocular; silent; without interaction, and torn away from context. In cutting them off from the local people, the panoramic military drawing is a tool that powerfully helps not only the capture of strategic information, but also in the inculcation of the appropriate power relations necessary for the successful functioning of military officers.

The optics of Panorama entertainments

An anonymous guidebook to the lakes of Killarney in Ireland that appeared in 1776 reminds us that was plenty of interest in panoramic views from high places before the Panorama entertainment was invented. The author describes the view of the lakes from a mountain in the centre of them, named Turk:

> To those who would have a perfect knowledge of the lakes, the top of Turk
> is the best station. From thence they appear as distinctly, as if delineated
> on canvas; but the minuter beauties are lost by the height of the mountain,
> and at best, a prospect from such an overtopping eminence is better
> calculated for the Ichnographist than the man of taste and fancy.[39]

The real view is compared with the view on canvas; mapping (ichnography) is set against 'taste and fancy'; in short order we encounter already appearing in 1776 some of the points that proved salient in the discussion of landscape during the period of Panorama entertainments, especially c.1790–1830.[40] The passage quoted above was given further circulation by being reprinted in a collection of engraved views of the lakes in *The Virtuosi's Museum; containing Select Views in England, Scotland, and Ireland; drawn by P. Sandby, Esq. R.A.* (1778–81).[41]

Our anonymous guide concludes his account with the view of Killarney's lakes from the top of another mountain, Mangerton:

> And now, traveller, having satisfied thy curiosity, plod thy way downwards;
> for the clouds begin to marshal, the vapours to accumulate, and soon will the
> scene thou gazest at vanish, and the spot where thou standest become the
> seat of darkness: unless thou indeed would'st inhabit the clouds, and sensibly
> experience that palpable obscure, which thou hast only read of in Milton.[42]

This framing of the description implicitly makes the case for the Panorama entertainment, for the comfort of protection from the weather and a view of a canvas surrogate rather than the hazardous real thing. The idea that a surrogate (here the verbal description) can double as the real thing is well conveyed by the playful address to the reader as if both guide and reader were on the real mountain rather than writing and reading about it in comfort. The panoramic visual field was clearly well in evidence in the decade or so immediately prior to Robert Barker's invention of his entertainment in 1787. Yet how did the surrogacy of the entertainments work? What were their relations with military or strategic representation? And were its ideological pitfalls limited to its relationship with military seeing?

Our conception of the ways in which the Panorama entertainments signified their subjects to their viewers is currently stuck on a reef of realism. One recent academic book states that the Panoramas 'popularised unselective 360-degree painted views' that 'emphasised inclusiveness rather than the selection of salient particulars as academic theory had advocated'.[43] The assertion is made that 'each part was given equal significance in relation to the observing subject'. An 'ideological fallacy' only arises through a jingoistic juxtaposition; that is, when scenes of the British fleet were shown 'along with' other panoramic views. That such statements can be made partly reflects the fact that we are no longer used to enjoying Panorama entertainments, despite the survival of several of them, and it also partly reflects weaknesses in an otherwise comprehensive and valuable work about Panorama entertainments, Stephan Oetterman's *Das Panorama* (1980).[44] Oetterman's attempt at theoretical framing of the subject is the book's weakest part. The author asserts that the Panoramas' aim was 'a total illusion of reality'.[45] He also claims that, apart from vantage point, the artist had no choices to make in his depiction of a subject: 'everything else was dictated by the need to reproduce reality as closely as possible'.[46] What is forgotten in this formula is that the 'illusion' of reality is hardly the same as the 'reproduction' of reality.

A similar type of assertion is also made in the newest book about the entertainments, when Bernard Comment claims that they 'replaced reality' and did away with 'the need for practical experience'.[47] It may be plausible to state that they 'wanted to be mistaken for reality' but to assert that a Panorama 'formed an almost encyclopaedic document of nature and abandoned itself to recording all the multifarious details of reality' in a way that 'no longer allowed ... licence and correction' is another matter completely, combining as it does highly positivist and essentialist elements.[48]

Refutation of these views can be undertaken in two ways.[49] The first would merely point to the contradictory evidence in the Panorama entertainments themselves. Making sense of the wide view by selection and visible interpretation was an important part of the making of a Panorama, as it proved for Robert Burford, for example, when he painted only half of the Tuileries

Palace in his *Paris Panorama* of 1828, in order to show also what was behind the palace yet invisible from his actual vantage point. L. Caracciolo's *Panorama of Rome* (1824) changes the position of certain Roman buildings in order to make a better picture, and makes interesting use of effects of light: the sky is pinker over St Peter's, thus enhancing the emotion in our view of that church, although the sun is shown in a different quadrant of the sky, over 'Ospizia S. Salbina'.[50] While the signs of light are intelligible, they are used for slight obfuscation, rather than for increased clarity. Another case of interpretation and selection is Thomas Girtin's 1802 *Panorama of London*, his *Eidometropolis*, in which the artist chose to obscure parts of the city behind painted mist and smoke in order to enhance picturesque effect.[51]

Girtin's studies for the *Eidometropolis* also make it clear how he enhanced the impact of various features while remaining true to what could be seen from his seat of seeing. The pencil drawing of the Westminster sector shows Westminster Bridge almost completely obscured by houses; but the watercolour of the same view shows how Girtin has brought the bridge out of the mass by enlarging it and making it pale grey among the slate and tile roofs – a brighter colour that emphasizes it. In the only surviving study of the City of London sector, a wash drawing, St Paul's Cathedral looms up huge and pale against a dark and stormy sky, floating over the huddled city like an enormous emanation or ghost of itself. These are distant objects: closer to hand, the carefully drawn architectural details of Blackfriars Bridge are very clearly seen and gain attention for the bridge in comparison with the flat planes of the burned-out Albion Mills adjacent.[52]

The second objection to the assertion that Panorama entertainments purveyed an absolute and somehow unproblematic reproduction of reality rests on a different strategy. The assertion downplays the entertainments' status as signs, and this has been a tendency in writing about them right from the beginning, as Robert Barker's advertisement in *The Times* for his *Panorama of London* in 1792 makes clear. He tells us that we are to see 'one painting ... which appears as large and in every respect the same as reality. The observers of this Picture being by painting only deceived as to suppose themselves on the Albion Mills from which the view was taken.'[53] However, if we look at what was said about Panoramas by a series of authoritative nineteenth-century witnesses, it becomes clear that, far from being unnoticeable, the semiotics of Panorama entertainments had a rhetoric, and indeed that the rhetorical trope dominating them was *transumption* or 'far-fetching'. This is a rhetorical effect in which a remote cause, origin or phenomenon is evoked in the immediate present or in nearby space, and all the intermediate steps connecting the two elements (the graduated stages between near and far, present and remote past) are suppressed. Transumption can be a powerful effect, awaking a sense of wonder in the viewer or reader, precisely because of the suppression of intermediate connections and the consequent sense of mystery that causes.

Transumption can be seen in action when William Wordsworth commented on the Panorama entertainments in a passage of his epic autobiographical poem, 'The Prelude: or, Growth of a Poet's Mind' (1805). In Book VII Wordsworth describes the effect of moving to London on the growth of the mind of a poet who had been brought up in the relative seclusion of the Lake District. He describes the streets full of exotic characters:

The Italian, with his Frame of Images
Upon his head; with Basket at his waist
The Jew; the stately and slow-moving Turk
With freight of slippers piled beneath his arm.
Briefly, we find ... all specimens of man
Through all the colours which the sun bestows,
And every character of form and face,
The Swede, the Russian; from the genial South,
The Frenchman and the Spaniard; from remote
America, the Hunter-Indian; Moors,
Malays, Lascars, the Tartar and Chinese,
and Negro Ladies in white muslin gowns.[54]

The following section, dealing with 'Spectacles / Within doors' uses transumption as assertively as the preceding passage: 'troops of wild Beasts, birds and beasts / Of every nature, from all climes convened'.[55] This line serves to introduce the section about Panorama entertainments:

And, next to these, those mimic sights that ape
The absolute presence of reality,
Expressing, as in mirror, sea and land,
And what earth is, and what she has to shew;
I do not here allude to subtlest craft,
By means refin'd attaining purest ends,
But imitations fondly made in plain
Confession of man's weakness, and his loves.
Whether the Painter fashioning a work
To Nature's circumambient scenery,
And with his greedy pencil taking in
A whole horizon on all sides, with power,
Like that of Angels or commission'd Spirits,
Plant us on some lofty Pinnacle,
Or in a Ship on Waters, with a world
Of life, and life-like mockery, to East,
To West, beneath, behind us, and before:
Or more mechanic Artist represent
By scale exact, in Model, wood or clay,
From shading colours also borrowing help.
Some miniature of famous spots and things
Domestic, or the boast of foreign Realms;
The Firth of Forth, and Edinburgh throned
On crags, fit empress of that mountain Land;
S. Peter's Church; or, more aspiring aim

In microscopic vision, Rome itself;
Or, else perhaps, some rural haunt, the Falls
Of Tivoli,
And high upon the steep, that mouldering Fane
The Temple of the Sibyl, every tree
Through all the landscape, tuft, stone, scratch minute,
And every Cottage, lurking in the rocks,
All that the Traveller sees when he is there.[56]

While suggesting that the Panorama entertainments convey effects of transumption, Wordsworth also tells us other things about them. He describes them as revelations of the earth, and earthly things, made with foolishness ('fondly'), plainly confessional of human inadequacy and yet of a loving spirit. In other words, the poet views them forgivingly, and redemptively, as primitive and appealing. The quality of naivety that Wordsworth detects in them may be the same as what prompted the landscape painter John Constable to state that Panoramas were painted 'minutely and cunningly, but with no greatness or breadth'.[57] Given that the customary size for the entertainments was 108 feet (33 metres) long and 18 feet (5.5 metres) high, the 'greatness and breadth' that Constable finds lacking must be mental properties capable of being signified by a particular manner of painting.[58] One would probably have to make an exception to this general law of Panoramic finishing in the case of Thomas Girtin's *Eidometropolis*, however, since breadth tends precisely to be a feature of Girtin's surviving work and he can be cited as the artist who brought that property to watercolour painting.

Wordsworth tells us that the Panoramas teemed with life and an irreverent imitation, before in the later part of the quoted passage emphasizing transumption again. He also reminds us that though big, Panorama paintings are small ('miniature') compared with the original scenes they represent. This point is relevant because of the entertainments' desire to 'ape / The absolute presence of reality'.

The French writer Chateaubriand was another witness to the Panorama's transumptive power: 'the illusion was perfect; ... never was a traveller subjected to so terrible an ordeal; I had not expected Jerusalem and Athens to be transported to Paris'.[59] In the twentieth century Walter Benjamin described Panoramas memorably as 'the aquaria of far-off places and the past'.[60] Given the force with which these writers and other eyewitnesses testify to this effect, we might term Panoramas as the displays of hyper-transumption, in which far-fetching reaches a hyperbolic level where Panoramas open themselves to the viewer as sensational, previously unseen displays of representational power.

We find testimony that this spectacular aspect is underwritten by, perhaps even eventually surpassed by, an alleged educational attribute. The French painter Pierre-Henri de Valenciennes hailed Panoramas in 1800 as 'this new

way of painting a general view that could contribute to the acquisition of knowledge'.[61] In England as early as 1789, the magazine *Woodfall's Register* was recommending that the new Panorama could function as a form of stored knowledge (and at the very highest level of society). It suggested 'the benefits of the Royal Family gaining knowledge of foreign lands through the panorama',[62] thus neatly tying a supposed educational purpose to Panorama's primary spectacle in an age of imperialism. The actual possession by the Royal Family of large areas of the world could be translated into purely symbolic form to enable cognitive possession without movement.

Thus the relatively simple idea – that one can find out a lot about foreign parts from visiting the Panorama – comes into being. Another witness, the eminent nineteenth-century art critic John Ruskin, seems to restate this in his autobiography of his early years, *Praeterita*, although it is possible that he also means something more. The relevant passage comes when Ruskin, visiting Milan, climbs onto the roof of the cathedral and enjoys the view:

> I had been partly prepared for this view by the admirable presentment of it in London, a year or two before, in an exhibition, of which the vanishing has been in later life a greatly felt loss to me – Burford's panorama in Leicester Square, which was an educational institution of the highest and purest value, and ought to have been supported by the Government as one of the most beneficial school instruments in London. There I had seen, exquisitely painted, the view from the roof of Milan Cathedral, when I had no hope of ever seeing the reality, but with a joy and wonder of the deepest; – and now to be there indeed, made deep wonder become fathomless.[63]

In this passage Ruskin takes praise of the Panorama considerably further than others. He praises its educational value, the 'exquisite' painting characteristic of it, the emotional impact, registered as 'joy and wonder', and the Panorama's ability to enhance the appreciation of the real scene, once that is visited. Given the nature of these emphases, it is possible that the educational value Ruskin felt in the Panorama was primarily aesthetic, rather than to do with geography or architectural history.

In *Woodfall's Register* and elsewhere the idea is that the Panorama is a repository of information stored and communicated in visual form. If we raise the simple question as to what sort of knowledge or information was communicated by the entertainments, then immediately the full insidiousness of the Panorama's alibi, as it were – the unthinking assumption that it simply reproduces reality – is made clear. If they reproduced reality, it would be total knowledge that would be stored in them. Clearly this is impossible and, as stated above, the idea of 'reproducing reality' and the idea of giving an 'illusion' of reality are hardly the same thing. One connotes a series of representational and aesthetic choices, and the other suggests that unthinking unselectivity in the name of the essential copy is both possible and (in this case) desirable. We now need to turn our attention to the ideological element

in the entertainments; that is, to the element which strove to maintain and promote a certain power relationship between national leaders, audiences and the people being depicted in the paintings themselves.

Indeed, the Panorama entertainments seem ideally suited as objects of inquiry into the question of ideological framing precisely because of the way in which they staked their representational and epistemological grounds on being mistaken for reproductions of reality. As T.J. Clark expressed it, 'Ideologies naturalize representation ... an ideology is a set of limits to discourse ... which closes speech against consciousness of itself as production.'[64] Or, to put it more specifically, which prevents a Panorama from being seen as a sign at all. Such a key operation of ideology seems to be precisely what Panorama entertainments can be understood as having achieved. Given the historical moment of the Panorama entertainments, during the apogee of imperialist expansion, and the very scope that Panorama entrepreneurs dared to embrace, the range of subjects over which the Panoramas cast the net of their ideological representations was very broad indeed. We have to come to terms with the problem of how knowledge is discursively constituted within the conceptual and compositional structures of the Panorama paintings themselves.[65] We must now turn to specific Panoramas and their contemporary explanatory leaflets.

One of the Panorama entrepreneurs who made some effort to attempt to overcome the built-in barrier to close involvement with local inhabitants was Robert Burford, and one of the Panoramas in which he attempted this was that of *Canton, the River Tigress, and the surrounding country* (1838), exhibited in Leicester Square. The Panorama, of course, does not survive, but an engraving derived from it accompanied Burford's descriptive leaflet (Figure 1.3). The leaflet adopts an interesting strategy towards the Panorama, in that it makes no reference to the painting as painting. It presents instead a partly historical and partly geographical and topographic description of the place depicted, written in the present tense. The lack of self-conscious references to the painting amounts to a verbal complicity with the *trompe l'oeil* to which Panorama aspires. It means that, so far as the text is concerned, there is no overt threshold acknowledged between representation and reality, and the status of the painting as sign is suppressed, which tends to enhance the sense that visitors on the Panorama's viewing platform are, for a few vertiginous moments at least, transported to the place that the Panorama is representing.[66] (Vertigo and even seasickness were a recurrent experience for visitors. To judge by one of the surviving Panoramas, John Vanderlyn's view of the gardens of Versailles mounted in the Metropolitan Museum in New York, the fleeting feeling of vertigo comes when the visitor, entering the centre of the Panorama's visual field, feels their own field of vision being peeled off, as it were, and replaced by that of the Panorama. There is a momentary foundering of free-will on the rock of Panorama's pre-determined vision). The commentary

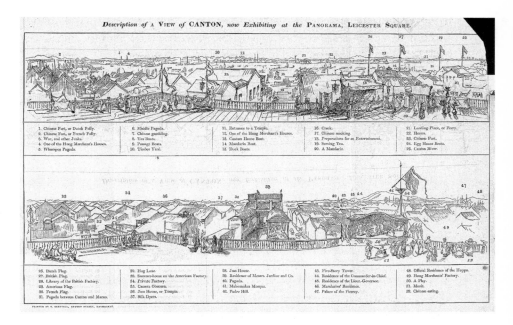

Description of A VIEW of CANTON, now Exhibiting at the PANORAMA, LEICESTER SQUARE.

1. Chinese Fort, or Dutch Folly.	6. Middle Pagoda.	11. Entrance to a Temple.	16. Creek.	21. Landing Place, or Ferry.
2. Chinese Fort, or French Folly.	7. Chinese gambling.	12. One of the Hong Merchant's Houses.	17. Chinese smoking.	22. Honan.
3. War, and other Junks.	8. Tea Boats.	13. Chinese House Boat.	18. Preparations for an Entertainment.	23. Chinese Port.
4. One of the Hong Merchant's Houses.	9. Passage Boats.	14. Mandarin Boat.	19. Serving Tea.	24. Egg House Boats.
5. Whampoa Pagoda.	10. Timber Yard.	15. Duck Boats.	20. A Mandarin.	25. Canton River.

26. Dutch Flag.	32. Hog Lane.	38. Joss House.	43. Five-Story Tower.	48. Official Residence of the Hoppo.
27. British Flag.	33. Summer-house on the American Factory.	39. Residence of Messrs. Jardine and Co.	44. Residence of the Commander-in-Chief.	49. Hong Merchants' Factory.
28. Library of the British Factory.	34. Private Factory.	40. Pagoda.	45. Residence of the Lieut.-Governor.	50. A Play.
29. American Flag.	35. Camera Obscura.	41. Mahomedan Mosque.	46. Mandarins' Residence.	51. Music.
30. French Flag.	36. Joss House, or Temple.	42. Padre Hill.	47. Palace of the Viceroy.	52. Chinese eating.
31. Pagoda between Canton and Macao.	37. Silk Dyers.			

PRINTED BY R. KNOTTELL, ARPENT STREET, HAYMARKET.

1.3 Robert Burford, engraving from descriptive leaflet for a *Panorama of Canton, the River Tigress, and the surrounding country*, 1838

starts, 'China stands alone among nations', and from that point to the end our attention is directed to the signified, and never to the signifier.[67]

The leaflet makes much of male pride and luxury in China, with mention of the mutilation of girls' feet to make them smaller. In general, blindness and deformation of limbs is common, we are told. In the early pages the topography is itemized, and attention is drawn to 'War and other Junks' in the river (p. 3), before Burford turns his attention to the groups of figures that he has painted in the foreground of the Panorama. One is a 'mandarin' (a ruling-class figure), and an account of that class is provided (p. 20). Others are serving and drinking tea, and the importance of tea in Chinese culture is emphasized (p. 19) just a few years before the British were transporting tea plants from China to India to start production of tea in India. However, it is when we focus on the group of 'Chinese smoking' (p. 17) that the commentary becomes of exceptional interest:

All classes of society, both male and female, enjoy the pipe, and tobacco of various qualities is raised in every province. Opium is a luxury much esteemed, and generally indulged in; its introduction into the Empire is strictly forbidden by law, as hurtful to health and morals; but some idea may be formed of the extent to which it is smuggled, when it is known to have formed one of the principal articles of British commerce for a long period, and in 1833 amounted to half the Company's imports,

being 11,618,167 dollars, or nearly 3 million pounds sterling; it is inhaled from a peculiar pipe, a small piece being enveloped in tobacco, or the tobacco steeped in a solution; after three or four whiffs, its narcotic effects become apparent.

By the standards of the time this is straightforward deadpan reporting, yet it almost manages to read like a sympathetic account, its sympathy being equally distributed. The people 'enjoy' smoking, and they esteem opium as a 'luxury', and Burford does not condemn them for doing so; the Chinese Imperial government has banned its import, as 'hurtful to health and morals', and Burford gives no intimation that the decision to do so was mistaken. Then he calmly shows to what extent the British East India Company was the chief drug smuggler. The passage closes with instructions about how to smoke the drug. In a few lines the whole economic and political situation around opium is spelled out, for we are on the eve of the Opium War, during which British trading interests forced opium onto the market in China by military action. In a sense this is the closest that Panorama came to disinterested reporting, and to fulfilling its function as conveyor of strategic information. The atmosphere here is a lot cooler than the overheated one to be encountered in contemporary battlefield Panoramas.[68]

Burford places local people, interacting with each other and enjoying their familiar customs, in the foreground of the work to help explain his subject.[69] Yet in a sense Burford's new-found technique of foregrounding local people in a sympathetic light is permitted by British mercantile involvements, which were interested in the Chinese taste for opium. In 1838 the volume of trade had risen to 40,000 'chests' per year, much of it grown in Bengal, the heartland of the Company in India. It was the government of the Chinese Empire that was the stumbling block to this trade, and it is the Empire which, while not overtly attacked, is distanced by Burford's Panorama. The custom of mutilating girls' feet, for example, also injurious to health, if not morals, is condemned in Burford's commentary, but not, so far as we are told, by the Empire. Nor are we told of any attempts that might have been made by the Empire to repair public health and combat blindness and deformity of limbs. Burford's even-handedness over the opium issue, therefore, is subtly undercut by other information that is presented, in an equally deadpan fashion, earlier in the text, and there is no need for overt jingoism to disrupt the informational/ educational alibi.

The remaining pages of the *Description* continue to lay out the geopolitical and economic situation. The Dutch flag could be seen in the Panorama, and the text uses the mention of it to comment on the relative trading status in China of Britain, Holland, the US and France (p. 26). Canton was the only port open to Western trade in the Chinese Empire. While French trade has diminished (a lesson to Britons about what must not happen to them), US trade has increased (a warning about present and future trends). The British flag is then

identified (p. 27), flying over 'Pow-wo-hong', or the British Factory, 'by far the most extensive and handsome', visitors are assured, of the 13 factories in Canton. In front of it, a 'large verandah commands a fine uninterrupted view both up and down the river', and for the moment, it seems, from this imperial panoramic point of view, all is as it should be, despite recent upheavals. The factory is decorated with portraits of King George IV and Lord Amherst, a magnate of the Honourable East India Company. Until the 1830s most of Britain's foreign policy in Asia had been set and executed by a single what we would now call multinational corporation – the Honourable East India Company, which, among other things ran a private army second only in size to the army of Russia.[70] The *Description* tells us, however, that 'On 22 April, 1834, the trade of the Company ceased, according to Act of Parliament, after having existed two hundred years'. This measure was a de-regulation of China trade, brought about by pressure from other mercantile interests and not by bad conscience about the Company's drug running. The trade simply passed into other (British) hands. The British Factory continued to function, and on p. 28 our attention is drawn to the Library of the British Factory (philanthropically stocked with Chinese language books, for employees). The US and French flags (pp. 29 and 30) now become signs of the geopolitical information that we have already been made privy to about their involvement in the China trade, and the survey of the port ends with places of religious significance. Pagodas, we are told, when 'in repair', support a 'crowd of idle and ignorant priests, deriving incomes from adjoining lands' (p. 40) rather like Roman Catholic monasteries viewed through ultra-Protestant eyes in Europe and, sure enough, quite close to the 'Mohammedan Mosque' (p. 41), the Joss House on 'Padre Hill' is home to a hundred priests (p. 42).

The impression is given of an open, cosmopolitan city, where workers are encouraged to read, smoke dope, drink tea, and respect the mandarins and Europeans. Diversity of religion is tolerated, and neither barbarous customs nor the Imperial administration weigh too heavily on the flow of trade. It presents a great deal of geographic and economic information. A nineteenth-century visitor seeking to be informed about an interesting and important corner of the world could have gone home satisfied. What is never brought to the surface is the extent to which the view corresponds to that of the British ruling class.

In 1839 the Opium War broke out after the Chinese government confiscated opium that had been warehoused by the British in Canton. A somewhat different picture of life in the Far East emerges from Burford's *A Description of a View of the islands and bay of Hong Kong; now exhibiting at the Panorama, Leicester Square. Painted by the proprietor, R. Burford; the figures by H.C. Selous; from Drawings, taken by F.J. White, Royal Marines, in 1843*[71] (London, 1844). The foreground (Figure 1.4) is all water, which was apparently seen from sea level, and the commentary begins with an paradox: 'The Panorama is

1.4 Robert Burford, engraving from descriptive leaflet for *A View of the Island and Bay of Hong Kong*, 1844

taken from a commanding situation in the Harbour' (p. 3). 'Commanding positions' are almost never at sea level; that would be a contradiction in terms, and this sentence, with its overt reference to the painted Panorama as signifier, contradicting Burford's usual practice, distances Hong Kong as it orients us to a somewhat unusual point of view. The point of view is in fact much closer to that of a coastal profile, and might serve to remind us that the drawing of coastal views while their ships were anchored in foreign harbours was a customary form of intelligence-gathering by Royal Navy officers.[72] F.J. White, who drew the scene, was a Royal Marine officer, belonging to a body of soldiers who habitually accompanied naval expeditions. Here is an example of a very common practice in relation to the Panorama entertainments, that of military officers providing the original drawings from which the entertainment is subsequently developed.[73] It was one of the chief avenues for crossover between military drawing and broad-based public entertainment. The leaflet sketches in the strategic situation of the Opium War and concludes by mentioning defeats of the Chinese army at Ning-Po and the occupation of the port of Chapoo (China's main port for the Japan trade), and destruction of various forts, after which the Chinese

ratified a peace treaty that gave the British Hong Kong and a further ransom of $21 million.

The Panorama of Hong Kong was obviously of less intrinsic interest than that of Canton, and the jumble of boats in the foreground has been anchored there in an attempt to make up the deficiency. The interest was mostly topical and external to the art work and even the subject: it was a result of the war.[74] Visitors may have come to gain a view of the latest addition to the colonies, but the question must become, can mere topical interest justify the immense amount of labour and effort spent in the preparation of a Panorama, when cheaper and more adaptable media – prints, and even illustrated newspapers (which had begun to appear in 1842) – could convey intelligible visual information more easily? From May to December 1842, *The Illustrated London News* printed 30 wood engravings of scenes from the Chinese theatre of war, ranging from three scenes of naval operations off Amoy (26 November) to the Porcelain Tower at Nankin (15 October). Illustrations are always accompanied by correspondents' despatches. How could the cumbersome Panorama entertainment hope to compete, on the level of topical reporting, with this flexibility? The question of topicality in the age of illustrated newspapers points to the eventual eclipse of the Panorama entertainments, and the passage of the panoramic visual field into other media, such as fold-out wood engravings and photographs.

While scholarship seeks to do justice to the spectacular visual impact of panoramic representation, it also needs to remember that Panorama entertainments were presentations of words and image; any inquiry into them that does not amount to a word and image inquiry therefore omits discussion of a crucial part of the visitors' experience of the entertainments and how that experience was discursively constituted. It should also be obvious by now that the Panoramas' displays of neither domestic nor foreign subjects can be taken to have been 'unselectively inclusive', or construable as simple factual reporting. Ideology permeates the construction of the panoramic visual field, from its origins in military drawing, through the Panorama entertainments, to late twentieth-century manifestations in the form of computer-generated diagrammatic images in newspapers, or of spy satellite photography. Any scholarly discussion that asserts that Panoramas simply imitated completely a pre-existing scene remains a dupe of that ideology. The Panorama entrepreneurs used the framing device of a verbal commentary to direct their viewers' attention, but in the images they also used proximity (foregrounding) versus distance, elevation versus depression, the enhancement of certain architectural features and not others, the selection of certain typical everyday activities for depiction and the suppression of others, and the selection of certain social groups or classes rather than others, to produce spectacles in which ideology was passed off as factual information, and in which the viewers' identification with a particular

position of power was sold in the guise of knowledge. First conceived as an entertainment, in which spectacle is prime, they are defined by reputable sources (Valenciennes, Ruskin and others) as an educational device. Yet close analysis of the Canton Panorama shows the ideological traps lurking beneath the educational surface. The ideological content is not a function of the painting alone, which by itself cannot convey enough information to be thought educational because it cannot incorporate the labelling function (present, for example, on the earliest panoramic military drawings, but to be avoided by an image that aspires to be mistaken for reality itself). Instead, the ideological element is a function of the conjunction of painting and explanatory text.

Responses to Panoramas

Panorama entertainments and the broad dissemination of panoramic views are among the defining features of visual culture of the period 1789–1840, when metaphorical uses of the word 'panorama' and verbal descriptions of the panoramic visual field abound. From this large selection of material, constraints of space here mean that we must limit ourselves to brief discussions of a small number of particularly pertinent examples. The impact of panoramic views and their relationship with military mapping are considered by William Wordsworth in his two poems of 1813–15 about a Lake District mountain, Black Combe.

'View from the Top of Black Combe'

This Height a ministering Angel might select:
For from the summit of BLACK COMBE (dread name
Derived from clouds and storms!) the amplest range
Of unobstructed prospect may be seen
That British ground commands: – low dusky tracts, 5
Where Trent is nursed, far southward; Cambrian hills
To the south-west, a multitudinous show;
And, in the line of eye-sight linked with these,
The hoary peaks of Scotland that give birth
To Teviot's stream, to Annan, Tweed, and Clyde: – 10
Crowding the quarter whence the sun comes forth
Gigantic mountains rough with crags; beneath,
Right at the imperial station's western base,
Main ocean, breaking audibly, and stretched
Far into silent regions blue and pale; – 15
And visibly engirding Mona's Isle
That, as we left the plain, before our sight
Stood like a lofty mount, uplifting slowly
(Above the convex of the watery globe)
Into clear view the cultured fields that streak 20

Her habitable shores, but now appears
A dwindled object, and submits to lie
At the spectator's feet. – Yon azure ridge,
Is it a perishable cloud? Or there
Do we behold the line of Erin's coast? 25
Land sometimes by the roving shepherd-swain
(Like the bright confines of another world)
Not doubtfully perceived. – Look homeward now!
In depth, in height, in circuit, how serene
The spectacle, how pure! – Of Nature's works, 30
In earth, and air, and earth-embracing sea,
A revelation infinite it seems;
Display august of man's inheritance,
Of Britain's calm felicity and power!

Wordsworth communicates the religious grandeur of nature partly through emphatic overtones of John Milton's poetry. The first line seems a clear reminiscence of the Archangel Gabriel's visit to Adam towards the end of Milton's 'Paradise Lost', when on top of a high hill Gabriel shows Adam a vision of the entire future of the human race. The phrase 'Look homeward now!' echoes Milton's 'Look homeward, Angel'. Although conditions of seeing are invoked in ll. 16–29 the poem is much more about the view itself, the things seen, and the exultation that can result to the mountain-climber from achieving so spectacular a view. The focus of interest changes in the other poem:

'Written with a Slate Pencil on a Stone, on the Side of the Mountain of Black Combe'

Stay, bold Adventurer; rest awhile thy limbs
On this commodious Seat! for much remains
Of hard ascent before thou reach the top
Of this huge Eminence, – from blackness named,
And, to far-travelled storms of sea and land, 5
A favourite spot of tournament and war!
But thee may no such boisterous visitants
Molest; may gentle breezes fan thy brow;
And neither cloud conceal, not misty air
Bedim, the grand terraqueous spectacle, 10
From centre to circumference, unveiled!
Know, if thou grudge not to prolong thy rest,
That on the summit whither thou art bound,
A geographic Labourer pitched his tent,
With books supplied and instruments of art, 15
To measure height and distance; lonely task,
Week after week pursued! – To him was given
Full many a glimpse (but sparingly bestowed
On timid man) of Nature's processes
Upon the exalted hills. He made report 20
That once, while there he plied his studious work

Within that canvass Dwelling, colours, lines,
And the whole surface of the out-spread map,
Became invisible: for all around
Had darkness fallen – unthreatened, unproclaimed – 25
As if the golden day itself had been
Extinguished in a moment; total gloom,
In which he sat alone, with unclosed eyes,
Upon the blinded mountain's silent top!

Wordsworth uses the ascent to the vantage point as an opportunity to meditate on the question of subjectivity and panoramic vision. Do we properly belong to the 'centre' or the 'circumference' (l. 11)? We creep out of the circumference to the centre, but we cannot occupy it for long: the centre is to be occupied by the 'bold Adventurer'(l. 1), having been occupied already by at least two other people, the poet and by the 'geographic Labourer' (l. 13). The vantage point which gives us such an exalted sense of our own subjectivity is a subject position, from which we shall have to return to become lost again in the circumference, and the intersubjectivity implied by this state of affairs is taken up by the poet's language, in his address to the Adventurer and use of 'thy' and 'thee'.[75] The poem is entirely about conditions of seeing, and the poet clearly enjoys the fact that nature is able to deny the cartographer (who we know was, in fact, General William Mudge of the Ordnance Survey) his seeing.[76] Utilitarian human aspirations to mundane map-making, complementing in an absurd way the ecstasy of the poet's vision of these panoramic views, can be humbled and set in perspective for a moment by nature's divine power.

The conjunction of a natural world informed by the presence of a God, and panoramic representation, forms the theme of a number of paintings by the German Romantic landscape painter, Caspar David Friedrich. One variant from 1810 is depicted here (Plate 1) – *Morning in the Riesengebirge*. In a panorama of mountain-tops a young woman, dressed in white as if she were a bride, assists a man to climb up the highest pinnacle and so to arrive at the foot of a crucifix. It is morning, and the landscape is full of light, hope and beauty. And yet there are limits to all these phenomena and feelings. We, the viewers, are not at the centre. We watch other subjectivities achieving that position. They will be able to see things we cannot. They are together; for a moment at least standing in front of the painting, we are alone. Yet even this couple will not occupy the most sovereign point of view depicted here, which is left to Christ on the cross.

A similar sense of exaltation tempered by limitation, thus producing yearning, comes from Friedrich's famous *Wanderer above a Sea of Fog*, 1818, which shows a red-headed man in a green frock coat gazing from a rocky pinnacle into a misty mountain-landscape with his back to the viewer. Yearning is awakened in at least two ways. He is where we want to be. We cannot see

everything he can see: he blocks part of our view. And the landscape we look at, and which he sees more completely than we can, has not yet come into being. He wears a coat associated with the liberal nationalists of the German states, with whose views Friedrich seems to have concurred, and whose aspirations for the emergence of a unified Germany after the defeat of Napoleon in the German War of Liberation (1813–14) were ended by the reactionary Congress of Vienna, which instead reconstituted the various German micro-states. The failure of a new Germany to emerge by peaceful means at this historical moment paved the way for the new state to be formed half a century later through Prussian conquest, and thus for Prussian militarism to dominate German nationalism – with disastrous consequences for the twentieth century. Thus the contours of the new state have not yet emerged from the fog in Friedrich's painting. The Wanderer endeavours to bring them into being as he gazes at them.

Thus in both Friedrich's painting and Wordsworth's poems there is a confluence of nationalist feeling and panoramic vision, but the facts of panoramic viewing can be as adroitly used to dramatize the limitations of nationalist aspirations. In 1820 C.R. Maturin published his extraordinary Gothic novel, *Melmoth the Wanderer*. In this work the Wanderer, like a latter-day Faust, has entered into a pact with the devil. He journeys to an island in the Indian Ocean and meets there its only inhabitant, a young beautiful noble savage named Immalee. She asks the Wanderer to show her the world, so he suggests they climb a conical hill on her island from the top of which at least part of the world can be seen. Her response clearly dramatizes the impulse to panoramic vision: 'I want to see it all,' she demands, 'and at once!'[77] On the hilltop the Wanderer gets out his telescope, which gives Immalee a series of views of religious buildings on the coast of India. It is worth emphasizing, with the help of an almost exactly contemporaneous watercolour painting by J.M.W. Turner (Figure 1.5), that the impulse to take in the whole view at once, and the desire to use a telescope to select and enlarge details, are the two related parts of a very consistent and orthodox response to panorama, and that the activities of the Wanderer and Immalee are not strange and bizarre in that respect. Turner's black-coated and top-hatted figures in the lower left of his *View of London from Greenwich* enact in their gestures and postures the two-stage response that Immalee adopts.

Once this is clearly understood, what happens next in Maturin's novel can be better appreciated. Once possessed of the Wanderer's telescope, Immalee sees, in turn, the 'Black pagoda of Juggernaut' surrounded by 'the bones of a thousand skeletons'; a temple of Mahadevi where the very young and very old are sacrificed to the goddess; a mosque in front of which Turks mistreat innocent Hindus; and a humble Christian chapel, the sight of which instantly converts Immalee to Christianity. Since this is the last thing the Wanderer wants, he has clearly lost control of his viewing instruments, and we are

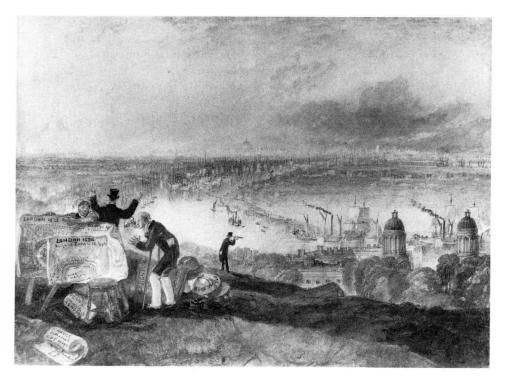

1.5 J.M.W. Turner, *View of London from Greenwich*, 21.3 × 28 cm (8⅜ × 11 inches), ink and watercolour, *c*.1825, The Metropolitan Museum of Art, New York

reminded that a panoramic view (as opposed to panoramic representation) is not in itself ideological; it is the interpretation of what can be seen that counts.

Let us test this question another way. Various commentators have noticed the similarity of architectural form between the Panorama entertainments and the model prison of Jeremy Bentham, the Panopticon, which emerged at the very same historical moment. Both structures feature a central viewing tower giving all-round views. The differences lie in what was seen from them and what the purpose of such seeing was. In the Panopticon the views showed cells of prisoners, each silhouetted against a window in the far side. Bentham predicted that the prisoners, not knowing whether in fact at any moment they were being observed from the dark tower, would assume that they were under constant surveillance and would internalize a power relationship based on the equation of looking/being looked at; they would, in short, quail before the all-seeing eye and regulate their own behaviour. Power is directly and demonstratively applied here, but it is clearly differently applied from that in the military drawings with which we started, gathering intelligence about

the land around which is all the more valuable if the inhabitants do not know they are being observed. It is also clearly different from the question of power in the Canton Panorama, for example, where manipulation of the audience's attitudes to a new strategic enemy depends on the verbal commentary as much as on the pictorial strategies of foregrounding versus distancing, suppression versus appearing to put everything in.

Various literary works of the time show the impact of panoptical thinking, more by employing one of the characters to reflect a sense of pressure felt from being constantly overlooked than by dramatizing a particular architectural form. A classic example of this is William Godwin's *The Adventures of Caleb Williams, or Things as They Are* (1794). The protagonist, Williams, lives as servant to the petty tyrant, Falkland, whom he endeavours to spy upon. Falkland, however, has a penetrating look, 'as if he would see my very soul'[78] and the tables are soon turned: Williams feels that 'I was his prisoner; and what a prisoner! All my actions observed; all my gestures marked. I could move neither to the right nor the left, but the eye of my keeper was upon me. He watched me: and his vigilance was a sickness to my heart.'[79] The language here – and elsewhere in the novel – is explicitly panoptic, although the situation is one of the victim living as a domestic servant in the watcher's house.

Williams finally manages to escape, and the gloomy ending of the book is not specifically dependent on the panoptic aspects. For this Radical novel, these panoptic effects are merely one element in the repressive 'machine' of society.[80] In another story that revolves around a panoptic seeing, Sheridan Le Fanu's 'The Familiar' (1872) the protagonist is not so lucky, nor does he deserve to be. Captain Barton finds himself haunted by a ghost. He has committed two deeds that count as crimes and indeed sins: he has deflowered the daughter of a sailor on one of his ships, and he has flogged the father to death. There is therefore ample reason in the exercise of an active bad conscience for him to suffer hallucinations of guilt. In other words, in a rather similar way as for the convicted criminals incarcerated in Bentham's Panopticon, there is a conscientious mechanism for the internalisation of guilt and oppressive power conveyed through the action of the gaze. For Captain Barton is more oppressed by the sense of being watched by this malignant ghost than he is, so far as we can tell, by a consciousness of his crimes. Indeed, the watchful presence becomes the outward sign of a reminder of the crimes. Another version of the same story was entitled 'The Watcher,'[81] and Barton tells a clergyman whom he consults, 'I stand in the gaze of death'.

Consideration of the Panopticon and Le Fanu's story takes us a long way from the panoramic vision and representation that we have been discussing in this chapter. Panorama's preoccupation seems to be with what might be termed objective knowledge, clearly seen, obscured by no atmospheric effects or psychological eccentricities. Such a preoccupation is subject to ideological

pressures. The panoptical, on the other hand, in Bentham, Godwin and Le Fanu, takes us into the domain of the psychological and the radically subjective. Le Fanu's story also invites us to consider, in the next chapter, a landscape of ghosts and spectres.

Notes

1. The name, Hoober Stand, combines the name of the hill on which the building stands, Hoober Hill, and a common term for a viewing platform (as in the *grandstand* of a race-course). For information about the domain of Wentworth Woodhouse, see Patrick Eyres, 'The Wentworths: Landscapes of Treason and Virtue: The Gardens at Wentworth Castle and Wentworth Woodhouse in South Yorkshire', in *New Arcadian Journal* 31/32 (1991); also Michael Charlesworth, 'The Wentworths: Family and Political Rivalry in the English Landscape Garden', *Garden History* 14, 2 (1986), pp. 120–137, and Geoffrey Howse, *The Fitzwilliam (Wentworth) Estates and the Wentworth Monuments* (Wentworth, near Rotherham: The Trustees of the Fitzwilliam Wentworth Amenity Trust, 2002).

2. Simon Pugh, *Garden, Nature, Language* (Manchester: Manchester University Press, 1988) p. 7.

3. Christopher Layer, promised a pardon by Sir Robert Walpole, was executed for his part in the Atterbury plot of 1721–23. John Mathews, printer, was executed for printing a Jacobite pamphlet. James Dawson, first cousin of the writer John Byrom, was hanged, drawn and quartered, as his fiancée watched, in 1746. Henry Oxburgh suffered a similar fate in 1715. There were many hangings of ordinary soldiers who had surrendered.

4. Rupert C. Jarvis, *Lord Malton and the '45: Collected Papers on the Jacobite Risings* (Manchester: Manchester University Press, 1971), vol. I, p. 45. Malton also found time to spy on the activities of the Roman Catholic magnate, the Duke of Norfolk, at nearby Worksop Manor, in the adjacent county of Nottinghamshire.

5. A written account of the tour, with watercolour illustrations, is in the British Library, Add. Mss. 42232, a bound volume entitled *Forrest's Tours*. The visit to Wentworth Woodhouse is on ff. 41–2. By consulting another copy in a private collection, Luke Herrman was able to specify the date as August 1774: see *Paul and Thomas Sandby* (London: Batsford, 1986), p. 57.

6. Information on Sandby has been taken from a number of sources, the most important of which are the *Dictionary of National Biography* (*DNB*); Herrman, *Paul and Thomas Sandby*; Michael Charlesworth, 'Thomas Sandby Climbs the Hoober Stand: The Politics of Panoramic Drawing in Eighteenth-Century Britain', *Art History* 19, 2 (1996), pp. 247–66; and Johnson Ball, *Paul and Thomas Sandby, Royal Academicians* (Cheddar, Somerset: Charles Skilton Ltd, 1985).

7. William Sandby, *The History of the Royal Academy of Arts* (2 vols, London, 1862), vol. I, p. 84.

8. Flitcroft also designed another major political monument, Alfred's Tower (1762–72) at Stourhead, for Henry Hoare. Alfred's Tower is also triangular in plan.

9. 'Dead ground' is ground that cannot be shot at, because it is inaccessible or invisible from a particular position. 'Fields of fire' are areas which can come within the path of bullets fired from particular locations. 'Cover' means 'that which serves for shelter or concealment' (*OED*).

10. British Library, Add. Mss. 15968(a).

11. Add. Mss. 15968(c).

12. I am using the word to designate a certain proportion of height to width (approximately 1:4 or more), combined with a view from an elevated position and a clear representation of details. These three factors, in combination, constitute the panoramic visual field.

13. Hugh Prince, conversation with the author, 22 September 2000.

14. Other countries, including Italy, produced panoramic drawings, of course: see Lucia Nuti's survey, 'Mapping Places: Chorography and Vision in the Renaissance', in D. Cosgrove (ed.), *Mappings* (London: Reaktion Books, 1999), pp. 90–108.

15. Ann Bermingham, *Learning to Draw: Studies in the Cultural History of a Polite and Useful Art* (New Haven and London: Yale University Press, 2000), p. 81, cites the seventeenth-century

artists Thomas and Jan Wyck and Peter Tillemans as being important in this respect. See also Hendrik Danckerts and John Talman's drawings reproduced in Kim Sloan's *'A Noble Art': Amateur Artists and Drawing Masters c.1600–1800* (London: British Museum Press, 2000), pp. 30–31, 26.

16. Cf. Bruce Robertson, *The Art of Paul Sandby* (New Haven: Yale Center for British Art catalogue, 1985), p. 18.

17. James Gandon, *Memoirs* (Dublin, 1846), pp. 186–7. While this is not an entirely reliable book, Gandon, an architect, at least knew Sandby personally.

18. See the survey of such material in the catalogue, *Gilded Scenes and Shining Prospects: Panoramic Views of British Towns, 1575–1900* by Ralph Hyde (New Haven: Yale Center for British Art, 1985), and Richard Godfrey, *Wenceslaus Hollar: A Bohemian Artist in England* (New Haven: Yale University Press, 1995). Sloan's *'A Noble Art'* shows how bird's-eye views fitted into the overall picture of this level of art during the period covered, as does Ann Bermingham's wonderful study, *Learning to Draw*.

19. William Sandby, *History of the Royal Academy*, vol. I, p. 84.

20. The architect Sir John Soane remembered with enthusiasm the effect on him, as a student, of Sandby's sixteen-feet-long watercolour of a design for a 'bridge of magnificence'. See Anonymous, 'Style and Rendering in the Architectural Drawings of Thomas Sandby' (Ploughkeepsie NY: Vassar College Art Gallery, 1990), pp. 8–9.

21. Robertson, *Art of Paul Sandby*, pp. 9–10. Paul's obituary in *The London Review and Literary Journal* (8 November 1809, p. 400) stated that Paul Sandby was 'the father of modern landscape painting in water-colours'. Certainly by 1809 there were many highly skilled watercolour artists working in Britain in a movement of which Paul's obituary describes him as the 'father'. Yet on the subject of paternity, Benjamin West, the President of the Royal Academy who knew both brothers personally, referred to this growth of watercolour art as 'a style of drawing ... practised in this country such as had not been seen in any other', but he attributed it to different parentage: 'with Thomas Sandby it had originated' (Benjamin West's dinner conversation, 28 March 1807, quoted by Joseph Farington, who sat next to him at dinner, in *The Diary of Joseph Farington*, ed. Kathryn Cave, vol. VIII, July 1806–December 1807 (New Haven and London: Yale University Press, 1982), p. 2998).

22. His work for the Ordnance Survey of Scotland is discussed by Jessica Christian, 'Paul Sandby and the Military Survey of Scotland', in N. Alfrey and S. Daniels (eds), *Mapping the Landscape: Essays on Art and Cartography* (Nottingham: University Art Gallery and Castle Museum, 1990), pp. 18–22. Nicholas Alfrey's essay, 'Landscape and the Ordnance Survey' (pp. 23–7) and Jocelyn Hackforth-Jones's 'Imagining Australia and the South Pacific' (pp. 13–17), in the same volume, also bear on the relations between panoramic images and mapping.

23. 'It was undoubtedly because of Thomas Sandby's association with the Duke of Cumberland that Paul could count among his patrons some of the most important men in the country': Robertson, *Art of Paul Sandby*, p. 10. By 1799 Paul Sandby had to petition the Royal Academy for charitable relief. At his retirement from Woolwich, he had been granted a pension of £50 per year, apparently taken from his successor's salary as Chief Drawing Master, which was reduced from £150 to £100. As his successor was his own son, Thomas Paul (who remained in the job until 1828), this was rather unfortunate! Details of the brothers' career finances, which show quite clearly how much more financially successful Thomas was, are in Ball, *Paul and Thomas Sandby*, especially pp. 129, 169, 193.

24. *Rules and Orders of the Royal Military Academy* (1764), pp. 4, 6, 8. The Master-General of the Ordnance, at this stage, was the cavalryman, Lord Granby.

25. *Rules and Orders of the Royal Military Academy* (1776), pp. 5, 14, 19.

26. *Rules and Orders* (1776) p. 25.

27. *Records of the Royal Military Academy 1741–1840* (1851), p. 46.

28. By this time the Master-General of the Ordnance, who wrote these orders, was Viscount Townshend, whose father came from a hard Walpolean Whig family, and whose mother, the daughter of an East India magnate, was a Jacobite sympathizer. The Viscount, early in his career an aide-de-camp to Cumberland, grew disgusted with him and left the army until Cumberland's retirement. He also developed characteristic Jacobite or Tory traits such as a hatred of standing armies (*DNB*).

29. Oliver Hogg, *The Royal Arsenal: Its Background, Origin and Subsequent History* (London: Oxford University Press, 1963), p. 383.

30. Bruce Robertson, 'Venit, Vidit, Depinxit: The Military Artist in America', in Edward J. Nygren, *Views and Visions: American Landscape before 1830*, exhibition catalogue (Corcoran Gallery of Art, Washington DC, 1986), pp. 83–104, quotation on p. 91. For a view that implicitly contrasts with Robertson's, see J. Russell Harper's *Painting in Canada* (Toronto: University of Toronto Press, 1966), especially pp. 37–170.

31. The case of George Heriot shows exceptionally clearly the impact of Paul Sandby's teaching after Heriot became a student at Woolwich in 1781, in contrast to drawings he produced in the West Indies, 1776–81. See Gerald Finley, *George Heriot: Postmaster-Painter of the Canadas* (Toronto: University of Toronto Press, 1983) and Finley, *George Heriot 1759–1839* (Ottawa: National Gallery of Canada, Canadian Artists Series, 1979).

32. The case of another lesser-known artist, Thomas Davies, is instructive. Robertson implicitly rules out the possibility of Sandby's 'influence' on the grounds that Davies attended the Royal Military Academy in 1755–56, before Sandby worked there, and was taught by Gamaliel Massiot. However, Davies's *View of the Attack on Fort Washington and Rebel Redouts near New York on the 16 of Nov. 1776* is remarkably similar in stylistic appearance to Paul Sandby's *View in Strathspey (Strath Tay) with Castle Menzies* (1747). If analysed in terms of interpersonal 'influence', this similarity might suggest that both artists were therefore influenced by Massiot. Yet, in arguing against Sandby's influence, Robertson has suggested that any ambitious officer cadet would hire a drawing master rather than simply rely on his Academy training. Since Paul Sandby was one of the most prominent drawing masters in London, the possibility opens up, therefore, that Davies was influenced by Sandby before the latter arrived at Woolwich! The circularity of this kind of argument shows the futility of basing our understanding solely on the idea of individuals influencing each other in the domain of personal style. Another level of abstraction is needed to confront the material, such as the level offered by Michel Foucault's theorization of discourse. In the present work I wish to concentrate attention on the construction of the visual field, rather than on 'style' and appearance. For Davies, see R.H. Hubbard (ed.), *Thomas Davies in Early Canada* (Ottawa: Oberon Press, 1972).

33. For Edward Thomas, see *The Collected Poems of Edward Thomas*, ed. R. George Thomas (Oxford: Oxford University Press, 1981), p. 191, diary entry for 25 March 1917 (for example). For the Second War, with illustrations, see Paul Gough, 'Tales from the "Bushy-Topped Tree": A Brief Survey of Military Sketching', *Imperial War Museum Review* 10 (1995), pp. 62–74, and 'Dead Lines: Codified Drawing and Scopic Vision in Hostile Space', *Point: Art and Design Research Journal* 6 (1998), pp. 34–41.

34. See Greg Smith, *Thomas Girtin: The Art of Watercolour* (London: Tate Gallery Publishing, 2002), p. 153.

35. Farington, *Diary*, vol. XI, p. 3922, entry for 2 May 1811.

36. For Australia, see Michael Rosenthal's valuable essay, 'A View of New Holland: Aspects of the Colonial Prospect', in C. Payne and W. Vaughan, *English Accents: Interactions with British Art c.1776–1855* (Aldershot: Ashgate, 2004), pp. 79–100; and for Scotland, see the Countess of Sutherland's work reproduced in Smith, *Thomas Girtin*, p. 257.

37. Ford Madox Ford, *No Enemy, A Tale of Reconstruction* (New York, 1929), p. 82.

38. As in earlier Dutch map-printing, and the later panoramic views of US towns produced by various companies in the nineteenth century, such as the 1894 view of Los Angeles lithographed by B.W. Pierce and published by the Semi-Tropic Homestead Company (Amon Carter Museum of Western Art, Fort Worth, Texas). The publisher's identity hints that panorama continued to be a colonialist's activity, in a capitalist rather than overtly military mode, a century after the Sandbys' deaths.

39. Anonymous, *A Description of the Lakes of Killarney* (1776), pp. 44–5.

40. Uvedale Price on 'prospect-hunters', cited in Michael Rosenthal, *Constable: The Painter and his Landscape* (New Haven: Yale, 1983), p. 108. As Professor of Painting at the Royal Academy, Henry Fuseli dismissed landscape painters as 'the topographers of art' – a comment that indicates a low artistic status for topographical work: Allan Cunningham's *Life of Fuseli* (1829), quoted by Eudo C. Mason, *The Mind of Henry Fuseli: Selections from his Writings with an Introductory Study* (London: Routledge & Kegan Paul, 1951), p. 273.

41. This work, published serially over three years, was one of Paul Sandby's attempts to profit from his print-making through publication. The illustration, of Killarney's middle and upper lakes, is inscribed 'Drawn by Viscount Carlow. Painted by Sandby. Engraved by Rider' (Plate 69).

42. Anonymous, *Description of the Lakes of Killarney*, pp. 45–6.

43. Charlotte Klonk, *Science and the Perception of Nature: British Landscape Art in the Late Eighteenth and Early Nineteenth Centuries* (New Haven and London: Paul Mellon Centre and Yale University Press, 1996). Quotations from pp. 149–50.

44. Oetterman's book has been translated into English by Deborah Schneider as *The Panorama: History of a Mass Medium* (New York: Zone Books, 1997).

45. *Ibid.*, p. 49.

46. *Ibid.*, p. 51.

47. Bernard Comment, *The Panorama* (London: Reaktion Books, 1999), p. 19.

48. *Ibid.*, pp. 104, 86.

49. Or rather, three ways, including the gender studies-based approach of Denise Blake Oleksijczuk, 'Gender in Perspective: The King and Queen's Visit to the Panorama in 1793', in *Gendering Landscape Art*, ed. S. Adams and A.G. Robins (Manchester: Manchester University Press, 2000), pp. 146–61.

50. The Panorama is on display in the Victoria and Albert Museum, London. Bernard Comment detects the changed position of buildings, *Panorama*, p. 200.

51. Girtin's Panorama entertainment, the *Eidometropolis*, is explained in Smith, *Thomas Girtin* (London: Tate Gallery Publishing, 2002).

52. The studies are in the British Museum and are well reproduced in Smith's *Thomas Girtin*, pp. 194–206.

53. Quoted in Oetterman, trans. Schneider, *Panorama*, p. 101.

54. Wordsworth, *The Prelude* (1805 text), ed. E. de Selincourt and Stephen Gill (Oxford: Oxford University Press, 1970), Book VII, ll. 229–233, 236–243.

55. *Ibid.*, ll. 245–247.

56. *Ibid.*, ll. 248–280.

57. Constable's 'minutely and cunningly' is quoted in C.R. Leslie, *Memoirs of the Life of John Constable, Composed Chiefly of his Letters*, 1843 (Ithaca, New York: Cornell, 1980), p. 17.

58. On this, see Charles Cramer's unpublished PhD dissertation, *Formal Reduction and the Empirical Ideal, 1750–1914: An Essay in the History of Ideas of Classicism*, University of Texas at Austin, 1997.

59. Quoted in Comment, *Panorama*, p. 130. The Paris Panorama of Jerusalem opened in 1819, and that of Athens in 1821.

60. Quoted in Oetterman, trans. Schneider, *Panorama*, p. 232.

61. Valenciennes, *Elements de Perspective Pratique*, quoted in Comment, *Panorama*, p. 130.

62. Quoted by Scott B. Wilcox, 'Unlimiting the Bounds of Painting', in *Panoramania!*, ed. Ralph Hyde (London: Barbican Art Gallery, 1988), pp. 33, 38.

63. Ruskin, *Praeterita*, 1885–89, ed. A.O.J. Cockshut (Kelle University Press: Ryburn Publishing, 1994), pp. 89–90.

64. T.J. Clark, *The Painting of Modern Life: Paris in the Art of Manet and his Followers* (Princeton: Princeton University Press, 1984), p. 8. Clark continues with statements that seem extremely pertinent to a discussion of the unbounded spectacular display of Panorama entertainments: 'knowledge, in ideology, is not a procedure but a simple array; and in so far as pictures or statements possess a structure at all, it is one provided for them by the Real.'

65. William Galperin, in the early chapters of *The Return of the Visible in British Romanticism* (Baltimore: Johns Hopkins University Press, 1993), discusses Panoramas mainly in terms of the visitor's and author's experience at the expense of a concentration on what was seen, thus omitting a rather crucial part of the equation. Histories of the Panorama include Heinz Buddemeier, *Panorama, Diorama, Photographie: Enstehung and Wirkung neuer Medien im 19 Jahrhundert* (Munich, 1970).

66. Burford had worked out this verbal strategy at least as early as the Panorama of Edinburgh in 1825. See *A Description of the View of the City of Edinburgh and surrounding country ... from drawings taken ... from the summit of Calton Hill* (London, 1825).

67. *A Description of a View of Canton, the River Tigress, and the surrounding country; now exhibiting at the Panorama, Leicester Square. Painted by the proprietor R. Burford* (London, 1838).

68. Some of which are described by Peter Harrington, *British Artists and War: The Face of Battle in Paintings and Prints 1700–1914* (London: Greenhill Books, 1993).

69. He used a similar technique in the *Panorama of Athens* (*Description of the View of Athens*, n.d., p. 12) but there the printed commentary filtered the perception through the words of Lord Byron, who had compared Albanians to the Highlanders of Scotland.

70. John H. Waller, *Beyond the Khyber Pass: The Road to British Disaster in the First Afghan War* (Austin: University of Texas Press, 1990), p. xxiv. This book contains a useful short summary of the Company's activities in India before 1842.

71. This title shows quite clearly the continuity of interest between Panorama entertainments and panoramic drawing from military purposes. Military officers returning from abroad became one of the chief sources for designs by Panorama entrepreneurs.

72. Luciana de Lima Martins, 'Mapping Tropical Waters: British Views and Visions of Rio de Janeiro', in *Mappings*, ed. Denis Cosgrove (London: Reaktion Books, 1999), pp. 148–68.

73. See, for example, Wilcox, 'Unlimiting', p. 37.

74. War scenes were a staple of Panorama entrepreneurs from the early days. Oettermann's index lists 40, from the Battle of The Glorious First of June 1794 (1795) to the Battle of Gettysburg (1883).

75. Two stimulating authorities on subjectivity are Emile Benveniste, *Problèmes de linguistique générale* (Paris: Gallimard, 1966) and Michel Foucault, *The Archaeology of Knowledge*, 1969, trans. A. Sheridan Smith (London: Tavistock, 1972).

76. Colonel Sir Charles Close, *The Early Years of the Ordnance Survey* (Chatham: Institution of Royal Engineers, 1926), p. 60.

77. Quotation and summary refer to the lengthy passage in C.R. Maturin, *Melmoth the Wanderer: A Tale* (1820), ed. Alethea Hayter (Harmondsworth: Penguin Books, 1977), pp. 386–96.

78. William Godwin, *The Adventures of Caleb Williams*, 1794 (London: Cassell, 1966), p. 122.

79. *Ibid.*, p. 157.

80. *Ibid.*, p. 201.

81. Sheridan Le Fanu, *The Watcher and Other Weird Stories* (London, 1894).

Ghosts and visions

Consideration of Le Fanu's stories, and 'The Familiar' in particular, brings up the question of the extent to which landscape in nineteenth-century Britain is haunted by ghosts and spectral visions. 'The Familiar' emphasizes that seeing ghosts is a function of subjectivity: ghosts 'haunt' specific individuals, particularly those with some crime or sin on their consciences. As we shall see, this can link up with subjectivity in optical inquiries or, to put it another way, the issue of how pathologies of vision are specific to individuals. Yet there remains another question to be explored first, which is that of whether, and if so how, ghosts can be culturally engendered.[1] That is to say, can ghosts be produced by historical factors within a culture and therefore have an origin outside the vagaries of psychological subjectivity? This chapter will test the question of whether ghosts are truly individualized and subjective or to what extent historico-cultural factors are involved in causing them to exist. As we shall see, this inquiry takes us to land of a specific kind and the way it informs culture.

Ghosts

The Gothic novel became extraordinarily popular in Britain from the 1790s until the 1830s. While Mary Shelley's *Frankenstein* dates from 1816, and Bram Stoker's *Dracula* from 1897, the Gothic novel's high tide lasted from the appearance of the novels of Ann Radcliffe and M.G. Lewis in the 1790s until C.R. Maturin's *Melmoth the Wanderer* (1820) which became, after Lewis's *The Monk* (1795) the best-known of the genre in France. Non-Gothic novelists exhibited a range of responses to these lurid upstarts: the Brontë sisters captured some of the energies of Gothic in *Jane Eyre*, *The Tenant of Wildfell Hall* and *Wuthering Heights*; while Jane Austen made satirical fun at the expense of the Gothic mode.

Catherine Morland, the heroine of Jane Austen's posthumously published novel *Northanger Abbey* (written 1797–98, published 1818), is put through some lessons in the 'picturesque' way of seeing by the novel's leading man, Henry Tilney. The picturesque, as we understand it, depends upon the subject having been exposed to poetry or art and on the basis of that exposure to have formed some mental paradigms by which real countryside can be judged for aesthetic pleasure.[2] The picturesque is therefore a way of being a tourist: of visiting and traversing real terrain and assessing not its productivity or its actual or latent economic profitability, but the extent of visual pleasure that it gives (though the pleasure is not strictly confined to the visual sense). Catherine Morland's mind, however, has not been formed by the innocence, or at least amorality, of the picturesque way of seeing. Instead she has read, apparently uncritically, the Gothic novels that she and her friends enjoy. She is thus prepared to assess real landscape not for its capacity to provide visual pleasure, but in the expectation that some, at least, of it will conform to the paradigms of Gothic fiction. Catherine assumes that murders have been committed and that life in the peaceful English countryside is full of dangers.

When Catherine visits Henry Tilney's home, Northanger Abbey, claiming never to have visited a real abbey before, she assumes, from observing the Tilney family's behaviour whenever Henry's dead mother is mentioned, that the unfortunate woman was murdered; and thus she inspects the house in a state of mental alertness to the question of which room witnessed the crime. The house contains some modern rooms, newly furnished: but Catherine is more interested in the rooms of the original mediaeval foundation of the building, and is vexed when General Tilney will not allow his daughter to show Catherine the room in which her mother died nine years previously. This small incident tends to confirm, in Catherine's view, that the General has indeed murdered his wife.

In revolving these matters, while she undressed, it suddenly struck her as not unlikely, that she might that morning have passed near the very spot of this unfortunate woman's confinement – might have been within a few paces of the cell in which she languished out her days; for what part of the Abbey could be more fitted for the purpose than that which yet bore the traces of monastic division? In the high-arched passage, paved with stone, which already she had trodden with peculiar awe, she well remembered the doors of which the General had given no account.[3]

In having fun with the conventions of the Gothic novel, Jane Austen is considerably indebted to Anne Radcliffe, who had helped to establish those conventions in a remarkable series of novels published in the 1790s. Radcliffe and her novels are alluded to repeatedly throughout *Northanger Abbey*, and are finally meditated on in a way which puts Gothic preoccupations in perspective:

Charming as were all Mrs. Radcliffe's works, and charming even as were the
works of all her imitators, it was not in them perhaps that human nature, at
least in the midland counties of England, was to be looked for ... In the central
part of England there was surely some security for the existence even of a
wife not beloved, in the laws of the land, and the manners of the age.[4]

Why should Catherine feel that a murder could have been more appropriately
committed in a part of the house which 'yet bore the traces of monastic
division'? What is acting upon her perception of the building in this moment?
It is Ann Radcliffe's *The Romance of the Forest* (1791) that can particularly help
with this question. In that novel the heroine, Adeline, flees Paris with the
family of an older man named La Motte. Late in the day, in the middle of a
vast wood, they come across the deserted ruins of a mediaeval abbey. Since
they need somewhere to stay, and to hide, they inspect the abbey to see if it
might be able to afford them accommodation. La Motte is impressed enough
by the architecture of the ruined abbey church to characterize the lives of
the original monks in terms of 'devotion' and 'penitence', which, however,
he immediately represses as 'superstition' and 'austerity'.[5] Soon his feelings
begin to shift again to a third sensation:

The deepening gloom now reminded La Motte that he had no time to
lose, but curiosity prompted him to explore farther ... As he walked over
the broken pavement, the sound of his steps ran in echoes through the
place, and seemed like the mysterious accents of the dead, reproving the
sacrilegious mortal who thus dared to disturb their precincts ...

Adeline with a smile, inquired of La Motte, if he believed in spirits.
The question was ill-timed, for the present scene impressed its terrors
upon La Motte, and, in spite of endeavour, he felt superstitious dread
stealing upon him. If spirits were ever permitted to revisit the earth, this
seemed the hour and the place most suitable for their appearance.[6]

The complete pattern shows 'devotion' being dismissed as 'superstition'
only to prompt thoughts of a 'sacrilegious mortal' who himself becomes
susceptible to 'superstitious dread'. In the face of the threatened return of the
repressed, the party find some modern rooms in the abbey where they feel
more comfortable than in the original monastic cells. They live in the modern
apartments for a while, but when Adeline makes forays into the older part of
the building she becomes a victim of terrifying happenings.

Ann Radcliffe, who never travelled outside Britain until much later in life,
and whose imagined France therefore reflects a purely British sensibility,
provides major clues about the historico-mythical dynamic that haunts ruined
abbeys. In fact she is responding to, and making very personal, a vision of
abbeys that had wide currency earlier in eighteenth-century Britain, when
the Whiggish poet William Shenstone had stigmatized the ruined abbeys that
dotted the British landscape as the former abodes of 'superstition' and 'mental

bondage'.[7] In his poem *The Ruin'd Abbey, or, the Effects of Superstition* (1746) he characterizes the mediaeval monks as murderous, gluttonous, fraudulent, avaricious, envious, proud, revengeful, shameful and 'libidinous'.[8] Shenstone is obviously exploiting a considerable inheritance of anti-Catholic, anti-monastic literature and rumour, and he does so at the time of the Jacobite Rebellion of 1745–46, when embattled supporters of the exiled Stuart kings briefly threatened to replace the Hanoverian dynasty of Protestant Georges on the throne by Roman Catholic monarchs.

Yet even with Shenstone we have not fully explained the fascination of Catherine Morland and Adeline with ancient monastic cells and the full ramifications of ruined abbeys as features in the British landscape taken up by Gothic literature. Radcliffe used her character La Motte to dramatize not only a dismissal of the monastic system as 'superstition', following an orthodox Protestant view, but more rivetingly to experience second thoughts expressed as encroaching 'terrors' and 'dread'. Here she draws close to, but also uses for her own individual purpose, an even earlier sixteenth- and seventeenth-century debate associated largely with the formidable figure of Sir Henry Spelman (1564?–1641). In his works *De non Temerandis Ecclesiis, churches not to be violated* (1613) and *The History and Fate of Sacrilege*, which was considered too controversial to publish with the rest of Spelman's posthumous papers, *Reliquiae Spelmannianae* (1695) and which only appeared 'published for the Terror of Evil Doers' as late as 1698, Spelman pointed out that while they had been ruined by the Protestant Reformation (specifically by Henry VIII's orders, 1536–40), the ancient abbeys, priories and nunneries had never been deconsecrated. They thus still amounted to spiritually potent sites. The new Protestant landowners thus risked God's condign punishments for sacrilege, especially if they did not contribute a considerable portion of the income they derived from former monastic lands to the support of the Church. Spelman's view does not compromise:

Sacrilege is an invading, stealing, or purloining from God, any Sacred thing
... Sacrilege was the first Sin, the Master-Sin, and the common Sin at the
beginning of the World, committed in Earth by Man in Corruption, committed
in Paradise by Man in Perfection, committed in Heaven itself by the Angels in
Glory, against God the Father by arrogating his Power, against God the Son
by contemning his Word, against God the Holy Ghost by prophaning things
sanctified, and against all of them in general by invading and violating the Deity.
Let us now see how God revenged himself upon Sinners, in this kind ...[9]

For a Protestant, therefore, a spiritual terror lurked in the still-sacred heaps of earth and rubble of ancient monastic places. However, the point is that peril does not simply exist where it is most concentrated, around the ruined abbey churches and monastic buildings. In Spelman's view any landowner who even owned farmland that had once contributed to the support of a monastic

institution, no matter how far removed from the building itself, could expose himself to God's wrath and risked divine retribution. The threat therefore extends across the entire countryside of Britain. Many of the anecdotes of misfortune that Spelman cites in support of his views have a distinctly Gothic atmosphere to them, featuring as they do insanity, murder, accidental murder and so on. Belief in divine wrath directed in this way threatens the occupation of monastic lands by secular Protestant landowners that was celebrated in poems such as Andrew Marvell's *Upon Appleton House* (1652). The argument remained controversial during the reign of the Catholic king, James II (1683–1688).[10]

Tracing this combination of sources enables us to see clearly that in the early nineteenth century ghosts and spectres could be produced by the culture and by history: they could be accessible to a wide variety of people, whose susceptibility to them did not simply depend upon a hyper-sensitive or even morbid subjectivity. It would be little exaggeration to say that Gothic stories emanate from Protestant guilt about the violence they have done to the body politic during the Reformation, the Civil War and the expulsion of James II.[11] Despite a constitutionally sanctioned Roman Catholic resurgence in Britain during the nineteenth century, it seems that such fascinated play on the question of spectral ruins, distantly propped on Spelman's anxiety, feeding from the question of Protestant guilt, faded as the century progressed. Nevertheless, it is possible to argue that faint ripples of Spelman's stark worries still found their way into Gothic literature towards the end of the nineteenth century. It is tempting to revert to Spelman to explain why Count Dracula, in Bram Stoker's novel of 1897, in arranging his move from Transylvania to London, needed to take with him several boxes of earth from his own castle. He seems like an exotic hothouse flower, improvising his own version of a Wardian case.[12] Here is an inversion of the idea of sanctified ground. Another famous vampire story, Sheridan Le Fanu's *Carmilla* (1872) discovers the vampire in a blood-bathed coffin in the deserted transept of a ruined church. The idea that evil spirits haunt their own tainted soil has a line of descent reaching back through the sources we have traced to Spelman on sacrilege. The repressed haunting their own soil is a theme that can also be enunciated in a way much more sympathetic to the original dispossessed populations, however. From a different part of the range of possible responses to ruins, one more sympathetic to Roman Catholics, comes the evocation of the heroine in Benjamin Disraeli's novel, *Sibyl, or the Two Nations* (1845). In this novel Disraeli uses the subject of the Old Faith (Catholicism) at the moment of its re-emergence in the nineteenth century, as a way of inaugurating his discussion of the forces and consequences of wealth and poverty in Britain during the period. In this novelist's view (reflecting the view current in Radical circles in Britain at the time), the historical perspective involved in understanding the situation of rich and poor begins with the Protestant Reformation and

its consequences. The novel's protagonist, Egremont, has met two strangers while visiting the ruins of an abbey in northern England:

The last words of the stranger lingered in the ear of Egremont; his musing spirit was teeming with many thoughts, many emotions; when from the Lady Chapel there rose the evening hymn to the Virgin. A single voice; but tones of almost supernatural sweetness; tender and solemn, yet flexible and thrilling.

Egremont started from his reverie. He would have spoken, but he perceived that the elder of the strangers had risen from his resting-place, and, with downcast eyes and crossed arms, was on his knees. The other remained standing in his former posture.

The divine melody ceased; the elder stranger rose; the words were on the lips of Egremont, that would have asked some explanation of this sweet and holy mystery, when in the vacant and star-lit arch on which his glance was fixed, he beheld a female form ... The blush of deep emotion lingered on a countenance, which though extremely young, was impressed with a character of almost divine majesty; while her dark eyes and long dark lashes, contrasting with the brightness of her complexion and the luxuriance of her radiant locks, combined to produce a beauty as rare as it is choice; and so strange, that Egremont might for a moment have been pardoned for believing her a seraph, that had lighted on this sphere, or the fair phantom of some saint haunting the sacred ruins of her desecrated fane.[13]

Apparitions

Le Fanu mentions Radcliffe's *The Romance of the Forest* and its heroine in his novel *Uncle Silas* (1864) during the heroine's search for Mr Charke's skeleton, thereby beginning to show the code, the intertextual tissue, on which his own novel depends.[14] However, through consideration of the work of Le Fanu we can leave this issue of the historical generation of spectres, and turn back to the question of individual subjectivity. In general, Le Fanu's Gothic fiction tends to betray much greater interest in inner, psychological, subjective questions. One of these is the question of the relationship between seeing and spectral visitation.

We have already begun to discuss this partially in relation to 'The Familiar'. Both this story and another more famous one, 'Green Tea' (1872), bear upon questions that were frequently debated in Le Fanu's own lifetime. What do you see when you see a spectre or ghost? Can you believe your eyes? And why do you see it? The ways in which the unfortunate protagonists of Le Fanu's stories are treated – first by other characters and then by their author – enables us to comprehend the issues involved in such questions. In 'The Familiar', the evil Captain Barton's friends can see the Watcher who haunts him, which suggests that this person has an objective material existence. Barton consults a physician, who suspects mental anxiety but detects 'derangement of the digestion'.[15] Barton then goes to a clergyman, who of all people might

be expected to believe in the reality of spirits, yet who initially talks of Barton's 'depression' originating in physical causes, and sees him as his 'own tormentor'.[16] The clergyman prescribes prayer to Barton, who does not believe biblical revelation. Barton's prospective father-in-law decides that Barton is being haunted by a living person harbouring murderous intentions.[17] In short, none of the characters believes that Barton sees real spectres. They assume that he is ill, or materially persecuted: that he is the victim of hallucinations or of illusions practised on him by an obsessive criminal.

The explanation of spectral emanations cannot be contained merely within the idea of bad conscience, which is what Barton's case implies. The innocent Mr Jennings, in Le Fanu's 'Green Tea', is himself a clergyman, and he comes to be afflicted by the vision of a monkey. The monkey is a malignant spirit, whose appearance increasingly alarms and distresses Mr Jennings. The monkey-apparition tries to persuade Jennings to kill himself. It shouts 'dreadful blasphemies' at him.[18] It appears sitting on his Bible when he ascends the pulpit to preach his sermon. Nobody but Jennings can see and hear all this. In the face of the great distress caused to Jennings by his inability to rid himself of this constant alarming companion, Dr Martin Hesselius, the German physician who narrates the tale, can only speculate vaguely about possible physical causes. He suspects that lack of physical exercise, or excess drinking of green tea, or staying up too late reading the ideas of Emmanuel Swedenborg about spiritual beings, may be causing this hallucination. The story ends before Dr Hesselius can satisfy himself about the cause, after Mr Jennings commits suicide.

Barton and Jennings seek professional help in their anguish, and the assortment of doctors and clergymen (and indeed the amateurs) to whom they speak assume that the protagonists are in the grip of hallucinations (visions generated mentally, from within) or illusions (perpetrated from outside by a malevolent criminal). The investigation of such phenomena was undertaken in the first half of the nineteenth century by a group of writers, prominent among whom was Sir David Brewster (1781–1868).

Brewster's *Letters on Natural Magic* of 1832, a work of sober non-fiction, included a particular case history of spectral illusions that we can conclude was drawn upon by Le Fanu. Like Captain Barton in 'The Familiar', Brewster's 'Mrs A.' was first subjected to a purely aural illusion, that of her husband calling her name 'in a loud, plaintive and somewhat impatient tone'.[19] The next illusion was visual, 'of a more alarming character'. She saw her husband standing in the drawing room in front of the fire. He had gone out for a walk half an hour before, so she was surprised to see him and asked him why he had returned so soon. 'The figure looked fixedly at her with a serious and thoughtful expression of countenance, but did not speak.' Mrs A. sat down nearby. 'As its eyes, however, still continued to be fixed upon her, she said after a lapse of a few minutes, "Why don't you speak?" The figure immediately

moved off towards the window at the far end of the room, with its eyes still gazing on her' and disappeared.[20] With great self-control Mrs A. decided that she had seen a 'spectral apparition' and consequently felt no alarm.[21] However, her hallucinations, both visual and aural, including one of a cat, continued. On 17 March 1830, for instance, she was preparing for bed by 'sitting with her feet in hot water', and exercising her memory by 'repeating to herself a striking passage in the *Edinburgh Review*', when she saw the apparition of her dead friend, her sister-in-law. 'Mrs A. tried to speak to it, but experienced a difficulty doing so.'[22] On another occasion, Mrs A.'s dead mother drew aside the bed curtains and lay down between Mr and Mrs A. in bed, dressed exactly as last seen by Mrs A. in Paris in 1824. On 26 October 1830, standing at the window, Mrs A. watched a coach and four drive up to the house, and as it approached all the people in it and on it turned into 'skeletons and other hideous figures'. Mrs A. had felt 'spell-bound'.[23] Another time, in a room full of people, at home, Mrs A. saw her dead friend. Not wanting to stare at it so that the others should think her intellect 'disordered', she crossed the room and, with remarkable self-control, sat down in the chair the spectre was sitting in, whereupon it disappeared. Brewster writes that this was a deliberate test that Mrs A. had learned from reading Sir Walter Scott's *Letters on Demonology*.[24]

At this point we can understand that another element in Sheridan Le Fanu's genius was to expose the current explanations of spectral phenomena to satire. In 'Green Tea' Mr Jennings first sees the malignant monkey one evening on the horse-drawn omnibus to the unromantic London suburb of Putney. Jennings pushes the end of his umbrella at and through the insubstantial body of the ape, thus applying the same test recommended in like cases by Scott and relayed here by Brewster. A second example comes from the explanation of Mrs A. During her first hallucinations, Mrs A. had had 'a cough', leading Brewster to conclude that, while she had a 'morbidly sensitive imagination ... long experience had put it beyond a doubt, that her indisposition arises from a disordered state of the digestive organs'.[25] This is precisely the explanation offered to him by Captain Barton's doctor, in 'The Familiar'.

Brewster wrote his book in reply to Sir Walter Scott's *Letters on Demonology and Witchcraft* (1830), which contains many case studies redolent of the atmosphere of Le Fanu's imaginative world. Although he concedes that the 'external organs' of sight can become 'deranged' and cause spectral illusions, Scott is interested in auto-suggestion, anxiety and bad conscience as explanations of such phenomena. He writes of the apparition of a skeleton to a gloomy melancholic who became so depressed that he died. The case had started with the apparition of a large cat.[26] The stories most redolent of Barton, however, are two. In 'Jarvis Matcham and the "Guilt-Formed" Phantom', the protagonist has murdered a drummer-boy in his regiment whom he thought was a 'spy' on his embezzlement. Matcham went to sea for years, returned, and saw the boy's ghost in the empty and ancient landscape of Salisbury

Plain. He confessed to murder because of the pressure of the spectre and was executed, an end that presumably came as a release. His companion could not see the 'little drummer boy' who was following Matcham closely.[27]

Scott's other Barton-like tale was related by a mariner who had been the mate of a slaving ship whose captain was 'of variable temper'. The captain took a dislike to an elderly sailor and abused him verbally a great deal. One day he swore at him for being slow to get out on the yardarm and hand a sail. When the sailor answered back the captain shot him fatally with a blunderbuss. Dying, the sailor said, 'Sir, you have done for me, but I will never leave you.' The captain swore at him again and boiled his body in the cauldron where the slaves' food was cooked. He made the crew swear to secrecy. The sailors told the mate that they saw the dead man's ghost regularly, out on the yardarm before anyone else. The captain confided to the mate that he saw the dead man all the time, even when talking to the mate. At last the captain jumped overboard and drowned, shouting, 'By —, Bill is with me now!'[28] Scott comments that this was 'the natural consequence of ... superstitious remorse' and that the tale 'properly detailed, might have made the fortune of a romancer'.

Both Scott and Brewster announce their indebtedness to their fellow-Scot Samuel Hibbert's *Sketches of the Philosophy of Apparitions*, which attempts to show a merely material range of reasons, with 'derangements' to various external and internal 'organs' as the sole causes of 'spectral impressions.'[29] Brewster emphasizes the retina as the surface of connection between external impressions emanating from the world outside the subject and internal processes in the brain, and he argues that messages from the brain when the system is disordered could become mixed up and confused with the incoming data, so that the sufferer apparently 'sees' in the normal sense (as if they are external) visions that are being produced internally.[30] Le Fanu's strategy is to make the possible material explanations – illness, mental derangement, criminal persecution – inadequate, so that we are forced to consider Barton's familiar and Jennings's monkey as neither hallucinations (since other people can see Barton's spectre) nor illusions imposed from without by trickery (never in question in 'Green Tea') but as genuine devils – malignant spirits from a world of spirits who win their struggle, in Jennings' case, against an the innocent clergyman by jeopardizing the future of his soul through forcing him to commit both a crime and a sin of despair against God, which is how suicide was conceived of during the period.

While the writers already mentioned provide various ways of describing the sorts of attacks that Mr Jennings experiences, another early Victorian authority goes even further. In a rare and strange book entitled *The Duality of the Mind* (1844), A.L. Wigan argues from the evidence that the brain is formed from a twin cerebellum, and seemingly from analogy inspired by the optical writers and their work on the two eyes (since many of his examples are shared by the writers on optics). He states that human beings possess two

brains; and that malfunctions occur when these two brains find themselves at odds with each other. Along the way of Wigan's argument we learn of a clergyman with 'opposing convictions' who talked simultaneously of how he had, and had not, ruined a friend in a financial speculation.[31] In discussing this case, where 'the individual could not tell which of the convictions were true, had he not the means of comparing them with those of other persons', Wigan states that

It is not strange that in days of superstition and ignorance this state of brain should have been attributed to *possession by an evil spirit* ... if one brain remained sufficiently complete to conceive and lament the wickedness of the other, and the want of power to control it – we need not wonder at the prevalence of the belief, and that the clergyman was resorted to for relief instead of the physician.[32]

Wigan's theory doubtless gives us another way of construing Mr Jennings's paralysis and inability to preach his sermon when the loathsome ape appeared, sitting on his Bible. No doubt one of Jennings's brains *did not want to be a clergyman at all* and, as it were, called up the spectre to *derail the purposes of his other brain.*

Wigan continues with understandable optimism, 'it is a strong proof of the general intellectual progress of the nation, that in the later editions of the Prayer Book the "Form for the Exorcism of Evil Spirits" is omitted; it has been quietly and unostentatiously suppressed – a wise proceeding, whether with or without authority'. He then concludes his paragraph with a short sentence, not elaborated, which while intriguing in landscape terms arrests us with surprise and some concern about our own author: 'Railroads will abolish the absurdity universally.'

In discussing the causes by which the two brains can be set at loggerheads, Wigan considers cases of extraordinarily rapid trains of contradictory thoughts.

Every man who has not been 'fed on honey, and drank only rose water,' but has tasted the bitters of life, must have felt this distressing balance of the mind, and how impossible it is to pursue any investigation, or arrive at any satisfactory conclusion, during the existence of such a state of cerebral excitement. Some persons find this form of pervigilium [wakefulness or, as here, insomnia] to be always produced by strong green tea.[33]

Scott and Brewster do not cite green tea as a trigger for mental disturbance, which tends to suggest that Le Fanu might have known Wigan's book – or was merely familiar with a more generally discussed controversy over the suitability of green tea. Clergymen provide Wigan with quite a large proportion of his examples, and he added an appendix, 'On the Influence of Religion on Insanity', which he begins by stating the comparative rarity of religious madness in Catholic countries, as compared with Great Britain.

Visions

The Scottish Protestant writers we have been discussing wrote their material explanations of spectral apparitions in the context of a tremendous expansion of interest in optical illusions and the optical devices that created them, in both Britain and France. This interest was both scientific and popular. Brewster himself had invented one contribution to this, the kaleidoscope, in 1816. The first half of the nineteenth century also saw the inventions of the phenakistiscope, the thaumascope, the zootrope and Wheatstone's stereoscope, all hand-held or table-supported small devices for inducing illusions based on the endurance of after-images in the vision, or the separation of the sight of each eye.[34] The ramifications of such investigations of sight were long-standing and profound. In his discussion of after-images and 'ocular spectra, or accidental colours', Brewster states that for a split second afterwards, even if you have only looked at a thing momentarily, you see the retinal after-image in the same colours as the original. How Brewster construes this is exceptionally interesting: 'In virtue of this property of the eye an object may be seen in many places at once; and we may even exhibit at the same instant the two opposite sides of the same object.'[35] In these words Brewster clearly anticipates the energies of Cubism, the practitioners of which could, on the basis of Brewster's investigations alone, claim to be depicting truths about vision that were as clear and valid as anything visible under the old pictorial mode of perspectival illusionism.

To this interest in small-scale devices built around after-images or separation of the visual field of the two eyes should be added a group of larger-scale visual entertainments involving purpose-built structures, all of which, as their names suggest, hoped to emulate the success of the Panorama: the Cosmorama (1832), the Néorama (1827) and L.J.M. Daguerre's Diorama (1822), which has been hailed as 'the *ne plus ultra* of scenic illusionism'.[36] All of these arose in Paris. There were also the Myriorama and the Cyclorama.

The Diorama induced in visitors the feeling of time passing. Exhibited in a space like a theatre, its images, painted on nearly transparent screens, could be lit first from the front to show a daylight scene, and then from the back, to show the same scene by night. The fading of one set of lights and raising of the other set involved a particularly pleasing sensation. The images could also become larger and smaller, by moving the screen towards or away from the audience. The Diorama particularly specialized in displaying scenes of Gothic buildings – Holyrood Palace, Roslyn Chapel, Trinity Chapel, Canterbury, or 'Ruins in a Fog', alternating them with mountain and marine scenery.[37] Thus the Diorama shows the continuing vigour of the connection between Gothic settings and optical inquiries and advances. In it the happy showmanship of optical toys and theatrical or operatic devices combines with the heavy portentousness of Gothic.[38]

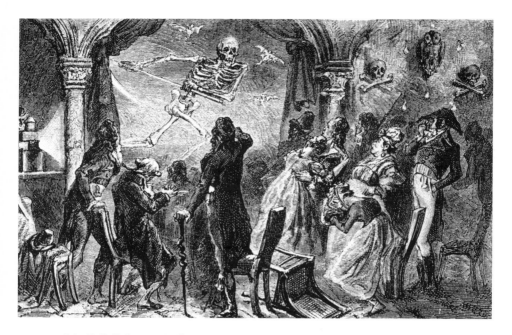

2.1 E.G. Robertson's Phantasmagoria

The Panorama was thus the conceptual progenitor of a range of later popular optical entertainments, and its invention in the late eighteenth century no doubt helped to stimulate the upsurge of interest in visual entertainments of all kinds. Others among these entertainments were based on another late eighteenth-century invention which, like the Panorama, gave its name to the language as a word applicable to far more than its own self, thus indicating its seminal status: the Phantasmagoria. This was invented in Paris by Philipstal and Robertson (a pioneer of ballooning) in the 1790s, as a development of the magic lantern show, which had been around for hundreds of years (Figure 2.1). The showmen of the Phantasmagoria painted glass slides with figures and projected them through a lantern onto smoke or gauze. This involved throwing a chemical substance onto a glowing brazier which then burned and smouldered with smoke of a certain colour, into the midst of which an assistant directed the beam of a magic lantern which projected an image from a small glass slide inserted across the lantern's beam. By this means, from the point of view of the audience, a spectre manifested itself in the smoke. While a later development substituted functionally invisible gauze instead of the more inconvenient smoke as a surface to bear the projected image, the classic definition of the Phantasmagoria involves a smoking brazier, which also gave the showmen a chance to give the impression that they were calling up spirits through the fire. Early displays took place

in an abandoned chapel in Paris – no doubt a suitably suggestive setting – and the movement of the smoke produced an unearthly effect during the projection of heads of recently executed or murdered revolutionaries, such as Marat, Danton and Robespierre.[39] Brewster gives a detailed description of Philipstal's Phantasmagoria, which Terry Castle points out is plagiarized from an earlier essay by an eye-witness, William Nicholson, after the show had travelled to London and Edinburgh in 1802.[40]

[Dim light reveals] a cave with skeletons and other terrific figures in relief upon its walls ... the spectators in total darkness found themselves in the middle of thunder and lightning ... followed by figures of ghosts, skeletons, and known individuals, whose eyes and mouth were made to move ... After the first figure had been exhibited for a short time, it began to grow less, as if removed to a great distance, and at last vanished in a small cloud of light. Out of this same cloud the germ of another figure began to appear, and gradually grew larger and larger, and approached the spectators till it attained its perfect development. In this manner, the head of Dr [Benjamin] Franklin was transformed into a scull; figures which retired with the freshness of life came back in the form of skeletons, and the retiring skeletons returned in the drapery of flesh and blood.

The exhibition of these transmutations was followed by spectres, skeletons, and terrific figures; which, instead of receding and vanishing as before, suddenly advanced upon the spectators, becoming larger as they approached them, and finally vanished into the ground. The effect of this part of the exhibition was naturally the most impressive. The spectators were not only surprised but agitated, and many of them were of opinion that they could have touched the figures. M. Robertson at Paris introduced along with his pictures the direct shadows of living objects which imitated ... the appearance of those objects in a dark night or in moonlight.[41]

In 1805 W.F. Pinchbeck tried to promote an improved version in his *Witchcraft: or, the art of fortune-telling unveiled*. In this book, in order to spare children unnecessary fears, he undertook to 'inform you how the artificial man, or apparition, is produced by the power and science of Opticks, which will explain the Phantasmagora [sic], or Magick Well'.[42] Pinchbeck's idea is to use a concave mirror in conjunction with a convex magnifying lens to project images of real living people. The mirror and magnifier would capture and reflect living figures, making them appear as large or larger than life. Pinchbeck pretends to have received a letter from a delighted customer: 'I am delighted with the construction of your Phantasmagora, the vision it produces being the reflection of life itself ... and must be far more striking, than the semblance produced by the late improvement on the magick lanthorn, falsely termed Phantasmagora.'[43] Brewster took over this invention in his *Letters on Natural Magic*, labelling it by the hard name of Catadioptrical Phantasmagoria, and alleging that Michelangelo himself could not have painted a convincing figure on a magic lantern slide having only an inch of space to work with.[44]

In writing their de-mystifying accounts of optical illusions, the Scottish Protestants we have discussed were motivated by religious conviction as well as by scientific inquiry. 'For Brewster, a Scottish Calvinist, the maintenance of barbarism, tyranny and popery had always been founded on closely guarded knowledge of optics and acoustics.'[45] Brewster wished to rend the enchanter's veils, exposing to the cold light of northern Protestant science the subterfuges of Catholicism. This leads him to construe as a magic-lantern imposture the episode in the *Autobiography* of the Italian sculptor Benvenuto Cellini (1500–71) in which Cellini accompanies a Sicilian priest to the Colosseum in Rome by night in order to see him call up demons. At least, Brewster reminds us that the magic lantern was invented by Athanasius Kircher in the middle of the seventeenth century. Yet in the face of the recorded complaint by the boy who accompanied Cellini, that on the way home after the ritual 'two of the demons whom we had seen at the amphitheatre went on before us leaping and skipping, sometimes running upon the roofs of the houses, and sometimes upon the ground', Brewster asserts that this could be explained by the supposition that the necromancer had a magic lantern that, as the party plodded homeward, continued to project its images.[46] The presumption is that Catholic priests had invented the magic lantern and kept it secret for their own deceptive purposes long before Kircher announced it to the world. The magic lantern is therefore strongly associated with hidden knowledge of optical deceptions. The itinerant Carpathian fortune-teller who sells Carmilla a charm, and then vexes her by offering to cut down her sharp teeth, in Le Fanu's story, carries a magic lantern on his back, which thus becomes an index of knowledge of the occult arts.[47]

To what extent were artists of the period prepared to borrow from the apparatus of optical illusions and effects or to learn from the exposure and descriptions of these effects by writers such as Brewster, Scott, Hibbert and Pinchbeck? Ségolène Le Men has reminded us that Victor Hugo refers to the Phantasmagoria and the kaleidoscope in his Gothic novel, *Notre Dame de Paris* (1831). She argues that novelists developed narrative techniques analogous to the effects of such devices.[48] However, the question of the extent to which artists allowed themselves to be influenced by – or to put it another way recognized good ideas in – optical devices and effects has not been subjected to much scrutiny. Traditional art historians have not liked to think that 'high' art borrows from 'low' popular entertainment, despite the obvious contradiction provided by L.J.M. Daguerre himself, who worked as a scene decorator and set designer in the opera before inventing the Diorama, and who was an accomplished landscape painter before inventing one version of photography.

Some paintings come immediately to mind when the question is posed. Anne-Louis Girodet-Trioson's *Apotheosis of Dead French Heroes*, or *Ossian Receiving Napoleonic Officers* has already been hailed as closely related to the

effects of the Phantasmagoria.[49] Sarah Burns suggests that Francois Gérard's *Ossian Calls up Phantoms with the Sound of his Harp on the Banks of Lora* (1801) also qualifies as influenced by the Phantasmagoria, while Jörg Traeger adds J.A.D. Ingres' *Dream of Ossian* (1813).[50] These are all very convincing suggestions, as the painters represent spectres manifesting themselves on and within mist, often with the 'wildly hallucinating atmosphere' of the Phantasmagoria, and in the case of Girodet employing a 'meteoric effulgence to flood the scene ... a grayish translucent radiance' together with 'hazes of phosphorescent blue'.[51]

Other paintings suggest themselves. J.M.W. Turner's *Death on a Pale Horse* (*c*.1825–30) should not let its biblical subject deflect attention from the way in which the horse and crowned skeleton are dimly seen in smoke or mist which palpably surrounds everything: indeed, the horse can barely be seen and seems to be constituted of vapour. The same artist's *Parting of Hero and Leander* (1837) contains, on the right, figures piled up into a bank of mist in a way very reminiscent of the figures in Girodet's *Ossian*. Turner's painting shows the parting immediately before Leander dies in attempting to swim the Hellespont. It was exhibited together with these lines, allegedly by the Greek poet Musaeus:

The morning came too soon, with crimsoned blush
Chiding the tardy night and Cynthia's warning beam;
But Love yet lingers on the terraced steep,
Upheld young Hymen's torch and failing lamp,
The token of departure, never to return.
Wild dashed the Hellespont its straited surge,
And on the raised spray appeared Leander's fall.

The translation is believed to be that of Francis Fawkes.[52] The verses seem to suggest that a prophetic vision of Leander's death manifests itself in the spray, in a way that Turner has represented. If Turner has decided to borrow from the Phantasmagoria, it is because he is dwelling on questions of what we see, how we see, and how what we see displays itself to us. These are the questions that the Phantasmagoria raised, and they can be regarded as questions given repeated investigation in Turner's late works.

Brian Lukacher has argued that Turner pursues these questions about vision in *Snow Storm – Steam-Boat off a Harbour's Mouth Making Signals in Shallow Water and Going by the Lead. The Author was in this Storm the Night the Ariel Left Harwich* of 1842 (Figure 2.2). He finds shadowy spectral figures floating in the air either side of the centre of the painting.[53] Anomalies in the title, which aspires to point to an authentic incident, include the fact that no steamship named Ariel can be linked with the port of Harwich, and that Ariel was the chief fairy, capable of causing storms, in Shakespeare's play *The Tempest*. The shadowy figures can therefore be identified as suggestive of spectral emanations. A hostile critic in 1842 compared Turner's paintings to a form of

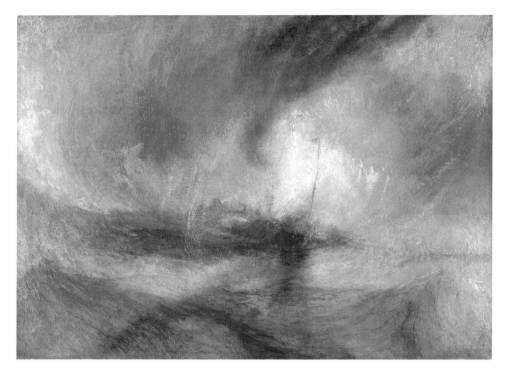

2.2 J.M.W. Turner, *Snow Storm – Steam-Boat off a Harbour's Mouth Making Signals in Shallow Water, and Going by the Lead. The Author was in this Storm on the Night the Ariel Left Harwich*, 91.4 × 121.9 cm (36 × 48 inches), oil on canvas, 1842, The Tate Gallery, London

magic lantern show, 'the "Dissolving Views" at the Polytechnic ... where one subject is melting into another, and there are but half indications of forms'.[54] For Lukacher, the painting amounts to a critique of the 'technological and social changes' of the age of steam. Lukacher's argument is valuable over and above its specific application to the *Snow Storm*. It encourages us not to be put off by seeming hostile comments by Victorian snobs, and to look at Turner's paintings open to the possibility that they meditate on vision by borrowing from the visual culture that was happening all around Turner during his adult life. We can take as intentional what we find in his paintings. If such approaches can be discerned in Turner's works, it would indicate that in his investigations of vision he was reversing John Locke's primary and secondary properties of objects. For Locke the primary qualities are the measurable ones – dimension, weight, volume, hardness; while the secondary qualities (with all the connotation that adjective has of being less important) are not measurable. Texture, hue and tone might be among them. Turner seems to

suggest that vision must come to terms with such properties, even if scientists have been reluctant to, since they are what chiefly confronts the sight in acts of perception, while the so-called 'primary' qualities are often occult. Seeing is as much about vagueness, indeterminacy, ambiguity, mistake and jumping to conclusions as it is about the calm sight of evenly lit solid objects.

If we are prepared to look at Turner's difficult works for lengthy periods with an open mind, forms do start to emerge from them that cannot be hastily perceived or satisfactorily photographed. A range of mysterious forms is certainly perceptible in the painting usually taken as inaugurating Turner's late period, *Ulysses Deriding Polyphemus* (1829). Water sprites bathe in the lapis sea. Over the mountain, the arm of the monster is raised in frustrated rage in a way that is oddly echoed by the stern of one of Ulysses' vessels. There are not one but two rock arches behind one another, as if one is an after-image of the other. And out of the sunrise rear up the translucent outlines of Apollo's giant horses. Turner may be staying very faithful to features of Alexander Pope's translation of the *Odyssey*, and therefore scoring a triumph for poetic feeling over the more literal painting of natural phenomena; but he is also surely questioning the possibility of pure perceiving of natural phenomena in ways unaffected by knowledge of poetry and myth.[55]

In fact I would date the turn towards this newer sort of question about what happens when we see to the previous year, and to a painting of a different classical myth, *Vision of Medea* (Plate 2). For an artist so interested in all sort of questions about seeing colour and light, it is surely significant that this is the only title in all of Turner's works to employ the word 'vision'. In what sense does this word apply? Are we having a 'vision' of Medea, or is it Medea's own 'vision' that is in play? The fact that Turner chose to frame the painting with rope, an everyday ordinary object, by pointing up the commonplace deepens the contrast with the visionary scene of the painting. The scene, a climactic moment in the legend of Jason and Medea, was suggested to Turner by J.S. Mayr's opera, *Medea in Corinto*, that was performed in the Haymarket in the years 1826–28. So perhaps we see Turner's own 'vision' of the staging of *Medea*. The lines of Turner's own poetry that accompanied the painting explain nothing of what is happening in the centre and right-hand side of the image. They draw attention to the enraged Medea's conjuring of a dragon; throwing to the ground of a bowl filled with a spell-bound life; lifting a snake; and throwing her children into a burning palace. All this can be discerned – albeit dimly – in the left-hand half of the painting, where the main figure waving a stick is Medea performing an incantation, while the small figure in the clouds is also Medea, now throwing her children into the palace. In the centre of the painting float transparent globes that are reminiscent of those Turner painted for his lectures as Professor of Perspective at the Royal Academy.[56] How they relate to the narrative of Medea is not certain, although traced inside them in

white outline are future continuations of the action of this visionary scene. The pink cherubic section of the painting just below the globes and to their right shows a vision of one part of Medea's revenge against her faithless lover, Jason: it shows a child mounting a chariot that is drawn by a white dragon. The lower globe, or bubble, shows a dragon's wing and a falling or screaming figure (but an adult waving a club rather than a child). The other part of Medea's revenge involved her fashioning a poisoned robe for Jason's new bride, and the cauldron at Medea's feet has apparently been prepared to cook it up in. What part, if any, of this relates to the actual staging of the opera, with transformation scenes and other visual effects, has not yet been clarified. The libretto of the opera, however, allows for phantasmagoric effects since it contains stage directions for subterranean noises and for fire, which would allow for smoke (possibly coloured) and therefore for projection of visionary scenes on the smoke: 'She hastens to the altar, and kindles the fire; she describes a circle with her magic wand, and then begins the spell ... A subterranean sound is heard, the mark of the presence of the shades.'[57] Medea's invocation to the Furies reads in part, 'Come to me from Stygian abodes, / By this same fire, and our solemn compact'. This suggests an idea that Medea conjures the Furies through or out of the flames. What is important for our purposes, however, is that in this painting in which influence from popular entertainment intersects with the inauguration of Turner's later period and the word vision is explicitly used, spectres emerge from the sky. Immediately behind Medea's raised stick a thin white cloud takes on the form of an old man whose arm is raised over the neck of a dragon. The dragon at first sight looks to be simply a brown cloud, but two dots of paint, like glowing coals, indicate the creature's eyes.

The emergence of unearthly forms in the sky of this seminal painting surely entitles us to expect the emergence of kindred forms and figures in Turner's later skies that supplement the themes of those works. Indeed, if one contemplates for long enough Turner's *Slavers Throwing Overboard the Dead and Dying – Typhoon Coming on* (1840) in the Museum of Fine Arts in Boston, an unphotographable angelic being emerges in the sky (Plate 3). Of enormous size, this figure becomes white – a colour which, in its contrast with the yellows, oranges and reds all around, possesses a frigidity; or better yet, a quality of stillness and quiet. The stillness of the being is enhanced by its form as an asymmetrically winged figure balanced on end, hovering above the Atlantic Ocean. The figure is apparently drawing closer, or perhaps just waiting. What can this be but an exterminating angel, poised to direct the souls of the slaves on their onward journeys, or to ensure the foundering of the ship, or to deal with the soul of the slave-ship's captain? Turner's inclusion of this startling element at a time of high positivist and utilitarian thought elevates to a metaphysical or supernatural or divine level the goal of slave and slave trade abolition to which the painting is dedicated.

Epilogue

This chapter began by discussing apparitions in Gothic novels, relating them to long-standing debates on the question of the sanctity of lands owned by the monastic system. We explored the ways in which scientifically minded writers attempted to explain spectres on a material rather than supernatural basis, and did so against a background of considerable popular interest in optical devices and entertainments that spilled over into 'high art' applications in painting. Such material explanations were known in France, too, of course. The main authorities on spectral vision in France were interested in mental illness as a cause of hallucination, and tend to pile up the examples in attempts to classify types of hallucination. It becomes apparent from reading them that most of the work of investigation of spectres took place in Britain. Among many of its examples, Fulgence Marion's *Optical Wonders* cites A.L. Wigan's case of a man who 'could at will evoke his own image'. This amused him until the called-up self refused to go away again and started arguing all the time with the normal self![58] Marion's book was translated from the French, and his authorities range from Brewster and Abercrombie to the foremost French work, Alexandre Brièrre de Boismont's *On Hallucinations: A history and explanation of Apparitions, Visions, Dreams, Ecstasy, Magnetism and Somnambulism.*[59]

On the basis of one example after another, occupying over three hundred pages, Boismont's book tries to compile a comprehensive system for classifying hallucinations. He is rather impeded, however, by evidently having little clue as to what causes them. Among causes of hallucinations he cites: holding the head down for long periods; great excitement; a 'pre-occupied state of mind, or an association of ideas that cannot always be explained'; all mental labour, by over-exciting the brain; being confined in a dungeon; drugs (although these hallucinations are only temporary); historical factors, such as Puritanism in England, which produced by its gloom 'a national horror unknown in other periods of her history'; climate; solitude; after-images; the state of the atmosphere; masturbation; alcohol; gases; plants; starvation; and being hanged. Hallucinations can also be hereditary.[60] Boismont himself was a practitioner of mental medicine: at his own asylum he favoured a regime for patients of eight-hour baths, '*douches d'irrigations*' (a sort of enema), vomits and meagre diets.[61] Here and elsewhere he reminds us of the rebarbative aspects of the treatment and classification of mental disease in the nineteenth century. He explains that by the standards of 1844 George Fox, the founder of the Quakers, would be classified as a lunatic.[62] And then, for an extraordinary moment, we get a completely unfamiliar glimpse of a famous man. Discussing combined hallucinations of hearing and sight, Boismont tells us that

Some years back there was in the hospital at Bedlam a lunatic by the name of Blake, who was called the seer. [He talked to the Archangel Michael,

Moses, Semiramis, but he saw King Edward III most and] made a portrait
of him in three sittings. [He drew Richard III and described him as]
'terrible to behold'. Blake is a tall man, pale, speaks well, and sometimes
eloquently: he is not deficient in talent as an engraver and artist.[63]

To encounter William Blake, one of the greater English poets and artists,
and one of the more revolutionary figures of Romanticism, in this way
induces a feeling of vertigo. The passage shows, of course, how little known
Blake was in nineteenth-century France, where he features in the cultural
landscape merely as another hapless lunatic in the grip of hallucinations.[64]
The account of Blake has been garbled during its progress into and through
French sources. Blake was not a lunatic, and was never confined to Bedlam
Hospital.

There was one other major cause of spectral visions in nineteenth-century
Britain and France, and to introduce it we need to return to the case of
Brewster's remarkably stoical 'Mrs A.' As we have seen, Brewster attributes Mrs
A.'s visions to 'derangement' of the digestive organs. He tells us that during
the period when she beheld her first three apparitions she had a troublesome
cough, and 'the weakness which this occasioned was increased by her being
prevented from taking a daily tonic'.[65] Brewster does not tell us what this tonic
was, but we must acknowledge that another of the reasons why there were a
lot of spectres around in early nineteenth-century Britain was that there was
a lot of opium splashing around during that period. Sir Walter Scott warned
in his *Letters on Demonology* that an excess of wine or spirits 'or any other
intoxicating drug, as opium or its various substitutes must expose those who
practise the dangerous custom to the same inconveniences' of haunting by
apparitions.[66] We have already seen that opium was grown by the East India
Company in Bengal, but although some of that harvest was taken to Britain
most of the opium used in Britain was imported from Turkey.[67] Opium was
one of the cheapest and most universally used medicines, readily available for
adults in the form of pills or the liquid laudanum, and appearing in a range
of cordials, elixirs and tonics, including several for babies such as Godfrey's
Cordial (guaranteed to stop babies crying). Recent historians have emphasized
the universality, across all social classes in nineteenth-century Britain, of the
recreational use of opium, which was particularly prevalent in the counties of
Norfolk and Lincolnshire where opium was grown as a crop.[68] This means,
among other things, that a large proportion of the audience viewing the
Panoramas of Canton and Hong Kong that we discussed in Chapter 1 would
have had personal experience of opium and opiates, and therefore even
perhaps some sympathy for the Chinese who enjoyed its use and the British
attempt to force it onto the Chinese market. Opium use was not necessarily
seen as problematic in Britain before the late nineteenth century.[69] In literary
terms, however, its use and abuse was inaugurated as a topic for discussion

in 1821 by Thomas De Quincy's *Confessions of an English Opium-Eater*.[70] This book was greatly admired, translated and meditated on by the French poet Charles Baudelaire, and we shall see in a later chapter how Baudelaire's mind set about making use of the example set by De Quincy.

Notes

1. An excellent discussion of British concerns with a wide range of forms of the 'unseen' is contained in Kate Flint, *Victorians and the Visual Imagination* (Cambridge: Cambridge University Press, 2000). Most of Flint's examples come from later in the nineteenth century, while in the present chapter I concentrate mainly on the earlier part of the century. For later developments, see also N. Brown, C. Burdett and P. Thurschwell (eds), *The Victorian Supernatural* (Cambridge: Cambridge University Press, 2004).

2. General authorities on the Picturesque include Malcolm Andrews, *The Search for the Picturesque: Landscape Aesthetics and Tourism in Britain, 1760–1800* (Aldershot: Scolar Press, 1989); S. Copley and P. Garside (eds), *The Politics of the Picturesque: Literature, Landscape and Aesthetics since 1770* (Cambridge: Cambridge University Press, 1994) and Malcolm Andrews, *The Picturesque: Literary Sources and Documents*, 3 vols (Robertsbridge: Helm Information, 1995).

3. Jane Austen, *Northanger Abbey*, 1818 (Harmondsworth: Penguin Books, 1972), p. 191.

4. *Ibid.*, p. 202, Ch. 25.

5. Ann Radcliffe, *The Romance of the Forest*, 1791 (Oxford: Oxford University Press, 1986), pp. 15–16.

6. *Ibid.*, pp. 16, 18.

7. William Shenstone, *The Ruin'd Abbey, Or the effects of Superstition* (1746) and 'Elegy XXI' (1746) in *The Works in Verse and Prose* (2 vols, 4th edn, 1773).

8. Shenstone, *The Ruin'd Abbey*, ll. 60–64, 344–9, in *The Works*.

9. Sir Henry Spelman, *The History and Fate of Sacrilege* (London, 1698), from Chapter One; reprinted in Michael Charlesworth, *The Gothic Revival 1720–1870* (3 vols., Robertsbridge: Helm Information, 2002), vol. 1, p. 118.

10. In 1687 Nathaniel Johnston published *The Assurance of Abbey and other Church lands in England to the Possessors*, a work written at King James's instigation and in reply to Sir William Coventry, *A Letter written to Dr Burnet, giving an account of Cardinal Pool's Secret Powers, from which it appears, that it was never intended to confirm the Alienation that was made of the Abbey-lands* (London, 1685).

11. An important historical summary bearing on this is William Cobbett's *A History of the Protestant Reformation in England and Ireland: showing how that event has impoverished the main body of the people in those countries* (London, 1824–27). This is reprinted in Charlesworth, *Gothic Revival*, vol. 2, pp. 473–715. See also the discussion in Charlesworth's 'Introduction' to the same work.

12. Invented by Nathaniel Ward in 1839, the Wardian case was a sort of terrarium designed to transport living plants safely by ship across widely differing climatic zones. They proved crucial to establishing Indian tea farming by keeping tea plants from China alive during transport.

13. Benjamin Disraeli, *Sibyl, or the Two Nations*, 1845 (Harmondsworth: Penguin Books, 1980), pp. 96–7.

14. Sheridan Le Fanu, *Uncle Silas: A Tale of Bartram Haugh*, 1864, Chapter LIV (Oxford: Oxford University Press, 1981), pp. 350–351.

15. *Best Ghost Stories of J.S. Le Fanu* (New York: Dover Publications, 1964), p. 218.

16. *Ibid.*, pp. 225, 227.

17. *Ibid.*, p. 231.

18. *Ibid.*, p. 200.

19. Sir David Brewster, *Letters on Natural Magic Addressed to Sir Walter Scott*, 1832 (New York, 1835), p. 45.

20. *Ibid.*, p. 46.

21. Brewster's correspondence about this case was entirely with the husband, however; so accounts of Mrs A.'s stoicism may be exaggerated.

22. *Ibid.*, p. 49.

23. *Ibid.*, p. 49–50.

24. *Ibid.*, p. 50.

25. *Ibid.*, p. 52.

26. Sir Walter Scott, *Letters on Demonology and Witchcraft, addressed to J.G. Lockhart, esq.*, 1830 (New York, 1831), pp. 36–39, 40.

27. *Ibid.*, pp. 309–11.

28. *Ibid.*, pp. 306–8.

29. Samuel Hibbert, *Sketches of the Philosophy of Apparitions; or, an attempt to trace such illusions to their physical causes* (2nd edn, Edinburgh, 1825, dedicated by the author to Walter Scott), 'Preface'. Jennings, in 'Green Tea,' angrily dismisses 'mere materialist' explanations as useless (Le Fanu, *Best Ghost Stories*, p. 188).

30. Brewster, *Letters on Natural Magic*, pp. 53–9.

31. A.L. Wigan, *A New View of Insanity: the Duality of the Mind Proved by the Structure, Functions, and Diseases of the Brain and by the Phenomena of Mental Derangement, and Shown to be Essential to Moral Responsibility*, London, 1844 (New York: Joseph Simon, 1985), p. 68.

32. *Ibid.*, p. 69.

33. *Ibid.*, p. 165.

34. The devices are discussed by a variety of writers: see for example Jonathan Crary, *Techniques of the Observer: On Vision and Modernity in the Nineteenth Century* (Cambridge MA: MIT Press, 1990).

35. Brewster, *Letters on Natural Magic*, p. 34.

36. Stephen Bann, *The Clothing of Clio: A Study of the Representation of History in Nineteenth-Century Britain and France* (Cambridge: Cambridge University Press, 1984), pp. 56–7.

37. R. Derek Wood, 'The Diorama in Great Britain in the 1820s', *History of Photography* 17, 3 (1993), pp. 284–95. This excellent article prints an extremely useful comparative table of subjects exhibited in the Dioramas in Paris, London, Liverpool, Manchester, Dublin and Edinburgh.

38. For the Diorama and its inventor, Daguerre, see Stephen Pinson's PhD thesis, *Speculating Daguerre*, Harvard University, Department of History of Art and Architecture, May 2002.

39. John Wyver, *The Moving Image: An International History of Film, Television, and Video* (London: Blackwell and BFI Publishing, 1989), pp. 7–8.

40. Terry Castle's outstandingly useful essay is 'Phantasmagoria, Spectral Technology, and the Metaphorics of Modern Reverie', *Critical Inquiry* 15, 1988, pp. 21–61.

41. Brewster, *Letters on Natural Magic*, pp. 81–2.

42. W.F. Pinchbeck, *Witchcraft: or, the art of fortune-telling unveiled* (Boston MA, 1805), p. 14.

43. *Ibid.*, p. 17.

44. Brewster, *Letters on Natural Magic*, p. 85. On the art of slide-painting, however, see Charles Middleton (b. 1756, d. c.1818), *Magic Lantern Dissolving View Painting* (London, 1876).

45. Crary, *Techniques*, p. 133. See Brewster, *Letters on Natural Magic*, especially pp. 60–77, 150–161.

46. Brewster, *Letters on Natural Magic*, pp. 76–7. Brewster's alternative explanation is that the illusion was worked by mirrors.

47. Le Fanu, 'Carmilla', in *Best Ghost Stories*, pp. 295–6.

48. Ségolène Le Men, *La Cathédrale illustrée de Hugo à Monet: Regard romantique et modernité* (Paris: CNRS Editions, 1998), pp. 98–9.

49. Sarah Burns, 'Girodet-Trioson's *Ossian*: The Role of Theatrical Illusionism in a Pictorial Evocation of Otherworldly Beings', *Gazette des Beaux-Arts*, 6th ser., vol. 95, January 1980, pp. 13–24. Jörg Traeger agrees: 'L'épiphanie de la Liberté. La Révolution vue par Eugène Delacroix', *Revue de*

l'art 98 (1992), pp. 9–28. Traeger's own suggestion, that Delacroix's *Liberty on the Barricades* shows signs of being inspired by the Phantasmagoria is less convincing, mainly because the light in the painting, and its relation with the smoke, is very different from the treatment of those factors in Girodet's image.

50. Burns, 'Girodet-Trioson's *Ossian*', pp. 16–17; Traeger, 'L'épiphanie', p. 22.

51. Burns, 'Girodet-Trioson's *Ossian*', pp. 22, 13.

52. Martin Butlin and Evelyn Joll, *The Paintings of J.M.W. Turner*, 2 vols (New Haven: Yale University Press, 1984), vol. *Text*, p. 221.

53. Brian Lukacher, 'Turner's Ghost in the Machine: Technology, Textuality, and the 1842 *Snow Storm*', *Word & Image* 6, 2 (1990), pp. 119–137.

54. *Blackwood's Magazine*, July 1842, p. 26, cited by Lukacher, 'Turner's Ghost', p. 136.

55. See the interesting entry in Butlin and Joll, *Paintings of J.M.W. Turner*, vol. *Text*, pp. 183–5.

56. See Maurice Davies, *Turner as Professor: The Artist and Linear Perspective* (London: Tate Gallery, 1992), pp. 52–3.

57. Quoted by Cecilia Powell in the excellent section on this painting in her book *Turner in the South: Rome, Naples, Florence* (New Haven and London: Yale University Press, 1987), pp. 151–6, quotation p. 155.

58. F. Marion, *Optical Wonders*, trans. C.W. Quin (London, 1868), pp. 50–51.

59. *Ibid.*, pp. 25, 47, 50–51.

60. Alexandre Brierre de Boismont, *On Hallucinations: A history and explanation of Apparitions, Visions, Dreams, Ecstasy, Magnetism and Somnambulism* (1844), 3rd edn, trans. and abridged by Robert Hulme (London, 1859), pp. 52, 53, 54, 61, 151, 283, and (on Puritanism) 319–322, 313.

61. *Ibid.*, pp. 79–81.

62. *Ibid.*, p. 391.

63. *Ibid.*, pp. 83–5. The passage contains a great deal of Blake's conversation. Boismont is drawing on an account in the *Revue Britannique* of July 1823, p. 184.

64. Blake was almost as little known in Britain at the time. It took the combined efforts of his first biographer, Alexander Gilchrist (1863), and his first critical interpreter, the poet A.C. Swinburne (1868), to make him better known and to rebut the malicious rumour that Blake had been insane.

65. Brewster, *Letters on Natural Magic*, p. 52.

66. Scott, *Letters on Demonology*, p. 29.

67. Countries of origin and patterns of importation are discussed in Virginia Berridge and Griffith Edwards, *Opium and the People: Opiate Use in Nineteenth-Century England* (London and New York: Allen Lane and St Martin's Press, 1981).

68. Berridge and Edwards, *Opium and the People*, pp. 11–62.

69. *Ibid.*, especially pp. 150–209 for the growth in distrust of opium.

70. For an introduction to the literary side, see Alethea Hayter, *Opium and the Romantic Imagination* (Berkeley and Los Angeles: University of California Press, 1968).

Into the abyss of time

Christian religion constituted an undercurrent of cause, explanation or affliction with regard to the seeing of ghosts, as considered in the last chapter. The very security of such religious beliefs received a huge shock from the rise of geology as a science in the first half of the nineteenth century.

Even before the publication of Charles Darwin's *Origin of Species*, the development of geological science was impinging upon biblical theories of creation. The Scottish artist William Dyce's painting *Pegwell Bay* (1860) can be looked at, together with a cluster of other works, as a monument to this moment in history. In showing the crumbling of some of the world's newer sedimentary rocks, the chalk cliffs of Kent, by the action of the sea, Dyce meditates on the geological truths established over the previous half-century. Depicting a comet in the sky, he compares the sciences of astronomy and geology as well as questions of geological and astronomical time and the way they contrast with the daily time of the human beings wandering on the beach. This chapter will pursue the insights derived from Dyce through poems by Lord Tennyson and Matthew Arnold and will consider two nineteenth-century landscape gardens, Biddulph Grange in Staffordshire, made from the 1840s to the 1870s, and Durlston Park in Swanage, from the 1880s to the 1890s. In these gardens central features represent geological concerns. The full debate between, on the one hand, Christian advocates and, on the other, scholars and popularizers of geology was far too extensive for comprehensive summary here. Yet by considering the diverse works selected in this chapter we can at least begin to trace some main patterns of thinking that contributed to a debate which had highly important consequences for how landscape was viewed and interpreted.[1]

At Pegwell Bay

William Dyce exhibited his painting, *Pegwell Bay: A Recollection of October 5th, 1858* (Plate 4), in 1860. The title admits that the picture was not painted on the

spot; that it was painted to commemorate a particular day, a specific memory. The image is based on, or rather developed from, a watercolour of Pegwell Bay in Kent, made by the artist in 1857.[2] The oil painting is a strange picture; it seems to show an afternoon and setting in which nothing, in particular, is happening. Compared with other mid-Victorian paintings, there seems to be no narrative, very little anecdote and no very serious theme. So what is the painting about?

The making and exhibiting of the painting embraces the years 1857–60, which constituted a rather crucial period for the British, and indeed international, scientific community. This was the period when the scientific advances of geology were supplemented by the theory of evolution advanced by Charles Darwin in *The Origin of Species*. Publication of that work occurred in 1859, but for a two- or three-year period beforehand the scientific community was being privately sounded out and canvassed with respect to the question of where each scientist stood, in an attitude of support or opposition, to the theory.[3]

Dyce's biographer, Marcia Pointon, has written about *Pegwell Bay*, arguing that it is a painting on the theme of time.[4] Daily time is dramatized by the sunset, geological time by the chalk cliffs, and astronomical (or universal) time by the appearance in the sky of Donati's Comet, which was particularly brightly visible on 5 October 1858 (the comet, clearly visible in the painting, rarely shows itself in photographic reproductions). The title of the painting draws our attention to seasonal time (this painting depicts autumn) as a side-effect of the earth's orbit around the sun. Furthermore the holiday-makers on the beach (and the donkey-rides being offered in the background show that early October was still, just, holiday season) have time on their hands.

It is an appealing and persuasive view, although Pointon spends no time discussing the crucial debate about the length of time that Dyce's painting seems to meditate upon. Yet if the painting deals with time in these varied ways, it must be conceded to depict, in equally emphatic fashion, the theme of place and space. Pegwell Bay is on the south end of the Isle of Thanet, at the eastward extremity of the county of Kent. We are poised between land and sea. As we look westward in the painting over the lower reaches of the River Stour, where the Romans built their fort at Richborough, the sun sets over the edge of the earth. By a reflexive meditation we can conceive of our planet, too, as a heavenly body within the solar system: in any case, a third, and much rarer, heavenly body is visible in the form of the comet, which will eventually make its way out of our vision into more universal space. The painting is cosmic in theme. Pegwell Bay certainly seems small in such a perspective, yet the painter has made it his main subject. All time and all space lead to this place at this time: the banal setting of the bay, where, as Allen Staley put it, 'the landscape is bleak, the figures collect their shells with a seriousness that verges on gloom, and the mood is distinctly melancholy'.[5]

If all space and time lead to here, now, this bay on 5 October 1858, it is reasonable to ask what the human beings visible in the painting are doing with their time in this place. Staley assumes that those in the foreground are gathering shells from the beach, and Pointon agrees, although she adds 'and fossils'. If they are gathering shells, the implication is that they are not doing anything serious. They presumably value the shells as pretty decorative objects. An artist on the extreme right of the painting is looking up at the comet; but the woman and children in the foreground have turned their backs on it and are following a trivial pursuit, rejecting the manly seriousness of science, particularly the difficult science of astronomy, and, if turned backs are symbolically significant, rejecting the geology of the cliffs. However, Pegwell Bay is locally famous as a place where fossils can be easily and plentifully found.[6] Perhaps the women and child are indeed collecting them? To understand what difference this might make to our interpretation of the painting we need to pause here to contemplate what was at stake about fossils, and chalk cliffs that they fell from, in the late 1850s.

Pegwell Bay is on the southern edge of the Isle of Thanet. Where is the rest of the island, the very name of which applies to a remote historical era, since in 1858 it was no longer an island? Presumably the isle once stretched out beyond its current highest cliffs at the North Foreland in the north-east corner: that part is gone, eroded away, returned to the sea whence it came. The idea that water comes from rock is a common and long-standing one: it is biblical, and was commemorated in emblematic mode by the sixteenth-century sculptor Giambologna in his huge statue of Apennine for the Medici garden at Pratolino in Tuscany, preserved today as part of the Parco Demidoff, in which the giant personifying the mountains squeezes water from the head of a turtle. Yet the idea that rock comes from water does not seem obvious, particularly since ordinary observation at the seashore shows rocks being worn away, destroyed, by the sea. It was an achievement of the nineteenth century to establish clearly that limestones, chalk, and marbles are all related to each other in their original formation at the bottom of ancient lakes and seabeds. This understanding was still new at the time Dyce painted *Pegwell Bay*, which therefore shows us a scene of destruction *and creation*. As James Hutton had explained at the end of the eighteenth century, the formative actions that had created the rocks of the earth's crust are still continuing.[7] The vast stretches of time necessary for such actions displaced forever the established religious belief, based on Bishop Ussher's calculations from the Old Testament, that the world had been created in the year 4004 BC. The concept of geological time had been formed by establishing the idea of sequence in the formation of the rocks of the earth's crust, and to this enterprise the fossil record had been crucial. Fossils found in some rocks such as the Kentish chalk were identical with creatures still living: obviously such rock was more recently formed than other rocks whose fossils bore no resemblance to living creatures. Overlapping

groups of similar fossils could be linked together in chains or sequences that embraced huge but indeterminable gulfs of time (and thus created the idea of sequence in the rocks that bore them).

The clash between patiently observed and intellectually convincing geological fact, on one hand, and religious faith, on the other, was felt as a deep disturbance by certain sensibilities in an age of fading, but still vigorous, religious resurgence (Roman Catholic resurgence took place after the passing of the Catholic Emancipation Act in 1829, while the high tide of gloomy Protestant evangelicalism stretched from the second to the fifth decades of the century). One specific issue can testify to this disturbance. Chalk had been identified by Professor Ehrenberg as formed from the innumerable bodies of microscopic marine animals.[8] Thus, as well as the sweeping away of Ussher's length of time, the chalk cliffs, and the fossils they contain, testified to death. The fossil record showed not only millions of individual deaths of animals of all shapes and sizes, but the extinctions of species. Life was revealed in more prodigal numbers than had hitherto seemed possible, accompanied by death on an unprecedented scale – death and the extinction of species. Where, in this enormity of death, in which one cubic inch of chalk needed ten million deaths to form it, was there room for a loving and compassionate God?[9] As the intelligent layman, Robert Chambers, put it in his anonymously published *Vestiges of the Natural History of Creation* (1844), 'it will occur to everyone that the system here unfolded does not imply the most perfect conceivable love or regard on the part of the Deity towards his creatures'.[10] Not only did geology point to death on an unimaginable scale, but it stated that rocks were still being created, and implied that other forms of life were also still being formed. Where was the God of Genesis, if creation was not yet over?

Professional geologists such as Sir Charles Lyell and intelligent laymen like Chambers could formulate and accept the theories which challenged so comprehensively biblical revelation, but others, as we shall see in due course, could decide to refute them. And where did Dyce himself, a Christian of the established church, stand with respect to these debates? Compared with cosy religious belief, such visions of eternity and infinity as geology and science provided could produce feelings quite like despair. Tennyson felt them, and grappled with them through several stanzas of his poetic meditation on life and death, 'In Memoriam' (1850):

LIV

Oh yet we trust that somehow good
Will be the final goal of ill,
To pangs of nature, sins of will,
Defects of doubt, and taints of blood;

That nothing walks with aimless feet;
That not one life shall be destroyed,

Or cast as rubbish to the void,
When God hath made the pile complete;

That not a worm is cloven in vain;
That not a moth with vain desire
Is shrivell'd in a fruitless fire,
Or but subserves another's gain.

Behold, we know not anything;
I can but trust that good shall fall
At last – far off – at last, to all,
And every winter change to spring.

So runs my dream: but what am I?
An infant running in the night:
An infant crying for the light:
And with no language but a cry.

LV

The wish, that of the living whole
No life may fail beyond the grave,
Derives it not from what we have
The likest God within the soul?

Are God and Nature then at strife,
That Nature lends such evil dreams?
So careful of the type she seems,
So careless of the single life;

That I, considering everywhere
Her secret meaning in her deeds,
And finding that of fifty seeds
She often brings but one to bear,

I falter where I firmly trod,
And falling with my weight of cares
Upon the great world's altar stairs
That slope thro' darkness up to God,

I stretch lame hands of faith, and grope,
And gather dust and chaff, and call
To what I feel is Lord of all,
And faintly trust the larger hope.

LVI

'So careful of the type?' but no.
From scarped cliff and quarried stone
She cries, 'A thousand types are gone:
I care for nothing, all shall go.

Thou makest thine appeal to me:
I bring to life, I bring to death:
The spirit does but mean the breath:
I know no more.' And he, shall he,

Man, her last work, who seem'd so fair,
Such splendid purpose in his eyes,
Who roll'd the psalm to wintry skies,
Who built him fanes of fruitless prayer,

Who trusted God was love indeed
And love Creation's final law –
Tho' Nature, red in tooth and claw
With ravine, shriek'd against his creed –

Who loved, and suffer'd countless ills,
Who battled for the True, the Just,
Be blown about the desert dust,
Or seal'd within the iron hills?

No more? A monster then, a dream,
A discord. Dragons of the prime,
That tare each other in their slime,
Were mellow music match'd with him.

O life as futile, then, as frail!
O for thy voice to soothe and bless!
What hope of answer, or redress?

The 'she' of LVI is of course Nature herself, the 'type' of which she speaks means a species, and the person implied by 'thy' in the penultimate line is Arthur Hallam, in mourning for whom the poem was written. Mid-Victorian despair in the face of the new testimony of death from the 'cliff' and 'quarry' is here well expressed. It is not simply Bishop Ussher's length of years that has been overturned, but with it, in a Protestant nation that tended to take its Bible literally, the cosy, perhaps even smug, dependency on a benevolent God.

At almost the same moment Matthew Arnold gave classic expression to a sense of horror that the newly godless universe could cause in his poem 'Dover Beach'. The location is just a few miles round the Kent coast from Pegwell Bay where chalk cliffs, far greater than Thanet's, also loom up.

The sea is calm tonight.
The tide is full, the moon lies fair
Upon the straits; – on the French coast the light
Gleams and is gone; the cliffs of England stand,
Glimmering and vast, out in the tranquil bay.
Come to the window, sweet is the night-air!
Only, from the long line of spray
Where the sea meets the moon-blanched land,

Listen! you hear the grating roar
Of pebbles which the waves draw back, and fling,
At their return, up the high strand,
Begin, and cease, and then again begin,
With tremulous cadence slow, and bring
The eternal note of sadness in.

Sophocles long ago
Heard it on the Aegean, and it brought
Into his mind the turbid ebb and flow
Of human misery; we
Find also in the sound a thought,
Hearing it by this distant northern sea.

The Sea of Faith
Was once, too, at the full, and round earth's shore
Lay like the folds of a bright girdle furled.
But now I only hear
Its melancholy, long, withdrawing roar,
Retreating, to the breath
Of the night-wind, down the vast edges drear
And naked shingles of the world.

Ah, love, let us be true
To one another! for the world, which seems
To lie before us like a land of dreams,
So various, so beautiful, so new,
Hath really neither joy, nor love, nor light,
Nor certitude, nor peace, nor help for pain;
And we are here as on a darkling plain
Swept with confused alarms of struggle and flight,
Where ignorant armies clash by night.

We do not know exactly when the poem was written. The most likely date is from the early 1850s when Arnold passed through Dover on his honeymoon. The poem is much more clearly modernist in its forms, being free verse, than is Tennyson's. It can also be thought of as modern in its advocacy of love (between two humans) as the only antidote we have for the ills and lack of hope in the world. For our purposes, the evocation of a shingle beach at the foot of chalk cliffs as the site of this struggle with spiritual despair is significant, as is the figuring of Christian faith in retreat through the image of a tide receding on a shore that surrounds the world. Together, Tennyson's and Arnold's poems, and Dyce's 'distinctly melancholy' painting, make the seashore the central site of the mid-Victorian crisis.

Dyce's painting, in its melancholy feeling, its carefully painted and clearly seen cliffs, its seawater wearing away but also forming the rocks of the land, and its heavenly bodies, amounts to a profound meditation on a very urgent question of the age. The image brilliantly encapsulates most of the

chief elements in the whole issue of debate about the length of time and the formation of the world. It is, as Pointon states, 'the attempt of a nineteenth-century intellectual to discourse in pictorial terms on the nature of the universe'.[11] There is a final element in this attempt to which we have only paid sporadic attention so far: the activity of the human beings on the beach, which forms a central part of Dyce's meditation, and it is a part in which, perhaps unexpectedly, some comfort could lie for a mid-nineteenth-century sensibility. In thinking of these figures I cannot be satisfied with Pointon's explanation that in them 'all activity is desultory and meaningless whether that of the donkey-keeper, the artist or the boy looking for shells and fossils'.[12] Surely if the artist contemplates the comet and the women and boy pick up not shells for their prettiness but fossils for their curiosity and scientific value, then these people participate, albeit in a small way, in the epoch-making investigations going on in their time. Geology, in particular, was for a long time thought of as being uniquely accessible, among sciences, to the amateur. As late as 1937 Sir Alfred Trueman could write:

Geology is pre-eminently the layman's science. In it more than in any other science there is opportunity for a beginner to make original observations, to weigh up evidence, to coordinate his facts, and in general to acquire a scientific outlook, whereas a layman can do no more in many sciences than accept ready-made conclusions, often explained by clever but dangerous analogies, without any prospect of understanding the steps by which they have been reached.[13]

By participating so, the women and child in Dyce's painting surely serve to dramatize the factor that alone truly distinguishes humankind from other species (and the question of such a distinction – of what it could be founded on and whether that factor, whatever it might be, could be attributed to divine creation – was a considerably urgent one around the time of publication of Darwin's book). This factor is intelligence; the capacity to reason; the very ability to work out calculations of huge distances in space, predict the return of comets, construct sequences for rock formation, comprehend the significance of fossils. All the achievements of astronomy and geology were the result of rational thought and mathematical calculation put to work on observations. The weight and distance of the planets, the return of the comets, had all been worked out on the basis of observing and then thinking about what had been observed.

If *Pegwell Bay* is about this distinguishing ability, then it accords with what Archbishop Sumner had concluded over half a century earlier, which made Charles Lyell cite the Archbishop with approval in his *Geological Evidences of the Antiquity of Man* (1863). Sumner had extolled 'improvable reason' as the quality that distinguished human beings from the other species.[14] By this he meant not simply native intelligence, but intelligence that could be led through a long series of educational experiences and by them induced to function

much better than it could in a natural unimproved state. In their own small and unpredictable ways some of the figures on the beach in *Pegwell Bay* link themselves with this species-wide intellectual capacity. Dyce has achieved a profound meditation on the greatest spiritual problem of the age.

The place where the land meets the sea, the seashore – particularly sea-cliffs – had become a crucial site for the gathering of scientific knowledge, but (and perhaps therefore) also the place for feeling the spiritual consequences of the new knowledge. James Hutton, the eighteenth-century father of geology, had shown that the same processes that built the world are still at work in it and that, as he put it, like the body of an animal the earth's crust is constantly 'wasted'[15] while it is still forming. He had made some of his crucial discoveries on the shore and, according to his friend and colleague John Playfair, these were associated with feelings of joyous wonder, as on the day in 1788 when Hutton, Playfair and Sir James Hall landed from a small boat at Siccar Point in Scotland:

On landing at this point, we found that we actually trode on the primeval rock, which forms alternately the base and summit of the present land. It is here a micaceous schistus ... this rock runs with a moderate ascent to ... high-water, where the schistus has a thin covering of red horizontal sandstone laid over it; and this sandstone, at the distance of a few yards farther back, rises into a very high perpendicular cliff. Here, therefore, the immediate contact of the two rocks is not only visible, but is curiously dissected and laid open by the action of the waves ...

Dr Hutton was highly pleased with appearances that set in so clear a light the different formations of the parts which compose the exterior crust of the earth, and where all the circumstances were combined that could render the observation satisfactory and precise. On us who saw these phenomena for the first time, the impression made will not easily be forgotten ... What clearer evidence could we have had of the different formation of these rocks, and of the long interval which separated their formation, had we actually seen them emerging from the bosom of the deep? We felt ourselves necessarily carried back to the time when the schistus on which we stood was yet at the bottom of the sea, and when the sandstone before us was only beginning to be deposited, in the shape of sand or mud, from the waters of the superincumbent ocean. An epocha [sic] still more remote presented itself, when even the more ancient of these rocks, instead of standing upright in vertical beds, lay in horizontal planes at the bottom of the sea, and was not yet disturbed by that immeasurable force which has burst asunder the solid pavement of the globe. Revolutions still more remote appeared in the distance of this extraordinary perspective. The mind seemed to grow giddy by looking so far into the abyss of time; and while we listened with earnestness and admiration to the philosopher who was now unfolding to us the order and series of these wonderful events, we became sensible how much farther reason may sometimes go than imagination can venture to follow.[16]

A few decades later, how different the feelings of the seashore and the cliffs are for Tennyson, Arnold and Dyce, when religious certainties with what might be fairly termed a complacent edge had been overturned. Dyce was

a devout believer according to the tenets of the established church, as no doubt was Tennyson. For Lyell, however, it simply did not matter if people wanted to persist in some sort of belief – so long, presumably, as their wish to believe was not allowed to interfere with their understanding of and acknowledgement of scientific truth. To an example – a spectacular example – of such an interference we now have to turn.

At Biddulph Grange

In the present chapter, the issue of vision is one of interpretation. Unlike the previous chapter, the question is not 'What are we seeing and is it real?' Instead it is a matter of how things clearly seen can be construed, understood, comprehended and interpreted. No doubt fossils had been discovered at Pegwell Bay for hundreds of years before William Dyce arrived there. It is the new context of interpretation provided by the new knowledge that exercised the authorities we have so far discussed. The next site to which we turn is exactly a place where the question of interpretation becomes paramount.

The garden at Biddulph Grange was made in the middle years of the nineteenth century by James Bateman (1811–97).[17] Bateman first became famous as a collector of orchids in Central America, particularly Guatemala and Belize. At Biddulph he began to collect countries: that is to say, he designed parts of the garden to evoke various geographical locations – Egypt, the Himalayas, Italy, China (Plate 5) – through a combination of planting and provision of built structures evocative of those places. Transitions from one part to another are handled with great playfulness: the exit from 'Egypt', for example, takes visitors into a small stone model of an Egyptian temple: down a dark corridor one encounters the statue of a baboon, the hideous 'ape of Thoth'.[18] Descending to the lower floor, visitors emerge from a timber-framed Cheshire cottage emblazoned with the date 1856 into a Pinetum planted with many specimens of trees from North America. The route from the Pinetum to the Rhododendron Ground lies through a forbidding tunnel of huge rough blocks of stone. The effect of such features which evoke successfully distant parts of the globe at Biddulph is surely one of *transumption*, or far-fetching. This effect is gained when an immediate situation is related to a distant cause or origin with no hint of cause-and-effect connection, or stages of transition, between them. To this extent there is a consistency of effect with that of Panorama entertainments, and an intimation that transumption is a distinguishing factor that defines nineteenth-century visual culture in distinction to eighteenth and twentieth century concerns. We also used the term 'far-fetched' with a dubious and disparaging sense, some of which comes across at Biddulph but is deliberately prepared for by the designers' sense of fun.[19]

Was pleasure, geographical curiosity and delight in plants enough to cause the garden to be designed in this way? No further reason is necessary, but Brent Elliott has suggested that these factors may have been supplemented by Bateman's religious beliefs. Bateman was an evangelical Anglican, and in an essay he wrote in 1848 on 'the final and universal triumph of the Gospel' he had quoted the *Churchman's Monthly Review*:

We live in an age of fossil geology. In all directions the buried remains of past ages are dug up and brought to light with persevering zeal. The records of China ... the sculptured triumphs of Sesostris, the mounds of Babylon ... A thoughtful mind will perhaps discern in this ... a sign of some great change that is approaching, the consummation of the whole course of Providence for six thousand years ...[20]

This seriousness, indeed portentousness, might not quite match the playful aspect of the gardens (although Bateman might have taken the view that it was possible to enjoy one's wait for Judgement Day) but it seems quite close in tone to another part of Bateman's domain that he provided for visitors. Bateman's thirst for collecting extended to fossils and palaeontological specimens, of which he amassed a collection so fine that it now belongs to the University of Keele. These Bateman exhibited in his Geological Gallery, which was built on one side of a courtyard where visitors to Biddulph Grange were permitted to wait for the transport coming to take them away. The Gallery was over a hundred feet (30 metres) long, lit from above, heated by central heating, and it housed specimens of Roman and Central American antiquities together with some Indian sandstone. The main exhibit, however, was geological, as Edward Kemp described it in 1862:

Advancing into the gallery, it will be found treated in a way that is quite unique, and is singularly illustrative of the great geological facts of the globe. On one side, at about 3 feet from the ground, a series of specimens, showing the earth's formation, and exhibiting all the various strata in their natural succession, are let into the wall, in a layer *c.* eighteen feet wide; and above this are arranged the animal and vegetable fossils that the respective strata yield. Many rare and elegant examples are here brought together, and as the once-living organisms are placed exactly above the strata from which their remains were taken, the series constitutes at once the most simple and complete lesson in practical geology which could be imagined.

The specimens of rocks and fossils were arranged, in fact, in orthodox fashion derived ultimately from the insights of the seminal *Strata Identified by Organized Fossils* (1816) by William Smith (1769–1839), the canal surveyor and inventor of the geological map. It was Smith who had made the extraordinary conceptual breakthrough in geology expressed in the phrase 'the rock strata can be identified by the fossils within them' – putting fossils at the centre of the entire geological endeavour. On the other side of the gallery geological maps and cross-sections were exhibited. It is, however, in Kemp's next sentence that the surprise occurs:

The whole is distributed into 'days' supposed to correspond with the six (so-called) 'days' of the Mosaic Cosmogeny beginning with the granites and passing into the slates, the limestones, the old red sandstones, the coal formations, etc. with such animal and vegetable remains as occur in each.[21]

At the time, evangelical Protestants believed that Moses had written the book of Genesis, so 'Mosaic Cosmogeny' refers to the account in Genesis of the creation of the world. In other words, Bateman and his deeply religious wife have not been able to give up their adherence to the Old Testament of the Bible, and have decided that the geological record could be accommodated to the six days of creation in Genesis by the simple expedient of deciding that, on certain days, God created the rocks and fossils together. Kemp is clearly suspicious, with his inverted commas and parenthetical 'so-called'.[22]

Here we see head-on the Victorian dilemma: the clash between patiently assembled and intellectually unanswerable geological inquiry, on the one hand, and immovable simplicities of religious belief on the other. While Bateman sees the impeccable logic of the analysis, he does not want to believe it. He was hardly alone in this. In fact his solution to the problem of his geological gallery appears to owe a great deal to the marine biologist and devout member of the Plymouth Brethren, Philip Gosse, and in particular to Gosse's book *Omphalos: an Attempt to Untie the Geological Knot* of 1857. Gosse's popularizations of marine zoology, which owed a lot of their success to his skill as an artist, helped to create the craze for the seashore in mid-Victorian times, but he was a serious man of science and Fellow of the Royal Society. Our best witness of what happened with respect to *Omphalos* is Gosse's son, Edmund, who begins the relevant section:

So, through my father's brain, in that year of scientific crisis, 1857, there rushed two kinds of thought, each absorbing, each convincing, yet totally irreconcilable ... he allowed the turbid volume of superstition to drown the delicate stream of reason. He took one step in the service of truth, and then he drew back in an agony, and accepted the servitude of error.[23]

Edmund Gosse reports how his father discussed the question of mutability of species with Darwin, Hooker and Lyell, the last of whom was sounding out the scientific community to see how individuals stood in advance of publication of *The Origin of Species*. Edmund continues:

My father, after long reflection, prepared a theory of his own, which, he fondly hoped, would take the wind out of Lyell's sails, and justify geology to Godly readers of 'Genesis'. It was, very briefly, that there had been no gradual modification of the surface of the earth, or slow development of organic forms, but that when the catastrophic act of creation took place, the world presented, instantly, the structural appearance of a planet on which life had long existed.

The theory, coarsely enough and to my father's great indignation,
was defined by a hasty press as being thus – that God hid the fossils
in the rocks in order to tempt geologists into infidelity.[24]

In fact the argument of *Omphalos* is quite mad. Its structure is as follows: 1)
The rich and varied geological evidence of the great age of the earth derived
from rock strata and fossils is circumstantial, since no one has actually seen a
mastodon, let alone a dinosaur or pterodactyl. 2) If God had created things,
he would have done so in a way that they showed signs of a past they had
not had. For example, he created Adam with a navel, although Adam had
no earthly mother. 3) Therefore God *had* created everything! *Q.E.D.* From
this point Gosse can sail his book onward to his final triumphant sentence,
'The field is left clear and undisputed for the one Witness on the opposite
side, whose testimony is as follows – ' IN THE SIX DAYS JEHOVAH MADE
HEAVEN AND EARTH, THE SEA, AND ALL THAT IN THEM IS'.[25] The elder
Gosse has sacrificed his reason on the altar of his dogmatic religious belief.

During the winter that followed, a few letters, mostly disapproving, arrived
at Gosse's Devon house. Even the religious Charles Kingsley, whom the elder
Gosse had expected to accept the theory, 'wrote that he could not "give up
the painful and slow conclusion of five and twenty years' study of geology,
and believe that God has written on the rocks one enormous and superfluous
lie".'[26] Nevertheless, Gosse did not abandon his idea, and Bateman, at least,
seems to have been aware of and accepted it. Gosse later reaffirmed his
position in *Geology and God: Which?* (1866), and he went so far as to ban the
study of geology by his son, as tending 'directly' to the encouragement of
infidelity.[27]

Discussion of Gosse brings up another question about the figures in Dyce's
Pegwell Bay. Perhaps, instead of picking up shells or fossils, they are gathering
sea anemones, sea urchins, hermit crabs and other forms of marine life?
As a popularizer of interest in shore life, Philip Gosse perhaps takes some
responsibility for the presence of these holiday-makers on the beach. If that
is so, perhaps those same figures are debating in their own minds a clash of
convictions similar to that Gosse himself lived through. And they are almost
certainly contributing to an ecological catastrophe. Edmund blamed his
father for causing the destruction of the British seashores by his writing and
his very early promotion of aquaria: 'The ring of living beauty drawn about
our shores was a very thin and fragile one ... These rock-basins ... thronged
with beautiful sensitive forms of life ... An army of "collectors" has passed
over them, and ravaged every corner of them.'[28] Perhaps we see part of this
despoliation, too, in Dyce's painting. At any rate, the example of Gosse leads
to the conclusion that the seashore, as well as being a place for the gathering
of scientific insight, and feeling the spiritual consequences of such insight,
was a site of contestation.

At Durlston Park

A generation after the excitements of the late 1850s, George Burt (1816–94) made his cliff-top landscape garden of Durlston Park, just outside Swanage. Burt intended the garden to be a frame for a new residential development that never happened, so only the garden survives.[29] The features of the garden are an old man's work, as Burt was 70 years old when he began work on the landscape. He may have been the uncrowned 'King of Swanage' who spoke with a local accent, but he does not fit the conventional idea of the self-made man.[30] He was made by his uncle, John Mowlem, whose working life had started in the quarries of the Isle of Purbeck, where Swanage and Durlston Park are situated, before he moved to London and built up the demolition firm of John Mowlem & Company, which in the twentieth century became one of the capital's biggest building firms. Burt took over Mowlem's after 1844. By 1887 he was old, wealthy, skilled in demolition and paving, and had returned to his birthplace of Swanage.[31]

John Mowlem knew stone. He had been a quarryman, and owned quarries on the island of Guernsey that supplied him with granite for paving jobs in London.[32] Burt was more of a manager. It is less clear how well he knew stone, or geology. While he probably understood the properties of stone, did he comprehend geology? Where did Burt stand with regard to the Victorian dilemma that we have been following? On the side of science or of the human desire to worship a deity?

The Isle of Purbeck is a geologically interesting and significant place which, like Thanet, is not an island but a peninsula. Sarah Burnham described it in her *Limestones and Marbles* of 1883:

The Purbeck formation has a limited extent, but is important for the three distinct classes of fossils it contains ... The Upper Strata, about fifty feet in thickness, are exclusively of fresh-water origin, and made up, to a great extent, of shells, the Palaudina and Cypris being very abundant; the Purbeck marble belongs to this series. The Middle Purbeck contains beds of limestone partly of fresh-water and partly of brackish water origin, enclosing fossil mammalia, while the Lower Purbeck strata include fresh-water limestones. Between the layers of the Purbeck beds occur what are called 'Dirt Beds,' with petrified trees which, in some instances, constitute fossilized forests. Some of the trees are erect, with trunks broken off three or four feet from the root; others are prostrate.[33]

Burt may have known about stone in a practical sense; the necessity for it to cure, its properties in use, its tensile strengths and so on. But did he know how his native place had been formed in the immemorial past? Did he even acknowledge an immemorial past? The twentieth-century archaeologist Jacquetta Hawkes wrote eloquently in more tangible terms about Purbeck's making in her discussion of the 'Jurassic seas':

3.1 A Claudean composition at Durlston Park, Swanage, Dorset: Durlston Head and
Durlston Castle from the north

The age has a smaller and more fantastic bond with the medieval builders.
Towards its end sedimentation and changing levels had formed a fresh-
water lagoon in the Dorset area whose weedy floor was thick with the
water-snail *Viviparus*. Their coiled shells accumulated in vast numbers
to form the dark green Purbeck marble that the medieval masons loved
to cut and polish into slender columns. So Jurassic water snails, the
individual lives commemorated by murky scribings on the surface
of the marble, helped medieval Christians to praise their God.[34]

Burt undoubtedly knew of the mediaeval uses of Purbeck marble, and
brought down to the garden of his house in Swanage some columns of the
stone from St Stephen's Chapel in the Palace of Westminster.[35] However, only
an examination of the garden features he left at Durlston Park can give us an
inkling of where he stood with respect to the formation of the world and how
he communicated that to visitors.

Burt made two exceptionally fine garden features. He built Durlston Castle,
to a design by the architect George Crickmay, on the cliff of Durlston Head
(Figure 3.1). The building is a place of refreshment for visitors, but is built
in miniature castellated style so that when it is seen from a distance from
the north near Peveril Point it forms a perfect architectural completion of a

view that looks as if it could have been designed by the seventeenth-century painter Claude Lorrain as one of his seascapes.[36]

The Claudean vision depends on the Castle's true small size being unapprehended from the distance. Once the building is reached, its function and imaginative presence change. The southerly wall supports three carved stone tablets, while another stands nearby. One is a carved relief map of part of Dorset, with distances marked on it as concentric circles centred upon Durlston Head. The nearby tablet shows a larger area of the English Channel, embracing northern France and much of southern England, with a series of direction lines to various places and distances marked: Ushant is 200 miles (320 km) away, Calais 170 (273 km), and so on. The two relief maps clearly represent an attempt to centre all space (all space that can be seen on a clear day, but also all space in so far as the far larger area embraced by the maps functions as a mere part of an unmapped whole) in Durlston, in the place occupied by the visitors for the duration of their visit. From here we can turn around towards the English Channel and face the world. The remaining inscriptions give us information about the strangeness of time and about the convexity of the earth. One is concerned with time:

DURATION OF THE LONGEST DAY.
AT LONDON 16 hours 30 mins. HAMBURG 19 hours. SPITZBERGEN 3 months.
THE POLES 6 months.
CLOCK TIMES OF THE WORLD.
THESE DIFFER FROM GREENWICH 4 MINUTES EVERY DEGREE. WHEN 12
NOON AT GREENWICH, SWANAGE 11.52, EDINBURGH 11.47, DUBLIN 11.35,
NEW YORK 7.04.

The other inscription tells us:

CONVEX OF THE OCEAN.
ON LOOKING AT A VESSEL FROM OCEAN LEVEL WE LOSE, IF ONE MILE
DISTANT 8″, FIVE MILES 16ft 7, TEN MILES 36 feet.

The seas, Burt induces us to believe, are paradoxical: they 'BUT JOIN THE NATIONS THEY DIVIDE'. We are also told about tides, and measurements of spring and neap tides at various places are listed.

This is an unusual type of garden inscription, being interested in time, tide, the rotundity of the earth, and vision, all expressed in a hectoring tone quite unlike the more suggestive one used in many earlier garden inscriptions elsewhere. If we turn round, which we do, we see the Large Globe that Burt had built in Mowlem's yard in London in 15 pieces of Portland stone and brought down to Durlston for assembly (Plate 6). This giant globe is about ten feet (3 metres) across and weighs forty tons (36 tonnes). The pedestal on which it stands seems hardly big enough, as if the Globe risks rolling down the cliff and leaping into the sea. The precise geography of the Globe seems

wrong: India hangs down into the Indian Ocean like the dewlap of a cow, and the inscribed names of places are sometimes vague in their position. Since the inscription SOUDAN covers most of north Africa, and the words SOUTH AFRICA cover most of the rest of the continent, the British Empire seems larger than it actually was. Care has been taken to label quite small parts of it, too, such as the Caroline Islands, New Ireland and the Falkland Islands. However, we must remember that the Globe was put up in 1887, the year of Queen Victoria's Jubilee. In a precinct around the Globe are carved inscriptions which continue to give us nuggets of science, positively asserted:

THE RATE OF THE EARTH'S MOTION AT THE EQUATOR IS ABOUT 1,040 MILES PER HOUR. A GALE OF WIND TRAVELS AT THE RATE OF 80 to 100 MILES PER HOUR. THE COMMON BLACK SWIFT FLIES AT THE RATE OF 200 MILES PER HOUR ... THE CARRIER PIGEON FLIES AT THE RATE OF 40 MILES PER HOUR.

But there is also another type of inscription:

GIVE ME THE WAYS OF WANDERING STARS TO KNOW
THE DEPTHS OF HEAVEN ABOVE, AND EARTH BELOW
TEACH ME THE VARIOUS LABOURS OF THE MOON
AND WHENCE PROCEED THE ECLIPSES OF THE SUN
WHY FLOWING TIDES PREVAIL UPON THE MAIN
AND IN WHAT DARK RECESS THEY SHRINK AGAIN
WHAT SHAKES THE SOLID EARTH WHAT CAUSE DELAYS
THE SUMMER NIGHTS AND SHORTENS WINTER DAYS

<div align="right">VIRGIL 70–10 B.C.
TRANS. BY JOHN DRYDEN 1631–1700</div>

And immediately beneath the stone that carries Virgil's words translated into ponderous rhyming couplets is carved another inscription which seems to settle the question of where Burt stood:

O THOU ETERNAL ONE WHOSE PRESENCE BRIGHT
ALL SPACE DOTH OCCUPY ALL MOTION GUIDE
THOU WHO FROM PRIMEVAL NOTHINGNESS DIDST CALL
... LORD ON THEE

There is a strange clash of manners in Burt's inscriptions which evidently helped to stimulate the artist Paul Nash's discovery of 'surrealism' in Swanage, and which David Lambert also notices: 'the inscriptions juxtapose lyricism and hard data in a way that is oddly disturbing and evocative'.[37] To this apparent discordance we may add that the lettering of the inscriptions is a peculiarly unattractive late-Victorian sans serif which looks as if it would be more suited to a plain utilitarian purpose. There is none of the elegance of italic or classical letters that are more conventional in garden inscriptions, for example.

Yet we can recognize this style in which fact – stern, certainly; bald even;

perhaps 'hard' – is juxtaposed with poetic meditation as that of the nineteenth-century encyclopaedist. Robert Chambers, author of the famous *Cyclopedia*, began *Vestiges of the Natural History of Creation* by telling the reader:

It is familiar knowledge that the earth which we inhabit is a globe of somewhat less than 8000 miles in diameter, being one of a series of eleven which revolve at different distances around the sun, and some of which have satellites in like manner revolving around them. The sun, planets, and satellites, with the less intelligible orbs termed comets, are comprehensively called the solar system, and if we take as the uttermost bounds of this system the orbit of Uranus (though the comets actually have a wider range), we shall find that it occupies a portion of space not less than three thousand six hundred millions of miles in extent.

As the reader is striving to take this in, Chambers immediately adds, 'The mind fails to form an exact notion of a portion of space so immense'.[38] Burt's sudden changes of approach, language and focus are close to the more modest aposiopesis of Chambers. In the more poetic of his two manners, Burt, the old man, tried to express his sense of the mystery and optimism of life. One moment he sounds like a Victorian master of ceremonies:

THE EARTH IS A PLANET AND ONE OF GOD'S GLORIOUS CREATIONS,
SHEWING THE WONDERS OF LAND, AIR AND SEA. AS SEEN FROM
THE NEAREST PLANET IT WOULD APPEAR LIKE THE BEAUTIFUL
'EVENING STAR', HAVING ITS PLACE IN THE MIGHTY SYSTEM OF
WORLDS, AS PART OF THE MARVELLOUS PLAN OF THE UNIVERSE.

Then he borrows from the eighteenth-century poet Alexander Pope: 'All are but parts of one stupendous whole, whose body nature is, and God the soul.'
 As we proceed on our cliff-top walk the poetic element comes to dominate. There is a unmistakable sense of progression away from hard scientific fact as we continue along the cliff-top, leaving Castle and Globe behind. The inscriptions we meet use the immediate location or view as a starting point for more rarefied reflection. At a place where we cannot see the cliff and the waves at its foot, Burt invokes a different sense from that of sight:

AN IRON COAST AND ANGRY WAVES
YOU SEEM TO HEAR THEM RISE AND FALL
AND ROAR ROCK THWARTED IN THEIR BELLOWING CAVES
BENEATH THE WINDY WALL

 ABOVE SEA 149FT

And at another place on the cliff-top: 'Look round / And read / great nature's open book'.
 Burt's landscape embellishments end on a broad man-made ledge halfway up the sea cliff directly in front of Tilly Whim caves – Tilly Whim being the ledge that was cut in order to quarry the stone for loading into lighters pitching

on the waves below. In these caves John Mowlem, who gave Burt his position in life, had first started his working life before leaving for London in 1807. The caves, hollowed out beneath where we have been walking, remind us that while Burt might have enjoyed contemplating the horizontal dimensions of the world, it is extraordinary that not once in his inscriptions does he dwell on the question of the rock that lies beneath our feet. Unlike Hutton, William Smith or Lyell, his vision could not, or did not want to, penetrate into the earth's crust and meditate on what can be found by doing so. Instead above one of the cave entrances can be read the final inscription of London's demolition man:

THE CLOUD CAPP'D TOWERS
THE GORGEOUS PALACES
THE SOLEMN TEMPLES
THE GREAT GLOBE ITSELF
YEA, ALL WHICH IT INHABIT
SHALL DISSOLVE
AND LIKE THE BASELESS
FABRIC OF A VISION
LEAVE NOT A WRACK BEHIND

Shakespeare's speech from *The Tempest* has been adapted by Burt. The phrases have been moved around, other phrases omitted, and one word changed – Shakespeare's 'inherit' has become Burt's 'inhabit', which emphasizes that Burt is referring to the last day, the day of dissolution of the earthly fabric itself, when material inhabitation will cease. Reading the inscription in its extraordinary location induces a powerful effect. We are obliged by its placing to face the land: the slowly crumbling cliff of Purbeck stone with the sky above. We are poised between the creating and destroying water and the rock formed by it yet steadily eroding. We have just admired the 'Large Globe' and here we are asked to contemplate the demolition of our entire world (including the British Empire) at some future date known only to its demolisher.

Burt may not have had much interest in geology, or he might have wished simply to direct visitors' attention to 'higher things', but he was a master of changes of scale, from the carved maps (which, though small, show much more than we can contemplate of the wide world with our eyes from one place) to the globe, mounted at one of the few places on the earth where the spherical nature of the planet can be perceived, as one of Burt's inscriptions points out, with the naked eye, and which shows us a symbolic form of the whole of which we can see only part. Skilful manipulation of scale was also a feature of Chambers, who used the eddies of a river to illustrate for the reader the idea of binary and ternary solar systems, which are otherwise quite difficult to grasp.[39] In Burt's landscape work the scale also changes to allow the cliff on which we perilously stand to symbolize the whole world at the moment when we are informed that the world will dissolve. Burt additionally

plays with our perceptions and comprehensions when evoking the waves through the sense of hearing, or by comparing nature to a book. Through these deft manipulations he induces a sublime effect. After reading Shakespeare's ecstatic evocation of physical destruction, we can turn again on the cliff and contemplate the next headland, Anvil Point, with its lighthouse, the sun gleaming through the haze beyond it, the waves gnawing perpetually at the base of the land, and the English Channel opening out in the background to a broader sea across which we do not yet have to travel.

Applying paint

This section is no more than a small extension to the chapter's discussion, inspired by the possible benefit of considering William Dyce's *Pegwell Bay* in conjunction with Claude Monet's *Etretat, Sunset* of 1883 (Plate 7). Both paintings show the waters of the English Channel, chalk cliffs and a setting sun. Their similarities and differences should be able to tell us about oil painting of landscapes in the second half of the nineteenth century.

Monet's painting confirms that, in such views, it takes the setting sun (for him and Dyce) or night-time (for Matthew Arnold) to make the cliffs strange enough to provoke questions such as 'what is sea?', 'what is land?', 'what is earth?', 'is the earth a heavenly body?' (as Burt suggested). To these may be added, with respect to Monet's painting, 'what is air?', which emerges as an issue here but not in Dyce, where the air is perfectly transparent and therefore unproblematic. These questions are raised by Monet, but his painting lacks the theme of geology as a pursuit of active investigation that comes from Dyce's painting (and especially from his figures, which have no equivalent in Monet's).[40] Monet puts us out of doors, on the beach during the few minutes of sunset; he shows us the air that surrounds us as an all-but-palpable thing; through the mist and clouds we contemplate the earthly circulation of water from sea to air; we wonder about the full ramifications of the earth's relationship with the sun; we see that the sea has been knocking down the cliffs; whether we understand that at one stage it made those cliffs is very much up to us. Monet's hasty, sketchy *facture* is dedicated to giving us the effect of immediate experience.

For his subject matter Dyce's painstaking technique of clear, careful, hard-edged painting of the crumbling chalk and the stones on the beach is very well-suited since it brings to our attention the idea of observation of concrete details on which geological investigation depended. The painting may be highly finished and therefore not modernist in its handling (modernism being for our purposes definable in terms of formal experimentation by the artist in the search of more appropriate ways of conveying the feeling of being alive – more appropriate than traditional ways, that is). Does this mean that we

must consign Dyce to a place in the dustbin of the old-fashioned, and nail our modernist colours to Monet's mast? Well, in the face of such a suggestion we can certainly decide that Dyce's painting is a painting of modernity, if that word is defined as denoting the psychic impact of processes of modernization. Such processes are often thought of as economic, political, governmental and institutional, but in this case we must also conclude that they are intellectual or scholarly: the pursuit of geology and the radical revision of ideas and beliefs – indeed creation of new ideas – that it necessitated.[41]

Monet's painting raises the grand questions we have specified and it does so all the more by virtue of its brisk modernist handling – the questions, but no answers. The painting, we feel, has been painted by an expert; but an expert painter, not an expert geologist. Dyce has painted with a sense that the significance and the expertise within geology can be communicated.

Notes

1. The rise of geology as a subject in the history of science, and the way it impinges on art, has been considered by a number of scholars, including William Vaughan, *Art and the Natural World in Nineteenth-Century Britain* (Lawrence: University of Kansas, 1990), Martin J.S. Rudwick, *Scenes from Deep Time: Early Pictorial Representations of the Prehistoric World* (Chicago: University of Chicago Press, 1992) and (for the situation in North America) Rebecca Bedell, *The Anatomy of Nature: Geology and American Landscape Painting 1825–1875* (Princeton: Princeton University Press, 2001).

2. See the discussion in Marcia Pointon, *William Dyce 1806–1864: A Critical Biography* (Oxford: Oxford University Press, 1979), pp. 169–76; and Francina Irwin, 'William Dyce "At Home" in Aberdeen', *National Art Collections Fund Annual Review* (London, 1991), pp. 137–43, who adds a discussion of meteorological conditions on the day in question.

3. Edmund Gosse, *Father and Son: A Study of Two Temperaments*, 1907 (London: Penguin in association with William Heinemann Ltd, 1986), p. 102.

4. Marcia Pointon, 'The Representation of Time in Painting: A Study of William Dyce's *Pegwell Bay: A Recollection of October 5th, 1858*', *Art History* 1, 1, March 1978, pp. 99–103. See also Pointon's *William Dyce*.

5. Allen Staley, *The Pre-Raphaelite Landscape* (Oxford: Clarendon Press, 1973), p. 168.

6. BBC television, BBC2, 'Wonders of Kent', 9 p.m., 22 June 2005.

7. James Hutton, *Theory of the Earth, with Proofs and Illustrations* (2 vols, Edinburgh, 1795). For some discussion of this in the context of cosmological theories and land art, see Michael Charlesworth, 'Nature, Landscape, and Land Art', in *Art in the Landscape* (Chinati Foundation, Marfa, Texas: 2000), pp. 93–113. For discussion of Hutton in the context of innovation in eighteenth-century mapping, see Michael Charlesworth, 'Mapping, the Body, and Desire: Christopher Packe's Chorography of Kent', in Denis Cosgrove (ed.), *Mappings* (London: Reaktion Books, 1999), pp. 109–24.

8. C.G. Ehrenberg, *Die Bildung der europäischen, libyschen, and arabischen Kreidefelsen und der Kreidemergels aus mikroskopischen Organismen*, Berlin, 1839.

9. Figures from Robert Chambers, *Vestiges of the Natural History of Creation* (1844: reprinted Leicester: Leicester University Press, 1969), p. 118.

10. Chambers, *Vestiges*, p. 383.

11. Pointon, 'Representation of Time in Painting', p. 103.

12. *Ibid.*, p. 103.

13. A. E. Truman, *Geology and Scenery in England and Wales* (published as *The Scenery of England and Wales*, 1938), Harmondsworth: Penguin Books, 1971. Preface to 1st edn, pp. 13–14.

14. Sir Charles Lyell, *Geological Evidences of the Antiquity of Man* (1863), pp. 496–7.

15. Hutton, *Theory of the Earth*, vol. 2, pp. 560–562.

16. John Playfair, *Illustrations of the Huttonian Theory of the Earth* (Edinburgh, 1802: reprinted at Urbana: University of Illinois Press, 1956, introduced by George White), p. xiv.

17. On Biddulph and Bateman, see Peter Hayden, *Biddulph Grange, Staffordshire: A Victorian Garden Rediscovered* (London: George Philip and the National Trust, 1989).

18. The current National Trust guidebook to the gardens contains the solemn instruction, 'On reaching the Ape of Thoth, turn right'. *Biddulph Grange Garden: An Illustrated Souvenir*, National Trust, 1996, p. 23.

19. Edward Cooke, the artist and author of *Grotesque Animals* (1872), helped Bateman with the design of Biddulph Grange.

20. Bateman, 'Substance of Two Lectures on the Final and Universal Triumph of the Gospel' (1848), pp. 43–4, quoting the *Churchman's Monthly Review* (1844), p. 473; quoted in Brent Elliott, *Victorian Gardens* (Portland OR: Timber Press, 1986), p. 106.

21. Edward Kemp, *Gardeners' Chronicle* (London, 1862), p. 527.

22. Dean William Buckland had advanced an allegorical interpretation of the 'days' of Genesis in which a 'day' meant an immense extent of geological time, in *Reliquiae Diluviae* of 1824. See Noel Annan, *The Dons* (London: HarperCollins, 1999), p. 29. There is no evidence, however, that this is what Bateman intended; in fact his citation from *The Churchman's Monthly Review* demonstrates the opposite.

23. Edmund Gosse, *Father and Son*, p. 102.

24. *Ibid.*, p. 104.

25. Philip Gosse, *Omphalos: An Attempt to Untie the Geological Knot* (London, 1857), p. 372.

26. Edmund Gosse, *Father and Son*, p. 105.

27. *Ibid.*, p. 142.

28. *Ibid.*, p. 125.

29. Information about Durlston Park comes from Patrick Eyres (ed.), *Four Purbeck Arcadias*, the overall title for the single issue of *New Arcadian Journal* 45/46 (1998); also from Paul Nash, 'Swanage: or, Seaside Surrealism', *Architectural Review* LXXIX (April 1936), p. 154; and from my visit there in 2000.

30. Thomas Hardy used this phrase of Burt in 1892, viewing him as self-made. See Florence Emily Hardy, *The Life of Thomas Hardy 1840–1928* (London: Macmillan, 1975), p. 249.

31. For Mowlem and Burt and their effect on Swanage, see David Lewer and Bernard Calkin, *Curiosities of Swanage, or Old London by the Sea* (Yeovil: Galvin Press, 1971).

32. David Lambert, 'Durlston Park and Purbeck House: The Public and Private Realms of George Burt, King of Swanage' in Eyres, *Four Purbeck Arcadias*, pp. 15–52, especially pp. 16–17.

33. S.M. Burnham, *History and Uses of Limestones and Marbles* (Boston: S.E. Cassino and Company, 1883), p. 130.

34. Jacquetta Hawkes, *A Land* (London: Cresset Press, 1951), p. 76.

35. Lambert, 'Durlston Park and Purbeck House', in Eyres, *Four Purbeck Arcadias*, p. 44.

36. *Ibid.*, p. 24.

37. *Ibid.*, p. 29.

38. Chambers, *Vestiges*, p. 1.

39. Chambers, *Vestiges*, p. 19.

40. Other paintings by Monet of the same and nearby cliffs emphasize rather more of the geological structure, which features particularly emphatic horizontal lines of flint. See Robert Herbert, *Monet and the Normandy Coast* (New Haven and London: Yale University Press, 1994).

41. My use of the terms 'modernization', 'modernity' and 'modernism' is indebted to the thinking about these issues in several works by Charles Harrison, for example, his *Modernism* (London: Tate Gallery Publishing, 1997), and T.J. Clark, *The Painting of Modern Life: Paris in the Art of Manet and his Followers* (Princeton: Princeton University Press, 1984).

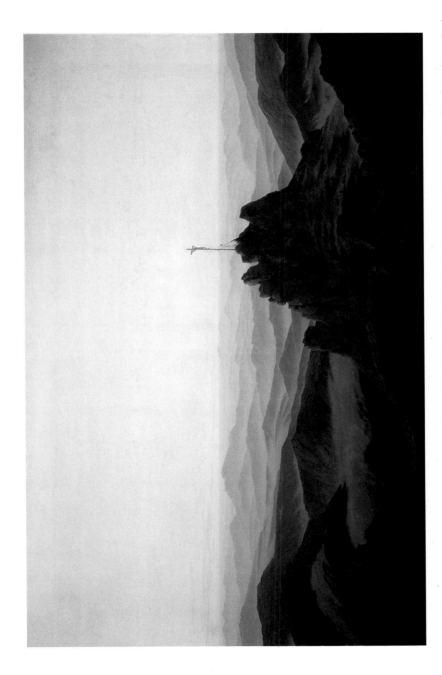

1 Caspar David Friedrich, *Morning in the Riesengebirge*, 108 × 170 cm (43 × 67 inches), oil on canvas, 1810, Schloss Charlottenburg, Berlin

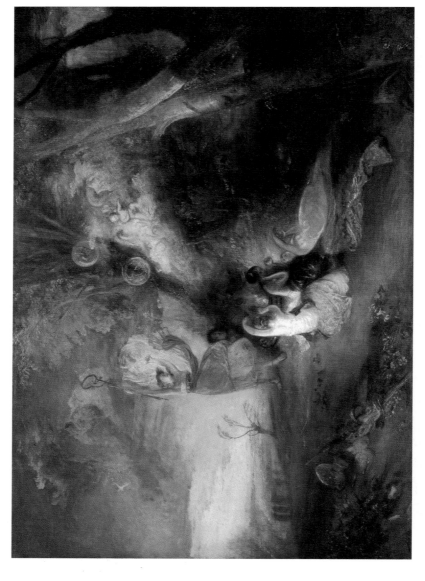

2 J.M.W. Turner, *Vision of Medea*, 173.5 × 249 cm (68 × 98 inches), oil on canvas, 1828, The Tate Gallery, London

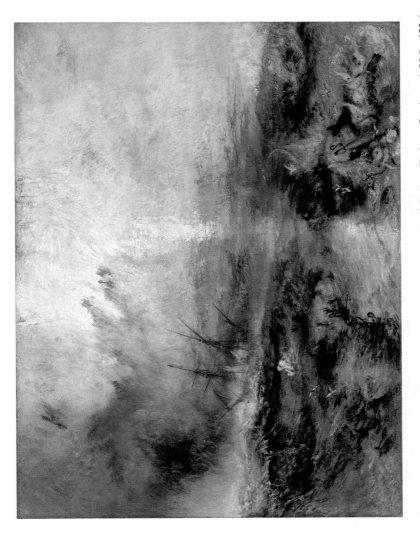

3 J.M.W. Turner, *Slave Ship (Slavers Throwing Overboard the Dead and Dying – Typhoon Coming on)*, 90.8 × 122.6 cm (35¾ × 48¼ inches), oil on canvas, 1840, Museum of Fine Arts, Boston. Photograph © 2008 Museum of Fine Arts, Boston

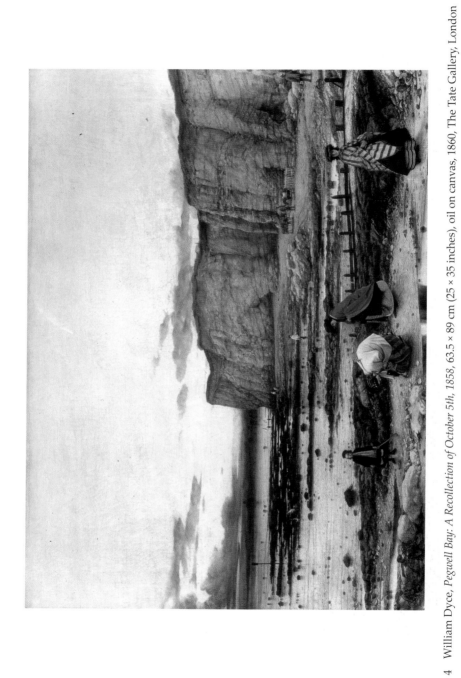

4 William Dyce, *Pegwell Bay: A Recollection of October 5th, 1858*, 1858, 63.5 × 89 cm (25 × 35 inches), oil on canvas, 1860, The Tate Gallery, London

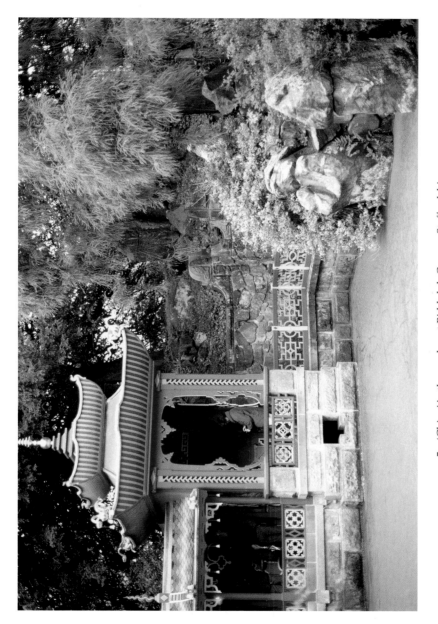

5 'China' in the garden at Biddulph Grange, Staffordshire

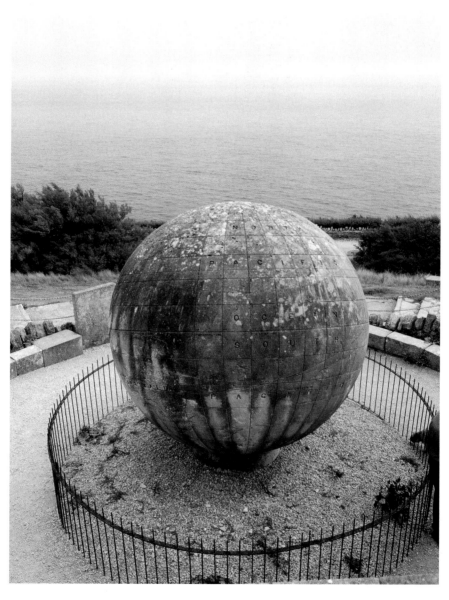

6 George Burt's Large Globe in Durlston Park. English Channel beyond

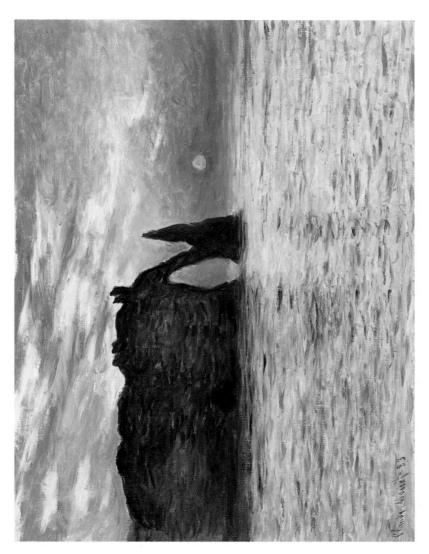

7 Claude Monet, *Etretat, Sunset*, 60.5 × 81.8 cm (24 × 32 inches), oil on canvas, 1883, North Carolina Museum of Art, Raleigh

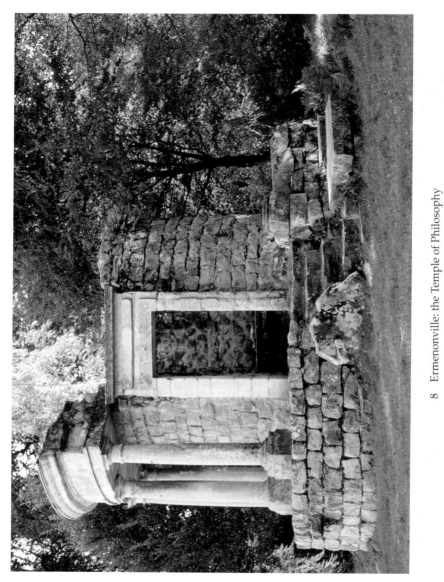

8 Ermenonville: the Temple of Philosophy

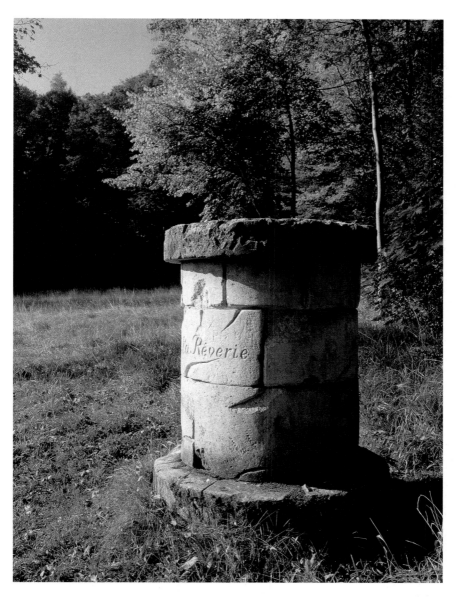

9 Ermenonville: the Altar of Reverie. Photo Henri Gaud © Edition Gaud

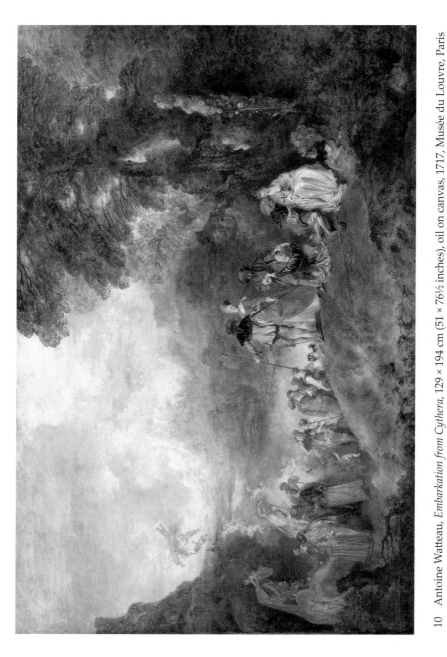

10 Antoine Watteau, *Embarkation from Cythera*, 129 × 194 cm (51 × 76½ inches), oil on canvas, 1717, Musée du Louvre, Paris

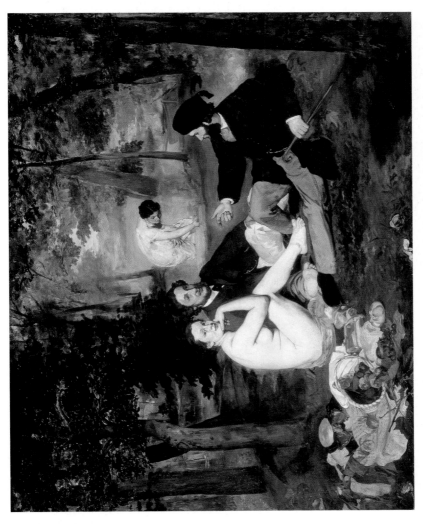

11 Edouard Manet, *Le Déjeuner sur l'herbe*, 208 × 264.5 cm (82 × 104 inches), oil on canvas, 1863, Musée d'Orsay, Paris

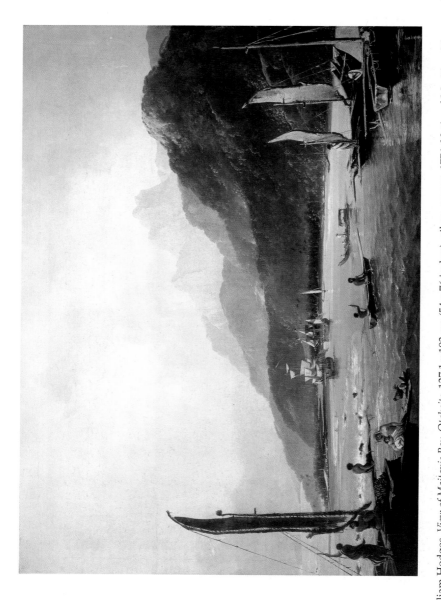

12 William Hodges, *View of Maitavie Bay, Otaheite*, 137.1 × 193 cm (54 × 76 inches), oil on canvas, 1776, National Maritime Museum, London

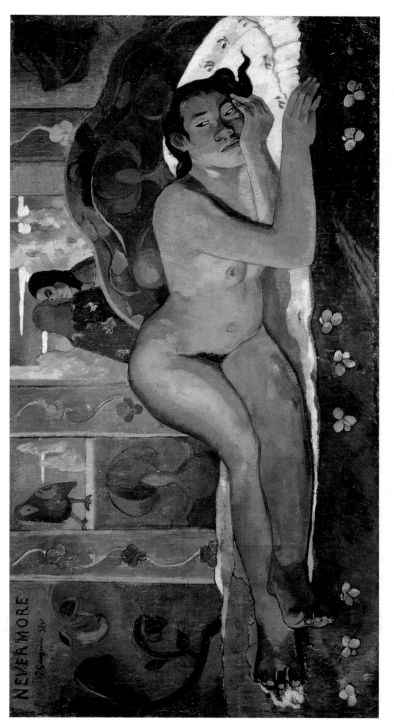

13 Paul Gauguin, *Nevermore*, 60.5 × 116 cm (24 × 45⅝ inches), oil on canvas, 1897, Courtauld Institute Galleries, London

14　Paul Gauguin, *Barbarian Tales* (*Contes Barbares*), 131.5 × 90.5 cm
(51½ × 35½ inches), oil on canvas, 1902, Museum Folkwang, Essen

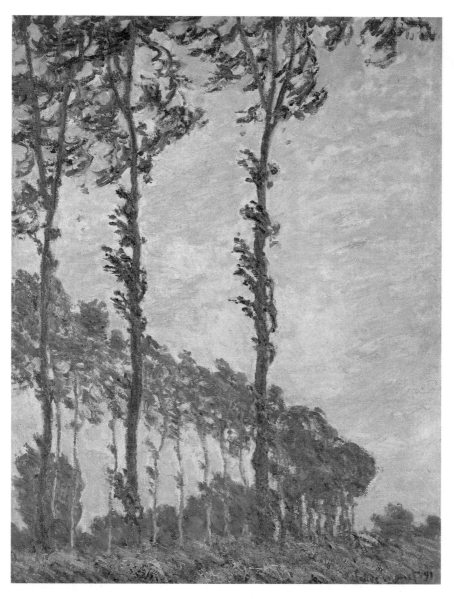

15 Claude Monet, *Poplars (Wind Effect)*, W.1302, 100 × 73.5 cm
(39⅜ × 28⅞ inches), oil on canvas, 1891, Musée d'Orsay, Paris

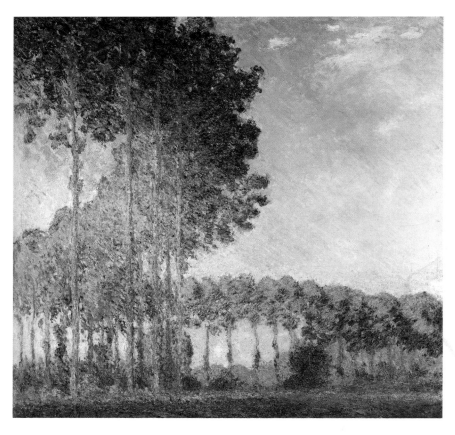

16 Claude Monet, *Poplars (Banks of the Epte, View from the Marsh)*, W.1312, 88.3 × 92.7 cm (34¾ × 36½ inches), oil on canvas, 1891, private collection

Reverie and imagination

The question of subjectivity came up in Chapter 1 as a discussion of the subject positions provided by panoramic vantage points. In Chapter 2 the question of whether the seeing of ghostly apparitions was really confined, in its causation, to the unpredictable vagaries of psychological subjectivity was tested against the historical factors within British culture of the period that tended to make ghosts and spectres culturally engendered apparitions. The refusal by Philip Gosse and Bateman to acknowledge geological time, which we discussed in Chapter 3, was based on the penetration of their sense of sovereign subjectivity by religious prejudice. Clearly the issue of subjectivity is an important one in an inquiry into visual culture of the nineteenth century.

Subjectivity and more

We cannot embrace the whole question in this chapter; rather we must confine ourselves to exploring its connections with landscape and with respect to the specific factor of Anglo-French connections. The work of the French enlightenment philosopher Jean-Jacques Rousseau (1712–78) is centrally important to the idea of subjectivity in the modern period. With Rousseau, as with the other cultural figures whose work we shall be discussing in this chapter, William Wordsworth and Charles Baudelaire, the question of subjectivity is intimately bound up with their relationship to the world around them, to their environments. For these writers, the set of problems that gather round the question of subjectivity is thus an aspect of the visual culture of landscape. As Walter Pater put it, 'an intimate consciousness of the expression of natural things, which weighs, listens, penetrates, where the earlier mind passed roughly by is a large element in the complexion of modern poetry.'[1] Pater states that this 'intimate consciousness' began with Rousseau and reached its 'central and elementary expression' in Wordsworth.

In an attempt to comprehend Rousseau's importance to the involvement of landscape with subjectivity, we can start with the very concrete example of the place where he was buried (especially since it will continue to be central to the following chapter).

Rousseau had fallen on hard times when he took up an offer made by the Marquis de Girardin (1735–1808) to live on the Marquis's estate at Ermenonville, some 30 miles (48 km) north-east of Paris.[2] Rousseau moved to Ermenonville in May 1778. There, Girardin had created a very early example of the landscape garden in France.[3] East of Ermenonville an open plain supports cereal agriculture. West of the village thick woods grow on poor sandy soils, the forest of Ermenonville merging with the famous Valois forests of Chantilly and Mortefontaine. The village, château and garden of Ermenonville are situated between those contrasting areas in the narrow marshy valley of a small river, La Launette. From 1766 Girardin had made here what became one of the more famous gardens of the age. At Ermenonville Rousseau enjoyed botanizing with the owner's youngest son, rambling over Le Désert, a uniquely interesting area of heathland, consisting largely of sand, that was incorporated in the garden to the north-west, chatting with villagers, and practising archery with Girardin at the butts erected for use by Girardin's family, his guests and local people.[4]

While visitors to Ermenonville included Marie-Antoinette, Napoleon, Benjamin Franklin and Robespierre, all visitors were not necessarily of elevated or even middling social background, for Girardin's reform-minded liberalism was also practised at home. He allowed the villagers of Ermenonville to use his landscape garden as much as they wished, provided that they did not damage anything. He provided a dance floor for festivals on Sundays and holidays at the foot of the Great Beech, and another covered floor, for wet weather, close by, on the grounds that people who only have one day of leisure a week should not lose a single moment.[5] South of the château, the Arcadian Prairie, a big meadow of long grass, dotted with rustic huts and other features, blended farming with garden design and eventually contained several features playing on the theme of the natural piety of rustic folk.

We might expect that all this was congenial to Jean-Jacques Rousseau. In fact, even before his arrival there the garden at Ermenonville had been partly inspired by his published ideas. The most salient feature stands on a shoulder of a low hill overlooking the lake. It is a temple which appears ruined when seen from a distance and which is modelled on a real ruined building in Italy, the Temple of the Sibyl at Tivoli. Ermenonville's building is not, in fact, ruined: it is the perpetually unfinished Temple of Philosophy, dating from 1776 (Plate 8). Certain parts of the building, such as the door-frame and the six columns to the left of it, are perfectly finished. Others are still rough or not even begun. The Latin inscriptions on the structure are carved in elegant italic lettering very unlike the utilitarian letters of Durlston Park. Over the door is a statement of the solemn goal of philosophy's efforts: 'To know the causes of things'.

4.1 Ermenonville: the Isle of Poplars and Rousseau's Tomb

The column furthest away from the Temple's door is inscribed, 'NEWTON Lucem' ('Light'). The remaining columns read, in order: 'DESCARTES Nil in rebus inane' ('No vacuum in nature'); 'W. PENN Humanitatem' ('Humanity'); 'MONTESQUIEU Justitiam' ('Justice'); 'VOLTAIRE Ridiculum' ('Ridicule'); 'ROUSSEAU Naturam' ('Nature'). The philosophers are all modern.

On the ground near the temple steps lie more columns, waiting to be erected. But a column-base to the right of the steps is inscribed 'Who will complete this?' and carries on another face the forbidding statement, 'It is impossible to build on falsity'. Ermenonville's Temple of Philosophy possesses great power and, as a perpetually unfinished building, is unique in garden history, as it symbolizes and embodies the infinite.

The mythic dimension and real spaces of the garden were strongly united after Rousseau's sudden death on 2 July 1778. At midnight two days later the great man was interred on the artificially created Isle of Poplars in the lake south of the house overlooked by the Temple of Philosophy. The funeral was lit by a procession of grieving villagers bearing torches. Over his grave a finely carved neoclassical tomb, designed by the artist Hubert Robert (1733–1808) was erected (Figure 4.1). With the grove of Lombardy poplar trees growing around, the island, made sacred by the burial, became a famous and powerful image in the European imagination. (The feature was imitated in at least

four other European gardens: the Island of Poplars in Arkadia, Poland; the Rousseauinsel at Wörlitz, Germany; an isle of poplars at Sturefors, Sweden; and the Rousseauinsel in the Tiergarten, Berlin, itself probably imitating Wörlitz.) Inscriptions on the tomb at Ermenonville designate Rousseau as 'the man of nature and of truth'.

Rousseau only spent six summer weeks at Ermenonville, but his impact on the garden, in a process that began even before he arrived, was enormous.[6] His death effectively set the seal on the sacredness of the garden, which also registers the impact of his subjectivity and his experience in dealing with the early modern world in such a way as contributed powerfully to its overthrow in the Revolution of 1789–94 and the inception of modernity.

We shall have to return to Ermenonville, and to Rousseau, later in this chapter after considering Wordsworth, whom Pater links to Rousseau and 'an intimate consciousness of the expression of natural things'. However, first I would like to introduce another well-known figure in French culture, the poet and critic Charles Baudelaire (1821–67). While Baudelaire is celebrated as an arch-figure of modernity, the connections between his work and Rousseau's thought, which will be elucidated here, are more obscure and little-researched.

To bring up Baudelaire here involves, of course, acknowledging that cities can be landscapes too. Baudelaire's environment was distinctly urban, while we think of those of the others as rural, despite the years during which they lived in towns and cities. Baudelaire, in contrast to them, represents the urban consciousness in its mostly greatly developed form, and I would argue that the sensibility represented in his work amounts to an 'intimate consciousness of the expression of urban things'. In other words, despite the apparent great difference between the earlier writers' rural nature and Baudelaire's urban landscapes, I shall seek to demonstrate considerable continuities of thought and imagination between these three figures. Initially at least, this involves a return to the issue that emerged at the end of Chapter 2, which was the effect of opium use in stimulating visions in the nineteenth century.

Baudelaire published his poem, 'The Seven Old Men' in 1859. It takes its place in *Tableaux Parisiens*, part of *Les Fleurs du mal*. The first lines of the poem, 'Fourmillante cité, cité pleine de rêves / Où le spectre, en plein jour, raccroche le passant!' ('Teeming city, city full of dreams / Where the spectre, in broad daylight, accosts the passer-by!') are very famous, not least because they were imitated by T.S. Eliot in 'The Waste Land' of 1922 ('Unreal city, / under the brown fog of a winter noon').[7] Together the two poets give a resonant and influential image of an urban landscape, a modern city: Eliot's tendency to dwell on the brown and yellow fogs that were provoked by huge amounts of coal smoke from the burning of coal in houses, offices, shops, workshops and the many steam engines of industry and the railways, in this and other urban poems, is directly derived from Baudelaire. In his turn, Baudelaire has

preserved more than a little of Coleridge's 'The Rime of the Ancient Mariner' (1798) in which the ancient mariner abruptly accosts a wedding guest, the two figures utterly unknown to each other. With this and its use of 'fourmillante' (*fourmi* is French for 'ant'), Baudelaire's poem is immediately about anonymity in the city; alienation; the feeling of being alone.

Swarming city, city full of dreams
Where the spectre, in broad daylight, accosts the passer-by!
Mysteries flow everywhere like vital powers
Sluicing through the narrow veins of a forceful giant.

One morning, although in the sad street
Mist made the houses seem taller
So they imitated the embankment of a canalised river
And the setting matched the actor's spirit,

A dirty yellow fog flooding all the space,
I was wandering, bracing up my nerves like a hero,
And arguing with my already worn-out soul,
Through the neighbourhood shaken by heavy soil-carts.

All of a sudden an old man whose yellow rags
Reflected the sodden sky
And whose appearance would have attracted showers of charity
Had not evil glinted in his eyes

Appeared to me. It was as if his eyeballs were pickled
In malice. His gaze was sharpening the chill
And his long beard, stiff as a sword,
Stuck out like Judas's.

He wasn't so much bent, as snapped,
His back making with his leg a perfect right-angle,
So that his stick added the finishing touch
Giving him the shape and awkward gait

Of a maimed quadruped or a three-legged Jew.
Over the snow and the mud he stamped along
As if to crush the dead beneath his clogs
Hating the universe – not just indifferent.

His identical copy followed him: beard, eye, back, truncheon, rags,
Nothing altered, sprung from the same hell
This centenarian twin; and these baroque spectres
Were marching in step towards an unknown goal.

Was I the butt of some hellish joke,
Or was it evil chance that humiliated me so?
For I counted seven times, from minute to minute,
This sinister old man who spawned himself!

Whoever laughs at my anxiety
And is not shaken by a kindred shiver
Should realise that despite decrepitude
These seven ugly monsters exuded immortality!

Would I have been able to confront the eighth
Without dropping dead? Inexorable *doppelganger*,
Ironic, deadly, disgusting phoenix, son and father of himself!
– But I turned my back on this hellish cortege

Maddened like a drunkard who sees double
I retreated home, slammed my door, exhausted,
Sick and chilled to death, my soul feverish and dismayed
Wounded by the mystery and the absurdity!

In vain did my rational self try to take the helm;
The storm wrenched it loose
And my soul was dancing ... dancing, an old
Dismasted barge, on a monstrous and infinite sea![8]

Fog, rain, dirt, stone, snow, traffic, strangers – in short order Baudelaire produces a lasting definition of the modern city. Nature lies constrained; traditional personification is anatomized. The cityscape is economical, weighty, convincing; and compared with the narrator's internal seascape. The narrator is evidently in an unstable state, or at least divided against himself, as the poem opens. He steels his nerves and argues with his own already tired soul. In his feverishly active, even hypersensitive perception he sees the malice in the old man's eyes immediately. The seven old men represent a mystery as crazy as it is unfathomable. They are inexplicable; and their effect is of the most disastrously destabilizing sort.

The narrator combines a susceptibility to horror (indeed to seeing visions) with a very keen awareness of concrete details of the scene and of the figure that confronts him. To this extent he is reminiscent of the narrator of Thomas De Quincy's *Confessions of an English Opium-Eater* (1821). Indeed, the influence on the poem of De Quincy's book, which Baudelaire admired greatly, can be felt in other ways. De Quincy uses the ocean as a figure for mental stability twice in his work. When discussing the 'pleasures' of opium, he writes: 'The ocean, in everlasting but gentle agitation, and brooded over by a dove-like calm, might not unfitly typify the mind and the mood which then swayed it. For it seemed to me as if then first I stood at a distance, and aloof from the uproar of life'.[9] Later on, in the section on the 'pains' of opium that describes the 'tyranny of the human face', he writes, 'upon the rocking waters of the ocean the human face began to appear ... my agitation was infinite, – my mind tossed – and surged with the ocean.'[10] De Quincy's narrator returned to the same metaphor when characterizing his cure at the end of the essay. 'One memorial of my former condition still remains,' he writes: 'my dreams are not

yet perfectly calm: the dread swell and agitation of the storm have not wholly subsided.'[11] Baudelaire wrote 'Les Sept vieillards' in 1859 while translating De Quincy's essay (a translation that appeared in Baudelaire's essay on drug-taking, *Les Paradis artificiels*).[12] It seems that this recurrent metaphor, encountered in an essay that he greatly admired, might have suggested to Baudelaire the final devastating metaphor of his poem.

This is a new sort of narrator, distinctly nineteenth-century; there are similar elements of hypersensitivity bordering on hysteria in the narrator of Matthew Arnold's 'Dover Beach'. 'Les Sept vieillards' also gives us a new kind of spectral terror. Baudelaire's interpretation of De Quincy had emphasized the ability of opium nightmares to reproduce disturbing people encountered in waking life. In De Quincy's book a classic effect of transumption takes place when an East Asian man knocks on the door of the narrator's cottage in the Pennine mountains of Yorkshire. 'What business a Malay could have to transact amongst English mountains I cannot conjecture,' wrote De Quincy.[13] The man spoke no English. De Quincy spoke to him in ancient Greek and he replied, presumably in Malayan, which was not one of De Quincy's languages, and lay down on the floor for an hour. Assuming that all Asians were familiar with opium, De Quincy gave the man a parting gift of the drug. To his alarm he saw the Malay put the whole piece in his mouth at once, but afterwards no reports came in of dead foreigners being found on the roads. The consequence was severe, however, for the narrator: 'This Malay ... fastened afterwards upon my dreams, and brought other Malays with him worse than himself, that ran "a-muck" at me, and led me into a world of troubles.'[14] Baudelaire seized delightedly on this incident in his translation of and commentary on De Quincy's text, but slightly re-phrased the expansion of Malays from one to many: 'Note well this Malay,' he tells the reader; 'we shall see him again later; he will reappear, multiplied in a terrible way.'[15] De Quincy's Malay brought others with him; as translated by Baudelaire, he reproduced himself. The idea of the re-duplication of the spectre in 'Les Sept vieillards' may well have come from Baudelaire's interpretation of De Quincy's passage. This means that Baudelaire's poem takes on the character of an opium nightmare.

Mass-produced as if from a ghostly version of one of the new factories, the spectral old men in Baudelaire's poem belie their apparent infirmity with a demonic energy reminiscent of that manifested by Ratapoil, the caricaturist Honoré Daumier's satirical figure, made first as a statue and then becoming a drawn figure, that the artist invented to condemn the activities of the vagabond supporters of the dictator, Napoleon III.[16] Most of these hooligans and *agents provocateurs* were drawn from the lumpenproletariat and organized through the Society of Relief of 10 December.[17] Their function had been to provoke unrest in the streets before Napoleon III's seizure of power in the coup d'état of December 1851. Ratapoil's stick was a club; his once-good clothes were battered, ragged and scruffy; his jutting beard made his middle-

age look older; and his rounded back and small size belied his effectiveness as a covert disturber of the peace. I do not mean to push the analogy between Baudelaire's old men and Daumier's Ratapoil too far, but to suggest that it is a factor in Baudelaire's formation of this threatening figure.

Ratapoil differs from Baudelaire's old men not least in that the latter are bent over. They need to be bent double to clinch the identification with another work that helps to inform the conception of Baudelaire's poem. This is a classic landscape poem by William Wordsworth (1770–1850), written in 1807, which we examine in the next section.

The moors and subjectivity

'Resolution and Independence'

I
There was a roaring in the wind all night;
The rain came heavily and fell in floods;
But now the sun is rising calm and bright;
The birds are singing in the distant woods;
Over his own sweet voice the Magpie chatters;
And all the air is filled with pleasant noise of waters.

II
All things that love the sun are out of doors;
The sky rejoices in the morning's birth;
The grass is bright with rain-drops; – on the moors
The hare is running races in her mirth;
And with her feet she from the plashy earth
Raises a mist, that, glittering in the sun,
Runs with her all the way, wherever she doth run.

III
I was a Traveller then upon the moor,
I saw the hare that raced about with joy;
I heard the woods and distant waters roar;
Or heard them not, as happy as a boy;
The pleasant season did my heart employ;
My old remembrances went from me wholly;
And all the ways of men, so vain and melancholy.

IV
But, as it sometimes chanceth, from the might
Of joy in minds that can no further go,
As high as we have mounted in delight
In our dejection do we sink as low;
To me that morning did it happen so;
And fears and fancies thick upon me came;
Dim sadness – and blind thoughts, I knew not, nor could name.

V

I heard the sky-lark warbling in the sky;
And I bethought me of the playful hare;
Even such a happy Child of earth am I;
Even as these blissful creatures do I fare;
Far from the world I walk, and from all care;
But there may come another day for me –
Solitude, pain of heart, distress, and poverty.

VI

My whole life I have lived in pleasant thought,
As if life's business were a summer mood;
As if all needful things would come unsought
To genial faith, still rich in genial good;
But how can He expect that others should
Build for him, sow for him, and at his call
Love him, who for himself will take no heed at all?

VII

I thought of Chatterton, the marvellous Boy,
The sleepless Soul that perished in his pride;
Of Him who walked in glory and in joy
Following his plough, along the mountain-side:
By our own spirits are we deified:
We Poets in our youth begin in gladness;
But thereof come in the end despondency and madness.

VIII

Now, whether it were by peculiar grace,
A leading from above, a something given,
Yet if befell, that, in this lonely place,
When I with these untoward thoughts had striven,
Beside a pool bare to the eye of heaven
I saw a Man before me unawares:
The oldest man he seemed that ever wore grey hairs.

IX

As a huge stone is sometimes seen to lie
Couched on the bald top of an eminence;
Wonder to all who do the same espy,
By what means it could thither come, and whence;
So that it seems a thing endued with sense:
Like a sea-beast crawled forth, that on a shelf
Of rock or sand reposeth, there to sun itself;

X

Such seemed this Man, not all alive nor dead,
Nor all asleep – in his extreme old age:
His body was bent double, feet and head
Coming together in life's pilgrimage;
As if some dire constraint of pain, or rage

Of sickness felt by him in time long past,
A more than human weight upon his frame had cast.

XI
Himself he propped, limbs, body, and pale face,
Upon a long grey staff of shaven wood:
And, still as I drew near with gentle pace,
Upon the margin of that moorish flood
Motionless as a cloud the old Man stood,
That heareth not the loud winds when they call
And moveth all together, if it move at all.

XII
At length, himself unsettling, he the pond
Stirred with his staff, and fixedly did look
Upon the muddy water, which he conned,
As if he had been reading in a book:
And now a stranger's privilege I took;
And, drawing to his side, to him did say,
'This morning gives us promise of a glorious day.'

XIII
A gentle answer did the old Man make,
In courteous speech which forth he slowly drew:
And him with further words I thus bespake,
'What occupation do you there pursue?
This is a lonesome place for one like you.'
Ere he replied, a flash of mild surprise
Broke from the sable orbs of his yet-vivid eyes,

XIV
His words came feebly, from a feeble chest,
But each in solemn order followed each,
With something of a lofty utterance drest –
Choice word and measured phrase, above the reach
Of ordinary men; a stately speech;
Such as grave Livers do in Scotland use,
Religious men, who give to God and man their dues.

XV
He told, that to these waters he had come
To gather leeches, being old and poor;
Employment hazardous and wearisome!
And he had many hardships to endure:
From pond to pond he roamed, from moor to moor;
Housing, with God's good help, by choice or chance,
And in this way he gained an honest maintenance.

XVI
The old Man still stood talking by my side;
But now his voice to me was like a stream

Scarce heard; nor word from word could I divide;
And the whole body of the Man did seem
Like one whom I had met with in a dream;
Or like a man from some far region sent,
To give me human strength, by apt admonishment.

XVII
My former thoughts returned: the fear that kills;
And hope that is unwilling to be fed;
Cold, pain, and labour, and all fleshly ills;
And mighty Poets in their misery dead.
– Perplexed, and longing to be comforted,
My question eagerly did I renew,
'How is it that you live, and what is it you do?'

XVIII
He with a smile did then his words repeat;
And said that, gathering leeches, far and wide
He travelled; stirring thus above his feet
The waters of the pools where they abide.
'Once I could meet with them on every side;
But they have dwindled long by slow decay;
Yet still I persevere, and find them where I may.'

XIX
While he was talking thus, the lonely place,
The old Man's shape, and speech – all troubled me:
In my mind's eye I seemed to see him pace
About the weary moors continually,
Wandering about alone and silently.
While I these thoughts within myself pursued,
He, having made a pause, the same discourse renewed.

XX
And soon with this he other matter blended,
Cheerfully uttered, with demeanour kind,
But stately in the main; and when he ended,
I could have laughed myself to scorn to find
In that decrepit Man so firm a mind.
'God,' said I, 'be my help and stay secure;
I'll think of the Leech-gatherer on the lonely moor!'

The contrasts with Baudelaire's poem could hardly be more pronounced. The poet sets off on a lovely morning in the English Lakes, rather than on a gloomy day in a filthy metropolis. The man he meets is unique, rather than uncannily reproduced, and friendly rather than malicious and hostile. The storm is already over, while the storm in Baudelaire's poet's inner landscape starts at the end, on the terrified return home. Wordsworth's poet derives strength from his encounter with the sturdily independent leech-gatherer who, he feels, has been sent to 'admonish' him for his fears. Leeches were

used in medical practice, so it could be argued, if necessary, that the leech-gatherer is performing a socially useful function (this thought is prepared for by stanza VI of Wordsworth's poem). This can hardly be said for Baudelaire's spectre; indeed the question of social usefulness simply seems an absurd question in nineteenth-century Paris.

Where the poems lie not so far apart is in the sensibility of the narrators. Wordsworth's poet finds himself subject to a pronounced plunge in mood, as the joy he feels in beautiful nature gives place to anxiety about his place within it, and within society (stanzas V and VI). He begins to brood on poets like Chatterton and Robert Burns ('Him who walked in glory and in joy / Following his plough' – stanza VII) who committed suicide or went mad. This sudden change in mood is inexplicable: the poet tries to explain it as a bereft sense of the subject's split nature brought on by the very intensity of the joy produced by sense impressions of the beautiful morning.[18] In stanza IV these lines describe the dilemma:

But, as it sometimes chanceth, from the might
Of joy in minds that can no further go,
As high as we have mounted in delight
In our dejection do we sink as low

However, it might be objected that this is simply one way of trying to explain a psychological movement that is open to several possible explanations. At any rate, Wordsworth's poet is hardly less divided against himself than Baudelaire's before he meets the leech-gatherer. In both cases neurotic fears are present; the crucial development in each case lies in the encounter with the old man, his character, and how the poet responds to him. The Parisian poet's response is determined by the character of the multiple spectre, which is a specifically urban and opium-induced product; in the softer, more hospitable environment of the northern English moors, where even isolated pools offer a means of grubbing a living, both poet and old man can afford to be more benign. Despite one line in which the leech-gatherer feels like a figure encountered in a dream there seem to be no stronger signs that drug-taking is involved at all.

One conclusion that we can reach is that the energies of English Romanticism poured through Baudelaire's imagination, helping him to form 'Les Sept vieillards' and with it the form of his imagining of the city in which the *Tableaux Parisiens* played so pivotal a part. Rural England – the Lake District and the northern mountains – helped to form *a contrario* the urban landscape of the French metropolis, and through it, the archetype of the urban wasteland. Yet what about Wordsworth? Was he not also indebted in his turn to a cross-channel energy that helped him to form his poem? For another conclusion we can reach is that the narrative poet of 'Resolution and Independence' is having a Rousseauan *rêverie*.

Reverie and more

Elucidation of the social significance of reverie, and its central value as a mode of enjoying landscape, takes us again to Ermenonville, where one further garden feature is closely associated with Rousseau and records the impact of his subjectivity more strongly than any other. The Altar of Reverie is situated at the edge of a wood, in front of a sweetly beautiful grassy valley, at a point where a view of the lake opens out across the stream (Plate 9). A simple cylinder or drum of stone fashioned like an ancient Roman altar, it occupies a place where three different environments meet, and was a place where Rousseau once spent some time day-dreaming. When he came out of this reverie he is supposed to have written a *sgrafito*, 'A la rêverie' on the altar that already occupied the spot. After his death the pencil writing he had left was reverently chiselled over to form the present inscription, which therefore commemorates the actual handwriting of the great man, as well as a single moment of his life.[19] Some of the stones were artfully carved with cracks in order to give some fictive age-value to the monument. The Altar of Reverie seems to commemorate the momentary, the absolutely personal and subjective, the Romantic impulse to self-veneration. We deem handwriting to be unique and therefore to maintain an irreducible existential link with the person who wrote it, akin to a fingerprint. Meanwhile a day-dream would seem to be the most ephemeral and incommunicable of experiences. We can therefore stand beside the Altar at Ermenonville and imagine the moment in 1778 when Rousseau enjoyed a reverie here which cheered him up. We can look across towards the lake and imagine his disfocused eyes gazing in that direction as he sat thinking of something else. And we can appreciate the impulsive, enthusiastic impulse to reach in his pocket for a pencil and rededicate the altar. The feature therefore seems to draw us closer to the life of the man than does his tomb, for example, or the column in the Temple of Philosophy.

However, there is more involved in the Altar than this veneration of individuality and existential uniqueness. We must ask, what is reverie? And how does it fit into Rousseau's potently revolutionary thought? Addressing this question will allow us to establish the cultural dimension of the Altar that complements the subjective one. Some idea of the hostility of the cultural context can be gathered from considering the definition of 'Reverie' in the first edition of the *Encyclopaedia Britannica*, compiled by 'A Society of Gentlemen in Scotland' in 1771. It defines reverie as: 'the same with delirium, raving, or distraction. It is used also for any ridiculous, extravagant imagination, action, or proposition, a chimera or vision. But the most ordinary use of the word, among English writers, is for a deep disorderly musing or meditation.' The final sentence might seem relenting a bit, but clearly in a Protestant culture in which idleness is too often equated with vice, reverie is deeply suspicious.[20]

Things are only a little better in the *Encyclopédie* of Diderot and d'Alembert (1765):

We call reverie all vague ideas, all bizarre conjecture which lacks sufficient basis, all ideas that come to us during the day and in a waking state, as we imagine dreams come to us during sleep, letting our understanding wander wherever it pleases, without taking the trouble to conduct it; what are you writing there? I don't know; a reverie that passed through my head, and which will become something or nothing. To [day]dream is also a synonym for 'to be distracted'. You daydream in such good company, that is impolite. It means on other occasions a deep examination.[21]

The idea of a very deep introjection only emerges at the end and very briefly from the description of a chaotic or 'disorderly' state. Are these varying degrees of hostility to day-dreaming what Rousseau intended? To address this questions and to give an idea of how he changed the European standing of the concept of reverie, I wish to draw on two sources of evidence – Rousseau's last work, the *Reveries of the Solitary Walker* (written 1776–78), and two episodes from his enormously influential novel of sentiment, *Julie, ou la nouvelle Heloise* (1761).

The *Reveries* may in general address the question, 'what am I?'[22] but examination of the most beautiful of them, 'Fifth Walk' (which is the Walk that reflects at greatest length on the process of reverie itself) shows that they also depict Rousseau having reveries in a state of particular stimulus from the natural world. In the 'Fifth Walk' he remembers living on an island in Lake Bienne, Switzerland, in 1765. He lived there for two months, 'the happiest time of my life', and wishes he could have stayed forever.[23] His time was devoted to a sweet idleness, during which, 'in a silence broken by no other sounds but the cries of eagles, the interrupted chirping of other birds, and rushing of torrents which flowed from the mountain',[24] he botanized, helped with farming activities, and enjoyed day-dreaming. Some of the day-dreams happened in a boat:

I would row to the middle of the lake when the weather was calm, and there, stretching myself out in my boat with my eyes turned to the sky, I would let myself go and drift slowly in the currents of the water, sometimes for several hours, plunged in a thousand confused but delicious reveries ...'[25]

Others took place on the shore:

When evening came on, I would descend from the summits of the island and happily go and sit on the beach at the shore of the island, in some hidden spot; there the sound of the waves and the movement of the water captivating my senses and chasing all other disturbance from my soul would plunge it into a delicious reverie where night would often find me without me having noticed it. The rhythmic movement of the water, its sound continuous, but magnified at intervals, striking without interruption my ears and eyes, supplied the place of

the internal movements that reverie had extinguished in me, and sufficed to make me feel my existence with pleasure, and without taking the trouble to think.[26]

Reveries clearly constitute a consoling, even a healing force. In phrases such as 'everything is in continual flux on earth',[27] Rousseau meditates on the transitory nature of pleasure and attempts to come to terms with what constitutes happiness:

But if there is a state in which the soul finds a solid enough basis to rest on entirely and recuperate there its whole being, without needing to remember the past or project the future; where time means nothing for it, where the present lasts forever without making that duration noticeable and without any trace of time's flight; without any other feeling of deprivation or of joy, of pleasure or of pain, of desire or of fear, save that only of our existence, and that feeling alone fills our whole soul; as long as that state lasts, he who feels it can call himself happy, not with an imperfect, poor and relative happiness, such as that which we find in the pleasures of life, but with a sufficient, perfect and full happiness, which leaves the soul with no emptiness that it feels the need to fill. Such is the state in which I often found myself on the isle of Saint-Pierre in my solitary reveries, either lying in my boat as I let it drift in the currents of water, or at the edge of a beautiful river or stream trickling over pebbles.

From what does one feel bliss in such a situation? From nothing outside oneself, from nothing if not from oneself and one's own existence; as long as that state lasts we are sufficient to ourselves, like God. The feeling of existence stripped of all other emotion is by itself such a precious feeling of happiness and peace, that it is alone enough to make that existence dear and sweet to the person who can turn from himself all the earthly and sensual impressions which ceaselessly come to disturb us and distract us here below. But most men, agitated by continual passions, hardly know this state, and having only tasted it imperfectly for a few fleeting moments retain only an obscure and confused idea of it that they cannot find charming.[28]

It would be difficult to conceive of a higher tribute Rousseau could pay to a psychic state than to assert that it makes us feel like God. The self-sufficiency of this feeling is clearly set against the over-sophistication of most civilized life. The reveries also, it seems, depend upon sensory stimulus. Rousseau groups all these next to water, which has certain properties of sound and look, as well as touch (if only through cooling the air near it). Rousseau also relishes the movement of the boat – another kind of touch – and he has already described the characteristic general sounds of the lake. After stating that not everyone is capable of feeling these 'compensations',[29] Rousseau specifies what is needed in the external situation to best induce such reveries: 'We need neither absolute stillness nor too much agitation, but a uniform and moderate movement without jolts or interruptions ... If the movement is unrhythmic or too strong it wakes us up, recalling us to the objects around ... An absolute silence brings us sadness. It offers an image of death.'[30] Such a conducive environment might be thought to be offered by a garden, and Rousseau himself evidently found that the landscape garden at Ermenonville supplied the right external

circumstances. Apart from anything else, a situation in which the subject feels safe and comfortable is essential ('it is necessary that the heart be at peace ...') and this, combined with gentle natural simuli, is what a garden provides better than any other place.[31]

If they do amount to musings on the place of the subject in the world ('what am I?'), these reveries also seem to depend, at their best, on being in a situation in which the natural world can, as it were, make its presence felt. To that extent they can be taken to be one part of a dialogue; the subject receives natural stimuli, and in turn produces certain thoughts. The dialogue model perhaps falls down to the extent that the two parties can be deemed not to be speaking to each other, or to be occupied with different subject matters. Yet in an underlying sense there is surely an urgency or a pertinence to the idea of exchange. The subject, by stimuli to the senses, feels himself or herself to be in the world, without having to involve himself or herself with specific external circumstances, and this in turn intensifies the address in the question, 'what am I?' While the natural world can offer promptings to the feelings (and this is perfectly consistent with commonly held eighteenth-century assumptions about the relationship between feelings and sensory stimulus), a reverie will rarely take nature as its subject matter.

Another important function of reverie in Rousseau's thinking is that reverie helps to curb self-love (*amour-propre*) while promoting love of self (*amour de soi*). Self-love is a sort of narcissism that is agitated by social life and stirs the subject to all the human vices. Love of self, by contrast, is a simple urge to self-preservation which, when developed rationally, leads to 'various human virtues'. Since self-love is stimulated by society it can be curbed by shunning social life and 'devoting ourselves to a sweet and unambitious laziness'.[32] Thus, in *Lettres morales* (1757–58) Rousseau exhorts his young female correspondent to 'learn to be alone without boredom. You will never hear the voice of nature, you will never know yourself, without that ability ... Solitude is always sad in a town ... [but in the country] things are smiling and agreeable, they stimulate recuperation or reverie.'[33] The quotation continues by paying tribute to the sensory stimulus of rural places:

The woods, the streams, the greenery remove from our heart the gaze of men; the birds ... offer us in solitude the example of freedom; one hears their song; one smells the odour of the meadows and woods; the eyes, uniquely struck by the sweet images of nature, best bring her close to our heart.

While in the *Reveries of the Solitary Walker* as well as elsewhere in Rousseau's writings we can find discussions of the importance of reverie in general, his novel *Julie: ou la nouvelle Heloise* dramatizes applied examples, as it were, of the moral importance of reverie. To put it another way, Rousseau became able to write purely and directly of reverie after exploring the action of reverie and its moral benefits in the earlier novel. In particular, two of St Preux's

crucial reveries in *Julie* testify to its moral importance. The first takes place soon after St Preux meets Julie again. She has been his early love, but has married another man, Wolmar, and become a mother. St Preux, however, still loves her passionately. The reverie takes place in Julie's garden, the 'Elysium' which she has developed in an old orchard. This place is likened by St Preux to the Pacific islands of Tinian and Juan Fernandez, and we are repeatedly told how it looks like the product of nature's forces and processes rather than those of art. (Julie's art has achieved the effacement of the traces of her own interventions.) On his second visit to the place, St Preux enters the Elysium alone, promising himself a ravishing reverie about Julie thought of as a lover. However, he immediately remembers her husband's rebuke to him from the previous day (doubtless triggered by the association of place): 'learn to respect the places where you are; they have been planted by the hands of virtue'.[34] St Preux finds, instead of his expected reverie, that he experiences a dreaming contemplation of Julie not in her aspect as lover, but as virtue personified. The two hours that are passed in this delicious reverie constitute 'two hours that I value more than any other time of my life', and St Preux also finds that 'there is in the meditation of honest thoughts a sort of well-being that the wicked have never known'. We are left to conclude that the process of reverie, even if it involves little self-scrutiny, and is concerned with contemplation of an absent person or object, at least allows more virtuous or moral responses to develop in the soul than might have been possible without it.

The second example is even clearer about the moral utility of reverie. A few days later, St Preux's conceptions of virtue are put to a severe test when he and Julie are rowed in a boat on Lake Geneva. After St Preux has directed expressions of hopeless love at Julie during a landing, they return to the boat unable to speak to each other. St Preux hands Julie aboard but sits down without relinquishing her hand. Three servants row: 'the regular noise of the oars caused me to day-dream', he reports. Despite the serene sky and bright moonlight, he falls into a deep melancholy that is only exacerbated by memories of his past happiness. 'To find myself next to her; to see her; to touch her; to speak to her; to love her; to adore her, and, while almost possessing her, to feel her lost for ever from me; that is what threw me into a transport of rage and fury that by degrees agitated me to despair.'[35] Such is St Preux's misery that he conceives the idea of pushing Julie overboard and throwing himself into the water with her so that he can die in her dying arms. We are relieved when instead of offering this shocking violence he lets go of her hand and moves to the prow of the boat. There a 'softer feeling insinuated itself in my soul, tenderness mounting over despair' and he cries wholeheartedly into his handkerchief. Returning, relieved, he finds that she too has been crying, and exclaims, ' "Ah, I see that our hearts have never stopped understanding each other!" "It is true," she said in an altered voice; "but let this be the last time that they speak in this tone." ' When they eventually disembark safely,

although exhausted by their emotions, St Preux concludes that both he and Julie have scored great victories for liberty and virtue after, in her case, 'the greatest struggle that a human soul has been able to bear'.[36]

Reverie is therefore a process of self-communion by which the human self is brought back into greater harmony with the natural world and through it with the Creator's intentions and purposes. It is thus important, for the success of the process, that the subject be in the natural, as opposed to the social world (and so one thing Rousseau acknowledges by his dedication of the Altar of Reverie at Ermenonville is that the landscape garden is natural enough to be conducive to reverie). The very clear lesson of St Preux's reveries is that, as a result of this process of realignment with the harmony of the Creator's greater work, the subject can develop decisions about his or her beliefs and moral conduct. As exemplified by its role in St Preux's striving to be a better person, reverie directly assists and promotes virtue. Reverie brings us to a harmony or accord with natural order. On the threshold of Romanticism and the age of Revolution, extreme subjectivity by human beings is shown to be part of God's intentions, and idling time away in a landscape garden, attending to sensory stimuli in a place of safety and hospitality, can become one of the foundations of a virtuous and revolutionary life!

Queen of the faculties

Wordsworth admired and indeed revered Rousseau enough to make a pedestrian pilgrimage in the summer of 1790 through revolutionary France and into Switzerland to Lake Bienne, the site of Rousseau's 'Fifth Walk' in the *Reveries*, and with Lake Neuchâtel not far away, one of Rousseau's 'visionary haunts'.[37] He and his companion even rowed out on the lake to the isle of St Pierre. This was the last object on the walking tour, Wordsworth's ultimate goal. No doubt the impact on the 20-year-old student was profound, given the natural beauty of the setting, its similarity, up to a point, with his native Lakeland, and his reverence for the author whose monument it had become. Among other lessons, Lake Bienne no doubt dramatized that it is possible to produce important ideas and literary works well away from the self-important metropolitan centres; and that a place of great natural beauty can also be a cultural monument.

The poet of 'Resolution and Independence' sets off hopefully for his walk. He is highly aware of the stimulus of his natural surroundings; the fresh invigorated appearance of the world after the nocturnal storm; the song of the skylark; the hare chasing around, and even the spray that it scatters in its antics (this is close observation, given that the hare would not have allowed the poet to approach very closely – a rural equivalent, perhaps, of the hypervigilance of Baudelaire's poet noting the glint in his spectre's eyes).

His mind is open to all this, but not particularly preoccupied with anything else (Rousseau has explained that to have a reverie you can be thinking of something, or nothing in particular, but you must not be trying to direct your thoughts around a particular problem.) When the poet's reverie begins it concerns the perils involved in his own choice of poet as his occupation. His mood plunges, but the unexpected encounter that he has is assimilated to his experience of reverie; the leech-gatherer seems to be a contribution to the same theme. He becomes a figure sent to admonish the poet for the spiritual weakness of his doubts and fears. In a parallel way works the sudden and unexpected encounter suffered by Rousseau in his 'Second Walk'. A large dog, a Great Dane, running alongside its aristocratic master's coach and appearing suddenly over the crown of a hill, knocks Rousseau down and causes quite severe head injuries.[38] For a famously paranoid man, Rousseau is very forgiving of both dog and owner, and the feelings he has when regaining consciousness after the accident become an integral part of his reverie:

> The night was coming on. I perceived the sky, some stars, and a bit of grass. This first sensation was a delicious moment. I felt myself to be nowhere but there. I was born at that instant into life ... I remembered nothing, I had no distinct notion of my individuality ...[39]

He had been lamenting his troubles and resenting the way people had treated him, but the beautiful experience of feeling alive drives all that away and allows him to accept what God requires: 'God is just; he wants me to suffer; and he knows that I am innocent ... let us learn to suffer without complaining.'[40] The untoward incident thus becomes integrated into the reverie.

For the poet of Wordsworth's 'Resolution and Independence' the reverie works, as it were, as an affirmation of life, solitude and the choice of poetry as an occupation. The same can hardly be said, at least at first sight, for the poet of Baudelaire's 'Les Sept vieillards'. To assert, as I have done, that this poem uses Wordsworth's is also to assert a connection between 'Les Sept vieillards' and Rousseau's reveries. Baudelaire's poetic narrator must answer Rousseau's question, 'what am I?', by saying, 'a paranoid neurotic hallucinating sensibility oppressed by the very city in which he lives'. Unlike Wordsworth's, Baudelaire's poetry of course avoids long autobiographical self-revelations. However, working by means of short lyrics the poet reveals the characteristics of a tormented sensibility that presides over the assemblage and architecture of the poems as well as the individual experiences that they conjure up. In doing this Baudelaire transforms whatever biographical experience he may have had into an array of imagined poetic moments representative of a generalizable urban experience.[41] Under the terms of modernity, the self's sense of kinship with others can best arise not from enunciation of overall rules of conduct or principles of life, but from contemplation of specific moments or phenomena.

To do this, the poet's imagination must work on whatever raw material can be made to represent something larger than itself. The question of imagination thus becomes crucial. I have already emphasized the connections with De Quincy and Wordsworth, but in 1859 Baudelaire was steeped in British examples that were not confined to poetry and prose. His review of the Salon of that year was deeply dissatisfied with most of the French art on display, and lamented the lack of a large British contingent of artists. There had been a promise, he writes, of foreign guests who never appeared, and in response to his disappointment he wrote a paragraph of regrets of a kind 'rarely expressed'. He had been looking forward to seeing works of 'charming artists too long little-known', renewing acquaintance with:

Leslie, that rich, naïve and noble humourist, sharpest expression of the British spirit; the two Hunts [Holman and William Henry], the one a stubborn naturalist and the other an ardent and wilfull creator of Pre-Raphaelism; with Maclise, audacious in composition, as impetuous as sure of himself; with Millais, this meticulous poet; with J. Chalon, this Claude mixed with Watteau, historian of beautiful afternoon outings in grand Italian parks; with Grant, the natural heir of Reynolds; with Hook, who knows how to flood his *Venetian dreams* with magic light; with that strange [Noel] Paton, who takes the spirit back to Fuseli and embroiders a gracious Pantheistic chaos with all the patience of an earlier age; with Cattermole, water-colour *history painter*, and with that other whose name I forget, an architect-dreamer who on paper builds towns with bridges whose supports are elephants, and lets pass between their many colossal legs, all sails set, gigantic three-masted barques![42]

The remainder of the paragraph sets out why Baudelaire likes this collection of foreign artists:

A space had even been prepared for these friends of the imagination and local colour, for these favourites of the muse of the bizarre; but alas! ... my hope was deluded. So tragic ardours, gesticulations like [the actors] Keane and Macready, cosy intimacies of home, oriental splendours reflected in the poetic mirror of the English spirit, Scottish greenery, enchanting freshnesses, fugitive depths of water-colours that seem the size of panels while remaining small, we shall not contemplate you, this time at least. Enthusiastic representatives of imagination and the most valuable faculties of the soul, were you so badly received the first time, and do you deem us unworthy of comprehending you?

Clearly, in this year at least, the British are on the side of imagination, and it is a lack of this faculty that plagues the Salon of 1859. A later section of this same essay, entitled 'Queen of the Faculties', is dedicated to extolling imagination, and Baudelaire decides that imagination creates the world and also governs it. The following section, 'The Government of Imagination' begins with some thoughts about the difference between imagination and fancy that derive ultimately from Coleridge's famous statements on the subject.[43] For Coleridge the fancy is very much a secondary faculty, much given to sorting through personifications, allegories and other systems of symbols that have already

been created, while the imagination synthesizes, integrates and makes new wholes in powerful creative acts. 'It dissolves, diffuses, dissipates, in order to re-create; or when this process is rendered impossible, yet still ... it struggles to idealize and to unify. It is essentially *vital*, even as all objects (as objects) are essentially fixed and dead.'[44] Baudelaire himself quoted an English language source:

By imagination, I do not simply mean to convey the common notion
implied by that much abused word, which is only *fancy*, but the *constructive*
imagination, which is a much higher function, and which, in as much as
man is made in the likeness of God, bears a distant relation to that sublime
power by which the Creator projects, creates, and upholds his universe.[45]

As Coleridge had put it, 'The primary imagination I hold to be the living power and prime agent of all human perception, and as a repetition in the finite mind of the eternal act of creation in the infinite I AM.'[46] Thus in 'Les Sept vieillards' we can watch Baudelaire making use of De Quincy, Wordsworth and Daumier,[47] but out of their work forging a new poem into which he poured his own imagination of the city so forcefully as to make it into one of the stronger visions of urban conditions, and in its turn a powerful tool for Eliot to use. In his essay Baudelaire goes on to quote the painter Eugène Delacroix that 'Nature is merely a dictionary',[48] the point being that a dictionary is not in itself a poetic composition, and poems and novels do not emerge until the contents of the dictionary have been taken over and given a completely different arrangement by the novelist or poet. Baudelaire states that landscape painters are particularly in danger of merely copying the 'dictionary' and producing 'the vice of banality'. He was not, perhaps, writing during the most inspiring period of French painting.

Baudelaire then proceeds to tell us what is wrong with contemporary landscape art, as he searches through it for works that match or surpass our perceptions of life and art. In doing so he crucially takes us back to reverie. At the beginning of his section about landscape he asserts that all hinges on the sensibility of the beholder. 'If an arrangement of trees, mountains, water and houses, that we call a landscape, is beautiful, it is not so on its own, but by me, by my own grace, by the idea or the feeling that I attach to it.'[49] Thus the poet's creative power is transferred to the critic, as indeed why should they not be, since they are the same subjectivity? Baudelaire's preliminary conclusion from this is that 'any landscape artist who does not know how to convey a feeling by means of an arrangement of mineral or vegetable matter is not an artist'.[50] A few pages later he laments that, 'Yes, imagination flees landscape. I understand that a spirit applied to making notes cannot abandon itself to the prodigious reveries contained in the spectacles that nature presents; but why should imagination flee the studio of the landscape artist?'[51]

This question leads him to dwell on the gap between a sketch and a finished painting, and refer to an exhibition of hundreds of pastel sketches of sea and sky by Eugène Boudin, simply the raw material for future finished works, and yet very appealing to Baudelaire: 'all these splendours,' he writes, 'mounted into my head like a strong drink or the eloquence of opium'.[52] However, he understands that it is not simply marine painters who are letting us down, but also 'a genre that I would willingly call the landscape of great towns, that is to say the collection of grandeurs and beauties which result from a powerful agglomeration of people and monuments, the deep and complicated charm of an aged capital grown old in glories and tribulations.'[53] Baudelaire could not paint the missing pictures, but he was a poet, and we are conceptually and temporally on the threshold of *Tableaux Parisiens*. The first poem in that sequence is entitled 'Landscape'. It celebrates the view from the poet's garret, of 'Chimneys, bell-towers, these masts of the city / And the great skies that make you dream of eternity'. More emphatically than this it celebrates the poet's imagination, which will plunge him into the 'sensory delight / Of evoking the Spring by sheer will-power / Of pulling a sun out of my heart, and of making / A warm season from my burning thoughts'.[54]

Meanwhile, finished landscape paintings continue to be disappointing. By the end of his essay on landscape, in a moment of nostalgia for an earlier phenomenon of urbanism, Baudelaire wants to be

… taken back to the dioramas whose brutal and enormous magic knows how to impose on me a useful illusion. I prefer to contemplate the stage-sets of a theatre, where I find artistically expressed and tragically concentrated my dearest dreams. These things, because they are fictions, are infinitely closer to the truth; while most of our landscape artists are liars, simply because they have neglected to lie.[55]

Notes

1. Walter Pater, 'Wordsworth' (1874) in *Appreciations, with an Essay on Style* (London: Macmillan, 1924), p. 41.

2. Information on Ermenonville comes from sources cited hereafter and from Denis Lambin, 'Ermenonville Today', *Journal of Garden History* 8, 1 (1988), pp. 42–59.

3. Jean de Cayeux, *Hubert Robert et les jardins* (Paris: Editions Herscher, 1987), states that precedence in the issue of the first introduction of the landscape garden to France from England is debated between several gardens of the 1760s, including Ermenonville (pp. 93, 146, 2nd col., n. 4), although one would also have to remember Baron de Montesquieu's transformation of the surroundings of the château of La Brède in 1731.

4. R. Mathieu, *Ermenonville* (Paris: Nouvelles Editions Latines, 1996), p. 23. Like several aristocratic families deriving their genealogy from outside France (in Girardin's case from Italy), the Marquis was a liberal and a reformer. During the 1780s he supported the king when Louis XVI attempted to persuade the aristocracy and the clergy to pay taxes to repair the nation's economy, which had been ruined by financing the American Revolution. The aristocracy and clergy's refusal to cooperate meant that revolution in France became inevitable. Like other reformers, Girardin was an anglophile, preferring English economics, where the necessities of life were still cheap, while luxuries were taxed, to the French system, which made necessities expensive too. His book *De la Composition des paysages* (1777) praised the economic and social consequences of English

farming and of the existence of village greens. See René-Louis de Girardin, *De la Composition des paysages* (1777), printed with Anonymous, *Promenade des jardins d'Ermenonville* (2nd edn, 1811), ed. with 'Postface' by Michel Conan (Paris: Editions de Champ Urbain, 1979). Girardin's book was translated into English by Daniel Malthus as *An Essay on Landscape* (1783).

5. Anonymous, *Promenade*, pp. 154–5.

6. Apart from the Temple of Philosophy, another area of the garden that was designed before Rousseau's arrival was the Monument of Former Loves at the edge of The Desert, and its Philosopher's Hut. Cf. Anonymous, *Promenade*, pp. 160–163 and discussion by Conan, 'Postface', pp. 190–192.

7. T.S. Eliot, 'The Waste Land' (1922), ll. 60–61.

8. In the original French:

(A Victor Hugo)

Fourmillante cité, cité pleine de rêves
Où le spectre, en plein jour, raccroche le passant!
Les mystères partout coulent comme des sèves
Dans les canaux étroits du colosse puissant.

Un matin, cependant que dans la triste rue
Les maisons, dont la brûme allongeait la hauteur,
Simulaient les deux quais d'une rivière accrue,
Et que, décor semblable à l'âme de l'acteur,

Un brouillard sale et jaune inondait tout l'espace,
Je suivais, roidissant mes nerfs comme un héros
Et discutant avec mon âme déjà lasse,
Le faubourg secoué par les lourds tombereaux.

Tout à coup, un vieillard dont les guenilles jaunes
Imitaient la couleur de ce ciel pluvieux,
Et dont l'aspect aurait fait pleuvoir les aumônes,
Sans la méchanceté qui luisait dans ses yeux,

M'apparut. On eût dit sa prunelle trempée
Dans le fiel; son regard aiguisait les frimas,
Et sa barbe à long poils, roide comme un épée,
Se projetait, pareille à celle de Judas.

Il n'était pas voûté, mais cassé, son êchine
Faisant avec sa jambe un parfait angle droit,
Si bien que son bâton, parachevant sa mine,
Lui donnait la tournure et le pas maladroit

D'un quadrupède infirme ou d'un juif à trois pattes.
Dans la neige et la boue il allait s'empêtrant,
Comme s'il écrasait des morts sous ses savates,
Hostile à l'univers plutôt qu'indifférent.

Son pareil le suivait: barbe, oeil, dos, bâton, loques,
Nul trait ne distinguait, du même enfer venu,
Ce jumeau centenaire, et ces spectres baroques
Marchaient du même pas vers un bout inconnu.

A quel complot infâme étais-je donc en butte,
Ou quel méchant hasard ainsi m'humiliait?
Car je comptai sept fois, de minute en minute,
Ce sinistre vieillard qui se multipliait!

Que celui-là qui rit de mon inquiétude,
Et qui n'est pas saisi d'un frisson fraternel,
Songe bien que malgré tant de décrépitude
Ces sept monstres hideux avaient l'air éternel!

Aurais-je, sans mourir, contemplé le huitième,
Sosie inexorable, ironique et fatal,
Dégoûtant Phénix, fils et père de lui-même?
– Mais je tournai le dos au cortège infernal,

Exaspéré comme un ivrogne qui voit double,
Je rentrai, je fermai ma porte, épouvanté,
Malade et morfondu, l'esprit fiévreux et trouble,
Blessé par le mystère et par l'absurdité!

Vainement ma raison voulait prendre la barre;
La tempête en jouant déroutait ses efforts,
Et mon âme dansait, dansait, vieille gabarre
Sans mâts, sur une mer monstrueuse et sans bords!

9. De Quincy, *Confessions of an English Opium-Eater* (1821), ed. Malcolm Elwin (London: Macdonald & Co., 1956), pp. 343–433, quotation p. 399.

10. De Quincy, *Confessions*, pp. 424–5.

11. *Ibid.*, pp. 432–3.

12. Baudelaire's poem was first published in September 1859; he was still working on the translation of De Quincy in December of that year when the English writer's death was announced in the Paris newspapers.

13. De Quincy, *Confessions*, p. 406.

14. *Ibid.*, p. 408.

15. Charles Baudelaire, 'Un Mangeur d'opium' (1860), in *Artificial Paradise*, trans. Ellen Fox (New York: Herder and Herder, 1971), p. 122. This sentence is quoted in relation to 'Les Sept vieillards' by Richard Burton, *Baudelaire in 1859: A Study in the Sources of Poetic Creativity* (Cambridge: Cambridge University Press, 1988), p. 118. There is also a reading of 'Les Sept vieillards' in William C. Sharpe, *Unreal Cities: Urban Figuration in Wordsworth, Baudelaire, Whitman, Eliot, and Williams* (Baltimore: Johns Hopkins University Press, 1990), pp. 43–8.

16. For some of the significance of Ratapoil, see T.J. Clark, *The Absolute Bourgeois: Artists and Politics in France 1848–1851* (1973: Princeton: Princeton University Press edn, 1982).

17. See Karl Marx, *The 18th Brumaire of Louis Bonaparte* (1852), in K. Marx and F. Engels, *Selected Works* (New York: International Publishers, 1968).

18. This would put Wordsworth in line with one of the main thrusts of twentieth-century psychoanalytic thought, deriving ultimately from Freud, which sees humans as fundamentally split subjects, prone to oscillate across a chasm of desire between pursuit of bliss, on one hand, and a relative prostration before a sense of one's split self, induced by the very intensity of the stimuli experienced or pursued.

19. Mathieu, *Ermenonville*, p. 23. This is, of course, a founding 'myth' of the Altar.

20. For the question of virtue, vice and idleness depicted in art in the eighteenth and nineteenth centuries, see Michael Charlesworth, 'Movement, Intersubjectivity, and Mercantile Morality at Stourhead', in Michel Conan (ed.), *Landscape Design and the Experience of Motion* (Washington DC: Dumbarton Oaks, 2003), pp. 263–85.

21. *Encyclopédie*, vol. 14, 1765 (facsimile reprint, Stuttgart-Bad Cannstadt: Friedrich Fromann Verlag (Günther Holzboog) 1967), entry for '*Rêver*' ('to dream').

22. This question occurs on the first page of the 'First Walk'. Cf. Jean-Jacques Rousseau, *Les Rêveries du promeneur solitaire* (1782), ed. Jacques Voisine (Paris: Flammarion, 1964), p. 35. It is singled out as the work's prime question by Charles Butterworth in the 'Interpretative Essay' to his translation, *The Reveries of the Solitary Walker* (New York: New York University Press, 1979), p. 151.

23. Rousseau, *Les Rêveries*, p. 97.

24. *Ibid.*, p. 95.

25. *Ibid.*, p. 99.

26. *Ibid.*, p. 100.

27. *Ibid.*, p. 101.

28. *Ibid.*, p. 102.

29. *Dédommagements* – a word with restorative or even healing connotations, in this context. *Ibid.*, p. 103.

30. *Ibid.*, p. 103.

31. *Ibid.*, p. 103.

32. Quotations from Butterworth, 'Interpretative Essay', p. 218. The classic discussion of these two concepts is in *Emile*. Cf. Rousseau, *Oeuvres complètes* (Paris: Gallimard, 1959), vol. IV, pp. 490–494.

33. Rousseau, *Rousseau's Religious Writings*, ed. and trans. Ronald Grimsley (Oxford: Clarendon Press, 1970), pp. 61–2.

34. Rousseau, *Julie: ou la nouvelle Heloise*, in *Oeuvres complètes*, vol. III, p. 242.

35. *Ibid.*, pp. 287, 289.

36. *Ibid.*, pp. 289–90.

37. Kenneth R. Johnston, *The Hidden Wordsworth: Poet, Lover, Rebel, Spy* (New York: W.W. Norton, 1998), pp. 230–231.

38. Leo Damrosch indicates that they probably contributed to Rousseau's death a few months later: see his *Jean-Jacques Rousseau: Restless Genius* (New York: Houghton Mifflin, 2005), pp. 485–9.

39. Rousseau, *Les Rêveries*, pp. 48–9.

40. *Ibid.*, p. 54.

41. Brett Bowles, 'Les Sept vieillards: Baudelaire's Purloined Letter', *French Forum* 23, 1 (1998), pp. 47–61, emphasizes the gap between poem and biography. We cannot assume that any reference to an 'I' represents Baudelaire's sovereign subjectivity; rather, as in any poem, it represents a subject position, a dramatized 'poet' introduced to get the ball rolling, a 'figure'.

42. Baudelaire, *Salon de 1859*, I: 'L'Artiste moderne', in *Oeuvres complètes* (Paris: Bibliothèque de la Pléiade, 1968), p. 1026.

43. The derivation from Coleridge is not signalled by Baudelaire himself, but clarified comprehensively by Winfried Kreutzer, *Die Imagination bei Baudelaire* (Würzburg: Inaugural-Dissertation der Julius-Maximilians-Universität, 1970), pp. 47–52, drawing on Richard Beilharz, 'Fantaisie et imagination chez Baudelaire, Catherine Crowe et leurs prédécesseurs allemands', in 'Baudelaire: Actes du colloque de Nice (25–27 Mai 1967)', *Annales de la Faculté des Lettres et Sciences Humaines de Nice* 4, 5 (1968), pp. 33–5.

44. Samuel Taylor Coleridge, *Biographia Literaria* (1817), extracted in R. Wilson, *A Coleridge Selection* (London: Macmillan, 1963), p. 113.

45. Baudelaire, *Salon de 1859*, IV. 'Le Gouvernement de l'imagination', in *Oeuvres complètes*, p. 1040.

46. Wilson, *A Coleridge Selection*, p. 113.

47. And possibly Shakespeare's *Macbeth*, as suggested by Y.-G. Le Dantec in his edition of Baudelaire's *Oeuvres complètes* (Paris: Bibliothèque de la Pléiade, 1954), pp. 1404–5, and further argued by Richard D.E. Burton, 'Baudelaire and Shakespeare: Literary Reference and Meaning in "Les Sept vieillards" and "Beatrice" ', *Comparative Literature Studies* 26, 1 (1989), pp. 1–27.

48. Baudelaire, *Salon de 1859*, in *Oeuvres complètes*, p. 1040.

49. *Ibid.*, p. 1076.

50. *Ibid.*, p. 1076.

51. *Ibid.*, p. 1081.

52. *Ibid.*, p. 1082.

53. *Ibid.*, pp. 1082–3. He cites the engraver Charles Meryon as an artist who had successfully tackled this genre.

54. Baudelaire published the first version of 'Landscape' in 1857, which shows that his mind had revolved the issues of landscape, imagination and the city since that time at least. The 1857 version did not have the four last lines quoted above, however, which were presumably written in 1859 or 1860 in preparation for the second edition of *Les Fleurs du mal*, 1861 (*Oeuvres complètes*, 1968 edn, p. 1536).

55. *Ibid.*, p. 1085. Both of the Parisian Dioramas had burned down by the time Baudelaire wrote this. For a vivid idea of the way in which the Diorama's 'brutal magic' could stimulate the poetic imagination in France, readers should consult Gerard de Nerval's account of the re-opening of the Diorama in 1844 in his *Selected Writings*, reprinted (for example), translated and edited by Richard Sieburth (London: Penguin, 1999), pp. 187–90.

Cythera and the loss of Venus in France

Having examined some of the preoccupations involving landscape in nineteenth-century Britain, having discussed the central questions of reverie and imagination, and having begun to grasp the question of modernity, and how modernism differs from Romanticism, by comparing Baudelaire's poetry with historical precedents involving cross-Channel exchange of poetic insights, we are now in a position to study a theme in landscape that is more purely French. This is not to say that the theme cannot be traced in other European cultures of the period such as those of German-speaking states or Britain. However, when considered properly the theme proves capable of illuminating large areas of French culture in the 1850s and 1860s – that is, under the Second Empire (of Napoleon III, 1851–1870).

The theme is that of the loss of Venus, the classical goddess of love, which does not seem like a theme in landscape at all until we consider, as indeed is necessary and inevitable, the birthplace of Venus. As much as on the figure of Venus herself, powerful movements in French culture impinge upon Cythera, the island where, in classical myth, Venus emerged from the sea after she had been engendered when the semen of Ouranos fell into the sea nearby. To flesh out the significance of the myth most heartily, therefore, we could say that Cythera's importance in the Western imagination was as the place where love – specifically sexual love – first existed. Sandro Botticelli produced a memorable painting of this theme in his *Birth of Venus* of c.1484. Thereafter Cythera remained a theme in art, although never a particularly prominent one, with one marked exception.

The vision involved in this chapter is poetic vision. How do the poets see and imagine Cythera? To put it another way, how do the artists, including literary artists, represent the birthplace of Venus? Addressing this question will allow us to explore in particular the divisions between modernist and academic sensibilities in French art, and modernist and

Romantic sensibilities in French literature of the period. These divisions undoubtedly had effects beyond French culture.

An important place to start from is this poem from 1852 (published in 1855) by Baudelaire:

'A Voyage to Cythera'

My heart leaped up joyful as a bird
Skimming freely around the rigging;
The ship was rolling under a cloudless sky
Like an angel drunk on the incandescence of the sun.

What is that island sad and dark? – 'That's Cythera,'
One told us, 'a place famous in the songs,
Banal Eldorado of all the old boys
And after all that, look: it's a wretched place.'

– Island of sweet secrets and festive hearts!
The proud phantom of the classical Venus
Glides over your waters like a fragrance
And inspires souls with love and idleness

Beautiful isle of green myrtles, full of open flowers
Venerated forever by all peoples
Where the sighs of adoring hearts
Flow like incense over a rose-garden

Or the eternal cooing of doves!
– Cythera is nothing but a most barren land;
A stony desert troubled by sharp cries.
But I glimpsed a strange thing!

It wasn't a temple in a shady grove,
Where the young priestess who loves flowers
Was strolling, her body burnt with secret heats,
Her gown opening to the passing breeze;

But as we shaved the coast close enough
To scare the seabirds with our white sails
We saw it was a three-branched gibbet,
Black against the sky like a cypress tree.

Ferocious birds perching on their prey
Were destroying in their rage a hanged man;
Each planting like a pick its filthy beak
In all the bloody crevices of that ripe rottenness;

The eyes were two pits, and from the sunk belly
Heavy guts slopped over his thighs
And the gluttons, guzzling on these hideous delights
Had with their stabbing beaks castrated him.

Beneath the feet, an envious four-footed troop,
Muzzles lifted, fidgeted round and round;
The biggest beast in the middle flared up
Like an executioner amidst his henchmen.

Inhabitant of Cythera, child of so beautiful a heaven,
Silently you were suffering these degradations
To expiate your sordid rites
And the sins too infamous for burial.

Ridiculous villain, your sufferings are mine!
At the sight of your waving limbs
I felt mounting against my teeth like puke
The long flow of bitterness from old sufferings;

Before you, poor devil of such dear memory,
I have felt all the beaks and all the jaws
Of the piercing birds and the black panthers
Who formerly liked so much to flay my flesh.

– The sky was smiling, the sea was smooth;
For me everything was bloody and black from now on,
Alas! and I had, as in a thick shroud,
My heart buried in this allegory.

On your island, Venus! I found nothing upright
But a symbolic gibbet where my image hung ...
Ah! Lord! give me the strength and the courage
To behold my heart and body without disgust!

The atmosphere is stark. The intention, successfully carried out, has been to
shock. Perhaps to revolt. Yet, beyond this initial effect, what sort of vision
of Cythera is this? How is Baudelaire managing the cultural precedents and
what sort of statements is he making – to put it very crudely – about modern
conditions? And what, if anything, has this poem to do with the paintings
of the early 1860s, *Olympia* and *Déjeuner sur l'herbe*, by Baudelaire's friend
Edouard Manet?

The poem works by reference to a very strong idea of Cythera coming down
to the mid-nineteenth century from the past and associated in particular with
an artist not mentioned by name in the poem. This precedent is introduced by
the terse phrase, 'Banal Eldorado of all the old boys' and is then characterized
by the second and third stanza and the first line of the fourth. These lines allude
to the idea of Cythera given most memorable form by two of Antoine Watteau's
paintings from 1717 and 1719, both entitled *Embarkation from Cythera*.[1] The
paintings show the same theme in a strongly similar way, although they are
far from being identical in colour and details. We can assume that the version
in the Louvre in Paris was the one known to nineteenth-century French poets
(Plate 10).

Watteau's painting, dating from the middle of the *ancien régime* in France, amounts to an attempt to paint the subtleties of love itself, when every posture and movement of the beloved takes on transcendent significance. He paints the delicate nape of the beloved's neck (she has her hair up), and the lover's careful glances. Venus is present only in effigy as a landscape monument, a statue, for everyone is in modern dress and by 1717 Venus was obviously no longer the centre of a functioning cult; however, transformed into a generalized cultural figure, she still personified the spirit of sexual love. Although satisfyingly subtle, Watteau's Cythera is rather bloodless: it is a mild island of love, rarely becoming the scene, the viewer suspects, of passionate outbursts. The painting seems informed by a gentle sense of regret; a quiet elegiac feeling; the lovers are leaving the island. The embarkation takes them away from this green bower where they have spent some pleasant hours and had a nice picnic. Our sojourn in happiness is a temporary one in this human life, the allegory suggests. We cannot live on Venus's island; we are only permitted to visit it. The island itself is a garden, for Venus was goddess of gardens too. There is clearly an echo of this allegory in the Isle of Happiness made in his landscape garden, Le Désert de Retz, by François Racine de Monville between 1774 and 1789: on the little island stands a 'Turkish Tent'; that is, a temporary dwelling; not only is happiness difficult to reach (we cannot simply stroll right up to it) but we cannot stay there permanently.[2]

All this on one level. On another, Watteau emerges on the side of political dissent to the socio-cultural norms emanating from the absolutist monarchy of the Bourbon court. Watteau was also the inventor of the *fête galante* as a subject for painting, and his *Embarkation* is the painting with which he created this sub-genre. Numbers of poets and artists produced many variations of this genre, including Jean-Baptiste Pater (Watteau's only pupil), Nicolas Lancret, Fragonard and Paul Verlaine. The *fête galante* as a social ritual pre-existed Watteau's invention of it in painting. It was connected with social opposition among France's wealthy élite to centralized royal power in the court. Watteau's painting has therefore been linked to a cultural politics of opposition and resistance to the absolutist monarchy on the part of a land-owning class whose power had been broken by onslaughts from absolutism in the seventeenth century.[3] Unable any longer to rebel in arms against this oppression, as they had in the 1620s and again in the 1640s–1650s, the élite developed cultural modes of resistance to court demands.

Baudelaire's poem works by the starkness of the contrast it brings about to all that the painting by Watteau represents. Modern Cythera is a disaster. A corpse hangs there, mutilated by birds and beasts. There is a particular emphasis on physical suffering suggestive of the kind of public torture that still happened before the French Revolution: images of castration, disembowelling, ex-oculation. This is the island of love in modern form, in a

poem written during an epidemic of the disease that Baudelaire himself was to die of – syphilis.[4]

The physical suffering implied by the corpse is no doubt related to disease, but we must also remember to see the suffering as metaphorical too. Even if you do not catch a fatal disease, there is something wrong with modern love that makes it painful. In the world of this poem, love has become the wound, rather than the antidote.

Baudelaire did not invent this theme, and a comparison between his poem and work by the actual author of the idea is instructive in that it provides a way to distinguish what is properly modern in Baudelaire's version. It was Gérard de Nerval (1808–55), in his *Voyage en orient*, who provided Baudelaire and other French cultural figures with the theme of Cythera marred. Parts of Nerval's written account of his journey to Egypt and Constantinople appeared in the journal *L'Artiste* in 1844, and the definitive version followed in 1851. A note in Baudelaire's hand on the manuscript of his poem clarifies that the idea derived from the earlier of the two publications, and authorities believe that Baudelaire sent Nerval a copy of his poem.[5] The relevant passage in Nerval's *Voyage* reads:

'Across this sea,' said Corinna turning towards the Adriatic, 'there is Greece. Doesn't that idea fill you with emotion?' ... I was going to see her at last, shining, rise from the waters at dawn! ... [the dawn] comes; she approaches, she slides lovingly over the divine waves which gave birth to the Cytherean ... But what am I saying? Before us, yonder, on the horizon, that rosy coast, the purple hills that seem like clouds, is the real island of Venus; is ancient Cythera with rocks of porphyry: today this island is called Cérigo, and belongs to the English.

There is my dream ... and here is my awakening! The sky and the sea are still there; the sky of the Orient and the Ionian Sea exchange every morning the holy kiss of love; but the earth is dead, dead under the hand of man, and the gods have fled!

To return to prose, it must be admitted that of all her beauties Cythera has only retained the porphyry rock, as sad to see close as ordinary sandstone. Not a single tree on the coast that we were following; not a rose, alas! Not a shell the whole length of the shore where the Nereids once selected the conch for Cyprian Venus. I looked for the shepherds and shepherdesses of Watteau, their boats hung with garlands, pulling up on flowery shores; I was dreaming of mad bands of love's pilgrims in coats of shimmering satin ... all I saw was a *gentleman* shooting at snipe and pigeons, and blond Scottish soldiers dreaming, perhaps, of the fogs of their homeland ...

The rocky height that dominates the town is the site of a former temple of Venus ... Setting foot on the soil of Cérigo, I was unable to reflect without pain that this island had belonged to France in the first years of this century. Inheritor of the possessions of Venice, our country felt herself stripped in her turn by England, which here, as at Malta, announces to passers-by in Latin on a marble tablet that 'the peace of Europe and the love of these islands has assured to her, since 1814, the sovereignty over them.' Love! God of the Cythereans, is it really you who has ratified this pretension?

While we had been hugging the coast, before reaching harbour, I made out a
small monument on top of a rock, vaguely silhouetted against the blue sky,
which seemed to be the still-surviving statue of some protective goddess ...
But, approaching nearer, we clearly saw the object that drew the attention
of travellers to that shore. It was a gibbet; a three-sided gibbet; but only one
side was being used. The first real gibbet I have yet seen is on the soil of
Cythera, an English possession, and it was given to me to comprehend it![6]

We can detect an unmistakable note of excitement in the last phrase. He may
not have decided how best to develop the theme, but the narrator understands
that he has stumbled upon an enormity. Nerval hated the English; his father
was a Napoleonic medical officer and his mother had perished on one of
Napoleon's campaigns, and the allusions to changing French power in the
Mediterranean are no doubt strongly intended, while the indignation at
British pretensions is strongly felt. The gibbeting of corpses was a common
British practice connected with capital punishment, and the triangular plan
of the gibbet accords with those used in the British Isles. However, the force
of the incident lies in Nerval's identification of the gibbet as a 'monument'
and his contrast of it with the expectation of a more proper statue honouring
the former goddess, or even the remains of a temple. Where we might expect
veneration, there is desecration of the most dramatic order. Setting the gibbet
in this pair of comparisons sets up a series of possible monuments that enforces
the idea of connection along a sliding scale of commemoration: temple – statue
– gibbet. The final term must therefore be taken as a reflection on the ancient
goddess of love and the present sorry state of (irreverent) attitudes towards
her.

 While the ancient hallows of Cythera have been destroyed by time, there is
equally no trace of the more recent artistic imagining of Cythera by Watteau,
whose 'shepherds and shepherdesses, ... mad bands of love's pilgrims' are
here allowed to be a bit more lively than they are in Baudelaire's version
or indeed in Watteau's painting. In Nerval's *Voyage*, Watteau's Cythera thus
has the status of an unattainable dream of the *ancien régime*. It has a certain
different valency when Nerval refers to it again in his tales of the Valois region
of his childhood: 'Angélique', *Les Faux saulniers* and *Sylvie*.[7] The Valois that
Nerval knew best, some 30 miles north of Paris and slightly east, contained
the village of Mortefontaine, Nerval's childhood home, quite close to the other
towns and villages surrounded by the marshy valleys, rocky outcrops and
immense woods of the region: Ermenonville, Senlis and Chantilly. Nerval
identified this region as a traditional stronghold of opposition to court
and centralized control. The good Valois kings had been succeeded by the
disastrous Absolutists, the Bourbons; Henri de Montmorency who had led
the rebellions of the 1620s had owned Chantilly; his Italian wife, nick-named
'Sylvie' (wood-dweller) by the poets and artists she patronized and protected,
had brought a warm current from the culture of the Mediterranean into the

region; in Nerval's view *les Illuminés*, the illuminati, masonic 'precursors of socialism', had plotted the French Revolution in the chateau of Ermenonville.[8] And over all loomed the figure of Rousseau, who as we have seen had entered the region to die at Ermenonville.

Referring in *Les Faux saulniers* to Henri IV, the royal founder of the Bourbon dynasty and with it political absolutism, Nerval wrote: 'Rousseau ... had completely ruined the royal edifice founded by Henri. The whole thing had fallen. – His immortal image remains standing on the ruins.'[9] This is an ecstatic vision of Rousseau's power, sealing Nerval's beloved Valois as the triumphant centre of resistance to overbearing central oppression. It is a landscape vision, placed in a specific setting, figured in terms of a particular feature – the ruin in the landscape. The quotation comes from the chapter in which the wandering narrator arrives at Ermenonville to visit the chateau and the garden, making for Rousseau's tomb on the Isle of Poplars.

Nerval linked Watteau's painting to the Valois by writing:

Watteau's Voyage to Cythera was conceived in the translucent and coloured mists of this region. It is a Cythera that imitates an islet in a pool created by the flooding of the Oise and the Aisne, – those rivers that are so calm and peaceful in summer.

The lyricism of these observations shouldn't surprise you; – tired of the vain quarrels and sterile excitements of Paris, I find rest by revisiting this countryside, so green and so fertile; – I renew my strength in this maternal earth.[10]

Nerval is therefore clearly aware that Watteau's painting belongs on the side of dissent and resistance to centralized power; the side of rest and refreshment from the futility and agitation of the metropolis. This is, of course, a Rousseauan conviction.

Rousseau, Watteau and Cythera return in *Sylvie*, considered by most authorities to be the finest short story in French. References to Rousseau recur throughout the story, which can also be argued to have a Rousseauan theme, in which the actress Aurélie is set against the country girl Sylvie, the rural Valois against the city, and in which the narrator moves from rural childhood to urban maturity; or to put it another way, from a rural simplicity that he takes for granted and can hardly seem to value, to the meretricious sophistications of the metropolis that in the end he chooses. The story is about loss: Sylvie becomes more desirable as she slips through the narrator's fingers to become increasingly unattainable. However, as Alison Fairlie points out, the story is also, in the last chapter, about coming to terms with loss to achieve a measure of acceptance and peace of mind.[11] 'Every word,' she writes of the ending, 'contributes not to a sense of failure but to the joy and renewal of a fresh country morning.'[12] She also emphasizes that *Sylvie* is a landscape story: 'all [the story's allusions] are intimately and relevantly evoked by a fresh and real countryside.'[13] Umberto Eco has written a delightful essay

attempting to clarify the way that time works in *Sylvie*.[14] A similar essay waits to be written disentangling the geography of the story – elucidating the importance of place and the way Nerval uses it. The topography of *Sylvie* is like landscape perceived in a dream or through very distant memories. It is therefore a symbolic geography with which the reader has to deal, but one which intersects at crucial moments with features of the real countryside. And as Marcel Proust wrote, the magic of *Sylvie* 'is not in the words, it is not said, it is all among the words, like the morning mist at Chantilly'.[15]

One of these moments of intersection of the real and the symbolic occurs in Chapter IV of *Sylvie*, entitled 'A Voyage to Cythera'. The chapter begins by describing a village pageant for children staged in the village of Loisy, but a Loisy Nerval has put together from references to several villages of the area, particularly Ermenonville. Winners of various competitions in the fête were taken to a picnic

… on an island shaded by poplars and lime trees in the middle of one of those shallow lakes fed by the Nonette and the Thève. Boats decked with bunting took us to the island on which was an oval temple ... There, as at Ermenonville, the countryside was scattered with those light buildings from the end of the eighteenth century, where millionaire philosophers had inspired each other to their displays of taste dominant at the time ... The crossing of the lake had been conceived perhaps to recall the *Voyage to Cythera* of Watteau ...[16]

The shadow of the future looms over the occasion, however: Sylvie sulks because, as she complains of the narrator, 'It's me he has forgotten. We're village folk, and Paris is so lofty!' Watteau's Cythera is being slowly identified with the sort of enlightenment philosophical aspiration taken to its most dramatic point by Girardin's harbouring of Rousseau at Ermenonville. The story conjures up a world bathed in sadness for the loss of the urgency of Rousseau's lessons, and a sense of their continuing relevance expressed as a regret for failing to grasp them. In Chapter IX the narrator visits Ermenonville, looks at the Temple of Philosophy, and pays his respects:

... at the poplars of the isle, and the tomb of Rousseau, emptied of his ashes. O sage! You gave us the milk of the strong, and we were too weak for it to do us good. We have forgotten the lessons that our fathers knew, and we have lost the sense of your word, which was the last echo of classical wisdom. But let us not despair; and as you did in your last moment, let's turn towards the sunlight! ...

[The narrator wanders among the other features of the garden]: How lonely and sad it all is! The enchanted look of Sylvie, her impetuous larking about, her joyous cries previously gave so much charm to the places I had just wandered through! She was then still a child-savage, barefoot, skin bronzed despite her straw hat ... We went to drink milk at the Swiss Farm, and they said to me, 'how pretty she is, your lover, little Parisian!' Oh, in those days it wouldn't have been a peasant dancing with her! She danced with no-one but me, once a year, at the archery festival.[17]

Nerval thus gives us three versions of Cythera: Watteau's Cythera; Cythera Marred, as Cérigo; and through the metonymic links of the children's pageant and the allegation that Watteau's Cythera was born out of Valois mists, a Cythera that is connected with late eighteenth-century philosophical aspirations for a better society – aspirations that borrowed the cultural vocabulary and the architecture of the ancient world. This last and most tenuous version joins through geography the cultural opposition to central control.

Of these three, Baudelaire chooses one, elaborates it, takes it into the questions of physical suffering, and slyly contrasts it with Watteau's idea. We are reminded, from the fabric of these relationships between different authors and differing eras, of the importance in French culture of what Alison Fairlie describes as the 'aesthetic pleasure' given by the reader's ability to 'recognize creative variations on a familiar theme'.[18] Fairlie's chapters are a good starting point for an understanding of Nerval's writings since she keeps rigorously apart Nerval's art and his biography; she maintains her grip on the art of Nerval, not wishing to delve into the vexed biography. The biographer Richard Holmes takes the diametrically opposite view. In his account of how he failed to write Nerval's life he cheerfully tears down the boundaries between the art and life. He calls *Sylvie* 'the greatest of Nerval's *Promenades*', meaning overtly the literary form Rousseau had invented in his *Reveries*, but also asserting the same close resemblance to exist between the story and Nerval's life as we find between Rousseau's *Reveries* and his life.[19] Rousseau began the confessional revelation of autobiographical writings on the minute level of self-examination, displaying to the world a profundity of self-knowledge and also an intimation of pattern existing just the other side of the chaos of the daily. In Holmes's view of Nerval the pattern the other side of chaos was provided to the French Romantic by the tarot, the occult and the wonder of faerie spirits.[20] Ultimately, however, as Holmes confesses, such an approach to Nerval ends in aporia. The biography was never written.

Creative variations on the theme of Cythera/Cérigo, capable (as Fairlie puts it) of offering 'aesthetic pleasure', do not end with the writers we have already mentioned. Baudelaire's poem appeared on 1 June 1855, and in that month Victor Hugo (1802–85), living in exile on one of the Channel Islands because of his opposition to the military dictator, Napoleon III, wrote his own contribution to the theme we are examining. Scholars believe that Hugo's poem was a deliberate reply to Baudelaire's:[21]

'Cérigo'

I
Every man who ages is the solitary
And sad rock, Cerigo, formerly Cythera;
Cythera of the peaceful retreats; Cythera of the green myrtles;
The sacred conch of Cypris in the bosom of the seas.

A life of wisdom, drop by drop, hour by hour,
Seeps into whoever passes and whoever stays;
Yonder, Greece shines agonising, and the eye
Fills on seeing it, with light and with grief;
The earth shimmers; that little cloud is from smoking incense;
Flights of sea-birds dive through the spray;
The azure trembles; the water moves; and the rumours
Come with the winds, the currents, the boats, the rowers;
Far off runs some Greek or Cretan sail.
Cythera is there, gloomy, exhausted, stupefied;
Death's Head on a dream of love, and naked skull
Of pleasure; this masked singer, an unknown ghost.
Is it you? What have you done with your white tunic?
Hide your soiled breast and your impudent ugliness,
O wrinkled siren whose hymn has fallen silent!

Where are you then, soul? Star, where are you?

The island that was adored from Lemnos to Lepanto,
Where love twined the leaping fantasy,
Where the breeze kissed the trembling trees,
Where the shade said: I love! Where the very grass had senses,
What has been done to it? Where then are they,
The Olympians, the Immortals?
Where then is Mars? Where Eros? Where then Psyche?
Where is the sweet startled bird, happiness?
What have you done with it, rock, and what have you done with the roses?
What has happened to the songs within deep sighs,
Dances, lawns, melodious woods,
The shade that formed passageways for the Gods?
No more altars; O past! Vanished splendours!
No more dazzled virgins at the mouths of dark caves;
No more bees drinking the rose and thyme.
But the sky is still blue. That is to say, O Destiny!
On man, young or old, peace or suffering;
Always the same death and the same hope.
Cérigo, what have you done to Cythera? Night! Mourning!
Eden is eclipsed, leaving naked reefs.
O shipwreck survivor, alas! that you washed up there!
Even the owls fear the island of doves.
Isle, O you who were sought, you whom we flee,
O spectre of kisses, slum-dwelling for sunbeams,
Your name is oblivion! You are dying, gloomy captive!
And, while sheltering some furtive yawl
Your cape, where fabled temples shone,
Sees passing in its shadow and on great blue waves
The pirate in ambush or the sponge-fisher who
Prowls the horizon Venus flies from in dreams.

II
Venus! What are you saying about Venus? She is there.
Lift up your eyes. The day when God unveiled her

For the first time in the universal dawn
She shone no more brightly than she twinkles now.
If you want to see the heavenly body, man, lift your eyes.
The isle of the seas is extinct, but not the isle of the heavens;
Stars are living and are not things
Which fall, one summer evening, like rose-petals.
Yes, die Pleasure; but live Love! O vision,
Torch, bower of azure whose angel is peace;
Beauty of the human soul and the divine soul,
Love, the adolescent in the shadows senses you,
O splendour! and you make the old man luminous.
Each of your rays holds a man in its knots.
Oh! Live and shine in the trembling mist,
Mysterious marriages, hearts growing old together,
Unhappinesses shared with joy,
Devotion, sacrifice, austere sensual joys,
For you are love, the eternal gleam!
The sacred star that sees the soul, holy eye,
The lighthouse of all time, and on the black horizon
The morning and the evening star!
This lower world, where everything creeps and changes,
Contains what disappears: Cythera,
The garden that alters into a bare-sided rock.
The earth has Cérigo; but heaven has Venus.[22]

Victor Hugo, the aging heavyweight champion of Romanticism, unable to bear what the upstart modernist has done to Venus, asserts her continued relevance; not, indeed, as an earthly presence, but as a symbol or, more properly, a star whose influence makes itself felt on earth, motivating the adolescent, but also in later life felt through the mystery of marriages, through the unhappiness of one partner being shared joyfully by the other, and in the perhaps rather forbidding promise of 'austere sensual joys'. The other Romantic, Nerval, had represented Cérigo under an effect of irony, and had stopped short there. Hugo, taking that irony as his starting point, forges a metaphor, by which Cythera's Venusian energy is transferred to the planet Venus, the sky, the heavens and the creating Deity; Hugo's point being, on one level, that while myths change, human beings remain constant in their feelings and needs. Hugo asserts that the spirit of love endures. The modernist, Baudelaire, employs a strategy of synecdoche: he takes part of Nerval's irony, works into it, elaborates it, and from it develops a new whole which really transcends the source of the idea. Does love endure, except as torture? Is love a disaster, rather than a joy, balm or salvation?

What does all this have, if anything, to do with the famous works of the early 1860s painted by Baudelaire's friend Edouard Manet? Baudelaire's poem reveals a particular structure of ideas. The work is developed by comparison with a strong cultural model from the past (Watteau's Cythera). While the new whole stems from this contrast, and cannot have so strong a meaning

without it, it goes beyond its model to mean something very different and to contribute to a strongly contrasting effect.

The years 1859–65 saw a relatively large number of works of visual art on the theme of the birth of Venus appear in France. Claude-Marie Dubufe exhibited his in 1859; in 1861 C.-A. Fraikin exhibited a statue of the *Birth of Venus*, now in Brussels; in the Salon of 1863 both Alexandre Cabanel and Eugène Amaury-Duval showed canvases of the theme; and the years 1863–65 saw the emergence of the *Island of Cythera* by Adolphe Monticelli, a Fontainebleau painter. In the middle of all this, the island of Kythera, formerly Cérigo, became Greek: in 1864 it was the gift of Queen Victoria to the emerging modern Greek nation.

One factor enjoyed in common by all the artists mentioned in the above paragraph is that they were academic. In French art of the period it was the academics who wanted to paint, model and carve Venus.[23] To be an academic artist in the early 1860s was to be a conservative. Academics painted highly detailed scenes, paying careful attention to the modelling of figures, leaving behind very few obvious brushmarks, and using a very fine finish of the kind that the chief teaching institution of academic art, the Ecole des Beaux-Arts, instructed them to use.[24] The academic system taught artists that there was a hierarchy of genres in painting, with history painting (the painting of Greek and Roman myths and biblical stories) at the top as the most morally instructive art, and landscape down at the bottom with still life as the lowliest genres, least worthy of an ambitious artist's efforts. The academic institutions (the Ecole; the branch of the Institut de France that concerned itself with the fine arts; and the juried Salon in Paris which had become the main arena for artists to show their work and establish reputations for themselves) promoted an ideology of art in which a reverential attitude to Greek and Roman civilization was central. At the Ecole, students were taught classes in drawing, anatomy, perspective and ancient history (there were no painting classes). They were also taught, in general, to revere Greek and Roman art and the art of the Renaissance (such as that of Raphael), and to copy these revered works.

The varying fortunes of the academy in France closely followed the varying fortunes of conservatism and revolution in the body politic. The academy had been abolished during the French Revolution after a fiery speech in the Convention of Deputies by the painter Jacques-Louis David calling for abolition.[25] In the period of reaction beginning in 1795 the Institut Nationale was created, a part of which was renamed the Académie on restoration of the Bourbon monarchy in 1816. The new Academy controlled the Ecole des Beaux-Arts and reinstituted history painting. Under the supposedly more liberal regime of the Orleans monarch, Louis-Philippe (1830–48) the so-called *juste milieu* painting was encouraged; this was highly competent painting displaying academic-level technical proficiency operating over a wider range of subjects than strict academic orthodoxy would allow. It was not bound to academic genres. And in 1863 the architectural historian Viollet-le-Duc pushed

the Ecole to foster more originality and to terminate academic exercises that enforced a standardization of production.[26]

Thus there was a variety of other ways of approaching visual art, as represented by *juste milieu*; by the rise of Realism as a movement headed by Courbet and Millet; by the success of the Romantic painter Delacroix; and the continuing satire and oil painting of Daumier, not to mention the burgeoning of interest in the genre of landscape as shown by the Barbizon painters in the 1840s and later; in the face of this variety, to remain an academic was to remain conservative in French art. To be academic can thus be defined in respect to three issues: to accept the hierarchy of genres; to pay allegiance to the classical ideal; and to employ a meticulous *facture* (manner of applying paint) in order to produce an immaculate high finish: this was to be academic in the period up to the 1880s. It was academic painters, however, such as the pupils of Ingres, who could expect to be successful and to secure lucrative governmental commissions. The landscape painters, the Realists, and especially Edouard Manet when he emerged in the early 1860s, were scorned by such people as the Count de Nieuwekerke, Minister of the Fine Arts under Napoleon III's regime.

In a statement published for the private exhibition of his work organized in 1867, Manet set the quality of sincerity against the technical proficiency taught by the Ecole, and he characterized how the academic artists functioned as a conservative body of opinion.

The artist [meaning himself] does not say today, 'Come and see faultless work,' but 'Come and see sincere work' ... There is a traditional system of teaching form, technique, and appearances in painting, and ... those who have been brought up according to such principles do not acknowledge any other. From that they derive their naïve intolerance.[27]

Indeed, it is in light of sincerity rather than originality that the Academic artists come up a little short. Napoleon III thought that Alexandre Cabanel's *Birth of Venus*, exhibited at the Salon of 1863, was such good art that he bought it for his own collection. The painting shows a long-haired blonde reclining nude on a wave, smiling at the viewer. A small flock of putti hover in the air nearby and on the horizon looms a purple island: Cythera, obviously. Since the painting depicts ancient classical myth, it qualifies as a history painting, the highest level of art from which we the viewers are likely to derive the most useful moral instruction. William Bouguereau painted his *Birth of Venus* in 1879, and as late as 1890, Jean-Léon Gérôme felt that the *Birth of Venus* was still a viable theme, and produced his version, *Venus Rising* (Figure 5.1), which hardly induces in us any particular respect for the ancient Mediterranean deity, for whom the purple island awaits in the background. Gérôme had become a sort of grand old fogey of French art by opposing the idea of making a public memorial to Manet after the latter's death in

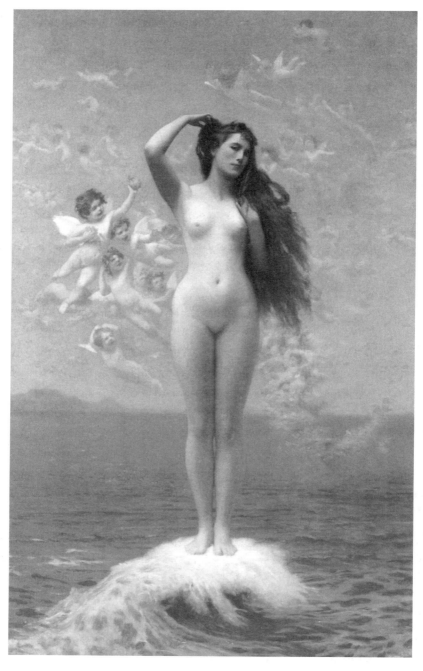

5.1 Jean-Léon Gérôme, *Venus Rising (The Star)* (*Vénus – L'Etoile*), 129.5 × 79.5 cm (51 × 31 inches), oil on canvas, 1890, private collection. Reproduced by permission of ACR Edition

1883, on the grounds that he did not like the way Manet had painted, and by opposing the Caillebotte bequest of Impressionist paintings to the French nation on the grounds that he did not like the way the Impressionists had painted. Both Cabanel and Gérôme were well-respected and well-rewarded Academic painters.[28] Their *Births* were the best the Academics could do.

The Academics, therefore, were asserting that Venus was still present – still viable – and were being encouraged by Napoleon III to do so. The Venus they insisted on displaying, however, was somewhat drained-looking: a touch anaemic. Hardly the hot powerful survivor of the English poet Swinburne's 'Laus Veneris' (1865) with its images suggestive of vampirism, fever and oral sex; or the emphatic brooding presence within the Venusberg of Edward Burne-Jones's *Laus Veneris* of 1879. Notice of Napoleon III's encouragement means that this is probably the place to mention the Countess of Castiglione, the young, beautiful blonde wife of an Italian aristocrat who had become Napoleon III's mistress in 1857. Summing up her appearance, one crony of Napoleon III's court said, 'In a word, Venus descended from Olympus'.[29] One suspects that Cabanel's Venus was quite close in appearance to the Countess. If a love-life for the nation's leader was easy and mercenary (though that aspect was no doubt politely camouflaged), we should also remember that, in the words of a contemporary, at the other end of the social scale, 'the girl on the street ... only asks two francs for a voyage to Cythera'.[30] This interesting usage dates from 1864. It shows 'Cythera' becoming degraded and tawdry as a slang metaphor for sexual climax. Yet even in this use we can hear beyond the words the faint echo of longing for something beautiful, powerful – and unattainable. In this respect mention must also be made of the opening chapter of Emile Zola's novel *Nana* (written in 1879 but set in 1867–70), in which a comic burlesque of the classical deities, centred around Nana performing as Venus, masks powerful yearning.

In this context appeared Manet's *Olympia*, exhibited to much hostility in the Salon of 1865.[31] The painting has been so well discussed so many times that I shall content myself with a mere verbal sketch to bring out the main points relevant to the present discussion (Figure 5.2). The painting depicts a room in which reclines the naked figure of a prostitute. Her black maid holds a large bouquet of flowers. On the bed a black cat pulls a comic expression. The prostitute, Olympia, looks at the viewer. So powerfully has this look been painted that she manages to endow the viewer with a fictive role in this imagined scene: we are a male admirer who has brought her the bouquet as a polite gesture to warm up what is otherwise a tawdry financial transaction. The look Olympia gives us has none of the blandishment of Cabanel's Venus or other depictions of the goddess. It is a stare of appraisal.

Manet's painting is modelled on the Renaissance painter Titian's *Venus of Urbino* (1538), a copy of which Manet had painted in oils in 1859. Titian's image (Figure 5.3) shows Venus reclining, looking at the viewer in an interested

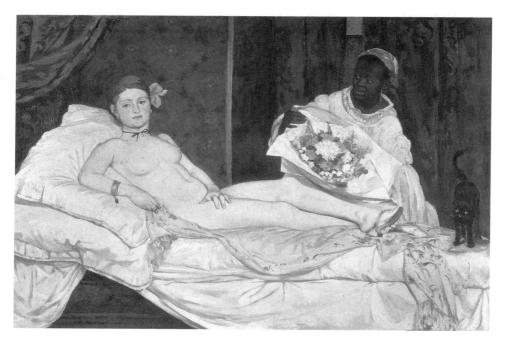

5.2 Edouard Manet, *Olympia*, 130.5 × 190 cm (51½ × 75 inches), oil on canvas, 1863, Musée d'Orsay, Paris

manner. Behind her a chamber opens out to a balcony overlooking a garden. Two white servants choose clothes from a chest. On the bed is the small dog of fidelity that Manet replaces with an independent and violent cat. Titian divides his composition into three mathematically equal parts. The part of the bed measures an equal area to the part of the curtain behind Venus, and to the part of the chamber. The place where all three areas meet is occupied by the genitals of the goddess, seat of sexual pleasure and fertility. Renaissance love of mathematical harmonies, and their use in intersecting with theme, could hardly be better represented.

Once the similarity has been established, it is the differences between Manet's and Titian's paintings that really tell. In Manet's painting space has closed in upon the main figure. The three-part division of the composition in *Olympia* lacks the mathematical precision of Titian: the three areas are no longer equal in size. The main figure's genitals no longer occupy the crucial place where the three parts meet; they are also more completely covered up by her hand. Things are going wrong, Manet seems to be intimating. The main difference between the paintings, of course, is that Manet does not paint Venus, but Olympia the prostitute. Something has gone so wrong with modern love in Napoleon III's Paris, we are being shown, that love can hardly be taken to

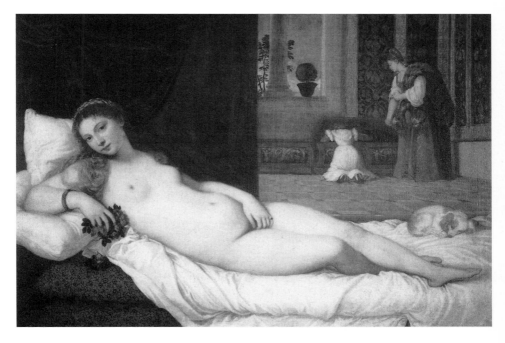

5.3 Titian, *Venus of Urbino*, 119 × 165 cm (47 × 65 inches), oil on canvas, *c*.1538, Galleria degli Uffizi, Florence

be in question any more. Sexual activity might remain, but it leaves love out. Venus has been lost.

Let us turn from *Olympia*, that monument of modernism in painting,[32] to Manet's other major work of 1863, *Déjeuner sur l'herbe* (*Luncheon on the Grass* – Plate 11). These were two of a remarkable series of paintings produced in the 1860s in which Manet launched attacks on the cultural politics of Napoleon III and his regime. Others include the *Execution of Maximilian* (1867–69) and the *View of the Exposition Universelle of 1867*.[33] *Luncheon on the Grass* is perhaps the most significant in its concentration on questions of painting, while the others have a broader, more social and political bearing while also continuing to pioneer innovation in painting. The general bearing of *Olympia* is against the sexual hypocrisy of the French ruling class, the large amount of prostitution that went on (at all levels in society), and the resulting stifling and stagnated state of love and marriage at the time (Manet's own marriage had to be kept secret for years; Baudelaire's love life was chaotic and pursued entirely outside wedlock; figures such as Napoleon III, Nieuwekerke and the famous Prefect of the Seine, Haussmann, openly pursued mercenary relationships outside their marriages, etc.). *Olympia* also amounts to a protest against the slavishness of traditional painting's

regard for Renaissance masters, and it does this by the very fact of trading on differences. On a more positive note, while love and respectability might be out of the picture, we are given a real woman: the matter-of-fact of the everyday.

So much has been written so well elsewhere about *Luncheon* that I do not need to discuss here every characteristic of the painting, in which four figures, one nude, one in undergarments and two completely dressed in contemporary modern clothes are enjoying, in a rather serious or indeed solemn way, a picnic.[34] Exhibited amid much ridicule at the officially sponsored Salon des Refusés in 1863, *Luncheon* was found by Napoleon III to be 'indecent'.[35] Unlike Alexandre Cabanel's *Birth of Venus*, which was simultaneously, of course, in Napoleon III's eyes, obviously very good art indeed. Like *Olympia*, *Luncheon* amounts to a joke by Manet made at the direct expense of Academic teaching.[36] For our purposes here I wish to emphasize that *Luncheon* is a sort of landscape painting, in that the setting and in particular how the setting is painted form a crucial part of Manet's purposes in making this work. I also want to bring out one other point about the painting which is rarely, if ever, noticed. First, however, it is in the painting of the landscape elements, in particular, that the artist asserts his right to decide when a work is complete. He asserts that the painting is complete even if it is unfinished in an Academic sense. Different parts of Manet's landscape elements are brought up to very different degrees of 'finish' and in particular the ruddy parts look as if they have barely been touched after the preliminary underpainting stage. The contrast with works by Cabanel, Dubufe, Amaury-Duval, Gérôme and their ilk is very marked. From this breakthrough the Impressionist painters were able to make a huge exploitation of the sketchy, the unfinished, and the suggestive as soon as the following decade.

My other point starts with the understanding that again the artist has used a grand Italian Renaissance work as a basis for the composition of his figures – this time a painting by Raphael known through an engraving by Marcantonio Raimondi. The three figures he has employed, however, come from the bottom right corner of that picture, as if Manet has deliberately decided to slight the main action of the scene or has found the tangential, the peripheral, to be more important to contemporary conditions in 1863 – to be more central to the experience of the modern, in art and, presumably, in life – than the obvious, the grand and the self-important. All of these ways of putting it could have had cultural political resonances during the repressive regime of Napoleon III. For our purposes it is as important that Raphael's painting depicted the *Judgement of Paris*: that moment from ancient Greek myth in which Venus figures in so central a role, being awarded the apple by Paris for her beauty, and rewarding him with the love of Helen. This is the event that started the Trojan War, leading to the fall of Troy and, in Virgil's continuation, the founding of Rome. All these grand events are very much offstage in Manet's adaptation of

the original.[37] In the transfer from Renaissance engraving to Manet's painting, Venus has again gone missing.

What we find, then, during the dictatorship of Napoleon III, is that artists and poets who can anachronistically and loosely be termed avant-garde (meaning that in their work retrospectively we detect the emergence of modernism and the probing of modernity) acknowledged the loss of Venus; while conservative academic artists continued to attempt to paint her as if straightforward depictions of Venus were still an aesthetically viable theme. None of the academics, however, succeeded in giving us as memorable and forceful a Venus as Edward Burne-Jones's *Laus Veneris*: but the English artist was working with a different line of descent. Given to him by the poet Swinburne, who was in turn inspired by a letter from Baudelaire telling him all about the staging in Paris in 1861 of Richard Wagner's opera *Tannhäuser*, the theme was ultimately bequeathed to the English by the German poet Heinrich Heine, who created the legend of *Tannhäuser* and the mediaeval Venus: how she seduces a knight who should have been out in the world performing knightly feats, and keeps him in the 'horsel', as Swinburne termed it, the cave under the mountain, under the Venusberg. Despite the appearance of Wagner's opera and Baudelaire's enthusiastic response, Heine's influence was much stronger in Britain than it ever became in France. It is Heine, for example, who lies behind Walter Pater's extraordinary tale of classical belatedness and survival, *Apollo in Picardy*.

What was at stake in the pattern? The loss of Venus and the ruin of Cythera embrace the loss of the antique world; a loss compounded for Nerval by the loss of the naturalized French version of Cythera, a mixture of Watteau and Rousseau only preserved earlier in the century as a pageant for children. Nerval and Baudelaire show versions of Cythera that make the island's ruin a function of the modern world, and so a symptom of modernity. Nerval's theme in *Sylvie* includes the loss of some good part of the nation's own past. Hugo detects the loss of (earthly) pleasure yet asserts the continued influence of love, which he links to the stars and to heaven as a transcendent power. Manet finds the nearest substitute for Venus to be a prostitute, Olympia; and he finds that, whether from a state of distraction endemic in modernity or from a sense that true value lies in the peripheral and ephemeral, the judgement of Venus's beauty is now less interesting than the arresting look of an attendant river deity and the consequent assertion of intersubjectivity as a principal factor in painting.[38] Manet's treatment of the landscape sections of *Luncheon* had enormous consequences for painting in general and landscape painting in particular; consequences fully exploited by the Impressionists. Here and in *Olympia* he founds modern painting on the loss of Venus. Such a loss must therefore be a spiritual value: one that involves the denial of the (allegedly) transcendent in the face of conservative allegations of its preciousness. Demonstration of the loss of the antique world in France

between 1851 (Nerval's *Voyage en Orient*) and 1890 (Gérôme's *Venus Rising*) is a demonstration of the out-of-date irrelevance of the academic approach to art. Cythera is not valuable for any intrinsic qualities of the past, but for what its present state says about modern conditions.

Notes

1. The history of the title of this painting is somewhat vexed. It was first officially recorded as *Pilgrimage to Cythera*. This was officially crossed out and *Une Feste galante* substituted; and for long periods the painting has been known as *Embarkation for the Island of Cythera*. This last certainly misleads, as the figures are clearly leaving the island, not preparing to sail there – hence my choice of *Embarkation from Cythera*.

2. See Diana Ketcham, *Le Désert de Retz: A Late Eighteenth-Century French Folly Garden, the Artful Landscape of Monsieur de Monville*, 1990 (Cambridge: MIT Press, 1994).

3. For an excellent and careful discussion of Watteau's work in this respect, see Julie Plax, *Watteau and the Cultural Politics of Eighteenth-Century France* (Cambridge: Cambridge University Press, 2000), especially pp. 108–53. The view of French history being summarized here ultimately stems from Montesquieu. On this theme, see also the article by Georgia Cowart, 'Watteau's *Pilgrimage to Cythera* and the Subversive Utopia of the Opera-Ballet', *Art Bulletin* LXXXIII, 3 (Sept. 2001), pp. 461–78.

4. This was also the century when syphilis became heavily literary. See Claude Quétel, *History of Syphilis*, 1986, trans. Judith Braddock and Brian Pike, 1990 (Baltimore: Johns Hopkins University Press, 1992), especially pp. 106–31.

5. Gérard de Nerval, *Oeuvres complètes*, ed. Jean Guillaume and Claude Pichois (Paris: Gallimard, 1984), vol. II, p. 1451, n. 5.

6. Nerval, *Oeuvres complètes*, II, pp. 233–5, 240. The word 'gentleman' is in English in the original.

7. *Les Faux saulniers* (1850) was abridged and re-published as the story 'Angélique' alongside *Sylvie* in *Les Filles du feu*, 1854 (Paris: Bookking International, 1997).

8. 'Precursors of Socialism' was the subtitle of Nerval's *Les Illuminés* (1852).

9. Nerval, *Les Faux saulniers* in *Oeuvres complètes*, II, p. 104: 'Rousseau ... a ruiné profondément l'édifice royal fondé par Henri. Tout a croulé. – Son image immortelle demeure debout sur les ruines.'

10. *Ibid.*, p. 55.

11. Alison Fairlie, *Imagination and Language: Collected Essays on Constant, Baudelaire, Nerval and Flaubert* (Cambridge: Cambridge University Press, 1981), pp. 280–285.

12. *Ibid.*, p. 282.

13. *Ibid.*, p. 283.

14. Umberto Eco, *Six Walks in the Fictional Woods*, 1994 (Cambridge MA: Harvard University Press, 1995), Chapter 2: 'The Woods of Loisy', pp. 27–48.

15. Marcel Proust, 'Gérard de Nerval', in *Against Sainte-Beuve*, quoted in Eco, *Six Walks* p. 29.

16. Nerval, *Sylvie*, in *Les Filles du feu*, pp. 117–118.

17. *Ibid.*, pp. 131–2.

18. Fairlie, *Imagination and Language*, pp. 296–7.

19. Richard Holmes, *Footsteps: Adventures of a Romantic Biographer*, 1985 (New York: Vintage Books, 1996), p. 253.

20. For example (though not one from Holmes's book), Nerval's narrator finds a hanged man on Cythera. The Hanged Man is a card of the tarot (where he is usually suspended by his foot, however). In interpretations of the tarot, the hanging is a punishment/reward for knowledge, etc.

21. Nerval, *Oeuvres complètes*, II, p. 1451, n. 5.

22. Piracy was associated with Cythera by the Latin author Polybius. Cf. J.N. Coldstream and G.L. Huxley (eds), *Kythera: Excavations and Studies conducted by the University of Pennsylvania Museum and the British School at Athens* (London: Faber and Faber, 1972), p. 39. Anyone wishing to know about the actual island should be directed to this volume, which discusses the Aphrodite cult there, and elucidates that the colour purple was associated with the island through dye manufacture, which depended on the *murex* molluscs and their shells, rather than from the colour of the rock.

23. This is made obvious, though it is not explicitly referred to, by Jennifer Shaw, 'The Figure of Venus: Rhetoric of the Ideal and the Salon of 1863', in C. Arscott and K. Scott (eds), *Manifestations of Venus: Art and Sexuality* (Manchester: Manchester University Press, 2000), pp. 90–108.

24. Academic art has been very well discussed elsewhere, and I do not intend to provide a particularly full discussion here. See, among others, Al Boime, *The Academy and French Painting in the Nineteenth Century* (London: Phaidon, 1971); F. Frascina et al., *Modernity and Modernism: French Painting in the Nineteenth Century* (London: The Open University and Yale University Press, 1993); Richard Shiff, *Cezanne and the End of Impressionism: A Study of the Theory, Technique and Critical Evaluation of Modern Art* (Chicago: University of Chicago Press, 1984).

25. See Lorenz Eitner (ed.), *Neoclassicism and Romanticism 1750–1850: An Anthology of Sources and Documents*, 1970 (New York: Harper and Row, 1989), pp. 115–118, for an abridged printing of the speech.

26. See Shiff, *Cezanne*, pp. 71–4, for a discussion of this point and Boime's book.

27. Printed and translated in G.H. Hamilton, *Manet and his Critics* (New Haven: Yale University Press, 1954), pp. 105–7.

28. Cabanel attended the Ecole des Beaux-Arts, won the Prix de Rome, became a Professor at the Ecole and was deluged with lucrative commissions. His reputation evaporated after his death in 1889. Gérôme was also a product of the Ecole, but came originally from a lowlier social class, and this may have delayed his full acceptance by the Academy. Nevertheless he became a Professor at the Ecole. He was a close friend of Nieuwekerke.

29. Princess Pauline von Metternich, quoted in Otto Friedrich, *Olympia: Paris in the Age of Manet*, 1992 (New York: Simon and Schuster, 1993), p. 55.

30. Alfred Delvau, *Dictionnaire érotique moderne* (1864), quoted and translated in Shaw, 'The Figure of Venus', in Arscott and Scott, *Manifestations of Venus*, p. 93.

31. See T.J. Clark, *The Painting of Modern Life: Paris in the Art of Manet and his Followers* (Princeton: Princeton University Press, 1984), especially pp. 79–146.

32. See the summary of the work's significance made by Charles Harrison, 'Modernism' in R. Nelson and R. Shiff, *Critical Terms for Art History* (Chicago: University of Chicago Press, 1996), pp. 142–55.

33. For the *Execution of Maximilian*, see especially Juliet Wilson-Bareau et al., *Manet: The Execution of Maximilian: Painting, Politics and Censorship* (London: National Gallery Publications, 1992). For the *View of the Exposition Universelle of 1867*, see T.J. Clark, *The Painting of Modern Life*, especially pp. 60–66, and Michael Charlesworth, 'Subverting the Command of Place: Panorama and the Romantics', in *Placing and Displacing Romanticism*, ed. Peter Kitson (Aldershot: Ashgate, 2001), pp. 129–45.

34. Especially to be recommended are the discussions in Michael Fried, *Manet's Modernism: or, the Face of Painting in the 1860s* (Chicago: University of Chicago Press, 1996), and Anne Hanson, *Manet and the Modern Tradition* (New Haven: Yale University Press, 1977).

35. Henri Perruchot, *La Vie de Manet* (Paris: Hachette, 1959), p. 131. Perruchot describes the ridicule with which the Salon des Refusés was received with considerable force in Chapter IV, 'Eighteen Sixty-three'.

36. As Linda Nochlin pointed out, 'The Invention of the Avant-Garde: France, 1830–1880', in Thomas Hess and John Ashbery (eds), *Avant-Garde Art* (London: Collier-Macmillan, 1968).

37. In employing this strategy, Manet can also be seen as contributing to the crisis of allegory that scholars have detected in French painting of the nineteenth century. See Marcia Pointon's absorbing chapter on *Luncheon* in her book *Naked Authority: The Body in Western Painting 1830–1908* (Cambridge: Cambridge University Press, 1990), pp. 113–134.

38. On (linguistic) intersubjectivity, see Emile Benveniste, *Problèmes de linguistique générale* (Paris: Gallimard, 1966).

The 'New Cythera': Bougainville, Hodges, Gauguin in Tahiti

Consideration of the fate of Cythera seems to invite consideration of Cythera's modern and colonial counterpart, the 'New Cythera'. This will enable us to come to terms with some aspects, at least, of colonial landscape, and the choice of specific location enables us to discuss the work of both an English and a French painter as well as various literary responses to the islands. 'Tahiti as a work of art' would be an alternative title for this chapter. In the late eighteenth century a feature was added to the rugged landscape garden of Hawkestone, in the county of Staffordshire in the north Midlands of England:

A path leads the visitor to a deep little sequestered glen, whose carpet of green is open only in front, shut up on every side by towering rocks and widely-spreading trees. This is called *a scene in Otaheite*, and imagination is assisted in her flight to the South-sea islands by a cottage constructed in the manner and fitted up with the furniture of their inhabitants; a canoe lying in front of it is introduced to aid the delusion.[1]

How did a trace of a Pacific island find itself in the northern Midlands of England? What did it signify? It got there because of two eighteenth-century travellers: Captain Cook and, before him, the French soldier and sailor, Louis-Antoine de Bougainville (1729–1811).

Bougainville, commanding the ships *La Boudeuse* and *L'Etoile*, reached Tahiti in April 1768. He was halfway through a voyage around the world that had been financed by the King of France. Unfortunately the king had imposed a time-limit on Bougainville, ordering him to return in little more than two years, and Bougainville was already late: according to his orders he was supposed to leave China by 'January 1768 at the latest' but by the time he anchored off Tahiti he had not yet reached China.[2] In the event he cut China from his voyage, thus departing from another part of the instructions by which he was supposed to search for an island off the Chinese coast that could be used as a base for trade in China by the French Compagnie des Indes.

In ordering him to be home in two years, the king did not give enough time to Bougainville to carry out his complicated orders. The king provided a frigate of 26 guns when a merchant vessel such as Cook used would have accommodated the crew, extra people and equipment better. *L'Etoile* was simply a supply vessel and there was no room on *La Boudeuse* to be occupied by detailed observations and scientific work.

Bougainville had proposed his voyage in a letter to the king's minister, the Duc de Choiseul, because the French North American colonies had been lost to the British in the war of 1755–63; and because, as he put it, 'all the riches of the earth belong to Europe, whose sciences have made her sovereign over the other parts; let us go then to reap this harvest'.[3] On this harvesting mission Bougainville did not take an artist. He took a cartographer, a naturalist and an astronomer. The naturalist's servant was a woman dressed as a man, but this was not discovered until Tahiti (after more than a year at sea), when the natives immediately saw the difference even when the servant was still clothed.[4] While he could not accommodate an artist, Bougainville took four musicians.[5]

Bougainville was not looking for Tahiti when he reached it because he had no idea of the island's existence. What his expedition found there can best be recounted in the words of its members. The naturalist, Philibert Commerson, wrote in his journal:

I gave it the name *Utopia*, that Thomas More gave to his ideal republic ... Its position in latitude and longitude is the secret of the government ... but I can tell you that it's the only corner of the world inhabited by people without vices, without prejudices, without needs, without quarrels. Born beneath the most beautiful sky, nourished by fruits of an earth fertile without having to be cultivated, ruled by family patriarchs rather than by kings, they know no other god than Love. All their days are consecrated to him, the whole island is his temple, all the women are his altars, all the men the sacrificers. And what women, you ask me? The rivals of Georgian women for beauty, and the sisters of the naked Graces. There, neither shame nor modesty exercise their tyranny: the lightest of gazes floats always with the winds and the desires; the act of creating your likeness is a religious act; the preludes are encouraged by the vows and the songs of all the people assembled, and the end celebrated by universal applause; every stranger is admitted to participate in these happy rites; it's even one of the duties of hospitality to invite them, so much so that the good Utopian rejoices ceaselessly either in the feeling of his own pleasures or in the spectacle of the delights of others ... [it is] the state of natural man, born essentially good, exempt from all prejudice, and following without suspicion as without remorse the sweet impulses of an instinct always sure, because it has not yet degenerated into rationality.[6]

Commerson also emphasizes the intelligence of the islanders, their interest in iron and their inquiring minds.

Louis Constant emphasizes that Bougainville's expedition failed on every scientific and commercial count. The haste demanded by the king spoiled everything. Charged by the king to find islands where spices grew – especially

nutmeg and cloves – Bougainville did not, just as he failed to find an island off the coast of China. He made no reliable charts of his discoveries, and brought back no visual images because he had no artist. On Tahiti he even failed to stock up adequately with provisions, which contributed to a famine on board ship in the western Pacific. All of these things were bitterly complained about in his journal by one of the expedition's writers, Starot de St-Germain.[7] Even the most scientific observations, those of Commerson, packed off to France after the naturalist's death on Mauritius, were never properly classified and sorted.[8]

Bougainville's own description of Tahiti occupies two chapters of the book he wrote giving an account of his voyage. The first chapter deals with an account of his stay and his impressions; the other provides further reflections about the island derived from conversations with Aotourou, an islander who volunteered to accompany the expedition back to France. Bougainville found that the appearance of the island,

… raised into an amphitheatre, offered us the most delightful spectacle. While the mountains there are of a great height, the rock is nowhere exposed in an arid nudity; all of it is covered with woods. We could scarcely believe our eyes, when we discovered a peak covered with trees right up to its isolated summit which rose above the level of the mountains, in the interior of the northern part of the island. It didn't appear to be more than thirty fathoms across and became more slender as it rose; from afar one would have taken it for a pyramid of immense height that the hand of an able decorator had swathed in garlands of leaves. The lower levels of the slopes were divided up into open spaces and thickets, and along the whole length of the coast stretched a low continuous ledge on the sea-shore, covered with plantations. It was there in the middle of banana-plants, coco-palms and other trees full of fruits, that we made out the houses of the islanders.

As we were cruising along the coast our eyes were struck by the view of a beautiful waterfall which tumbled from the heights of the mountains straight into the foaming sea. A village was built at its foot, and the sea seemed to be free of rocks. We all wanted to anchor near this beautiful place…[9]

The inhabitants seemed to bear out the promise of the place. When the first young woman made her way onto Bougainville's ship,

… the young woman negligently let fall a cloth that had been covering her, and appeared to the eyes of all just as Venus had allowed herself to be seen by the eyes of the phrygian shepherd: she had a divine form. Sailors and soldiers pressed around, and the capstan had never witnessed such an activity.[10]

This invocation of the Judgement of Paris set the reference for Bougainville's interpretation of what he found after landing on the island. He invoked Venus again as 'the goddess of hospitality' whose cult did not allow any mysteries: 'each coupling is a festival for the nation'. Groups of people watched and music was provided to accompany the love-making.[11] On land, so far as the

physical setting was concerned, Bougainville added another potent myth when believed himself 'transported into the garden of Eden'. This did not, however, prevent him from giving the islanders seeds of wheat, oats, rice, maize and onions to 'improve' Tahitian cultivation.[12]

In his more reflective chapter, Bougainville named the island *la nouvelle Cythère* ('the New Cythera'), and noted that on offshore islets the islanders maintained fires at night for fishing and for the safety of sailors.[13] On the island there was lots of wood and food; no mosquitoes, and Bougainville did not see any poisonous snakes. 'The climate is so healthy that although our people were working very hard, constantly in the water and full sun, sleeping on the ground under the stars, no-one fell ill.' The scurvied were cured.

For the rest: the health and strength of the islanders who live in houses open to all the winds, and who scarcely cover with a few leaves the ground that serves them as a bed; the happy old age which they attain with no inconvenience, the acuteness of all their perceptions and the particular beauty of their teeth, which they retain to the greatest age; what better proofs both of the health of the air and the goodness of the diet that the inhabitants follow?[14]

Bougainville reports that the islanders eat vegetables and fish, but hardly any meat. He thinks this keeps them healthy. They drink only water and are revolted by the smell alone of wine and spirits, as well as by tobacco and spices. Of one of the two races Bougainville found living on the island he reports that the men are tall, well-built and well-proportioned: 'models for Hercules or Mars'.[15] Both sexes tattoo their buttocks and thighs with a deep blue. They bathe all the time, and so are very clean. Housing and food seem to be held in common (this remark must be considered in the light of the rising cost of the necessaries of life – food and shelter – in contemporary France, as described, for example, by the Marquis de Girardin in his *Essay on Landscape*).[16] Bougainville at first concludes that Tahitians do not employ punishment for stealing more severe than a few blows from a stick and forced restitution of goods, but is later told that they hang thieves from trees. Religion is a mystery. It includes the placing of corpses on elevated platforms and their anointment until only a skeleton is left, which is then brought home. They kill all the male prisoners in wars with neighbouring islands, and take the women. They practise human sacrifice when the moon that is propitious for war is seen in the sky.[17] They seem to have both smallpox and venereal disease.[18] However, Bougainville cannot bring himself to emphasize these less attractive features of Tahitian life, partly perhaps because he does not see them with his own eyes. Instead he emphasizes that 'their only passion is love'. Children are looked after by both parents, and jealousy is an alien feeling. 'The air one breathes, the chants, the dancing almost always accompanied by erotic posturing, all recalls at every moment the sweetness of love; all cries to you to abandon yourself to it.' And the islanders are not given to reflection at all.[19]

In this relatively short but forcefully expressed account Bougainville created what might be termed the myth of Tahiti, which, as we shall see, endured for a long time (and perhaps is still with us).[20] The myth follows Bougainville's emphasis, forgetting the cannibalism and human sacrifice to concentrate on free love, the existence of happiness, and easy living. While his expedition failed in every other respect, he salvaged from it the invention of a tropical Garden of Eden presided over by Venus. One thinks of night-time in the pre-lapsarian Eden described by John Milton.

Bougainville had intended to stay 18 days, but the sharp coral reefs of the island repeatedly cut his anchor-ropes and he departed hastily. The entire myth of Tahiti was based on a stay of a mere eight days, during which time Bougainville's men murdered four islanders. The first was killed on 10 April and two days later three more natives were found 'killed or wounded' by bayonets. Native women, in tears, complained: 'You are our friends and you kill us'.[21]

The work of Hodges

All three of Captain Cook's Pacific expeditions visited Tahiti. The purpose of the first included observing the transit of the planet Venus from the southern hemisphere. The second was undertaken in part to ascertain whether or not a large continent existed in the southern ocean (scientists felt that there must be one in order to keep the earth balanced). The third aimed to complete and check work begun previously. Cook's expeditions replenished their food and water at Tahiti and endured the frequent thievery (there were expert pickpockets among the islanders) for the sake of enjoying the island's hospitality.[22] Cook and his men even enjoyed watching the natives surf-riding. Cook named one promontory 'Point Venus', although this was sheer coincidence, since this was the place from which members of the first expedition observed the transit of Venus across the face of the sun in 1769, and the name thus commemorated the planet rather than the classical deity. During the next visit on the circumnavigation of 1772–75 Cook had with him the first major Western artist to visit the South Pacific, William Hodges (1744–97).

Hodges had been employed by the Admiralty to be landscape painter on the expedition. He was there to provide drawings of strategic significance. These drawings conformed to types of drawing sought after by the Admiralty, and Hodges's work on the expedition certainly relates to the forms of drawing as military intelligence that we discussed in Chapter 1, and also to the Panorama of Hong Kong, made from drawings 'taken' from sea level. The most basic of the types of drawing Hodges was responsible for were profile drawings of a new coast when it became visible from a certain position. Invented by the Frenchman, Pierre Garcie, in 1520, coastal profiles were commonly used and

printed on charts by the Dutch in the sixteenth and seventeenth centuries. In England, when the Royal Naval Academy opened in 1733 the curriculum included the drawing of coastal profiles.[23] Such views were of value not for the expedition on which they were made, but for mariners arriving at the same place at a later date, who would be helped by the drawing to identify the stretch of coast at which they were arriving. Thus Alexander Dalrymple, hydrographer to the East India Company, states that 'Views are useful, not only in giving the most competent description of the Country, but in pointing out the proper places for *landing, watering, wooding, fishing,* &c.'[24] So, for example, the French navigator Jean-François de Lapérouse, on his attempted circumnavigation of 1785–88, identified '*le cap des Vierges*' in South America with British help: 'the view given by the editor of Admiral Anson's *Voyage* appeared very exact to me, and its position is perfectly determined on the chart of Cook's second voyage.'[25] The perceived usefulness of such drawings was as a primary tool for the exploration of the earth's surface by Western societies. Hodges also made more panoramic images showing from above stretches of coast much complicated by inlets.

Instructed to 'make Drawings and Paintings as may be proper to give a more perfect idea [of the voyage] than can be formed from written descriptions only',[26] Hodges also drew and painted portraits of South Pacific islanders and made drawings and paintings that clearly depicted the structure of native sailing craft. At a level distinctly above that of the prosaic usefulness of the coastal profile, the artist also produced more distant views of islands that, while by no means restricting themselves to the abbreviated and abstracted reduction of the coastal profile, clearly retain an idea of the importance of showing the shape or outline of the island from a position near sea level. One thing that distinguished Hodges' profile work from that of others was that many were painted in watercolour with no reliance on a drawn ink or pencil line. These wash-based profiles made by Hodges and others whom he taught (such as Henry Roberts on the second voyage) differ in another significant way from the line-based work of most previous British profiles in that they more successfully depict space: the recession of land masses seen from the ship on the open sea as coves, inlets and harbours open up to view is far more successfully conveyed by the progressively fading washes of tone in these paintings.

A final series of images that Hodges made were large paintings constituting monuments of the voyage, based on sketches made during the voyage but completed in England for the Admiralty after the expedition's return. Some of these preserve the trace of a coastal profile, such as *Tahiti Revisited* (1776) (Figure 6.1). The painting shows the island from a vantage point near water level. In fact we can recognize left of centre the tall pyramidal peak that so intrigued Bougainville; to the right of it leans over a peak described by Georg (George) Forster, one of Cook's naturalists, as a 'remarkable pinnacle, whose

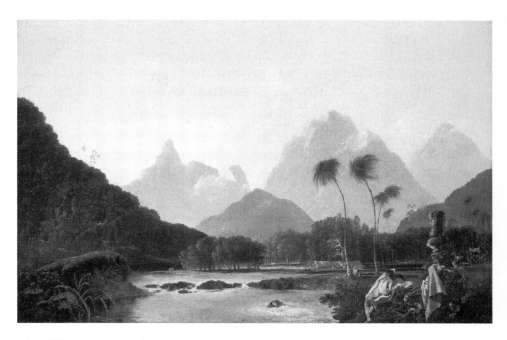

6.1 William Hodges, *Tahiti Revisited*, 92.7 × 138.4 cm (36½ × 54½ inches), oil on canvas, 1776, National Maritime Museum, London

summit was frightfully bent to one side, and seemed to threaten its downfall every moment'.[27] In addition to these traces of strategic vision, as Bernard Smith has shown, Hodges includes a great deal of other kinds of information about Tahiti in this painting.[28] The naked woman bathing enacts the leisure and life of ease that Tahitians seemed to enjoy. A more specific incident that dramatized what good swimmers some local women were also lies behind this figure: Forster wrote of the same anchorage that 'the view of several of these nymphs swimming nimbly all round the sloop, such as nature had formed them, was perhaps more than sufficient entirely to subvert the little reason which a mariner might have left to govern his passions'.[29] The tattooed buttocks of one of the women on shore tell us about the region's practices of personal ornament. The statue (or *tii* figure), the longhouse and the elevated platform for the body of a chief on the extreme right tell us about religious, housing and burial practices. And there is some *tapa* cloth (made from the bark of the tree, *Broussonetia papyrifera*) beneath the *tii* figure. However, this cloth has on it a painted mark that can have no equivalent within the Tahiti of the image: the debonair zig-zag yellow paintstroke is a sign of Hodges himself, evidence of his pride in his mastery of paint and his wish to show that mastery explicitly. The pure mark of the painter pursuing his art, perhaps it could be related to the 'manliness' found in the handling of paint by his

master, Richard Wilson; or to the excess of such subjective mark-making in the self-consciously modernist art of the following century.[30] In its lack of iconic status, the fact that it is the index of the artist himself, it also subtly inscribes Hodges at the scene.

As well as Tahiti, the painting can tell us about Hodges' procedure. In a practical episode of painting that shows continuity with his watercolour coastal profiles, the recession of the mountains in space, and the modelling of their three-dimensionality, are communicated by Hodges' variations of tone in his hues. Drawings in the British Library show how Hodges used the same technique in monochrome alone.[31] This point leads to another, which is to do with the way in which fine art practices have in turn influenced the necessity of drawing the coast. Hodges learned his art through being apprenticed to the Welsh landscape painter, Richard Wilson. Wilson used to gather his apprentices around his easel to observe his techniques.[32] We know from another apprentice that Wilson taught his pupils how to convey light and shadow in monochrome wash, as a way of guarding against them being 'dazzled' by colours.[33] Hodges clearly taught his own pupils on Cook's ships to do the same, and built upon the same technique in *Tahiti Revisited*.

Another of Hodges' monumental paintings, *View of Maitavie Bay, Otaheite* (1776) (Plate 12) shows, across the bay, Cook's hospital tent for sick sailors pitched on Point Venus. Details of the structure and rigging of the native craft are carefully shown, as is their contrast with the English vessels at the other side of the bay. The topography of the island is very solid, clear, and as calm as the atmosphere. One of the changes Hodges made to differentiate this painting from an earlier version of the same scene was to add a half-naked mother suckling a child in the foreground, and in the corner a native man pointing to her, like the admonishing figure of Alberti's theory of painting, who indicates to the viewer the most important part of the image. The woman and child are accompanied by a cockerel, some breadfruit and large bunches of red and green bananas. The group and these still-life elements clearly constitute an emblem of abundance, nourishment, nurture. They thus encapsulate the value of Tahiti to Cook and his men. In the light of Colin Newbury's mainly economic analysis of Tahiti's history we can assume that Cook and his men had very little actual value, at this stage in its history, for Tahiti.[34] Behind the woman, sitting on an outrigger of the canoe, a native man has been painted by Hodges as a version of the famous 'Belvedere Torso' – a Hellenistic statue in the Vatican museums that was usually taken as a representation of Hercules. This move by Hodges evidently takes up from Bougainville's encomium on native men as 'models of Hercules or Mars' (Bougainville's text had been translated into English by a member of Cook's expedition, Georg Forster, before Cook's second expedition left England). By sheer coincidence Hodges's native anticipates the work of the great French Romantic painter, Theodore

Géricault's painting of *The Raft of the Medusa* (1819) where again a man of another race (this time African) is shown as a version of the 'Belvedere Torso'.

Between Hodges and Gauguin

The history of Tahiti from 1770 to 1890 makes depressing reading. The population of the island is estimated to have been 40,000 when Cook visited. By the lowest point in the nineteenth century the native population had declined to 6,000.[35] Warfare and infanticide might have accounted for some of this, especially during the eighteenth century, but other factors causing the decline included activities by Christian missionaries, Western diseases, alcoholism and depression caused by general degradation and demoralization.

Already by the time Cook returned to the island on his second expedition he found evidence that a Spanish ship that had arrived earlier the same year had left a kind of gastric influenza that killed islanders. Tuberculosis, smallpox and dysentery followed.[36] Missionaries of the Christian cult of course identified Tahiti as a place that needed converting. A group of missionaries propagating a gloomy evangelical Protestantism arrived from the lower-middle-class London Missionary Society, and for the first 40 years Christianity on the island was Protestant. Otto von Kotzebue, a Russian navigator who visited in 1823 condemned it:

A religion like this, which forbids every innocent pleasure and cramps or annihilates every mental power, is a libel on the divine founder of Christianity ... It has given birth to ignorance, hypocrisy and a hatred of all other modes of faith, which was once foreign to the open and benevolent character of the Tahitian.[37]

It would be difficult to imagine two groups of people whose habits of behaviour were more diametrically opposed than the Tahitian islanders of Bougainville's and Commerson's accounts and the British missionaries. The latter were described by the twentieth-century US historian of the Pacific, C. Hartley Grattan, in the following terms: 'They hated nudity, dancing, sex (except within monogamous marriage), drunkenness, anything savoring of *dolce far niente*,[38] self-induced penury, war (except in God's name), heathenism in all its protean manifestations, and Roman Catholicism.'[39] In the missionary onslaught was dramatized not only a clash between religious beliefs, but between a hatred of idleness that we saw in Chapter 4 as the antithesis to Rousseau's celebration of reverie, and a native way of life that had evolved with just such an apparent leisure in rather large amounts.

The king of Tahiti was converted and, among other damage that was done, the wooden *tii* figures perished in mass burnings.[40] The *marae*, or sacred precincts to house the Gods, were torn down or lapsed into ruins in the Tahitian landscape.

Eventually it was the missionaries' hatred of Roman Catholicism that brought further change. The forced expulsion of Roman Catholic priests in 1835 and 1836 offered France a pretext for intervention, and the island was formally annexed by the French as a 'protectorate' in 1843. Now Roman Catholic missionaries could act freely. One of the eighteenth-century French philosophers of the Enlightenment, Denis Diderot, had foreseen the danger to Tahiti posed by Christianity. In his *Supplément au voyage de Bougainville* he had prophesied to the Tahitians that 'one day they will come, with crucifix in one hand and the dagger in the other to cut your throats or to force you to accept their customs and opinions; one day under their rule you will be almost as unhappy as they are.'[41] Diderot's prediction about how the conversion to Christianity would happen proved to be extraordinarily accurate. The British missionaries' procedure was to convert the king of the island and to let him use force to 'convert' the people.[42] This led to wars in the first two decades of the nineteenth century during which the king was supported by the missionaries under the banner of putting down 'rebellion'.[43] Further fighting against French annexation (itself as we have seen linked to the religious question between Protestant and Catholic) took place in the 1840s.

Tahiti's status changed in 1880 when the island officially became a colony. J. Métenier welcomed this in his book *Taïti: son présent, son passé, et son avenir* of 1883. He considered the move, by a European nation of over 40 million inhabitants, over a small Pacific island of barely 10,000 people, to be 'an enlargement of our colonial power'.[44] Nevertheless, Métenier praises the vegetation and vigour and the ease of living in ecstatic terms that go beyond a colonizer's utilitarian view, and concludes his book by quoting a recent visitor's celebration of 'scenes of a picturesque beauty almost unique in the world'.[45]

The work of Gauguin

In a letter to J.F. Willumsen, Paul Gauguin (1848–1903) described his reasons for travelling to Tahiti. He wrote,

I shall go to Tahiti, a small island in Oceania, where material life can be lived without money ... In Europe, terrible times are in store for the next generation: gold will be king. Everything is rotten, man and the arts alike. People are constantly being torn apart ... The Tahitian need only lift up his arms to pick his food; for that reason, he never works.[46]

What is arresting about this letter is less Gauguin's assertions that he will find ease and refreshment in Tahiti – this would be an expected conclusion given the ways in which works on Tahiti tended to characterize the island

– than Gauguin's prophecy about Europe. Europeans did indeed plough into a catastrophe, less than 25 years later, with the outbreak of the First World War.

On one level therefore Gauguin characterizes his move to Tahiti as a retreat. However, we can also view it as a trip to this specific colonial landscape in order to see it and understand it.

In this and many other statements before departure, Gauguin presented himself as plainly influenced by the belief – or the wish to believe – that a better, more authentic life could be lived in the remote Pacific rather than in metropolitan Europe.[47] In fact life was difficult for him, as for many others, in Tahiti too, where, as in Europe, a lot depended on how much money you had, and Gauguin had little. However, before we convict Gauguin of being fixated on a nostalgic Rousseauism (the Noble Savage), or condemn him for naivety,[48] or even for an attempt to exploit Tahiti himself, we should see this influence slightly differently. We should see it as an influence of the works of Baudelaire.

Noa Noa (*Scented Island*) was the primary written statement by Gauguin that emerged from his first visit to Tahiti.[49] The book begins with an epigraph from Baudelaire: ' "Dites, qu'avez-vous vu?" *Voyage.*' The reference is to 'Voyage', the final poem of *Les Fleurs du mal*, which concludes the section entitled 'Death'. The epigraph, framing Gauguin's text, sets up the idea that *Noa Noa* amounts to an answer to the question posed. What we must take in, however, are the other implications of the use of Baudelaire's words. As well as being steeped in art historical precedents, Gauguin was highly literary, and we should not dismiss or discount the seriousness of application of this reference. Baudelaire's poem focuses on the voyagers, the mariners, and the propulsion to travel that they feel. These voyagers are driven to wander ('curiosity torments us') in such a way that they will even try to take the approach of death as an opportunity, not caring whether they depart for heaven or hell so long as it is somewhere '*new*'. They live paradox: 'Man, in whom hope is never tired / To find rest runs around like a lunatic'. These travellers never find what they hope for. One stanza is very reminiscent of Baudelaire's 'Voyage à Cythère':

Every islet spied by the look-out
Is an Eldorado promised by destiny;
The imagination that prepares its orgy
Finds nothing but a reef in the morning light.

These mariners know that they are doomed to disappointment, but imagination is the important faculty. In the section immediately succeeding the question quoted by Gauguin, we read that

The glory of the sun on a violet sea
The glory of cities in the setting sun,

Lit up in our hearts a restless desire
To plunge into the sky so alluringly reflected.

This is the poem that Gauguin uses as a framing device for his own account of a trip to the 'New Cythera'. Therefore we must take Gauguin, ex-sailor and ex-stockbroker, as being fully aware of the possible disappointment of his belief, or his wish to believe: Baudelaire's poem clearly states the danger of finding the 'reef' instead of 'Eldorado'. Sure enough, very near the beginning of *Noa Noa* the narrator writes the epitaph of Papeete, the capital of Tahiti. 'It was Europe – the Europe that I had believed I was setting myself free from – under all the more aggravating circumstances of colonial snobbery, a puerile imitation grotesque to the point of caricature. This was not what I had come so far to find.'[50] Gauguin's responses to Tahiti are propped upon Baudelaire's literary achievements of 30 years earlier. Before he even sets foot in Tahiti, the narrator of *Noa Noa* knows that he will be disappointed. Yet the other implication must also be that he felt the important life to be that of the imagination: Baudelaire's poem admires its tormented mariners for the sheer drive of their thirst for discovery.[51] It is on this level, the level of what he imagined, and what his art could lead others to imagine, that Gauguin was making his stake.

How would this relate to specific paintings? Gauguin never shows us, as Hodges does, what might be termed the topography of Tahiti. His art is less concerned with the shape and forms of the island, and more concerned with depicting nooks, usually heavily vegetated and generally with a very limited amount of sky, in which some thought-provoking encounter is taking place. His figures often seem to be simply thinking, or day-dreaming. Gauguin's art was highly intellectual, yet most frequently, even down to our own time, he has been described as a 'decorator' and his art as 'decorative'.[52] The term was first employed (though not about the work of Gauguin specifically) by the critic Albert Aurier in an approving sense, relating to the increased abstraction that he welcomed in Symbolist art, but the relationship with specific qualities in works of art was always only a loose association, hardly even a simile: 'For decorative painting in its proper sense, as the Egyptians ... is nothing other than a manifestation of art at once subjective, synthetic, symbolic and ideist.'[53] Highly useful. We only need to understand four further definitions to be able to agree or disagree. The employment of the term quickly becomes vexed ('by 1906 the term had become unstable') and after that date it was used as often to disparage modern art as it was to praise.[54] This view of Gauguin's work was satirized by Jean-Paul Sartre in *The Age of Reason* (1945). In that novel, the first part of the *Roads to Freedom* trilogy, the central character, Mathieu, takes a young woman he fancies (Ivich) to an exhibition of paintings by Gauguin. Mathieu finds that he cannot enjoy the paintings as he had a few days earlier; he has fallen out with Ivich and finds the exhibition mounted in a building

festooned with the tricolour of the Third Republic and the insignia of the French state. He watches a bourgeois couple inspect a painting:

The gentleman tilted his head back, and eyed the picture with critical intentness. Obviously a personage: he was wearing the Rosette. 'Dear, dear, dear,' he observed, wagging his head, 'I don't like that at all. He positively seems to have conceived of himself as Christ. And that black angel – there, behind him, can't be seriously meant.'

The lady began to laugh. 'Bless me, it's true,' said she, in a flower-like voice, 'it's such a terribly literary angel.'

'I don't care for Gauguin when he tries to think,' said the gentleman portentously.

'The *real* Gauguin is the *decorator*.'[55]

Sartre is quite clear: Gauguin's work was intended for a ruling-class white audience; his intellectual aspirations can be too easily dismissed as naivety by an uncomprehending metropolitan elite: and the classification of him as a 'decorator' is a conservative approach to his art.

The 'black angel' Sartre evokes here can be related to Gauguin's famous painting, *Ia Orana Maria (Hail Mary)*, his depiction of the Virgin Mary and Christ as Tahitian, accompanied by a native angel (1892). The reference clarified in the English version of the title is to the Annunciation in the New Testament, when the archangel Gabriel informs the Virgin Mary that she has been chosen to bear the Saviour. The significance of this painting, in which not only the Virgin but the Redeemer are depicted as belonging to another (that is, non-white) people, can only be fully grasped if we understand that Gauguin wished to sell his works in Europe and that, by definition, because of their high cost and social status, oil paintings tend to be sold to a ruling-class audience.[56] Roman Catholic faith in 1892 disallowed the representation of the Virgin and Child as non-white, and it was not until 1951 that a decision by the Pope permitted them to be depicted thus.[57] Gauguin's image for the white ruling class of some industrialized nation, made in the context of a still-expanding imperial competitiveness, is ultimately controversial because it refutes deeply entrenched hierarchical views through its suggestion that *agapé* (disinterested and sexless love exemplified by the Virgin Mary) and redemption from sin can be found in another race in what became known later as the Third World. The concept of race, a nineteenth-century invention, and controversy over racial superiority may be in abeyance now, but was endemic at every level in industrialized nations in the 1890s.

This painting helps us to identify a strategy that Gauguin evolved to deal with such questions. Near the beginning of *Noa Noa*, the narrator, poorly in bed, is visited by a Tahitian princess, who welcomes him to Tahiti by saying 'Ia orana, Gauguin' ('I greet thee, Gauguin').[58] Gauguin is very gratified and excited to have been greeted like this, and thinks about it afterwards on

his sickbed, murmuring to himself 'Ia orana, Gauguin. Ia orana Princesse.' Painting and text together thus suggest that the Princess takes the place of the archangel Gabriel and Gauguin that of the Virgin Mary! What is conceived in the narrator at this moment? The idea of substitution and reversal as a mode of comprehending. As the Princess Vaïtua sits, the narrator finds her ugly, thinking of cannibals and animal life. As they drink and talk together, that feeling changes. The animal now resembles a '[purring] feline that is contemplating a horrible sensuality'. The narrator finds her 'beautiful, very beautiful ... delicious.' This small and partial conquest of prejudice (or perhaps replacement of one prejudice, racial, with another, sexual) is followed by ones more significant. The narrator moves out of Papeete to a village and some neighbours invite him to share their meal:

This was, between the savages and me, the beginning of a reciprocal winning-over. Savages! The word came inevitably to my lips when I considered these black beings with their cannibals' teeth.

Already however I was beginning to learn their real grace. That little brown head with quiet eyes on the earth, under the bunches of wide leaves of the pumpkins, that little child who studied me around my hut and ran off when my look met his ... As they for me, I was for them an object of observation, the stranger, who knows neither the language nor the customs, nor even the most basic types of labour, the most natural in life. As they were for me, I was for them the 'Savage'. And it was me who was wrong, perhaps.[59]

The crucial chiasmus, 'As they for me, I was for them', expresses the achievement of this part of the mental work of accommodating to a completely different people and way of life. It is repeated for good measure. Mutual understanding depends on reversal of positions and substitution of your normal for their place. This is a mode of comprehending the new situation and its demands.

Approaching Gauguin's works with this insight in mind can help to clarify certain elements in them and certain apparent inconsistencies in Gauguin's life and work that scholars have worried over.[60] Let us take, for example, *Nevermore* (1897) (Plate 13) from Gauguin's second trip to Tahiti. In the latest large exhibition catalogue George Shackelford discusses this painting but ventures no hypothesis about its meaning.[61] Richard Brettell discusses the painting's possible meaning in relation to Edgar Allan Poe's poem 'The Raven', from which the painting's title is derived, but finds few points of 'intersection' between them.[62] He states that Gauguin's figure 'has little of the brazen presence of Manet's *Olympia* to whom she has often been compared'.[63] This is quite true. In fact Gauguin's figure is in tears. This is a picture of deep sadness, and to understand its significance better we need to compare it not to *Olympia* but to the painting on which *Olympia* was modelled, Titian's *Venus of Urbino* (Figure 5.3). Gauguin's image is much closer to Titian's than it is to Manet's. While all three paintings foreground the space of the bed,

Titian's and Gauguin's show two attendant figures in the right-hand half of the background. They both show a fragment of landscape through windows. They both have windowsills quite prominently painted. Titian's lapdog of fidelity has been replaced by a bird of ill omen. What the painting surely signifies by its difference from Titian's is that never more can Tahiti be taken as the 'Isle of Venus'. Its Venusian figure, the young woman, is weeping. We do not know why (although the sketch above of Tahitian history suggests that there might be many reasons, including the prevalence of various types of disease introduced by Europeans). Just as Cythera was destroyed, so the 'New Cythera' has been destroyed. The allusion to Venus, wrapped up as it is in the profoundly melancholy atmosphere of the painting, with Poe's raven's curse barring any way back, surely suggests such inferences. Gauguin provides a monumental emblem of the island's history between Bougainville's time and his own. Gauguin's own comments on the painting referred to 'a certain long-lost barbaric luxury' suggested by this 'simple nude'. He emphasized that the feeling of luxury has been created by 'material made rich by the artist. No nonsense ... Man's imagination alone has enriched the dwelling with his fantasy.'[64] These comments assert the artist's Baudelairian imaginative power, but we should not overlook the way in which the last statement could also apply to Bougainville's apprehension of the island, as much as to Gauguin's painting.

Several works by Gauguin are structured around much stronger references to Manet's *Olympia*, of which Gauguin made a meticulous copy in 1891.[65] Gauguin also had a photograph of *Olympia* with him in Tahiti, which a local woman found 'beautiful', leading Gauguin to muse, 'She had a sense of Beauty! But what would the professors of the Ecole des Beaux-Arts say about her?'[66] Gauguin's *Manao Tupapau* (*Spirits of the Dead Watching*, 1892) (Figure 6.2) should be a relatively straightforward painting to construe, and is in fact one in which we can see Gauguin's mental pattern of substitution and reversal working in its most subtle way. The painting is closely related to an episode of *Noa Noa*. The narrator, unexpectedly delayed on his return home, enters his unlit hut in the early hours of the morning to find that his young Tahitian girlfriend is lying awake, terrified that the spirits of the dead are watching her. A metropolitan white Christian ruling-class audience in the Paris of 1892 is likely to think that the solution to this dilemma is more intense missionary activity, since (in this view) the girl is prey to superstitious terrors and Christians are set free from all that. This is hardly the view that Gauguin would have wanted to promote. Indeed, the narrator in *Noa Noa* is much more sympathetic, and the specific terms in which he describes the incident are important.

Motionless, naked, lying on her stomach on the bed, her eyes immeasurably larger through fear, Tehura looked at me and seemed not to recognize me. I myself remained

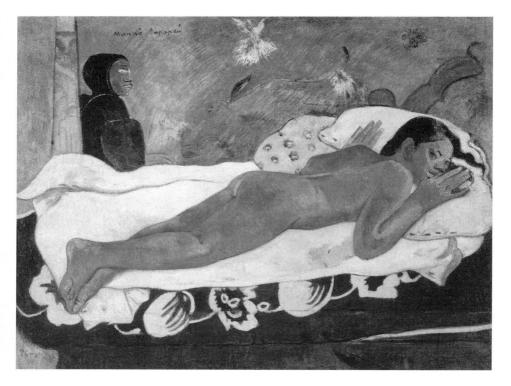

6.2 Paul Gauguin, *Spirits of the Dead Watching* (*Manao Tupapau*), 92.1 × 113 cm (36½ × 44½ inches), oil on burlap mounted on canvas, 1892, Albright-Knox Art Gallery, Buffalo

for a few minutes in a strange uncertainty. A contagion emanated from the terrors of Tehura. It seemed that a phosphorescent gleam flowed from her staring eyes. I had never seen her so beautiful ... In these shadows, peopled with dangerous apparitions and ambiguous suggestions, I feared to make some gesture which would carry the child to a frightful paroxysm. Did I know at that moment what I was for her?

The narrator thinks that he might be taken to be 'one of those demons or spectres'. His next idea completes the reversal and substitution by which he can enter sympathetically into Tehura's dilemma and proceed with patience and empathy: 'Did I even,' he writes, 'know what she was, in truth?'[67]

We can now see why Gauguin needed Manet's *Olympia* for this work. Manet's painting had set up a strict and compelling logic of the gaze. Olympia's look out of the painting is so powerful as to compel the audience to take up a fictional role within the action of the painting. It 'animates the back-space of the painting.'[68] T.J. Clark suggests that some of the animosity that critics directed at it could have been fuelled by their dislike of being put by art into a symbolic relationship that was a little too close to home.[69]

If we apply the same strict logic to *Spirits of the Dead Watching*, we can come to some interesting conclusions. The question of where, in the painting, these spirits are, is a starting point. In his *Cahier pour Aline* Gauguin wrote of the four greyish flashes in the background, 'These are *tupapau* flowers [that is, phosphorescent lights] and show that the spectres take an interest in us humans. That is the Tahitian belief.'[70] We seem to be required to take the figure leaning its back on a pole to the left to be a spectre, however solid and non-threatening it may seem to us (it seems rather like one of Gauguin's imaginations of the missing *tii* figures). However, this is not to deny that on another level the function of that figure is to clinch the identification with *Olympia* by providing an equivalent for the black servant of *Olympia* and to balance the composition.[71] Gauguin continues in the *Cahier*, 'The title *Manao Tupapau* ("*Thought or Belief and the Spectre*") can have two meanings: either she is thinking of the spectre or the spectre is thinking of her.' This is a characteristic Gauguin chiasmus.

Thus in *Noa Noa* there is an emphasis on exchange of vision, of looks; and in the *Cahier* one on the exchange of thinking. Given this insistence on reciprocity, and the logic introduced from *Olympia*, it is possible to make another answer to the question of where the spirits of the dead are, whether or not we accept the silent watcher as being one. The young woman is being frightened, oppressed, by the beings watching her. Who is watching her, and thinking about her, if not the ruling-class white metropolitan imperial audience gazing into Gauguin's painting in the mid-1890s? Gauguin uses Manet's logic to thrust into the faces of his audience an identity as oppressive spirits and a dilemma taking place on the very ground of supernatural belief on which some at least of that audience, presumably, feel so secure. It is difficult to believe that in pre-colonial Tahiti, with its practices of anointing corpses, bringing bones home, and revering (even worshipping) ancestors (among other things, using *tii* figures to do so), the cult of ancestors involved a large degree of terror. The association of the dead with terror is surely the product of Christian missionary activity, teaching the natives that their *tii*s are idols and their objects of reverence devils, or evil spirits.[72] Douglas Oliver, in *Ancient Tahitian Society*, has to rely for his most detailed accounts on the years after exposure to Christianity. Despite this handicap, he is able to clarify that pre-Christian Tahitians took steps, through ritual practices and religious observances often connected with specific days in the calendar, to prevent spirits of the dead from becoming angry.[73] What we can say is that for islanders caught between the old culture and Christianity, knowing that they were neglecting their ancient practices of respect and mollification of ghosts, the anger of the dead would, as it were, become more threatening. Satan was introduced to Tahiti by the missionaries, for it was they who created sin in the island.

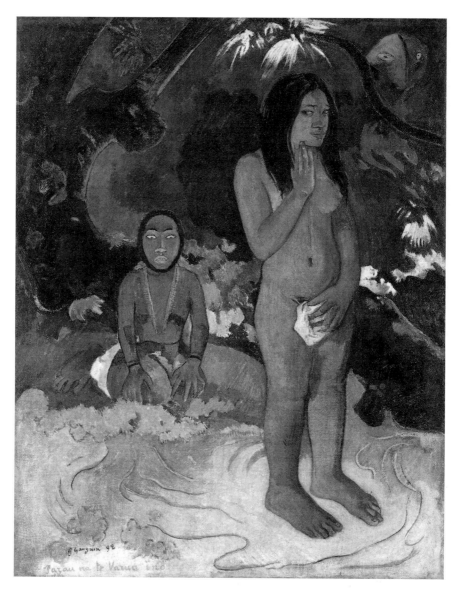

6.3 Paul Gauguin, *Words of the Devil* (*Parau Na Te Varua Ino*), 91.7 × 68.5 cm
(36 × 27 inches), oil on canvas, 1892, National Gallery of Art, Washington

Another painting by Gauguin from 1892, *Parau Na Te Varua Ino* (*Words of the
Devil*) (Figure 6.3) is surely relevant to this theme. In the 1988 catalogue, Charles
Stuckey writes that 'this painting's symbolism is ultimately indecipherable'.[74]
The young woman is usually identified as 'a' figure of Eve at the moment

after the Fall from grace in the Garden of Eden. Yet what would that mean once translated to the colonial Tahitian circumstance? She stands in a posture connoting shame. She hides her private parts with a handkerchief, and touches her cheek with her hand in a gesture of anxiety. Yet Commerson had reported that there was no concept of shame among Tahitian women. Who has introduced the concept of shame into this South Sea paradise? Surely not just the odd figure behind her with its giant foot. However much scholars agree to identify this figure as a 'demon'[75] or an 'evil spirit'[76] the fact remains that it does not seem particularly threatening or frightening. The figure is clothed in a parody of the long blue dress favoured by missionaries, which buttoned to the neck. It is also not the only threatening image in the painting. In the top right-hand corner a strange face-like mask, half red and half green, bites or sucks the thumb of a ghostly hand. Gauguin's mixture of Christian and native mythology, worked on by his characteristic substitution and reversal, strongly implies that the concept of shame that is oppressing this Tahitian woman has been introduced by the missionaries themselves. In *Noa Noa* he tersely reflects on the Protestant bishop, 'down there, what the missionary wants, God wants,' and is puzzled by strange marks on the face of an old woman until he is horrified to discover that in the old days the Protestant missionaries tattooed the faces of 'sinners' among the locals with marks of infamy.[77]

Gauguin sailed to France in 1893, to return to Tahiti in 1895. In 1901 he moved 740 miles to Hivaoa in the Marquesas Islands, another part of French Polynesia. In the last 18 months of his life he undertook various activities on behalf of native interests.[78] He refused to pay taxes, and encouraged the natives to do the same. He attempted to dissuade native parents from sending their daughters to school, and this provoked intervention from the Catholic bishop, who was then caricatured by Gauguin in statues displayed outside his house. He wrote against the islands' governor for the islands' independent newspaper. He tried to defend in court 29 islanders accused of drunkenness. He was sued for libel by the governor. Clearly Gauguin had gone a long way beyond his conception of the South Sea islands expressed in the letter to Willumsen some ten years before. He had become an activist.

One of the paintings that came from this period is *Contes Barbares* (Plate 14). The interpretation of this picture has been vexed for art historians.[79] Of the left-hand figure, Françoise Cachin has written, 'it is as if the painter's dead friend [Meyer de Haan] has returned, a dreaming, pathetic phantom, to personify Gauguin's Judeo-Christian metaphysics, his syncretic pantheon of mythologies and religions.'[80] However, how can the figure reasonably be described as 'pathetic' when it is consumed with a crazed feverishness, gnawing its own fingers and extending toes that lengthen into talons, equipped not with toe-nails but with claws? This is a demon. Other questions need to be raised. Was Gauguin's 'metaphysics' Judaeo-Christian? How does the figure of a gargoyle, which is what this is, 'personify' them? And how does a friend

personify Gauguin's personal beliefs? In the same volume Richard Brettell finds this figure 'a deliberate enigma' and finds it associated with 'the West'.[81] Brettell states that it is 'the central figure' in the painting.[82] Later on, however, he finds that the right-hand figure is 'the central figure'.[83] For Brettell, the only figure in the painting that is not 'central' is the figure in the middle.

Partly interpretation is vexed because of the way recent curators have chosen to translate the painting's title: as *Primitive Tales*. This translation throws away an antithesis that is fundamental in the painting's French title. Barbarians are only definable as barbarians by people who consider themselves as civilized. The word was first used by ancient Greeks for people who did not speak Greek. Thus the title *Barbarian Tales* sets up such an antithesis while *Primitive Tales* does not. Given Gauguin's characteristic rhetorical strategy, of substitution and reversal, this is important. It brings up, for example, the question, who are the barbarians here and who are the civilized ones? A white Christian metropolitan Euro-American audience of 1902 would surely be tempted to assume that the obvious representative of the white race, the figure on the left with his red hair and moustache, is civilized and the natives are by definition the barbarians. Yet such a reading is not tenable. The gargoyle's feverish intensity, his malicious face and claw-foot, all bespeak a devilish character. He is also dressed, ludicrously, in the kind of dress the missionaries put island women into.[84] The red hair of the native woman on the right links her to him by an association of colour, but surely we do not need to interpret this as anything more than a comment by the artist that European presence has already changed the South Pacific, a fact of which Gauguin was painfully aware every day he spent there.[85] Nevermore will there be an unspoilt South Sea.

According to this interpretation, the figure in the middle becomes (I dare to say it) central to Gauguin's reversal of expectations of the barbarian/civilized antithesis, and his substitution of the expectations of one race for another. I used to assume, as Brettell does, that this figure is female, until a class of undergraduates at the University of Texas at Austin in the Spring of 2005 pointed out that it could well be a young man.[86] In *Noa Noa* the narrator meditates on the androgynous character of certain Tahitian young men (and this section of Gauguin's text qualifies as a Rousseau-like – or St Preux-like – reverie that ends with the narrator's victory over himself to avoid taking potentially destructive action).[87] In *Barbarian Tales* the central figure's attention is directed towards the red-haired woman and he ignores the gargoyle behind him. He sits in a meditational Buddhist pose and his right hand reaches down towards the earth. The significance of this figure surely goes far beyond mere art historical source-hunting to find the motif in photographs Gauguin possessed of statues on the large Javanese Buddhist monument of Borobodur.[88] He represents the key element, in the absence of which we would have to conclude with Brettell that 'the various allusions created by Gauguin do not present a solution or meaning'.[89]

On the contrary, if we allow this figure enough weight, coherence emerges. The gesture he makes echoes that made by the Buddha Shakyamuni, touching the earth to call upon the earth to witness his right to achieve enlightenment after his victory over the demon Mara.[90] This is the crucial moment in the story of the Buddha, when enlightenment is achieved. In this painting Gauguin the activist may suggest that the way ahead for Pacific islands, away from the damage already caused by Euro-Western interference, is by rejecting the demonic influence of Christianity and by seeking out other (non-European) civilizations and spiritual beliefs; specifically, in fact, one of them – Buddhism. The narrative climax in *Noa Noa* supports the specificity of this assertion. The narrator spends the day at sea, fishing. He becomes inflamed with jealousy against his woman, Tehura, by jokes made by his fellow fishermen, and jumps to the conclusion that Tehura is taking a lover while the narrator spends the day at sea. That evening he accuses Tehura, who denies the accusation and then utters a prayer. What she says is a form of prayer recorded by J.A. Moerenhout, whose ethnological work was one of Gauguin's chief sources of information about ancient Tahitian beliefs.[91] The prayer is also printed, in English translation, by Douglas Oliver, who finds it 'pre-Christian in content [but] quite Christian in tone'.[92] After saying her prayer, Tehura turns to the narrator and says calmly, 'You must beat me, hit me a lot.' The narrator's anger is quite defeated by this idea, which Tehura then reiterates: 'It is necessary for you to beat me, hit me a lot, otherwise you will be angry for a long time and you will be ill.' The narrator instead embraces her, and continues, 'My eyes, which now admired her without suspicion, said these words of the Buddha: "Yes, it is by gentleness that you need to vanquish violence; by goodness, evil; by truth, lies".'[93] This utterance, and indeed the whole incident narrated in this episode of *Noa Noa*, can be related to one of the central teachings of Buddhism, the necessity to overcome anger, ignorance and desire to help escape from the cycle of suffering and achieve enlightenment. The victory is first won by Tehura, whose example then teaches the narrator. In his turn he overcomes his jealousy and anger. The central figure of *Barbarian Tales* emerges as an exemplar of an ancient civilization, flanked by a European barbarian and a native who has been changed by the barbarian touch. The Buddhist path might represent her best hope of avoiding an attack from the monstrous face emerging from the mist above the iris flower behind her.

Notes

1. Richard Warner, *A Tour thro' the Northern Counties of England, and the Borders of Scotland* (Bath, 1802), quoted in Michael Charlesworth, *The English Garden 1550–1910: Literary Sources and Documents*, 3 vols (Robertsbridge: Helm Information Ltd, 1993), vol. 3, p. 58. 'Otaheite' was the eighteenth-century British name for Tahiti.

2. The King's instructions are reprinted by Louis Constant in his 'Introduction' to L.A. de Bougainville, *Voyage autour du monde*, 1771 (Paris: Editions La Découverte, 1985), pp. viii–xi.

3. Quoted in Constant, 'Introduction', pp. vi–vii.

4. However, things being what they are, it is quite conceivable that, as commander, Bougainville was the *last* person aboard to have known about this concealment.

5. Constant, 'Introduction' p. xv.

6. Quoted in Constant, 'Introduction', pp. xvi–xvii. By 'Utopia', Commerson intends 'Happy Place' rather than 'No Place'.

7. Constant, 'Introduction', pp. xxii–xxiv.

8. *Ibid.*, p. xxiii.

9. Bougainville, *Voyage*, pp. 128–9.

10. *Ibid.*, p. 131.

11. *Ibid.*, p. 138.

12. *Ibid.*, pp. 138–9.

13. *Ibid.*, pp. 148–9.

14. *Ibid.*, pp. 151–2.

15. *Ibid.*, p. 153.

16. Louis-René de Girardin, *De la Composition des paysages* (Geneva, 1777), especially the final sections. Translated into English by Daniel Malthus as *An Essay on Landscape* (London, 1783).

17. Bougainville, *Voyage*, pp. 154–7.

18. *Ibid.*, pp. 154, 170.

19. *Ibid.*, pp. 157–8.

20. If we can judge by full-page coloured advertisements by Air Tahiti Nui printed in the *New York Times* supplement in the autumn of 2005, depicting a painting of a green Tahitian paradise completed by the figure of a young Tahitian woman and naming the nearby Bora Bora as the 'world's sexiest island'. The painting is a sort of combination of Hodges' and Gauguin's art.

21. Bougainville, *Voyage*, pp. 139, 141, 143, 147.

22. For example, 'most of our people made pritty free use of their Women': Captain Cook, *The Journals of Captain James Cook on his Voyages of Discovery: II, The Voyage of the* Resolution *and* Adventure *1772–1775*, ed. J.C. Beaglehole (Cambridge: For the Hakluyt Society at the University Press, 1969), p. 215.

23. A useful and brief summary history is provided in Andrew David (ed.), *The Charts and Coastal Views of Captain Cook's Voyages*, vol. I (The Hakluyt Society of London in Association with the Australian Academy of the Humanities, 1988), p. xxxviii.

24. Alexander Dalrymple, *Essay on Nautical Surveying* (1771), quoted in the really useful essay by Luciana de Lima Martins, 'Mapping Tropical Waters: British Views and Visions of Rio de Janeiro', in Denis Cosgrove (ed.), *Mappings* (London: Reaktion Books, 1999), p. 155.

25. Jean-François de Lapérouse, *Voyage autour du monde sur L'Astrolabe et La Boussole* (1785–88), ed. Hélène Minguet (Paris: Librairie François Maspero, 1980), p. 45.

26. Admiralty instructions to Cook about Hodges, quoted by John Bonehill, 'Hodges and Cook's Second Voyage', in G. Quilley and J. Bonehill (eds.), *William Hodges 1744–1797: The Art of Exploration* (New Haven and London: Yale University Press, 2004), p. 74.

27. George Forster, *A Voyage round the World*, 1777, quoted by David Bindman, ' "Philanthropy seems natural to mankind": Hodges and Captain Cook's Second Voyage to the South Seas', in Quilley and Bonehill, *William Hodges 1744–1797*, p. 23.

28. Information about the *tii* figure, the longhouse and the elevated platform comes from Bernard Smith, in Rüdiger Joppien and Bernard Smith, *The Art of Captain Cook's Voyages*, vol. II (New Haven: Yale University Press, 1985), pp. 63–64. Smith does not discuss Hodges' brushstroke or Forster's testimony.

29. Quoted in Bindman, ' "Philanthropy" ', in Quilley and Bonehill, *William Hodges*, pp. 23–4. Bindman argues that Hodges' Tahitian paintings can be related to contemporary proto-ethnological theorizations of sustenance/climate/character. Certainly such theories left their impact in the concepts found in Bougainville's *Voyage*. In the case of Hodges' paintings, such theorizations might find material in his work, but his work cannot be judged to illustrate such theories. Bindman's essay contains several minor errors: for example, he puts Bougainville on Tahiti in 1770 (p. 22) rather than 1768, and puts Wallis there in 1766, rather than 1767 (p. 23), thus giving the impression that four years, rather than the actual nine months, separated the two expeditions.

30. See, for example, and as just one example among many in a large number of essays by this scholar, Richard Shiff's discussion of a zig-zag blue brushstroke in a seascape by Claude Monet in 'Something is Happening', *Art History* 28, 5 (2005), pp. 765–7.

31. For example, British Library Add. Mss. 15743. The reproduction of these drawings in books, so much smaller than the originals, usually obfuscates this arresting aspect of the drawings.

32. Greg Smith, *Thomas Girtin: The Art of Watercolour* (London: Tate Gallery, 2002), p. 39.

33. *Ibid.*, p. 40.

34. Colin Newbury, *Tahiti Nui: Change and Survival in French Polynesia 1767–1945* (Honolulu: University Press of Hawaii, 1980).

35. Figures taken from Alan Moorehead, *The Fatal Impact: An Account of the Invasion of the South Pacific 1767–1840* (New York: Harper and Row, 1966).

36. *Ibid.*, p. 88.

37. Quoted in Moorehead, *Fatal Impact*, p. 87.

38. This Italian phrase means 'the sweetness of doing nothing' – an enjoyable idleness.

39. C. Hartley Grattan, *The Southwest Pacific to 1900* (Ann Arbor: University of Michigan Press, 1963), quoted in Moorehead, *Fatal Impact*, p. 80.

40. Ingrid Heermann, 'Gauguin's Tahiti – Ethnological Considerations', in C. Becker (ed.), *Paul Gauguin Tahiti*, exhibition catalogue (Stuttgart: Verlag Gerd Hatje, 1998), pp. 150–151.

41. Quoted in Moorehead, *Fatal Impact*, p. 43.

42. This procedure is complained about by J. Métenier, *Taïti: son présent, son passé, et son avenir* (Tours: Cattier, 1883), pp. 306–7.

43. Newbury, *Tahiti Nui*, pp. 34–48.

44. Métenier, *Taïti*, p. 330. Census figure of 10,347: p. 339.

45. *Ibid.*, p. 343.

46. Paul Gauguin, *Writings of a Savage*, ed. Daniel Guérin, trans. Eleanor Levieux (New York: Viking, 1978), p. 45. Original French edition, 1974. The letter is from 1890.

47. A selection of such utterances is discussed by almost everyone who writes about this artist's overseas work. See, for example, George Shackelford and Claire Frèches-Thory (eds), *Gauguin Tahiti*, exhibition catalogue (Boston: MFA Publications, 2004), pp. 4–24.

48. Frèches-Thory, in Shackelford and Frèches-Thory, *Gauguin Tahiti*, p. 18, toys with this idea.

49. Isabelle Cahn's essay on *Noa Noa* in Shackelford and Frèches-Thory, *Gauguin Tahiti*, pp. 91–114, does not interpret the text: she attempts to clarify the vexed history of the various manuscripts and publications and discusses the 'iconography' of the illustrations.

50. Paul Gauguin, *Noa Noa: voyage de Tahiti* (Paris: Les Editions G. Crès et Cie, 1929), Edition Définitive, p. 31.

51. For an idea of the importance to Gauguin himself of his created persona of artist-sailor see the excellent brief summary of his personality by Elizabeth C. Childs, 'Seeking the Studio of the South: Van Gogh, Gauguin, and Avant-Garde Identity', in C. Homburg (ed.), *Vincent van Gogh and the Painters of the Petit Boulevard*, exhibition catalogue (St Louis: St Louis Art Museum 2001).

52. This characterization is virtually ubiquitous. It is all over the art historical survey texts, and occurs, for example, in Becker, *Paul Gauguin Tahiti*, p. 20.

53. Albert Aurier (1891), quoted (in English) by Gill Perry, 'Primitivism and the "Modern" ' in Charles Harrison et al., *Primitivism, Cubism, Abstraction: The Early Twentieth Century* (New Haven

and London: Yale University Press and the Open University, 1993), p. 21. Perry's summary of 'decorative', drawing on the work of Roger Benjamin, is very useful.

54. Perry, 'Primitivism and the "Modern" ', p. 53.

55. Jean-Paul Sartre, *L'Age de raison* (1945), trans. Eric Sutton as *The Age of Reason* (1947: London: Penguin Books, 1961), p. 72. Emphases in the original. The whole of Chapter 6 relates to the Gauguin exhibition. The book is set in 1938. There was an actual Gauguin exhibition in Paris in 1936.

56. See Elizabeth C. Childs' summary of this question in 'Seeking the Studio of the South', in Homburg, *Vincent van Gogh*, p. 113.

57. R. Brettell et al., *The Art of Paul Gauguin*, exhibition catalogue (Washington: National Gallery of Art, 1988), p. 245.

58. Gauguin, *Noa Noa*, pp. 38–41.

59. *Ibid.*, p. 45.

60. Charles Stuckey, 'The First Tahitian Years', in Brettell et al., *Art of Paul Gauguin*, tends to be ironic about and suspicious of Gauguin on the grounds that there are contradictions within things Gauguin said, and between what he said and the works. Therefore Stuckey seems to fear that Gauguin was being insincere. Françoise Cachin's essay in the same catalogue shares this approach. Richard Brettell is much more patient with Gauguin. Christoph Becker takes a more confident approach in 'Gauguin and Tahiti', in Becker, *Paul Gauguin Tahiti*. However, in general irony in treatment of Gauguin is a marked feature of much of the writing about him. My own approach emphasizes the idea of separating the biography of the biological entity, Gauguin, from the literary device of the narrator's voice in *Noa Noa*.

61. Shackelford and Frèches-Thory, *Gauguin Tahiti*, pp. 156–8.

62. Brettell in *Art of Paul Gauguin*, pp. 411–413.

63. *Ibid.*, p. 412.

64. *Ibid.*, p. 411.

65. *Ibid.*, pp. 202–3.

66. Gauguin, *Noa Noa*, p. 47.

67. *Ibid.*, pp. 92–3.

68. Charles Harrison, lecture at the University of Texas, Spring 1996.

69. T.J. Clark, *The Painting of Modern Life: Paris in the Art of Manet and his Followers* (Princeton: Princeton University Press), pp. 98–103.

70. Quoted in Shackelford and Frèches-Thory, *Gauguin Tahiti*, p. 56.

71. Gauguin's strategy in deliberately evoking *Olympia* was recognized and the central figure dubbed 'the Olympia of Tahiti' in Paris as early as 1893. See Brettell et al., *The Art of Paul Gauguin*, p. 282.

72. Cf. Newbury, *Tahiti Nui*, p. 39, for increasing native use of the word 'Satani' to designate tutelary deities, and for the disrepair of some of the deities' sacred precincts by 1813.

73. Douglas Oliver, *Ancient Tahitian Society*, 3 vols (Honolulu: University Press of Hawaii, 1974).

74. Brettell et al., *Art of Paul Gauguin*, p. 268.

75. Becker, *Paul Gauguin Tahiti*, p. 40.

76. Brettell et al., *Art of Paul Gauguin*, p. 266.

77. Gauguin, *Noa Noa*, pp. 97–9.

78. My information about these years is derived from Gloria Groom's 'Chronology' in Brettell et al., *Art of Paul Gauguin*, pp. 379–87, and David Sweetman, *Paul Gauguin: A Life* (New York: Simon & Schuster, 1996).

79. See, for example, convoluted moves by House and Maurer summarized in Brettell et al., *Art of Paul Gauguin*, p. 494. George Shackelford finds it a 'most mysterious and elusive figure composition', Shackelford and Frèches-Thory, *Gauguin Tahiti*, p. 254.

80. Brettell et al., *Art of Paul Gauguin*, p. 169.

81. Meaning 'the Western or European world'. Brettell et al., *Art of Paul Gauguin*, pp. 492–3.

82. *Ibid.*, p. 492.

83. *Ibid.*, p. 494. Vexed interpretation continues in the 2004 *Gauguin Tahiti* catalogue (ed. Shackelford and Frèches-Thory), where Elizabeth C. Childs suggests that 'the meeting of the three figures might represent the shared spiritual ground of three great religious traditions' (p. 239). There is no justification in the image for this cosy ecumenical interpretation. In the same catalogue Shackelford finds the left-hand figure to be a 'monster', p. 254.

84. In a rather surprising interpretation, Stephen Eisenman states that this figure represents, among other things, an 'ugly old woman': see his *Gauguin's Skirt* (London: Thames & Hudson, 1997), p. 109. Eisenman describes the figure as 'grotesque' and also characterizes it as a male figure. He repeats the mistranslation of the title as *Primitive Tales*.

85. Eisenman believes the hair has been deliberately dyed red with lime, indicating 'sexual availability' (*Gauguin's Skirt*, p. 109). However, the sociological evidence that he cites to support this assertion derives from a different island, Samoa, and in any case the interpretation demands that we ignore the patently evident metonymic link between the two figures created by the artist.

86. *Ibid.*, p. 493, for Brettell's assumption. George Shackelford sees 'two women', in Shackelford and Frèches-Thory, *Gauguin Tahiti*, p. 254. So does Eisenman, *Gauguin's Skirt*, p. 109.

87. See Gauguin, *Noa Noa*, pp. 62–6.

88. For example, Elizabeth C. Childs, in Shackelford and Frèches-Thory, *Gauguin Tahiti*: 'a Polynesian woman (perhaps intentionally androgynous) sits in a yoga position derived from Borobudur photographs', p. 239.

89. Brettell et al., *Art of Paul Gauguin*, p. 493.

90. For this interpretation I am immensely indebted to conversations with my colleague Dr Janice Leoshko, who teaches Buddhist art at the University of Texas at Austin.

91. J.A. Moerenhout's *Voyages aux Iles du Grand Océan* was published in 1837.

92. Oliver, *Ancient Tahitian Society*, p. 127. (The pages in the three volumes are numbered consecutively.)

93. Gauguin, *Noa Noa*, pp. 151–2.

Monet re-states and Mallarmé suggests the subject matter

Introductory, including poplars

A reader picking up a book about landscape in the nineteenth century would probably anticipate sections dealing with the British watercolour painters, John Constable, the Pre-Raphaelites; and, across the Channel, the Barbizon painters and the Impressionists. Yet this present work so far contains little or nothing on most of these topics and the reader can be forgiven for feeling a little surprised about that. The main reason, of course, for omission has been because this book is not about the lines of descent of landscape painting; it is about visual culture, which means that, taking a holistic view, it embraces poetry and prose, landscape gardens, popular entertainments like the Panorama and the Phantasmagoria, as well as painting and drawing. The omissions made are also implicit in the methods applied in this study, which does not approach its subject as if drawing and painting, popular entertainments, landscape gardens and literature were positivist subjects hermetically sealed from each other and from cultural life going on around them; instead, it regards them as intersecting practices much given to affecting each other over or through conventionally placed disciplinary boundaries.

One could put it another way by changing the focus to the practitioners for a moment: however much the craft elements in poetry, garden design and visual art necessitate long apprenticeships, we cannot expect the poets, artists and designers to set about the making of their works in frames of mind that exclude everything they have been exposed to in culture except what pertains narrowly to their craft. Indeed, to suggest that they did proceed in such a sealed-off manner would amount to a sort of higher philistinism. In fact, the preceding chapters show that the opposite was the case. This book's interest lies in the insights into cultural history, in the two countries concerned, that can be gained from a study of the interactions of varying cultural practices around the themes of landscape and vision. To borrow Marcel Proust's phrase, this book is less about the trees themselves, but about the mist between the trees, at Chantilly.

One view of landscape painting during the nineteenth century could suggest that the elevation of the relatively low-status genre of landscape was one of the ways that the academic system was toppled in nineteenth-century France. Thus the Impressionist painters, exploiting conceptual breakthroughs made by Manet that we discussed in Chapter 5, amounted to a revolutionary force in French art. The elevation of another lowly genre, still-life painting, by Cézanne contributed to the victory. The Impressionists themselves drew also on the energies of *plein air* painting derived from the watercolour painters of Britain via Constable's presence in the Salons of the 1820s, and via Turner and Whistler.

Instead of going over all this I wish to turn to the period at the end of the century when the main campaign had been won. I would like to examine one example of a particular practice of landscape painting that emerged late in the nineteenth century and that is especially linked with the name of Claude Monet (1840–1926). This is Monet's practice of creating series of paintings of specific subject matters. As the example, I choose the series of 24 paintings of poplar trees on the River Epte, from 1891.[1] The point of examining what Monet achieved in these paintings is specifically to understand why he painted in series: what he gained by making a series of paintings showing small and subtle variations in the same subject, and what we gain by seeing them; and how this becomes a highly successful art of landscape – in fact we must discuss how such a practice amounted to the only way for him to achieve what he wanted.

One point that needs to be made as a preliminary clarification is that scholars agree that one of the chief precedents for Monet's painting in series was provided by the Japanese artists, Hokusai and Hiroshige.[2] Hokusai's *Thirty-Six Views of Mount Fuji* showed a series of differing views, all of which contained Mount Fuji in them, sometimes seen large in elevation, at other times as a small feature on the horizon, or even nearly completely concealed behind foreground action or vegetation. Hiroshige's *Famous Places around Edo* series contained several instances in which the same scene, printed from the same woodblock with different inking sequences, created very different images (for example, night and day views of the same place). An example of this specific technique owned by Monet were the day and night views from this series of *The Isle of Tsukuda*.[3] Monet's collection of Japanese prints also contained works by Hokusai. The Japanese artists had been, among many other things, in search of the communication of experience. Hokusai's views of Mount Fuji are interested in showing the subject constantly in or on the edge of consciousness; they value the same scene at different times of day. The French artist Henri Rivière seized on this aspect in his lively imitation, *Thirty-Six Views of the Eiffel Tower* (1888–1902). His print series, explicitly and heavily modelled on the Japanese examples and presenting itself in a Japanese idiom typographically and through the appearance of the prints, shows the

Eiffel Tower, beginning with its construction in 1888 ready for the Exposition Universelle of the following year. Some of the prints contemplate the Tower from close by; but in many it features as a small mark above the distant horizon, or as a half-seen or subliminally registered presence above roofs in the middle distance. The idea absorbed and pursued by Rivière has been to communicate some conception of the ways in which the Eiffel Tower impinges – or fails to – on the daily lives of Parisians (especially of the working class, who are the most frequently seen and foregrounded group in the images).

By 1891 Monet was living at Giverny, very close to the meandering River Epte, a diverted branch of which flowed through his garden. He had become wealthy; the days of dearth of the 1860s and 1870s were very firmly behind him. To paint his subject matter of 1891, the poplars, he had first to preserve the trees in question (on a temporary basis) by becoming their part-owner. The village of Limetz had planted them originally as an investment, and by 1891 they were ready for felling. In partnership with a wood merchant, Monet bought the trees at auction. The partner agreed not to fell until Monet had finished with them. The 24 paintings Monet made occupied most of the year, from spring to early autumn.

Paul Tucker has argued the case that in painting images of poplar trees Monet was reflecting on the French nation at a time of various crises in public life. He argues that poplars are national trees of France, symbolic of the nation as a whole, rather like oaks in Britain and Germany, and by making them central and dwelling on them at length Monet reasserts enduring French values in the face of the turmoil of loss in the Franco-Prussian war, doubt about national power, and so on.[4] While we ponder this position, it is worth looking a bit more closely at the trees themselves (Plates 15 and 16).

We can see clearly that the village has already been benefiting economically from the trees, which have been shredded; that is, their branches have all been cut off up to the crowns, to produce poles used in a variety of rural purposes without killing or felling the tree. This mediaeval practice of wood management had become obsolete in Britain by early in the eighteenth century, but was still standard practice in rural France into the twentieth century. The shredding provides the basis for a major element of composition in Monet's paintings.

The pattern of planting the trees has been determined by the winding of the River Epte. The trees are planted on the riverbank because they can grow well there at the water's edge in a place that otherwise would not be used economically. Like most trees in rural Europe they are there because they have an economic value. Monet could only paint them because of his own economic intervention. The pattern they make against the sky is therefore a product of human beings working in harmony with nature. Nature has produced the basic forms – the wandering Epte, the standard form of the poplars – but the trees have not grown spontaneously; they have been planted as cuttings by

people, for a purpose other than an ornamental one, and they have then been shaped; again, not for aesthetic reasons. All this has been happening on the level of the parish, but it has much larger, indeed global, ramifications.

These are not the native black poplar of northern Europe, a massive tree that grows leaning. Nor are they Lombardy poplars like the trees that stand around Rousseau's tomb at Ermenonville. Those trees, *Populus nigra italica*, are all clones of a single tree found growing in a fastigiate or pencil shape in northern Italy in the middle of the eighteenth century. It can now be found all over the world. It must therefore represent the most successful ever worldwide dissemination not of a species of life, but of *a single individual of a species*. Monet painted the Lombardy poplar in *The Poppy Field: (Giverny)* of 1890, and in a similar painting of the same name from 1891. A poplar of similar appearance that is native to Central Asia is a variant of the white poplar, *Populus alba pyramidalis*.

If Monet's trees in the 'Poplar' series are not these, then what kind are they? The eminent botanist and ecologist of woods, Oliver Rackham, identifies them as hybrid poplars in a passing comment:

Since this time [1805] fashions in hybrid poplars have come in quick
succession. The commonest, though now *démodé* poplar is the 'Black
Italian', a big leaning tree which looks like a factory-made poplar lacking
all its rugged distinctiveness (although the French Impressionist painters,
having no real black poplars, contrived to see beauty in it).[5]

This gets us somewhere. Hybrid black poplars (*Populus x euromerica* in one classification, *P. x canadensis* in another) were produced from crossing the European black poplar (*Populus nigra*) with the cottonwood (*Populus deltoides*) of North America.[6] They were planted throughout Europe as the hybrids proved to be more vigorous and more easily propagated than either parent. Many named clones are now available. There is the railway poplar, *regenerata*, a female clone that arose in France in 1814 and was widely planted especially to screen railways: but it is not this in Monet's paintings, because the branches of this subspecies ascend straight, parallel to the trunk, 'before arching over and fanning outwards.'[7] Monet's poplars branch out vigorously at acute angles, almost at 45° to the trunk. It is tempting to think that Monet's paintings show the male clone *robusta*, which also emerged in France, but that did not happen until the end of the nineteenth century, which would put Monet's trees a generation too early.

Of the hybrid blacks, *P. x euromerica serotina* is perhaps the oldest, and grows to 150 feet (45 metres) tall, with wide-spreading and ascending branches.[8] Oleg Polunin gives the vernacular name, black Italian poplar, *serotina*, describing 'bronze young foliage and yellowish-buff twigs'.[9] His illustration of a hybrid black poplar certainly shows Monet's tree, tossing in the wind.[10] We learn that *serotina* emerged in France in 1750, is very common in river valleys, and

has pale grey bark, deeply fissured vertically and peculiarly regularly.[11] This property of the bark is shown clearly by Monet in *Poplars (Autumn)* in the Philadelphia Museum of Art. Mitchell describes *serotina* as having a huge open-cup crown with the final branches nearly vertical. The tree has a broad triangular leaf and it grows astonishingly fast: perhaps 6 feet (2 metres) a year, over 100 feet (30 metres) in 30 years.[12] This is the tree that the village of Limetz decided upon for its investment.

What difference does it make to identify the precise variety of poplar depicted in the paintings? Aside from any intrinsic interest it may have, it probably makes very little difference. No doubt it is academic pedantry of a classic order. However, it is noticeable that the examples of images of poplar trees advanced by Tucker to show how poplars were depicted as a national French tree all show the Lombardy poplar and are, therefore, strictly speaking, not the same tree as those depicted by Monet. Perhaps this makes little difference to Tucker's thesis. No doubt the prime reason why poplars became chosen as the revolutionary Tree of Liberty and a symbol of Revolutionary and Republican France (as opposed to the monarchic and Napoleonic France of 1799–1830, 1831–1848 and 1853–1870) was the similarity in the French words *peuple – peuplier* (people – poplar). This pun would apply to *serotina* as much as Lombardy. The strongly similar quality of these clones, where every specimen of Lombardy poplar resembles every other, and every specimen of *serotina* every other, could be open to revolutionary allegory, given the importance of 'equality' in the famous motto of the French Revolution, 'Liberty, Equality, Fraternity'. This would apply to either variant. Why then was Lombardy poplar preferred as the Liberty tree, especially since *serotina* emerged in France rather than Italy? Perhaps the importance of the iconography of Rousseau's tomb at Ermenonville, around which the Lombardy poplar stands, should not be underestimated here. Paintings and engravings of the tomb popularized its iconography, and when Rousseau's ashes were brought to Paris in 1791 they rested overnight in the Tuileries Gardens in a staged setting designed to replicate the island at Ermenonville, with poplars in pots set around the urn. The scene was painted by Hubert Robert.

Painting a series

If we look at Monet's *Poplars (Wind Effect)* (Plate 15) we see an image that John Constable would have envied. When the British artist was asked what he was trying to paint in his art, he replied that he intended his paintings to be 'lively – & soothing – calm and exhilarating, fresh – & blowing' and 'silvery, windy & delicious'.[13] He aimed to capture 'light', 'dews', 'breezes', 'bloom' and 'freshness'.[14] The words all refer to the feeling of being out of doors on a day like the one depicted by the artist. Towards the end of his

life he sometimes felt pessimistic about the success of his achievement. 'Fresh – & blowing ... windy & delicious' would, however, serve as a suitable commentary on Monet's brilliant picture which has captured with great success the appearance of poplars in the wind, and therefore the look and feeling for us of a heavily overcast and windy day. Where Monet has perhaps been less successful in his series is in painting the way in which the leaves of poplars move incessantly in even the lightest breezes. This has been less easy for him, although in Plate 16 he shows the sheer brilliance of the foliage, something of its sparkle and flash as the sunlight alternately shines off the backs of the leaves (bright reflected light alternating with the dark back of the leaf) and gleams through the thin leaf to produce a very light green (or even, in the low angle of light in this particular painting, more of a golden colour). This alternation happens as the leaves move in the breeze. As the leaves move, they make a light tapping sound which is sometimes at least in fact a quiet clapping as the leaves hit each other. This element of sound has been difficult for Monet to convey. Constable despaired of being able to paint the rustling of leaves.[15] Any awareness of this behaviour on the part of Monet's trees, before his paintings, is owed more to our memory of actual trees than to anything painted in his pictures. Thus, while his paintings in series allow him to go far beyond what can be achieved in a single picture, there are still limits to what can be achieved in this most difficult of all the genres of painting.

Thoughts of their sound brings up the idea that poplars in a breeze, with their blunted flashes of bright green, pure light and mid-green, and their incessant flapping and rustling of their leaves, are well suited to offer a gentle stimulus to the senses of hearing and sight that is conducive to reveries of a Rousseauan order. As we have seen, Rousseau indicates, though he never states this in such bald terms, that the gentle stimulus to two or more senses simultaneously is what particularly helps reverie to occur. Modern behavioural psychologists studying relaxation and its pathologies concur.

A fascinating aspect of Monet's paintings is his capture of completely different feelings induced by the trees during differing conditions of light. Starting with the basic truth that at times the trees seem light against a darker sky and sometimes they loom up dark, Monet proceeds to record an extraordinary range of variation. *Poplars (Banks of the Epte)*[16] in the Philadelphia Museum of Art has rather a hard cold sky. The lower parts of the trees are dark. There is a psychological feeling of being excluded from where we want to be (among the lit poplars beyond). In *Poplars (Summer)*[17] the distant trunks are dematerialized to the lightest broken brown line applied with a dry brush in a single movement in each case. This makes the crowns of the trees float, which together with their shape makes them rather like the small light clouds above. Their colour makes them different. The sense induced by this equation of things being out of their places is enhanced by the perfect reflection in the surface of the river

in the foreground. The water itself is not palpable, not materialized. We see the reflection only. *Poplars*,[18] in the Metropolitan Museum of Art, New York, is marked by an unpleasant level of abstraction induced by the four dark trunks soaring out of sight above and, via the reflection, below. There is an oppressive sense of being barred from a more golden vista beyond. One could certainly hang the painting upside down and almost on its side. In the Tate Gallery's *Poplars (Banks of the Epte)*[19] the trees loom up dark from the still dark surface of the earth. The very beautiful *Poplars (Banks of the Epte, Twilight)*[20] contains a mauve and violet air which makes the trees subtle and mysterious. A breeze blows from left to right and the trees rustle. The sun gone down, the earth seems to exude colour into the sky. *Poplars (Banks of the Epte, Cloudy Day)*[21] presents a pink-magenta air, while the otherwise almost identical painting, *Poplars (Giverny, Cloudy Day)*[22] has a grey-brown sky. In it a breeze blows from right to left, while in the former of the pair the air is still. The juxtaposition of reproductions of these two paintings in Tucker's exhibition catalogue[23] confirms that, rather like a farmer his cows, Monet sees each tree as unique and individual: a bend of a trunk, the pattern of twigs and branches growing back on the shredded trunks, confer individuality. The effect of these two images together is very close to that of the Hiroshige prints of Tsukuda that Monet owned. In *Poplars (Spring)*[24] we notice that the pink in the air seems more concentrated by its reflection on the river than it is in the air itself. It is noon in high summer in *Poplars (View from the Marsh)*,[25] and the intense blue of the overhead sky diminishes to a light-filled shining pale blue over the horizon. The intensity of the pale blue light completely dematerializes the distant trees' trunks, so that their arching green crowns float without visible means of support, like the tail of some great green snake.

Finally (among these examples), *Poplars (Banks of the Epte, View from the Marsh)* (Plate 16) shows an extremely complicated and triumphant orchestration by Monet of closely analysed colours and tones of leaves, branches and twigs. Under a serene sky the hues discernible amongst the trees vary from deep red and violet to yellow with traces of orange and green. The painter has paid more attention to the architecture of the nearer trees' branches than in many of this series. This is a frank celebration, full of the movement (side to side, foreground to back, up and down) of the line of trees. Nothing is dematerialized. The painting is a celebration of the full richness and complexity of the trees' life, made with a density and a lightness of touch that not many landscape paintings can approach.

In many of these examples the trees become a pretext for painting the colour of the air that embraces them and moves all around them. Sometimes the air is transparent, sometimes misty, and sometimes violet and mauve. Light, which is to say the sun, gives colour to the air, which then gives value and tone to the trees. When Monet wrote about painting the sea in 1886, he said:

I well realize that in order really to paint the sea, one must view it every day, at every time of day and in the same place in order to get to know its life at that particular place; so I am redoing the same motifs as many as four or even six times.[26]

In 1891 Monet was evidently applying the same principles even more thoroughly to the poplars on a short stretch of the River Epte. As a result, he gives us a chance to know the life of these poplars on a surrogate basis.

In his series of 24 paintings Monet gives us the poplars. He paints them so carefully that we can identify the specific variety of the poplar species that is in question. He shows us the pale fissured bark, the habit of growth, the nearly equal replication of one clone and another, the ponderous large crowns, the straight trunks, and the small features that individualize each tree. What else does he give us? He gives us the appearance of the trees, at the same time as representing the trees themselves. He shows us that the appearance differs in different conditions of light, weather and season. He even shows us how the air, far from being transparent and empty, changes with changing light and weather. He shows us how colour hangs in the air: how the air is a volume of coloured light, and how this affects the appearance of the trees on differing days and at differing times of day. He shows us how the trees move when it is windy, how their branches bend in the wind. He shows us how the trees feel different at different times and in different conditions. All this is done with meticulous care, with a supreme regard for leaving a record – a record of perhaps 200 days in the history of the world, at one place, and not one particularly large in size, considered in relation to the geography of the globe – a geography emphatically signalled by, among other things, the names and places of origin of the species of tree he has chosen as his subject. Ultimately Monet's paintings, in their intense and even obsessional feeling, are about experience: about what it feels like to be alive in front of these trees, on this little river; and about how it feels good. The paintings take pleasure in the world of appearances, and in the objects that can be found in that world. They celebrate being alive. And they communicate that as a pleasure.

Words and nature

On 28 July 1891 Monet wrote to his friend, the poet and critic Stéphane Mallarmé (1842–98), mentioning the 'quantities of new canvases which I must finish'.[27] Several scholars have noticed the closeness of artistic interests between these two French cultural figures.[28] During the year preceding this letter from Monet, Mallarmé had written to the painter enthusing about his series of 'Grainstack' paintings in a way that shows the poet absorbing and being influenced by the painter's art: 'You have dazzled me recently with

these Stacks, Monet, so much! that I catch myself looking at the fields through the memory of your painting practice; or rather they impose themselves on me this way.'[29] The idea that nature begins to conform to expectations we have based on our exposure to art has a long line of descent from the increasing popularity of the picturesque way of seeing in the last quarter of the eighteenth century, which we discussed very briefly in Chapter 2, down to the present day.[30] A contemporary manifestation is provided by Oscar Wilde, arguing in *The Decay of Lying* (1891) that nature is created by art. The early 1890s was 'the period of Monet's closest association with Mallarmé'.[31] Mallarmé occupied a position in French culture far in excess of his low-paid occupation of schoolteacher.[32] Friend of Manet and James Whistler, great admirer of the poetry of Baudelaire, Mallarmé prized 'mystery' in art and valued highly the quality of 'suggestion', denying that a work of art could make a statement. In 1891 he told an interviewer,

I think ... there should only be allusion. The contemplation of objects, the image emanating from the dreams they excite, this is poetry. The Parnassians [a group of poets] take a thing whole and reveal it; by doing this they lack mystery: they deny the human spirit the delicious joy of believing that it is creating. To *name* an object is to suppress three-quarters of the enjoyment of the poem, which is created by the pleasures of gradually apprehending it. To suggest, that is the dream ... to choose an object and to derive from it a state of mind, by a series of decipherments.[33]

When we read Mallarmé's utterance that 'the contemplation of objects, the image emanating from the dreams they excite, this is poetry' we might recall the responses of Nerval, Baudelaire and Hugo to the gibbet on Cythera; Turner's vision of *Medea*; Burt on the cliff at Durlston; Wordsworth's encounter with a leech-gatherer; or Rousseau's reveries at Ermenonville; for that matter, we might think of Gauguin becoming a Baudelairean voyager to Tahiti. Elsewhere, Mallarmé also wrote that 'to speak of things does not convey their reality except in a commercial sense ... Nature occurs, we need not add to it; only cities, railways and several inventions which constitute our material world.' The poet felt joy in 'simply being on earth in all simplicity'.[34]

These utterances make it clear that Mallarmé could think of Monet's art as suggesting rather than stating. One can easily imagine a fictional situation in which someone asks Monet what the poplars on the Epte (the real trees) are like, expecting to be told one statement or shown a single painting in response. Instead, Monet produces 24 paintings, saying something like, 'the poplars are like this ... and this ... and this ... and this ...'. In Monet's series the suggestivity extends to the way in which paint is applied, or course: the trunk of a tree indicated as a dry broken brown line of paint; a sketchy finish to suggest the hasty notation of actual experience out-of-doors. Is there any other kinship of interest here? Is there another way, perhaps on a different level of analysis, by which the poet and the painter can be linked?

To address this question I wish to consider the poem from the very end of Mallarmé's life, 'Un Coup de dés' (1897). Figure 7.1 shows one double-page spread from that poem that most closely approximates to the layout Mallarmé specified during his life. Immediately, we see that the poem is a concrete one: the way in which the words are laid out on the page forms part of the perception and comprehension of the poem. The poem is only partially read. It is also looked at and perceived visually. The layout is part of the phenomenon; something for us to apprehend; something that works its suggestion on us. For 1897 this is a radical experiment in typographical design. The page immediately becomes something other than a convenient rectangular tablet on which the words are displayed in lines and columns. It becomes a space, within which the words float and from which they emerge in varied sizes. The page becomes a space of pure potentiality, out of which thought and image, bearing the traces of sense perception and mental conception, emerge for our apprehension. Mallarmé's work may be a monument of literary modernism and a cornerstone of experimental free verse with ramifications for modernism in painting, but the point in bringing it up here rests on the fact that it suggests or evokes a landscape, and that certain continuities or kinships of interest can be shown to exist between it and Monet's 'Poplar' series.

To take the first point: most authorities agree that, in as much as it evokes an image of anything, the poem hints at an idea of the night sky – specifically of the Milky Way seen from the deck of a sinking ship. Thus it qualifies as a sort of landscape: one might venture to call it a starscape or even a cosmoscape. The landscape is not only in the meaning of the words: it also emerges in the way that the words are laid out on the page. As the poet Paul Valéry expressed it in his joyful reaction,

There the marvel took place; there on the very paper some indescribable scintillation of final stars trembled infinitely pure in an inter-conscious void; and there on the same void with them, like some new form of matter arranged in systems or masses or trailing lines, coexisted the Word! I was struck dumb by this unprecedented arrangement.[35]

While the stars are therefore in question, as the poem unfolds we can also be struck by the way in which the pattern of the words in their double-page layouts also begins to show the shape of a wave which finally breaks to convert its forward motion into downward motion. Given, of course, how Mallarmé endorsed suggestion over statement, emanation and derivation over assertion, the poem deliberately remains imprecise; Milky Way, sloping deck, sinking ship passing beneath the wave: all these are interpretive moves we make, and to set them down here in curt phrases is already to distort the effect of the poem.[36]

If we place in sequence the words of the first two or three pages of the poem, we find this:

7.1 Two pages of Stéphane Mallarmé's 'Un Coup de dés' showing the spatial layout of the words

A throw of the dice / never / even when thrown in eternal circumstances / from the depths of a shipwreck / it be / that / the Abyss / whitened / spreads out / furious / beneath a slope / planes desperately / on a wing / its own / by / forward fallen back from an evil to prepare flight / and covering the spurtings / cutting off the leaps / very much inside takes up / the shadow hidden in the depth by this alternative sail / until to adapt to the stretch of the yard-arms / its yawning depth in so much like the hull / of a ship / listing to one side or the other ...[37]

The reader sees immediately that there is no firm grammatical bond between the various phrases and words. As they occur on the space of the page, the phrases of Mallarmé's poem are connected only through various types of apposition. In fact the poem is structured around a huge mass of appositional constructions, since the main sentence which overarches the whole, 'A throw of the dice will never get rid of chance', spreads over most of the poem's pages and all the other words of the poem cluster round various parts of this sentence. This state of affairs brings up the questions: what is apposition? And what are the advantages of it for Mallarmé's landscape poem?

Strictly speaking, appositional phrases represent alternative ways of stating the subject, and are normally simply juxtaposed to each other, separated from the main sentence by commas. Most examples given by linguisticians consist of only two parts rather than the multiple parts of Mallarmé's poem. The two parts constituting a subject and apposition amount to syntactically parallel expression with no more coherent protocol of relationship than simple juxtaposition. Thus one could write, 'George, the little black cat, entered the room.' A complete syntactically and grammatically correct sentence could be formed by either 'George entered the room' or 'The little black cat entered the room', but in neither of these cases is the reader's sense or understanding of the subject as full as it is when the phrases are combined. The construction in which 'the little black cat' stands in apposition to the name 'George' gives a fuller understanding of the subject. The reader's or listener's pause necessary for the assimilation of these syntactically parallel phrases is accepted as a worthwhile price for the accumulation of evidence gained. A pithy and comprehensive analysis of what he calls 'types of appositive construction in French' has been performed by Bohdan Bogacki.[38] He concludes that the entire variety of appositive constructions can be grouped into two types: those which provide further information about the subject; and those in which such further information emerges in what looks like a predicate of the sentence.[39] The two pages quoted from 'Un Coup de dés' contain several examples of both categories. For our purposes here it is enough to note Mallarmé's poetic utterance entirely revolves around apposition. What does the poet gain by this approach? No doubt the very loose syntactic structures involved helped a poet who wished to suggest rather than to state; to imply rather than describe. The precise relationships between the parts are left for the reader to reflect upon. Nevertheless an image, or rather a loosely connected set of

images, emerges in Mallarmé's poem from an even larger number of more fragmentary image-morsels. In the pages quoted above, for example, short phrases and even single words act as images in themselves: 'forward fallen back from an evil to prepare flight' might evoke the surge of waves around a stricken vessel and at the same time the vessel's attempts to continue to sail or even to float, as well as the baleful character of the fate that threatens. What is embedded very deeply within an evocation of external reality is a state of mind and even, in the last analysis, a spiritual state. The poem reflects on humankind's loneliness in a material and unknowable universe that is itself full of the kind of doubt and endless becoming implicit in the poet's repeated use of subjunctive and conditional moods of the verbs. More ambivalently poised in it, perhaps, are contemplations on the relative possibilities of free will and determinism: as the last line tells us, 'all thought emits a throw of the dice'.

In Mallarmé's advocacy of suggestion over statement in art we sense a retreat from one of the forms of thought that tended to dominate nineteenth-century French life: positivism. In the poem large moving masses of water are evoked; there is a ship, and a wing, therefore a bird: the word I have translated above as 'the stretch of the yard-arms' has also been translated as 'wing-span'.[40] So where does the bird end and the ship begin? There is a family crest in the poem, and a portrait of the ship's captain. A constellation appears, or more properly makes itself felt, and something sinks down the last page to a grounding in the last line. Is it the merest coincidence that the philosopher of phenomenology, Edmund Husserl, uses language close to that of Mallarmé when describing the crisis that positivism has brought about? Discussing mental processes such as perception, imagination, memory and predication, he writes,

In them the things are not contained as in a hull or vessel. Instead, the things come to be *constituted* in these mental processes, although in reality they are not at all to be found in them. For 'things to be given' is for them to be *exhibited* (represented) as so and so in such phenomena.[41]

The constituting of things in mental processes might be adopted as a subtitle to Mallarmé's poem. Husserl comes very close here to the views of Baudelaire and Coleridge on the power and primacy of the imagination, Baudelaire's 'Queen of the Faculties' and 'the living power and prime agent of all human perception ... a repetition in the finite mind of the eternal act of creation in the infinite I AM', as Coleridge expressed it.[42]

In the repeated conjurings-up of their subjects by Monet and Mallarmé, positivism has been rejected. This was an era when, as Husserl put it, 'every science of the natural sort and every mental characteristic of such a science ceases to count as something we properly possess. For cognition's reaching its object has become enigmatic and dubious as far as its meaning and possibility

are concerned.'[43] The poet and the painter take nothing for granted about the problem of cognition's reaching its object. Husserl wrote, 'the possibility of cognition becomes questionable, more precisely, how it can possibly reach an objectivity which, after all, is in itself whatever it is.'[44]

At the time of this crisis Monet re-states the object, over and over again, showing us that it is, in fact, never quite the same object. The re-statements become statements of the appearance of the object as well as the object itself. Sometimes, when you look at them, the tree-trunks disappear: at such times it would be a greater falsification for the artist to paint them than to leave them out, despite the fact that he knows that trees have trunks. In Monet's series there is no unisemic (that is, one and unified) definition of the subject matter such as science might gravitate towards. The phenomenon Monet paints is the trees in the act of perception of them. Mallarmé, on the other hand, barely reaches the object: or does so in the most oblique and tangential fashion imaginable. It is the enigma and doubt about meaning and possibility that fascinate the poet. The most direct and specific parts of his poetic meditations are those taken from other art forms: the concretion of the poem – the pattern or picture it makes on the page; and the concrete images residing in individual words. The rest is caught up in a superstructure at once spiritual and ideological. This chapter in juxtaposing works by Monet and Mallarmé might say, with Husserl, 'I have put here on the same level the "seeing" (act of) reflective perception and (the "seeing" act of reflective) imagination.'[45] The acts of seeing and imagination conjured up by Mallarmé's poem clearly go beyond Husserl, who reached the dry land of transcendental phenomenology out of his doubts with and rejection of positivist assertion.

Thirty years earlier, Mallarmé had characterized the art of Edouard Manet and the Impressionist painters in an article for a British journal in terms that seem to hover on the edge of an anticipation of Husserl's sober analysis. Towards the end of the essay Mallarmé states that 'the scope and the aim ... of Manet and his followers is that painting shall be steeped again in its cause, and its relation to nature'.[46] The critic then assumes a narrative voice belonging to a modern artist as a way of dramatizing his view of Manet's achievement:

Before everyday nature ... [the artist's] best efforts can never equal the original with the inestimable advantages of life and space. ... that which I preserve through the power of Impressionism is not the material portion which already exists, superior to any mere representation of it, but the delight of having recreated nature touch by touch ... I content myself with reflecting on the ... mirror of painting that which perpetually lives yet dies every moment, which only exists by the will of Idea, yet constitutes in my domain the only authentic and certain merit of nature – the Aspect. It is through her that when rudely thrown at the close of an epoch of dreams in front of reality, I have taken from it that which properly belongs to my art, an original and exact perception which distinguishes for itself the things it perceives with the steadfast gaze of a vision restored to its simplest perfection.[47]

This is a dense passage. We can note that only two letters, the 're' of 'recreated' in the fifth line, separate this dramatization of 1876 from Wilde's employment of paradox to suggest that nature is created by art in his dialogue *The Decay of Lying* of 1891. In general Mallarmé's passage seems to point in a phenomenological direction while falling short of a full achievement of that position. 'The material portion [of nature] already exists, superior to any mere representation of it': in these words can we find an anticipation of Husserl's 'the possibility of cognition becomes questionable, more precisely, how it can possibly reach an objectivity which, after all, is in itself whatever it is'? The natural world as itself is fundamentally unrepresentable. What can be shown is 'the Aspect', which seems close to the 'phenomenon' of phenomenology: that is, the appearance of the object or, as Mallarmé puts it, 'an original and exact perception which distinguishes for itself the things it perceives with the steadfast gaze of a vision restored to its simplest perfection'. In that last clause in particular seems to be implied a phenomenological reduction or bracketing-off of commonsense artistic conventions and alleged scientific facts in order to reach a perception without presuppositions.[48]

In the essay of 1876 we can see an understanding of Impressionism that is still relevant to comprehending Monet's 'Poplar' series of 1891. If in it some aspects of phenomenology are implied, so in contrast 'Un Coup de dès' of 1897 goes beyond phenomenology and well beyond Mallarmé's earlier essay on Impressionism in its implied doubt about the possibilities of perception and about the reliability and comprehensibility of nature. The differences between these two written works of his dramatize the movement of Mallarmé's sensibility during the period. Beside 'Un Coup de dès', Monet's 'Poplar' series, however subtle it be, looks remarkably robust in its assertions. There is predication, compared with the poet's perpetual apposition. For the poet on the threshold of the twentieth century, an extremely rarefied perception of the transient, tangential and accidental qualities of vision becomes a part of, and a condition for, an existence which requires experimental and improvised forms for its adequate representation.

Notes

1. On the subject of Monet's series of paintings of poplar trees, not a great deal has been written. S. Patin, 'Un tableau de la serie des peupliers de Monet', *La Revue du Louvre* 53, 2 (April 2003), pp. 22–4, deals with one painting, *Wind Effect*. John Klein, in 'The Dispersal of the Modernist Series', *Oxford Art Journal* 21, 1 (1998), pp. 121–35, discusses the concept of a series of paintings to be sold separately as a commercial marketing ploy.

2. Paul Tucker, *Monet in the 90s* (Boston: Museum of Fine Arts and Yale University Press, 1989), pp. 125, 172–4; John House, *Monet: Nature Into Art* (New Haven: Yale University Press, 1986), p. 194; Katharine Lochnan (ed.), *Turner Whistler Monet: Impressionist Visions*, exhibition catalogue (London and Ontario: Tate Publishing and Art Gallery of Ontario, 2004), pp. 22, 205. Scholars usually interpret the influence on the West of Japanese artists in this period in terms of formal characteristics of the image – framing, point of view, etc. This seems to me *petitio principii*.

3. House, *Monet: Nature into Art*, p. 194.

4. Tucker, *Monet in the 90s*, pp. 107–41.

5. Oliver Rackham, *The History of the Countryside*, 1986 (London: J. M. Dent & Sons, 1990), p. 208.

6. Roger Phillips, *Trees in Britain, Europe and North America* (London: Pan Books, 1978), p. 166.

7. Alan Mitchell, *A Field Guide to the Trees of Britain and Northern Europe* (London: Collins, 1974), p. 186.

8. Kenneth A. Beckett, *Concise Encyclopedia of Garden Plants*, 1978 (London: Orbis, 1985), p. 314.

9. Oleg Polunin, *Trees and Bushes of Europe* (Oxford: Oxford University Press, 1976), p. 39.

10. *Ibid.*, p. 40.

11. Mitchell, *Field Guide*, p. 186.

12. *Ibid.*, p. 186.

13. Quoted by Michael Rosenthal, *Constable: The Painter and his Landscape* (New Haven: Yale University Press, 1983), p. 166.

14. *Ibid.*, p. 218.

15. *Ibid.*, p. 226 quotes Constable's comment about this.

16. W 1298 is the standard identifying number applied to this painting.

17. W 1305, National Museum of Western Art, Tokyo.

18. W 1309.

19. W 1300.

20. W 1296.

21. W 1299, Ise Cultural Foundation, Tokyo.

22. W 1291, Museum of Art, Atami.

23. Tucker, *Monet in the 90s*, pp. 118–119.

24. W 1304.

25. W 1313, The Fitzwilliam Museum, Cambridge.

26. Quoted and translated in Tucker, *Monet in the 90s*, p. 29.

27. Quoted in House, *Monet: Nature into Art*, p. 201.

28. See, for example, House, *Monet: Nature into Art*, pp. 222–4; Tucker, *Monet in the 90s*, p. 93; Lucy Abélès, 'Mallarmé, Whistler and Monet', in Lochnan, *Turner Whistler Monet*, pp. 163–8.

29. Stéphane Mallarmé, *Correspondance II–XI, 1872–1898*, ed. H. Mondor and L.J. Austin (Paris: Gallimard, 1965–85), vol. IV, p. 119. See Abélès, 'Mallarmé, Whistler and Monet', in Lochnan, p. 241 n. 35, re: the date of this letter.

30. See, for example, Blue Tunnel Publications' *Eye Spy Trees*, including 'The Mountain Wilson' and 'Salvator Rosa Tree' (Willesden, West Yorkshire, 1980).

31. House, *Monet: Nature into Art*, p. 223.

32. See Gordon Millan, *A Throw of the Dice: The Life of Stéphane Mallarmé* (London: Secker & Warburg, 1994).

33. *Ibid.*, p. 223.

34. Stéphane Mallarmé, 'La Musique et les lettres' (1894) and *Divagations* (1897), quoted and translated by Abélès, 'Mallarmé, Whistler and Monet', in Lochnan, p. 167.

35. Quoted in translation by Henry Weinfeld, 'Commentary on "Un Coup de dés" ', in Weinfeld's edition of Stéphane Mallarmé, *Collected Poems* (Berkeley and Los Angeles: University of California Press, 1994), p. 265.

36. The poetic metaphor of a ship on a voyage derives to Mallarmé from (among other sources) Baudelaire, where it is particularly strong in his poems 'Voyage', 'Invitation to a Voyage' and 'Voyage to Cythera'.

37. 'Un coup de dés / jamais / quand bien même lancé dans les circonstances éternelles / du fond d'un naufrage / SOIT / qu / l'Abîme / blanchi / étale / furieux / sous une inclinaison / plane désespérément / d'aile / la sienne / par / avance retombée d'un mal à dresser le vol / et couvrant les jaillissements / coupant au ras les bonds / très a l'intérieur résume / l'ombre enfouie dans la profondeur par cette voile alternative / jusqu'adapter / à l'envergure / sa béante profondeur en tant que la coque / d'un bâtiment / penché d l'un ou l'autre bord ...'

38. Bohdan Krzysztof Bogacki, *Types de Constructions Appositives en Français* (Wroclaw, Warszawa, Krakow and Gdansk: Polskiej Akademii Nauk, 1973).

39. *Ibid.*, p. 88.

40. Weinfeld, 'Commentary', in Mallarmé, *Collected Poems*.

41. Edmund Husserl, *The Idea of Phenomenology*, trans. W.P. Alston and G. Nakhnikian (The Hague: Martinus Nijhoff, 1964), pp. 9–10. The text is a translation of five lectures Husserl gave at Gottingen in 1907.

42. See Samuel Taylor Coleridge in *A Coleridge Selection*, ed. R. Wilson (London: Macmillan, 1963), p. 113.

43. Husserl, *The Idea of Phenomenology*, p. 20.

44. *Ibid.*, p. 20.

45. *Ibid.*, p. 24.

46. Stéphane Mallarmé, 'The Impressionists and Edouard Manet' from *The Art Monthly Review and Photographic Portfolio*, London, 30 September 1876, pp. 117–122. This English-language essay is reprinted in C. Harrison, P. Wood and J. Gaiger (eds), *Art in Theory 1815–1900* (Oxford: Blackwell, 1998), pp. 585–93, qu. p. 592.

47. *Ibid.*, pp. 592–3. I have corrected a minor error in the reprint, omitting 'the' from before 'front'.

48. For an introductory explanation of elements of phenomenology, see the entry in vol. 3 of Michael Kelly (ed.), *Encyclopedia of Aesthetics*, 4 vols (Oxford: Oxford University Press, 1998).

Bibliography

Primary sources (before 1902)

Anonymous, *A Description of the Lakes of Killarney* (1776).
____ , Promenade des jardins d'Ermenonville, see Girardin.
____ , *Records of the Royal Military Academy 1741–1840* (1851).
____ , *Rules and Orders of the Royal Military Academy* (1764 and 1776).
Austen, Jane, *Northanger Abbey*, London, 1818.
Baudelaire, Charles, *Oeuvres complètes*, Paris: Bibliothèque de la Pléiade, 1968.
____ , *Oeuvres complètes*, ed. Y.-G. Le Dantec, Paris: Bibliothèque de la Pléiade, 1954.
____ , 'Un Mangeur d'opium', 1860, in *Artificial Paradise*, trans. Ellen Fox, New York: Herder and Herder, 1971.
Boismont, Alexandre Brierre de, *On Hallucinations: A history and explanation of Apparitions, Visions, Dreams, Ecstasy, Magnetism and Somnambulism*, 1844; 3rd edn, trans. and abridged by Robert Hulme, London, 1859.
Bougainville, L.A. de, *Voyage autour du monde*, 1771; Paris: Editions La Découverte, 1985.
Brewster, Sir David, *Letters on Natural Magic Addressed to Sir Walter Scott*, 1832.
Burford, Robert, *A Description of a View of Canton, the River Tigress, and the surrounding country; now exhibiting at the Panorama, Leicester Square. Painted by the proprietor R. Burford*, London, 1838.
____ , *A Description of the View of the City of Edinburgh and surrounding country ... from drawings taken ... from the summit of Calton Hill*, London, 1825.
Burnham, S.M., *History and Uses of Limestones and Marbles*, Boston: S.E. Cassino & Company, 1883.
Chambers, Robert, *Vestiges of the Natural History of Creation*, London, 1844.
Cobbett, William, *A History of the Protestant Reformation in England and Ireland: showing how that event has impoverished the main body of the people in those countries*, London, 1824–27.
Coleridge, Samuel Taylor, *A Coleridge Selection*, ed. R. Wilson, London: Macmillan, 1963.
Cook, Captain James, *The Journals of Captain James Cook on his Voyages of Discovery: II, The Voyage of the* Resolution *and* Adventure *1772–1775*, ed. J.C. Beaglehole, Cambridge: For the Hakluyt Society at the University Press, 1969.
Coventry, Sir William, *A Letter written to Dr Burnet, giving an account of Cardinal Pool's Secret Powers, from which it appears, that it was never intended to confirm the Alienation that was made of the Abbey-lands*, London, 1685.

De Quincy, Thomas, *Confessions of an English Opium-Eater*, 1821; ed. Malcolm Elwin, London: Macdonald & Co., 1956.

Diderot, Denis, *Encyclopédie*, vol. 14, 1765; facsimile reprint, Stuttgart-Bad Cannstadt: Friedrich Fromann Verlag, Günther Holzboog, 1967.

Disraeli, Benjamin, *Sibyl, or the Two Nations*, London, 1845.

Ehrenberg, C.G., *Die Bildung der europäischen, libyschen, and arabischen Kreidefelsen und der Kreidemergels aus mikroskopischen Organismen*, Berlin, 1839.

Farington, Joseph, *The Diary of Joseph Farington*, ed. Kathryn Cave, New Haven CT and London: Yale University Press, 1982.

Gandon, James, *Memoirs*, Dublin, 1846.

Gauguin, Paul, *Noa Noa: voyage de Tahiti*, Paris: Les Editions G. Crès et Cie, 1929.

———, *Writings of a Savage*, ed. Daniel Guérin, trans. Eleanor Levieux, New York: Viking, 1978.

Girardin, René-Louis de, *De la Composition des paysages*, 1777, printed with Anon., *Promenade des jardins d'Ermenonville*, 2nd edn, 1811; ed. and with 'Postface' by Michel Conan, Paris: Editions de Champ Urbain, 1979.

Godwin, William, *The Adventures of Caleb Williams*, 1794.

Gosse, Philip, *Omphalos: An Attempt to Untie the Geological Knot*, London, 1857.

Hibbert, Samuel, *Sketches of the Philosophy of Apparitions; or, an attempt to trace such illusions to their physical causes*, 2nd edn, Edinburgh, 1825.

Hutton, James *Theory of the Earth, with Proofs and Illustrations*, Edinburgh, 1795.

Johnston, Nathaniel, *The Assurance of Abbey and other Church lands in England to the Possessors*, London, 1687.

Lapérouse, Jean-Francois de, *Voyage autour du monde sur L'Astrolabe et La Boussole*, 1785–1788; ed. Hélène Minguet, Paris: Librairie François Maspero, 1980.

Le Fanu, Sheridan, *Best Ghost Stories of J.S. Le Fanu*, New York: Dover Publications, 1964.

———, *Uncle Silas: A Tale of Bartram Haugh*, London, 1864.

———, *The Watcher and Other Weird Stories*, London, 1894.

Leslie, C.R. *Memoirs of the Life of John Constable, composed chiefly of his letters*, 1843; Ithaca NY: Cornell, 1980.

Lyell, Sir Charles, *Geological Evidences of the Antiquity of Man*, London, 1863.

Mallarmé, Stéphane, *Collected Poems*, ed. and trans. Henry Weinfeld, Berkeley and Los Angeles: University of California Press, 1994.

———, *Correspondance II–XI, 1872–1898*, ed. H. Mondor and L.J. Austin, Paris: Gallimard, 1965–85.

———, 'The Impressionists and Edouard Manet', *The Art Monthly Review and Photographic Portfolio*, London, 30 September 1876, 117–122. Reprinted in C. Harrison, P. Wood and J. Gaiger (eds), *Art in Theory 1815–1900*, Oxford: Blackwell, 1998.

Marion, F., *Optical Wonders*, trans. C.W. Quin, London, 1868.

Marx, Karl, *The 18th Brumaire of Louis Bonaparte*, 1852; in K. Marx and F. Engels, *Selected Works*, New York: International Publishers, 1968.

Maturin, C.R., *Melmoth the Wanderer, A Tale*, Edinburgh, 1820; ed. A. Hayter, Harmondsworth: Penguin, 1977.

Métenier, J., *Taïti: son présent, son passé, et son avenir*, Tours: Cattier, 1883.

Middleton, Charles, *Magic Lantern Dissolving View Painting*, London, 1876.

Nerval, Gerard de, *Les Filles du feu*, 1854; Paris: Bookking International, 1997.

———, *Oeuvres complètes*, ed. Jean Guillaume and Claude Pichois, Paris: Gallimard, 1984.

———, *Selected Writings*, ed. and trans. Richard Sieburth, London: Penguin, 1999.

Pater, Walter, *Appreciations, with an essay on Style*, 1874; London: Macmillan, 1924.

Pinchbeck, W.F., *Witchcraft: or, the art of fortune-telling unveiled*, Boston MA, 1805.

Playfair, John, *Illustrations of the Huttonian Theory of the Earth*, Edinburgh, 1802.

Radcliffe, Ann, *The Romance of the Forest*, London, 1791.

Rousseau, Jean-Jacques, *Oeuvres complètes*, Paris: Gallimard, 1959.

——, *Rousseau's Religious Writings*, ed. and trans. Ronald Grimsley, Oxford: Clarendon Press, 1970.

——, *Les Rêveries du promeneur solitaire* 1782; ed. Jacques Voisine, Paris: Flammarion, 1964.

Ruskin, John, *Praeterita*, 1885–89; ed. A.O. J. Cockshut, Kelle University Press: Ryburn Publishing, 1994.

Sandby, William, *The History of the Royal Academy of Arts*, 2 vols, London, 1862.

Scott, Sir Walter, *Letters on Demonology and Witchcraft, addressed to J.G. Lockhart, esq.*, 1830.

Shenstone, William, *The Works in Verse and Prose*, 2 vols, 4th edn, 1773.

Spelman, Sir Henry, *The History and Fate of Sacrilege*, London, 1698.

Wigan, A.L., *A New View of Insanity: the Duality of the Mind Proved by the Structure, Functions, and Diseases of the Brain and by the Phenomena of Mental Derangement, and Shown to be Essential to Moral Responsibility*, London, 1844.

Wordsworth, William, *The Prelude*, 1805; ed. E. de Selincourt and Stephen Gill, Oxford: Oxford University Press, 1970.

Secondary sources

Abélèles, Lucy, 'Mallarmé, Whistler and Monet', in K. Lochnan, *Turner Whistler Monet*, pp. 163–8.

Alfrey, Nicholas, and Stephen Daniels (eds), *Mapping the Landscape: Essays on Art and Cartography*, Nottingham: University Art Gallery and Castle Museum, 1990.

Andrews, Malcolm, *The Search for the Picturesque: Landscape Aesthetics and Tourism in Britain, 1760–1800*, Aldershot: Scolar Press, 1989.

——, *The Picturesque: Literary Sources and Documents*, 3 vols, Robertsbridge (Sussex): Helm Information, 1995.

Annan, Noel, *The Dons*, London: HarperCollins, 1999.

Anonymous, *Style and Rendering in the Architectural Drawings of Thomas Sandby*, Ploughkeepsie NY: Vassar College Art Gallery, 1990.

Arscott, C. and K. Scott (eds), *Manifestations of Venus: Art and Sexuality*, Manchester: Manchester University Press, 2000.

Ball, Johnson, *Paul and Thomas Sandby, Royal Academicians*, Cheddar (Somerset): Charles Skilton, 1985.

Bann, Stephen, *The Clothing of Clio: A Study of the Representation of History in Nineteenth-Century Britain and France*, Cambridge: Cambridge University Press, 1984.

Barrell, John, *The Dark Side of the Landscape: The Rural Poor in English Painting 1730–1840*, Cambridge: Cambridge University Press, 1980.

——, (ed.), *Painting and the Politics of Culture: New Essays in British Art 1700–1850*, Oxford: Clarendon Press, 1992.

Barringer, Tim, *Reading the Pre-Raphaelites*, London: Weidenfeld & Nicolson, 1998.

Becker, C. (ed.), *Paul Gauguin Tahiti*, exh. cat., Stuttgart: Verlag Gerd Hatje, 1998.

Beckett, Kenneth A., *Concise Encyclopaedia of Garden Plants*, 1978, London: Orbis, 1985.

Bedell, Rebecca, *The Anatomy of Nature: Geology and American Landscape Painting 1825–1875*, Princeton NJ: Princeton University Press, 2001.

Beer, Gillian, *Open Fields: Science in Cultural Encounter*, Oxford: Oxford University Press, 1999.

Beilharz, Richard, 'Fantaisie et imagination chez Baudelaire, Catherine Crowe et leurs prédécesseurs allemands', *Baudelaire*: Actes du colloque de Nice (25–27 Mai 1967), *Annales de la Faculté des Lettres et Sciences Humaines de Nice* **4** (5) 1968, 33–5.

Benveniste, Emile, *Problèmes de linguistique générale*, Paris: Gallimard, 1966.

Bermingham, Ann, *Landscape and Ideology: The English Rustic Tradition, 1740–1850*, Berkeley CA: University of California Press, 1986.

——, *Learning to Draw: Studies in the Cultural History of a Polite and Useful Art*, New Haven CT and London: Yale University Press, 2000.

Berridge, Virginia, and Griffith Edwards, *Opium and the People: Opiate Use in Nineteenth-Century England*, London and New York: Allen Lane and St Martin's Press, 1981.

Bogacki, Bohdan Krzysztof, *Types de constructions appositives en Français*, Wroclaw, Warszawa, Krakow and Gdansk: Polskiej Akademii Nauk, 1973.

Boime, Al, *The Academy and French Painting in the Nineteenth Century*, London: Phaidon, 1971.

Bowles, Brett, 'Les Sept Vieillards: Baudelaire's Purloined Letter', *French Forum* **23** (1) 1998, 47–61.

Brettell, Richard, et al., *The Art of Paul Gauguin*, exh. cat., Washington DC: National Gallery of Art, 1988.

Brown, N., C. Burdett and P. Thurschwell (eds), *The Victorian Supernatural*, Cambridge: Cambridge University Press, 2004.

Buddemeier, Heinz, *Panorama, Diorama, Photographie: Enstehung und Wirkung neuer Medien im 19 Jahrhundert*, Munich: W. Fink, 1970.

Burns, Sarah, 'Girodet-Trioson's *Ossian*: The Role of Theatrical Illusionism in a Pictorial Evocation of Otherworldly Beings', *Gazette des Beaux-Arts*, 6th ser., **95**, January 1980, 13–24.

Burton, Richard D.E., 'Baudelaire and Shakespeare: Literary Reference and Meaning in Les Sept Vieillards and Beatrice', *Comparative Literature Studies* **26** (1) 1989, 1–27.

——, *Baudelaire in 1859: A Study in the Sources of Poetic Creativity*, Cambridge: Cambridge University Press, 1988.

Butlin, Martin, and Evelyn Joll, *The Paintings of J.M.W. Turner*, 2 vols, New Haven CT: Yale University Press, 1984.

Butterworth, Charles, 'Interpretative Essay', in J.-J. Rousseau, *The Reveries of the Solitary Walker*, trans. C. Butterworth, New York: New York University Press, 1979.

Castle, Terry, 'Phantasmagoria, Spectral Technology, and the Metaphorics of Modern Reverie', *Critical Inquiry* **15**, 1988, 21–61.

Cayeux, Jean de, *Hubert Robert et les jardins*, Paris: Editions Herscher, 1987.

Charlesworth, Michael, *The English Garden 1550–1910: Literary Sources and Documents*, 3 vols, Robertsbridge (Sussex): Helm Information, 1993.

——, *The Gothic Revival: Literary Sources and Documents*, 3 vols, Robertsbridge (Sussex): Helm Information, 2002.

——, 'Mapping, the Body, and Desire: Christopher Packe's Chorography of Kent' in D. Cosgrove (ed.), *Mappings*, pp. 109–124.

——, 'Movement, Intersubjectivity, and Mercantile Morality at Stourhead', in Michel Conan (ed.), *Landscape Design and the Experience of Motion*, Washington DC: Dumbarton Oaks, 2003, pp. 263–85.

——, 'Nature, Landscape, and Land Art', in *Art in the Landscape*, Marfa TX: Chinati Foundation, 2000, pp. 93–113.

——, 'Subverting the Command of Place: Panorama and the Romantics', in Peter Kitson (ed.), *Placing and Displacing Romanticism*, Aldershot: Ashgate, 2001, pp. 129–45.

——, 'Thomas Sandby Climbs the Hoober Stand: The Politics of Panoramic Drawing in Eighteenth-Century Britain', *Art History* **19** (2) 1996, 247–66.

——, 'The Wentworths: Family and Political Rivalry in the English Landscape Garden', *Garden History* **14** (2) 1986, 120–137.

Childs, Elizabeth C., 'Seeking the Studio of the South: Van Gogh, Gauguin, and Avant-Garde Identity' in C. Homburg (ed.), *Vincent Van Gogh and the Painters of the Petit Boulevard*.

Clark, T.J., *The Absolute Bourgeois: Artists and Politics in France 1848–1851*, 1973, Princeton NJ: Princeton University Press, 1982.

——, *The Painting of Modern Life: Paris in the Art of Manet and his Followers*, Princeton NJ: Princeton University Press, 1984.

Close, Colonel Sir Charles, *The Early Years of the Ordnance Survey*, Chatham: Institution of Royal Engineers, 1926.

Coldstream, J.N., and G.L. Huxley (eds), *Kythera: Excavations and Studies conducted by the University of Pennsylvania Museum and the British School at Athens*, London: Faber & Faber, 1972.

Comment, Bernard, *The Panorama*, London: Reaktion Books, 1999.

Copley, S., and P. Garside (eds), *The Politics of the Picturesque: Literature, Landscape and Aesthetics since 1770*, Cambridge: Cambridge University Press, 1994.

Cosgrove, Denis (ed.), *Mappings*, London: Reaktion, 1999.

Cowart, Georgia, 'Watteau's *Pilgrimage to Cythera* and the Subversive Utopia of the Opera-Ballet', *Art Bulletin* LXXXIII (3) (September 2001), 461–78.

Cramer, Charles, *Formal Reduction and the Empirical Ideal, 1750–1914: An Essay in the History of Ideas of Classicism*, unpublished PhD dissertation, University of Texas at Austin, 1997.

Crary, Jonathan, *Techniques of the Observer: On Vision and Modernity in the Nineteenth Century*, Cambridge MA: MIT Press, 1990.

Damrosch, Leo, *Jean-Jacques Rousseau: Restless Genius*, New York: Houghton Mifflin, 2005.

Daniels, Stephen, *Fields of Vision: Landscape Imagery and National Identity in Britain and the United States*, Princeton NJ: Princeton University Press, 1993.

David, Andrew (ed.), *The Charts and Coastal Views of Captain Cook's Voyages*, I, London: The Hakluyt Society of London in Association with the Australian Academy of the Humanities, 1988.

Davies, Maurice, *Turner as Professor: The Artist and Linear Perspective*, London: Tate Gallery, 1992.

Eco, Umberto, *Six Walks in the Fictional Woods*, 1994, Cambridge MA: Harvard University Press, 1995.

Eisenman, Stephen, *Gauguin's Skirt*, London: Thames & Hudson, 1997.

Eitner, Lorenz (ed.), *Neoclassicism and Romanticism 1750–1850: An Anthology of Sources and Documents*, 1970, New York: Harper & Row, 1989.

Elliott, Brent, *Victorian Gardens*, Portland OR: Timber Press, 1986.

Eyres, Patrick (ed.), *The Wentworths: Landscapes of Treason and Virtue: The Gardens at Wentworth Castle and Wentworth Woodhouse in South Yorkshire*, four articles comprising single issue of *New Arcadian Journal* 31/32, 1991.

—— (ed.), *Four Purbeck Arcadias*, four articles comprising single issue of *New Arcadian Journal* 45/46, 1998.

Fairlie, Alison, *Imagination and Language: Collected Essays on Constant, Baudelaire, Nerval and Flaubert*, Cambridge: Cambridge University Press, 1981.

Finley, Gerald, *George Heriot: Postmaster-Painter of the Canadas*, Toronto: University of Toronto Press, 1983.

——, *George Heriot 1759–1839*, Ottawa: National Gallery of Canada, Canadian Artists Series, 1979.

Flint, Kate, *Victorians and the Visual Imagination*, Cambridge: Cambridge University Press, 2000.

Ford, Ford Madox, *No Enemy, A Tale of Reconstruction*, New York: Macaulay, 1929.

Foucault, Michel, *The Archaeology of Knowledge*, 1969, trans. A. Sheridan Smith, London: Tavistock, 1972.

Frascina, F., et al., *Modernity and Modernism: French Painting in the Nineteenth Century*, London: The Open University and Yale University Press, 1993.

Fried, Michael, *Manet's Modernism: or The Face of Painting in the 1860s*, Chicago IL: University of Chicago Press, 1996.

Friedrich, Otto, *Olympia: Paris in the Age of Manet*, 1992, New York: Simon & Schuster, 1993.

Galperin, William, *The Return of the Visible in British Romanticism*, Baltimore MD: Johns Hopkins University Press, 1993 .

Godfrey, Richard, *Wenceslas Hollar: A Bohemian Artist in England*, New Haven CT: Yale University Press, 1995.

Gosse, Edmund, *Father and Son: A Study of Two Temperaments*, London, 1907.

Gough, Paul, 'Tales from the "Bushy-Topped Tree": A Brief Survey of Military Sketching', *Imperial War Museum Review* **10**, 1995, 62–74 .

____ , 'Dead Lines: Codified Drawing and Scopic Vision in Hostile Space', *Point: Art and Design Research Journal* **6**, 1998, 34–41.

Grattan, C. Hartley, *The Southwest Pacific to 1900*, Ann Arbor MI: University of Michigan Press, 1963.

Green, Nicholas, *The Spectacle of Nature: Landscape and Bourgeois Culture in Nineteenth-Century France*, Manchester: Manchester University Press, 1990.

Hamilton, G.H., *Manet and his Critics*, New Haven CT: Yale University Press, 1954.

Hanson, Anne, *Manet and the Modern Tradition*, New Haven CT: Yale University Press, 1977.

Hardy, Florence Emily, *The Life of Thomas Hardy 1840–1928*, London: Macmillan, 1975.

Harper, J. Russell, *Painting in Canada*, Toronto: University of Toronto Press, 1966.

Harrington, Peter, *British Artists and War: The Face of Battle in Paintings and Prints 1700–1914*, London: Greenhill, 1993.

Harrison, Charles, *Modernism*, London: Tate Gallery Publishing, 1997.

Hawkes, Jacquetta, *A Land*, London: Cresset Press, 1951.

Hayden, Peter, *Biddulph Grange, Staffordshire: A Victorian Garden Rediscovered*, London: George Philip and the National Trust, 1989.

Hayter, Alethea, *Opium and the Romantic Imagination*, Berkeley CA and Los Angeles: University of California Press, 1968.

Hemingway, Andrew, *Landscape Imagery and Urban Culture in Early Nineteenth-Century Britain*, Cambridge: Cambridge University Press, 1992.

Herbert, Robert, *Impressionism: Art, Leisure and Parisian Society*, New Haven CT: Yale University Press, 1988.

____ , *Monet and the Normandy Coast*, New Haven CT and London: Yale University Press, 1994.

Herrman, Luke, *Paul and Thomas Sandby*, London: Batsford, 1986.

Hogg, Oliver, *The Royal Arsenal: Its Background, Origin and Subsequent History*, 2 vols, London: Oxford University Press, 1963.

Holmes, Richard, *Footsteps: Adventures of a Romantic Biographer*, 1985, New York: Vintage, 1996.

Homburg, C. (ed.), *Vincent van Gogh and the Painters of the Petit Boulevard*, exh. cat., St Louis: St Louis Art Museum, 2001.

House, John, *Monet: Nature Into Art*, New Haven CT: Yale University Press, 1986.

Howse, Geoffrey, *The Fitzwilliam (Wentworth) Estates and the Wentworth Monuments*, Wentworth (near Rotherham): Trustees of the Fitzwilliam Wentworth Amenity Trust, 2002.

Hubbard, R.H. (ed.), *Thomas Davies in Early Canada*, Ottawa: Oberon, 1972.

Husserl, Edmund, *The Idea of Phenomenology*, trans. W.P. Alston and G. Nakhnikian, The Hague: Martinus Nijhoff, 1964.

Hyde, Ralph, *Gilded Scenes and Shining Prospects: Panoramic Views of British Towns, 1575–1900*, New Haven CT: Yale Center for British Art, 1985.

—— (ed.), *Panoramania!* London: Barbican Art Gallery, 1988.

Irwin, Francina, 'William Dyce "At Home" in Aberdeen', *National Art Collections Fund Annual Review*, London, 1991, pp. 137–43.

Jarvis, Rupert C., *Lord Malton and the '45: Collected Papers on the Jacobite Risings*, Manchester: Manchester University Press, 1971.

Johnston, Kenneth R., *The Hidden Wordsworth: Poet, Lover, Rebel, Spy*, New York: W.W. Norton, 1998.

Joppien, Rüdiger, and Bernard Smith, *The Art of Captain Cook's Voyages*, New Haven CT: Yale University Press, 1985.

Kelly, Michael (ed.), *Encyclopedia of Aesthetics*, 4 vols, Oxford: Oxford University Press, 1998.

Ketcham, Diana, *Le Désert de Retz: A Late Eighteenth-Century French Folly Garden, the Artful Landscape of Monsieur de Monville*, 1990, Cambridge: MIT Press, 1994.

Klein, John, 'The Dispersal of the Modernist Series', *Oxford Art Journal* **21** (1) 1998, 121–35.

Klonk, Charlotte, *Science and the Perception of Nature: British Landscape Art in the Late Eighteenth and Early Nineteenth Centuries*, New Haven CT: Yale University Press, 1996.

Koerner, Joseph, *Caspar David Friedrich and the Subject of Landscape*, London: Reaktion, 1990.

Kreutzer, Winfried, *Die Imagination bei Baudelaire*, Würzburg: Inaugural-Dissertation der Julius-Maximilians-Universität, 1970.

Kriz, K. Dian, *The Idea of the English Landscape Painter: Genius as Alibi in the Early Nineteenth Century*, New Haven CT: Yale University Press, 1997.

Lambert, David, 'Durlston Park and Purbeck House: The Public and Private Realms of George Burt, King of Swanage', in P. Eyres (ed.), *Four Purbeck Arcadias*.

Lambin, Denis, 'Ermenonville Today', *Journal of Garden History* **8** (1) 1988, 42–59.

Le Men, Ségolène, *La Cathédrale illustrée de Hugo à Monet: Regard romantique et modernité*, Paris: CNRS Editions, 1998.

Lewer, David, and Bernard Calkin, *Curiosities of Swanage, or Old London by the Sea*, Yeovil: Galvin Press, 1971.

Lochnan, Katharine (ed.), *Turner Whistler Monet: Impressionist Visions*, exh. cat., London and Ontario: Tate Publishing and Art Gallery of Ontario, 2004.

Lukacher, Brian, 'Turner's Ghost in the Machine: Technology, Textuality, and the 1842 *Snow Storm*', *Word & Image* **6** (2) 1990, 119–137.

Martins, Luciana de Lima, 'Mapping Tropical Waters: British Views and Visions of Rio de Janeiro', in D. Cosgrove (ed.), *Mappings*, pp. 148–68.

Mason, Eudo C., *The Mind of Henry Fuseli: Selections from his Writings with an Introductory Study*, London: Routledge & Kegan Paul, 1951.

Matheiu, R., *Ermenonville*, Paris: Nouvelles Editions Latines, 1996.

Millan, Gordon, *A Throw of the Dice: The Life of Stéphane Mallarmé*, London: Secker & Warburg, 1994.

Mitchell, Alan, *A Field Guide to the Trees of Britain and Northern Europe*, London: Collins, 1974.

Moorehead, Alan, *The Fatal Impact: An Account of the Invasion of the South Pacific 1767–1840*, New York: Harper & Row, 1966.

Nash, Paul, 'Swanage: or, Seaside Surrealism', *Architectural Review* **LXXIX**, April 1936, 154.

Nelson, R., and R. Shiff (eds), *Critical Terms for Art History*, Chicago IL: University of Chicago Press, 1996.

Newbury, Colin, *Tahiti Nui: Change and Survival in French Polynesia 1767–1945*, Honolulu: University Press of Hawaii, 1980.

Nochlin, Linda, 'The Invention of the Avant-Garde: France, 1830–1880', in Thomas Hess and John Ashbery (eds), *Avant-Garde Art*, London: Collier-Macmillan, 1968.

Nuti, Lucia, 'Mapping Places: Chorography and Vision in the Renaissance', in D. Cosgrove (ed.), *Mappings*.

Nygren, Edward J., *Views and Visions: American Landscape before 1830*, exh. cat., Washington DC: Corcoran Gallery of Art, 1986.

Oetterman, Stefan, *Das Panorama: die Geschichte eines Massenmediums*, Frankfurt am Main: Syndikat, 1980. Trans. D. Schneider as *The Panorama: History of a Mass Medium*, New York: Zone Books, 1997.

Oleksijczuk, Denise Blake, 'Gender in Perspective: The King and Queen's Visit to the Panorama in 1793', in S. Adams and A.G. Robins (eds), *Gendering Landscape Art*, Manchester: Manchester University Press, 2000, pp. 146–61.

Oliver, Douglas, *Ancient Tahitian Society*, 3 vols, Honolulu: University Press of Hawaii, 1974.

Patin, S., 'Un tableau de la serie des Peupliers de Monet', *La Revue du Louvre* **53** (2) April 2003, 22–4.

Perruchot, Henri, *La Vie de Manet*, Paris: Hachette, 1959.

Perry, Gill, 'Primitivism and the "Modern" ', in Charles Harrison et al., *Primitivism, Cubism, Abstraction: The Early Twentieth Century*, New Haven CT and London: Yale University Press and the Open University, 1993, pp. 3–85.

Phillips, Roger, *Trees in Britain, Europe and North America*, London: Pan, 1978.

Pinson, Stephen, *Speculating Daguerre*, PhD thesis, Harvard University, Department of History of Art and Architecture, May 2002.

Plax, Julie, *Watteau and the Cultural Politics of Eighteenth-Century France*, Cambridge: Cambridge University Press, 2000.

Pointon, Marcia, *Naked Authority: The Body in Western Painting 1830–1908*, Cambridge: Cambridge University Press, 1990 .

———, 'The Representation of Time in Painting: A Study of William Dyce's *Pegwell Bay: a recollection of October 5th 1858*', *Art History* **1** (1) 1978, 99–103.

———, *William Dyce 1806–1864: A Critical Biography*, Oxford: Oxford University Press, 1979.

Polunin, Oleg, *Trees and Bushes of Europe*, Oxford: Oxford University Press, 1976.

Powell, Cecilia, *Turner in the South: Rome, Naples, Florence*, New Haven CT and London: Yale University Press, 1987.

Pugh, Simon, *Garden, Nature, Language*, Manchester: Manchester University Press, 1988.

Quétel, Claude, *History of Syphilis*, 1986, trans. Judith Braddock and Brian Pike 1990, Baltimore: Johns Hopkins University Press, 1992.

Quilley, Geoff, and Bonehill, J. (eds), *William Hodges 1744–1797: The Art of Exploration*, exh. cat., New Haven CT and London: Yale University Press, 2004 .

Rackham, Oliver, *The History of the Countryside*, 1986, London: J.M. Dent & Sons, 1990.

Robertson, Bruce, *The Art of Paul Sandby*, New Haven CT: Yale Center for British Art, 1985.

Rosenthal, Michael, *Constable: The Painter and his Landscape*, New Haven CT: Yale University Press, 1983.

——, 'A View of New Holland: Aspects of the Colonial Prospect', in C. Payne and W. Vaughan, *English Accents: Interactions with British Art c.1776–1855*, Aldershot: Ashgate, 2004, pp. 79–100.

Rudwick, Martin J.S., *Scenes from Deep Time: Early Pictorial Representations of the Prehistoric World*, Chicago IL: University of Chicago Press, 1992.

Sartre, Jean-Paul, *L'Age de raison*, 1945, trans. Eric Sutton as *The Age of Reason*, 1947, London: Penguin, 1961.

Shackelford, George, and Claire Frèches-Thory (eds), *Gauguin Tahiti*, exh. cat., Boston MA: MFA, 2004.

Shanes, Eric, *Turner's Human Landscapes*, London: Heinemann, 1989.

Sharpe, William C., *Unreal Cities: Urban Figuration in Wordsworth, Baudelaire, Whitman, Eliot, and Williams*, Baltimore MD: Johns Hopkins University Press, 1990.

Shiff, Richard, *Cezanne and the End of Impressionism: A Study of the Theory, Technique and Critical Evaluation of Modern Art*, Chicago IL: University of Chicago Press, 1984.

——, 'Something is Happening', *Art History* **28** (5) 2005, 765–7.

Sloan, Kim, *'A Noble Art': Amateur Artists and Drawing Masters c.1600–1800*, London: British Museum Press, 2000.

Smith, Bernard, *European Vision and the South Pacific*, 2nd edn, New Haven CT: Yale University Press, 1985.

Smith, Greg, *Thomas Girtin: The Art of Watercolour*, London: Tate Gallery, 2002.

Staley, Allen, *The Pre-Raphaelite Landscape*, Oxford: Clarendon Press, 1973.

Sweetman, David, *Paul Gauguin: A Life*, New York: Simon & Schuster, 1996.

Thomas, Edward, *The Collected Poems of Edward Thomas*, ed. R. George Thomas, Oxford: Oxford University Press, 1981.

Traeger, Jörg, 'L'Epiphanie de la liberté. La Révolution vue par Eugène Delacroix', *Revue de l'Art* (98) 1992, 9–28.

Truman, A.E., *Geology and Scenery in England and Wales*, Harmondsworth: Penguin, 1971.

Tucker, Paul, *Monet in the 90s*, Boston MA: Museum of Fine Arts and Yale University Press, 1989.

——, *Monet at Argenteuil*, New Haven CT: Yale University Press, 1982.

Vaughan, William, *Art and the Natural World in Nineteenth-Century Britain*, Lawrence: University of Kansas, 1990.

——, *German Romanticism and English Art*, New Haven CT: Yale University Press, 1979.

——, *German Romantic Painting*, New Haven: Yale University Press, 1982, 2nd edn 1994.

Waller, John H., *Beyond the Khyber Pass: The Road to British Disaster in the First Afghan War*, Austin: University of Texas Press, 1990.

Wilcox, Scott B., 'Unlimited the Bounds of Painting', in R. Hyde (ed.), *Panoramania!*.

Wilson-Bareau, Juliet, et al., *Manet: The Execution of Maximilian: Painting, Politics and Censorship*, exh. cat., London: National Gallery, 1992.

Wood, R. Derek, 'The Diorama in Great Britain in the 1820s', *History of Photography* **17** (3) 1993, 284–95.

Wyver, John, *The Moving Image: An International History of Film, Television, and Video*, London: Blackwell and BFI Publishing, 1989.

Index